Great
Modern
Masters

Great Modern Masters

with an introduction by
Sir John Rothenstein

EXCALIBUR BOOKS

NEW YORK
IN ASSOCIATION WITH PHOEBUS

Co-ordinating Editor: Corinne Benicka
Production: Brenda Glover

Copyright © 1980 Phoebus Publishing Com-
pany/BPC Publishing Limited, 52 Poland Street,
London W1A 2JX

First published in USA 1980 by Excalibur Books
Distributed by Bookthrift New York, New York
10018

ISBN 0-89673-047-6
Library of Congress Number 79-57472

This material first appeared in *The Masters*
© 1963 Fratelli Fabbri Editori
© 1967 Purnell & Sons Ltd

Made and printed in Great Britain by Purnell &
Sons Ltd, Paulton (Bristol)

Introduction

BY SIR JOHN ROTHENSTEIN

The couple of centuries from the birth of Turner in 1775 to the death of Picasso in 1973 are probably unique in the variety of achievement that came to fruition in them. Most of the painters whose work is illustrated in this book were inevitably affected—sometimes more, sometimes less by their predecessors and contemporaries, but every one of them was distinctive and original. A student might, for example, attribute a Van der Goes to Memlinc, but it would be impossible for any student, however at sea, to confuse a Van Gogh with, say, a Matisse.

As might well be expected, a number of original artists, fresh from training, have produced work conformist with the dominant fashion of their time, but their originality is apt to assert itself.

The present volume consists of reproductions of the mature works of artists who have made paintings expressive of ways of seeing that were so original as to startle and antagonize, for a time at least, both the Establishment and the public.

About their work, apart from its originality, it is scarcely possible to generalize. Different, even sharply contrasting in character as it is, the work of Reynolds and of Gainsborough has often been compared. Comparison has also been made between Turner and Constable, but Turner belongs to a period earlier than do the others whose work is illustrated here, when traditions were still formidable and affected to some degree the early works, at least, of almost every artist. Turner's sheer genius eventually enabled him to ignore it. The work of the later painters expresses a rare degree of individuality increasing with the passage of time.

This phenomenon was rendered possible by the increasingly rapid erosion and eventual collapse of the traditions that once had commanded general assent. Besides, Turner, Manet and Renoir were less conspicuously detached from it than were Cézanne, Van Gogh, Matisse, Picasso. Today the collapse is virtually complete, so that even these last look traditional in comparison with many painters who are active today. But though tradition as a generally accepted discipline has almost entirely disappeared, it is deliberately and even strictly observed by a diminishing number of painters who include a few of exceptional talent.

Generalization, then, about the style or even the character of the illustrations that follow is hardly possible. In the virtual eclipse of traditions, the creators of the originals found the ability to express themselves with a freedom scarcely conceivable before the 19th century. Renoir would have adapted himself happily to the climate of the 18th, but in that age what would have happened to the imperiously personal and revolutionary Picasso? This last century of dwindling and finally vanished painterly traditions had encouraged painters 'to be themselves' with a freedom never before experienced. There was, after all, no option.

What the eventual effects of such freedom will be nobody can predict, but the brilliant originality and immense variety of the masters from Turner to Picasso nobody can question.

Contents

Joseph Turner

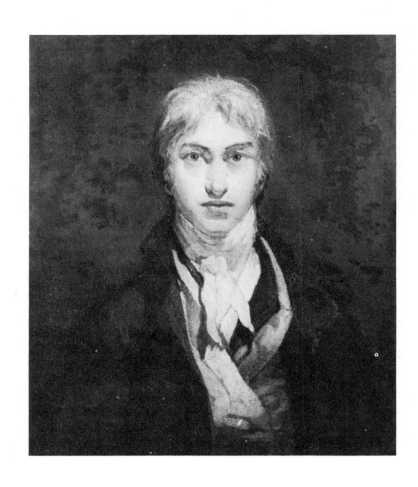

Joseph Turner
1775-1851

Joseph Mallord William Turner was born on 23 April 1775 in London, at a house in Maiden Lane behind Covent Garden. His father was a barber and wig-maker. He died on 19 December 1851, also in London, at 119 Cheyne Walk, Chelsea. Between his birth and his death his biography is almost exclusively one of his painting life.

His memory was done appalling disservice by a life published in 1861, written by a journalist named Walter Thornbury. Thornbury was in fact immediately discredited by the evidence of contemporaries and could only reply by speaking of 'a forthcoming second edition'. But he did nothing until 1877 when he issued a 'revised' edition that is almost a reprint of the first.

It is Thornbury who is responsible for the legend of a Turner who caroused and 'wallowed' in Wapping, who kept a number of very ugly mistresses, who was hard-fisted, boorish, and a showman avid for celebrity. There is no evidence for any of this. So boorish was he that Constable wrote of his 'wonderful range of mind', and Ruskin that he was 'good-natured' and 'highly intellectual'. Being unmarried he hired housekeepers. His attitude to the marketing of his pictures was businesslike: he regarded them as articles with a definite market value; but he was accommodating to a degree and reserved his fortune for charity.

Turner's talent manifested itself while he was still a boy, and by 1789 his father, who subsequently devoted himself to his son's career, had decided that he should be a painter. In that year he was admitted to the Royal Academy Schools. By 1794 he had five watercolours at the Academy Exhibition and attracted press notice for the first time. In the evenings, for some three years in the mid-'nineties, he was employed, along with Thomas Girtin, copying drawings by J. R. Cozens and others.

In 1795 he made one of his first sketching tours, to South Wales and the Isle of Wight. The tours continued throughout his life, the last being made in 1845. In fact Turner's life is without incident or history other than the history of his art. Until his last years he was physically strong; this strength and a single-minded austerity enabled him to work without respite. Moreover, businesslike as always, he so arranged his life that he was able to give all his time to drawing and painting, and with such determination that in his later years secretiveness and elusiveness became obsessions of his; so anxious was he to be left alone that he lived under various aliases. He was also closely secretive about his techniques, and some have died with him.

His first visit abroad was made in 1802 during the Peace of Amiens; he went straight through France to the Alps, on his way home spending between one and three weeks in Paris, studying in the Louvre, and with extraordinary insight, particularly the Titians and the Poussins. He was in Belgium and Holland and along the Rhine, for the first time, for some weeks in 1817, and in 1819 made the first of four visits to Italy. Of no less importance than his Italian journeys, however, was his frequent residence, after his father's death in 1829, as a favoured guest of the third Earl of Egremont at Petworth, Sussex, from 1830 to 1837.

Ruskin and Turner met for the first time in 1840, the first volume of 'Modern Painters' being published three years later. Turner was reticent about what he thought of this impassioned defence of himself—only remarking that Ruskin was a bit hard on other painters, as he did not know how difficult painting was. It is not surprising. Though no one did more for Turner, perhaps, than did Ruskin, in some respects he has served him as ill as did Thornbury. Much of Turner has disappeared from sight behind the eloquence and prolixity of Ruskin's prose, and his advocacy of Turner's later work has had the effect, which perhaps still lingers, of to some degree falsifying the perspectives along which we look at the earlier work and particularly the more apparently classical work.

Like Cézanne, Turner was inarticulate about painting and impatient of talk about it. His only known utterance, apart from observations on its difficulty, is, apparently, that painting is 'a rummy thing'.

'Wrecked, and faded, and defiled, his work still, in what remains of it, or may remain, is the loveliest ever yet done by man, in imagery of the physical world.' — RUSKIN

Although in the enormous range of his work and in its intrinsic qualities Turner is beyond doubt the greatest painter produced so far by the English-speaking peoples, and although his own gift of his paintings to the nation was munificent, there is none the less still disagreement about large tracts of his work and there is not yet any consensus about its evolution. One view still prevalent, and, I believe, entirely erroneous, is of a prodigiously gifted Turner who, in his early years, dazzled his contemporaries with a series of 'stunners' in which he challenged and dramatically outdid such painters as Poussin, Claude, Van de Velde and Cuyp, and who thereupon, having achieved popularity and financial independence, went his own way and for one reason or another—visits to Italy perhaps—proceeded to paint quite differently and to shock his public.

IN FACT there is a strong inner consistency about the evolution of Turner's work throughout his long and unremittingly industrious painting life. And yet there are difficulties in the way of seeing this consistency, and for one of them Turner is himself responsible. The condition of his painting is often deplorable. As early as 1805 he opened a gallery of his own—in Harley Street and subsequently round the corner in Queen Anne Street—and as the years went by its physical state, and with it that of its contents, deteriorated alarmingly. Much worse, he was himself, as far as the chemistry of paint was concerned, a reckless technician and an over-audacious experimentalist. 'No painting of Turner's', wrote Ruskin in the first volume of 'Modern Painters', 'is seen in perfection a month after it is painted . . . the vermilions frequently lose lustre . . . and when all the colours begin to get hard . . . a painful deadness and opacity comes over them, the whites especially becoming lifeless and many of the warmer passages settling into a hard, valueless brown'. Ruskin's evidence accords with much contemporary criticism even of the young Turner. Pictures that have darkened with time and the

painter's rashness, provoked contemporary anger at their high tonality and the 'violence' of the colour. Criticism such as this became common form from about 1802 onwards, when Turner was twenty-seven years old, and it was occasioned also by the 'stunners'.

Prodigiously gifted as indeed he was, Turner was far from being a chameleon. His first-known watercolour belongs to 1787, when he was twelve, and by 1794, in his late teens, he was already a master of the then traditional style and technique of topographical drawing and watercolour. These drawings reflect, too, without any originality, the current feeling for ruined abbeys and castles and the 'picturesque'. It was these that first attracted attention. He had made his mark by 1799 when, after nine years of exhibiting, he was elected an Associate of the Royal Academy. He was 24 years old. But many watercolours done between 1797 and 1799 show that, largely owing to a close study of sketches and watercolours of J. R. Cozens and to working with Thomas Girtin, Turner was already pouring new wine into old bottles, accepting conventional subjects and turning them, almost imperceptibly, to his own purposes.

Topographical watercolour drawing remained a constant preoccupation of Turner's all his life. His material he amassed in annual sketching tours, a practice from which he rarely deviated, in which, in every condition of weather and often on foot, he travelled through much of Europe and most of Britain, filling notebooks and storing a preternaturally retentive memory. From very early years these watercolours show Turner's consistently evolving passion for fluidity and atmosphere, for light and colour, which for the reason suggested earlier is to some extent obscured in many of his surviving oils. Indeed, like Cézanne's, Turner's handling of watercolour affected his handling of oil paint and is clearly responsible for his high tonality and his way of putting on the pigment. The watercolours, too, and the series of engravings he made from them, remained popular, and found purchasers, long after his exhibited oil pictures

11

remained unsold, and were largely responsible for his name becoming a household word.

Nowadays we prefer the lyric to the epic and painting that palpably preserves freshness of observation to painting that looks 'finished' (though in fact lack of 'Flemish finish' was another of the stock criticisms of the young Turner); we prefer the sketch to painting that is closely organized in a large composition. In any case 'history painting' is not to our taste. But just as in his watercolours, so in many or most of the ambitious pictures that were inspired by his emulation (itself a tribute) of Old Masters, Turner's ambition was not personal *réclame* through a melodramatic trumping of them; it was rather more painterly. He was, in fact, following Sir Joshua Reynolds' advice not to study the Old Masters by copying them but to learn from their art by doing others in a like manner. And he achieved not mannerism but, usually, something entirely his own. *The Fifth Plague of Egypt* (Plate II), exhibited in 1800, when Turner was twenty-five, is a sufficient example of this. It is 'after Poussin' and a dramatic landscape dominates the picture, but in it he is painting his own developing way of seeing and feeling; it is a stage in a prolonged effort to find himself, by working in the manner of masterpieces that he revered, to his own ends as they disclosed themselves in the process of working. In this case—although the method of working is alien to our own century's concept of originality—the observation in the picture came largely from a storm in North Wales in which Turner had found himself the year before.

TURNER'S first exhibited oil painting was almost certainly *Fishermen at Sea* (Fig. 2), shown in 1796; *Moonlight, a Study at Millbank* (Fig. 3), his first fully documented painting, followed a year later. It is significant that his very first oil should illustrate two abiding interests of his; that it is primarily an essay in light (moonlight and a lantern in a boat) is obvious enough; still more fascinating is the elliptical shape of the composition. Close observer as he was, Turner was well aware, as MacColl wrote of him many years ago, that 'our natural vision has the shape of a vague ragged oval, the subject, by our attention, shaping itself on this vague ellipse, clear in the centre, dim at the edges.' So it was that in his later and more immediately 'emotional' works the build of Turner's composition tended to move away from the rectangular panel shape to an oval, sometimes, as in his pictures of tranquillity and space, like *Norham Castle: Sunrise* (Plate XVI) 'curving into a receding shimmer of iridescent tone', sometimes, as in a tempestuous subject like *Snow Storm—Steam Boat off a Harbour's Mouth* (Plate XIII), becoming the whirling vortex that Turner also saw as expressive of the destructive forces of nature as they overarch the fragility and littleness of humankind. *The Shipwreck* (Plate III) and *Snow Storm: Hannibal and his Army crossing the Alps* (Plate VII) are further illustrations of Turner's seeing and composing in terms of the vortex or whirlpool.

For many, a first acquaintance with Turner's pictures can be a confusing experience; he was a painter who did a variety of things at the same time. He became a man who from unremitting study of nature and of art was exceptionally and minutely observant of every effect of light falling on form and who was able to find a complete visual equivalent for his every observation and emotion. Nor did he ever forget what his eye had seen. But in addition the operations of his mind were those of a poet, and a poet concerned with the precarious situation of man in the immensity and destructiveness of nature. But this vision of the human predicament he expressed not symbolically, so to say, or through the often lengthy titles he gave his pictures, nor yet through the verses, whether from Thomson's 'Seasons' or 'Liberty' or from his own meandering epic on 'The Fallacies of Hope', with which he often embellished them; he expressed it through the painting itself, through the modelling of a rock, let us say, by the light. Moreover, there is a sense in which, even in many of his latest most delicate and near abstract harmonies of colour, Turner was a 'realist' and, as Ruskin argued, distinguished by 'truth to nature'. Among the great pictures just mentioned *Snow Storm: Hannibal and his Army crossing the Alps* was based on Turner's personal observations of a storm at Farnley in Yorkshire and on his memories and sketches of the Alps, and meteorologists recently consulted have declared it very accurate. Similarly, evocative and dream-like as it is, seemingly painted, as Constable commented of an exhibition of Turner's in 1836, 'with tinted steam, so evanescent and so airy', *Norham Castle: Sunrise* has none the less so much close observation and discipline behind it that, oddly enough, it feels more 'real', more like a real place, than do many of his early topographical drawings. *Snow Storm—Steam Boat off a Harbour's Mouth* was the subject of one of the few recorded comments of Turner's about his own pictures and their critics. The critics were entirely puzzled by it. Turner explained that he had painted it only to show what such a storm was like. Sixty-seven years old, he had got the sailors (he was aboard) to lash him for four hours to the mast, so that he could watch it. The painting was described as 'soapsuds and whitewash', and for once Turner was galled. 'After dinner', Ruskin records, 'sitting in his armchair by the fire, I heard him muttering low to himself at intervals "Soapsuds and whitewash!" again and again, and again. At last I went to him, asking why he minded what they said. Then he burst out "Soapsuds and whitewash! What would they have? I wonder what they think the sea is like? I wish they'd been in it".' *Rain, Steam and Speed* (Plate XV) is based on observation from a carriage window of the train. A fellow passenger who had watched him also put her head out. In next year's Academy (1844) she saw the picture and overheard the complaint 'Who ever saw such a ridiculous conglomeration?' She was able to reply: 'I did.'

AS A PAINTER Turner was thoroughly happy with bad weather; avalanches and deluges, whirlwinds and vortex-like convulsions of the sea are deeply expressive of his spirit. Not, of course, that they are the only aspects of nature with which he was happy or that he was obsessed by them. In fact, there is probably no painter in history who can so magically convey in paint a sense of enchanted serenity and large tranquillity. *Buttermere Lake* (Plate I) is an early example. *Windsor Castle from the Thames* (Plate IV) is another, to which indeed a severely classical treatment gives a still and timeless quality. *The Thames near Walton Bridges* (Plate V) is entirely different in character. It belongs to a series of small oil sketches made circa 1807 in the open air, and mostly from a boat, up and down the Thames, of trees and woods and stretches of water under various effects of light.

Naturalistic and intimately observed as they are, this series of panels affords a good illustration of Turner's pictorial eye. His scrutiny of nature also composes a picture almost from the start, but, to quote MacColl once more, 'design is not a rhythm forced on objects from without or uncertainly apprehended in them. It is an eye for their own principle of construction, their private rhythm. He could

grow trees and rocks from within.' This series was made by Turner for himself and more than a century elapsed before they were exhibited.

Petworth, Sussex, the seat of the Earl of Egremont: Dewy Morning (Plate VI) is another painting of benignity and peace. It is topographical painting with a difference, the house itself being only one element among others in a total atmospheric unity. Moreover, as a hostile critic of the picture noted when it was exhibited, it was Turner's intention 'to express the peculiar hue and pellucidness of objects seen through a medium of air, in other words to express the clearness of atmosphere'. This being his aim, it is not surprising that, taking note of the effects of white paper on his watercolours, he began, as in this picture, to use a white ground for his oils. It was an innovation in technique which, although only fully exploited later, enabled him to create brilliant light by a harmony of light tones instead of by a contrast of light with dark ones. It was a simple innovation but a revolutionary one.

This intimacy and serenity of Turner's treatment of landscape is found in many other landscapes of this time, as in, for instance, the stillness and tenderness of *Frosty Morning* (Plate VIII), a universal favourite from its first exhibition in 1813—possibly because, as a critic put it, 'in silvery brightness of effect it is equal to the richest productions of Cuyp or Claude'. It is to be found in sea-pieces as well, such as *Dort or Dordrecht* (Plate X) of a few years later, another picture painted in a high key and with colouring so resplen-

dent that, as one contemporary said, 'it almost puts your eyes out'.

As TURNER grew older he moved, more and more, in and out of an enchanted world of his own, of colour and of light—yet a world, as I have argued, that feels more real than a world of sharply defined and solid forms. His evolution into this 'vision of enchantment' can, I think, be traced from early in his career. But it is likely that a natural development was in some ways accelerated and intensified by the visits to Italy that he made, first in 1819 for some five months, for another five months in 1829-30, and again for a few weeks to Venice in 1835 and 1840. Of these visits it is the second that was the most immediately fertile, even though it was Venice (which he did not visit on this occasion) that affected him most profoundly. But the relations between experience and imagination and remembered experience are immensely complex, and in fact it was not until fourteen years after his first visit that he made, at home, his first Venetian oil paintings. But the principal reason for the fecundity of Turner's brief visits to Italy and especially to Venice is to be read where Laurence Binyon read it, in the many watercolours that he made purely for his own satisfaction. Venice is a city set between sea and sky, so that in these drawings 'buildings that seem hardly more substantial than their reflection intercept the beating of the light only to enhance its glory'.

Turner's oils of Italian subjects were mostly made at

2. FISHERMEN AT SEA. F. W. A. FAIRFAX-CHOLMELY, ON LOAN TO THE TATE GALLERY, LONDON

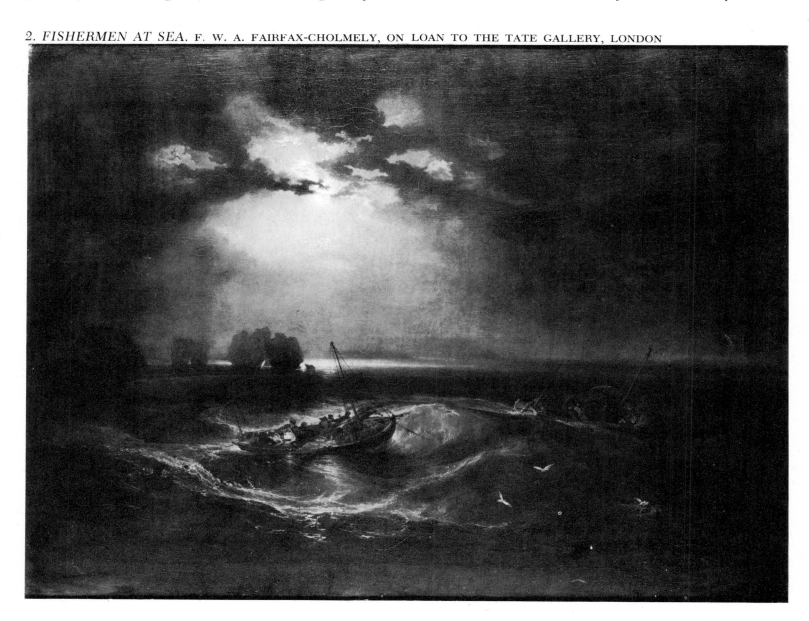

home afterwards, sometimes long afterwards. But there is a small group of oil sketches on millboard and of larger sketches on canvas, now in the Tate Gallery, that were made in Italy. *Rocky Bay with Figures* has affinities with these latter, although, unfinished as it is, it is in modelling and colouring a much subtler work. *Yachts approaching the Coast* (Plate XIV), of some fifteen years later, is likewise akin to a number of unexhibited Venetian oils painted at roughly the same time, in which the subject is not so much the behaviour of light as it falls on surfaces as light and colour in themselves.

Yet it is an over-simplification to attribute Turner's later style, in all its vast range and variety of technique, to the impact of Venice. As early as 1816 the young Hazlitt had complained that Turner's pictures were 'too much abstractions of aerial perspective and representations not properly of the objects of nature as of the medium through which they were seen . . . All is without form and void'. Someone said of his landscapes that they were 'pictures of nothing and very like'. Nor was Venice the only catalyst. There is another in the circumstances of his private life. In the September of 1829 Turner's devoted father died, and although he had known and visited Petworth House for some twenty years, from 1830 until its owner, Lord Egremont, himself died in 1837 Turner was a frequent visitor there, with a privileged position in the household and his own studio. Whatever be the reason, whether it be the beauty of the house and park, or the freedom and glory of nature, about whose effects on him Ruskin wrote with eloquence and insight in his celebrated chapter 'The Two Boyhoods' in the fifth volume of 'Modern Painters', or whether it be quite simply the exhilarating presence of the sardonic and wildly eccentric Lord Egremont himself, Petworth gave Turner a happiness that both fertilized and released his genius. At Petworth or through it he achieved a multitude of paintings of luminous enchantment on his own terms of colour and light. *Petworth Park: Tillington Church in the Distance* (Plate XI) is an early example of his work during this time of his life. It is a large sketch, modelled entirely in colour, for a picture to fill a specified place in the Grinling Gibbons room, and with its companions is often regarded as the finest of all his landscapes. And with reason: only the most complex experience of nature and an immense knowledge of art could yield a lyricism such as this or such spacious radiance or such idyllic stillness.

In subsequent oil paintings that he made at Petworth, all of interiors, light and colour become the principal subject of the painting, as they were Turner's principal preoccupation, and in some there is an almost complete dissolution of form. Light and colour dominate, too, *The Burning of the Houses of Lords and Commons* (Plate XII), and in the 'forties, in pictures in which yet again Turner returned to the destructiveness of fire and flood, distinctions between form and content are virtually dissolved. Yet as always there is knowledge behind this dissolution; as Turner himself commented of *Snow Storm—Steam Boat off a Harbour's Mouth*, this is what this storm at sea was like.

In his last years, before the decline of his powers, Turner was able, entirely through colour, to express both the themes he had pondered throughout his life and to say something about man and his place in nature: in the swirling forms of fire and flood (as in *Snow Storm—Steam Boat off a Harbour's Mouth*) his sense of human insignificance; in his evocations of tranquillity and peace (as in *Norham Castle: Sunrise*) his sense of the life-giving and life-enhancing essences of nature. It is entirely appropriate that his last great picture, exhibited in 1846, should have been *The Angel standing in the Sun*. It is a world, then, of colour and of light, and a world, too, that simply by colour and light mirrors, with terror or poignancy, the tragic destiny of man: his fragility and vulnerability; his aspirations and dreams; his longings and his ephemeral peace.

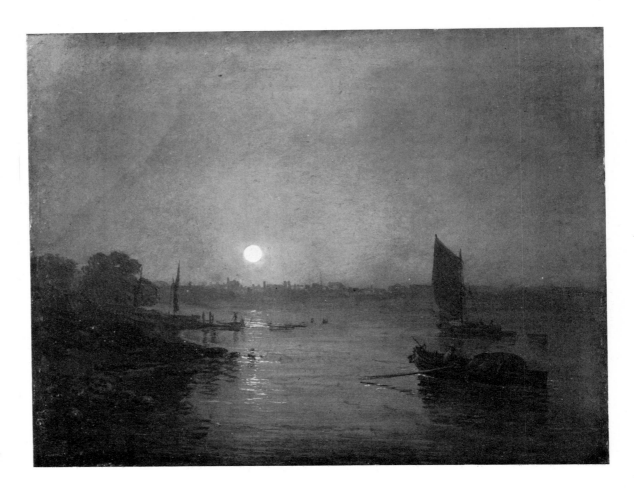

3. *MOONLIGHT, A STUDY AT MILLBANK.*
TATE GALLERY, LONDON

The Plates

I *BUTTERMERE LAKE WITH PART OF CROMACKWATER, CUMBERLAND, A SHOWER*
Oil on canvas, 35 in. × 46 in.
TATE GALLERY, LONDON

Exhibited Royal Academy 1798 – the year that also saw the publication of 'Poems and Lyrical Ballads'. Also on view at the Academy was Turner's *Morning amongst the Coniston Fells, Cumberland*, and these two works would seem to be the first major pictures of Lake District scenery, the setting of much of Wordsworth's subsequent poetry.

II *THE FIFTH PLAGUE OF EGYPT*
Oil on canvas, 49 in. × 72 in.
THE HEBRON MUSEUM OF ART, INDIANAPOLIS

Exhibited Royal Academy 1800. It is in fact not the fifth but the seventh Plague. For Turner, however, as for many Romantics, the Bible was a storehouse of evocative images and moods, and accuracy was inappropriate.

III *THE SHIPWRECK*
Oil on canvas, 67½ in. × 95 in.
TATE GALLERY, LONDON

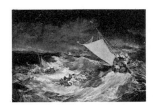

Exhibited in 1805 when Turner first opened his own gallery in Harley Street. His gallery subsequently moved to a nearby address, in Queen Anne Street, in 1820, where many of his pictures were stored in increasingly deplorable conditions until the end of his life.

Within the vortex-like composition of this picture Turner uses, as was his frequent practice, the dramatic effect of strong diagonals.

IV *WINDSOR CASTLE FROM THE THAMES* C. 1805
Oil on canvas, 35 in. × 47 in.
H.M. GOVERNMENT ON LOAN TO THE NATIONAL TRUST. LORD EGREMONT COLLECTION PETWORTH HOUSE, SUSSEX

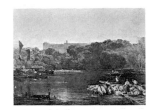

Its classical monumentality and colouring are akin to the similar qualities of a large history-painting exhibited in 1806, *The Goddess of Discord choosing the Apple of Contention in the Garden of the Hesperides.*

V *THE THAMES NEAR WALTON BRIDGES*
Oil on mahogany veneer.
14 in. × 29 in.
TATE GALLERY, LONDON

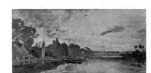

Painted between 1805 and 1810, and perhaps around 1807, from a boat. In this small series of Thames sketches the river generally appears in the foreground, but they are in fact painted as if from a point of view slightly above river level – a measure of detachment that hints that the view depicted is but part of an unbounded whole. 'To approach nature without ceremony', Sir Kenneth Clark once wrote, 'requires a long tradition of artifice.'

VI *PETWORTH, SUSSEX, THE SEAT OF THE EARL OF EGREMONT: DEWY MORNING* 1810
Oil on canvas, 35½ in. × 47½ in.
LORD EGREMONT, PETWORTH HOUSE, SUSSEX

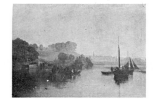

Exhibited Royal Academy 1810 and savagely criticized for its white ground and high tonality, and for slovenly execution and lack of finish. To this type of criticism, and to a general one of extravagance, Turner was well accustomed; he had heard and read it since about 1800.

VII *SNOW STORM: HANNIBAL AND HIS ARMY CROSSING THE ALPS*
Oil on canvas, 57 in. × 93 in.
TATE GALLERY, LONDON

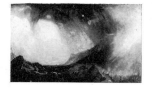

Exhibited Royal Academy 1812. The picture's theme is the fragility of man among the swirling tempestuous forces of nature, and the composition is itself organised (and seen) as a vortex.

VIII *FROSTY MORNING*
Oil on canvas, 44½ in. × 68½ in.
TATE GALLERY, LONDON

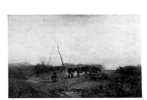

Exhibited Royal Academy 1813, with (like many other pictures of Turner's) a legend from Thomson's 'Seasons'. The impulse to paint it came from an experience of Turner's when travelling by coach in Yorkshire. For all its popularity, possibly because the anti-classical nature of his inspiration was apparent by 1813 and because Sir George Beaumont, a powerful *arbiter elegantiarum*, was loud in his dispraise, the picture was never sold.

IX *THE DECLINE OF THE CARTHAGINIAN EMPIRE*
Oil on canvas, 67½ in. × 95 in.
TATE GALLERY, LONDON

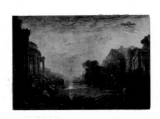

Exhibited (with a legend from Turner's own epic, 'The Fallacies of Hope') Royal Academy 1817. The critics objected to its too rich and, they thought, redundant colour. But when Ruskin saw it in the 'forties he was dismayed and shocked, in particular by its dullness in colour and its 'crude brown'. In Turner's first will it was destined for hanging between two pictures by Claude in the National Gallery, together with its companion, *Dido building Carthage*.

X *DORT OR DORDRECHT: THE DORT PACKET BOAT FROM ROTTERDAM BECALMED*
Detail
Oil on canvas, 62 in. × 92 in.
MAJOR LE G. G. W. HORTON-FAWKES

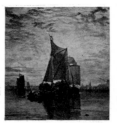

Exhibited Royal Academy 1818. It is to the *Dort* that Constable is almost certainly referring when he wrote of the singular beauty and intricacy of a painting of Turner's that he had seen: 'it was a canal with numerous boats making thousands of beautiful shapes, and I think the most complete work of genius I ever saw'. (Letter to Leslie, 14 January 1832.)

XI *PETWORTH PARK: TILLINGTON CHURCH IN THE DISTANCE*
C. 1830-31
Oil on canvas, 25½ in. × 58 in.
TATE GALLERY, LONDON

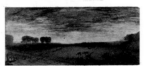

It is a sketch with several original features that were masked in the finished picture made from it: the boldly simple and elliptical composition, for example, and the procession of dogs streaming out into the distance to meet their returning master.

XII *THE BURNING OF THE HOUSES OF LORDS AND COMMONS*, 16th October, 1834
Oil on canvas, 36½ in. × 48½ in.
CLEVELAND MUSEUM OF ART, JOHN L. SEVERANCE COLLECTION

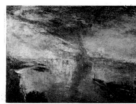

Exhibited Royal Academy 1835. Turner was in London, just back from Petworth, when the Houses of Parliament went up in flames. He made sketches of the fire from both banks of the river; two oils were exhibited in the following year, of which this picture, made as from the south end of Waterloo Bridge, is one.

XIII *SNOW STORM – STEAM BOAT OFF A HARBOUR'S MOUTH MAKING SIGNALS IN SHALLOW WATER, AND GOING BY THE LEAD. THE AUTHOR WAS IN THIS STORM ON THE NIGHT 'THE ARIEL' LEFT HARWICH*
Oil on canvas, 36 in. × 48 in.
TATE GALLERY, LONDON

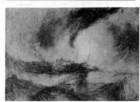

Exhibited Royal Academy 1842. Turner was on 'The Ariel', as his note, inserted into the picture's title, underscores, and he later explained that 'I got the sailors to lash me to the mast to observe it. I was lashed for four hours, and I did not expect to escape, but I felt bound to record it if I did. But no one had any business to like it.'

XIV *YACHTS APPROACHING THE COAST*
Oil on canvas, 40½ in. × 56 in.
TATE GALLERY, LONDON

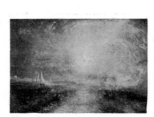

Painted about 1840-45. Turner's sketches in oil, however finished by present standards, were for him private or working material for his own eyes only. Although hardened to public criticism since 1800, when he was twenty-five, Turner would appear to have grown weary of it. This is one of the many pictures never exhibited in his lifetime – many of which have, indeed, only been put on view since 1938.

XV *RAIN, STEAM AND SPEED – THE GREAT WESTERN RAILWAY*
Oil on canvas, 35 in. × 48 in.
NATIONAL GALLERY, LONDON

Exhibited Royal Academy 1844. A sunlit wooded landscape seen through a shower of rain is in contrast with steam and smoke and the glow from an engine. It is poetry, but not fantasy. Turner is recorded to have put his head out of the window during a downpour and kept it there for almost nine minutes. Thereupon, streaming with water, he sat with his eyes shut for a quarter of an hour.

XVI *NORHAM CASTLE: SUNRISE*
BETWEEN 1840-1845
Oil on canvas, 36 in. × 48 in.
TATE GALLERY, LONDON

It would seem that Turner visited Norham Castle, on the Tweed, only twice, and not again after 1801. He drew and painted it several times. A watercolour was exhibited in 1798 and subsequent drawings were made for engravings, of which one, like the present picture in composition, was published in the 'Liber Studorium' and another in 'Rivers of England' in 1824. He resumed the theme in the evening of his life.

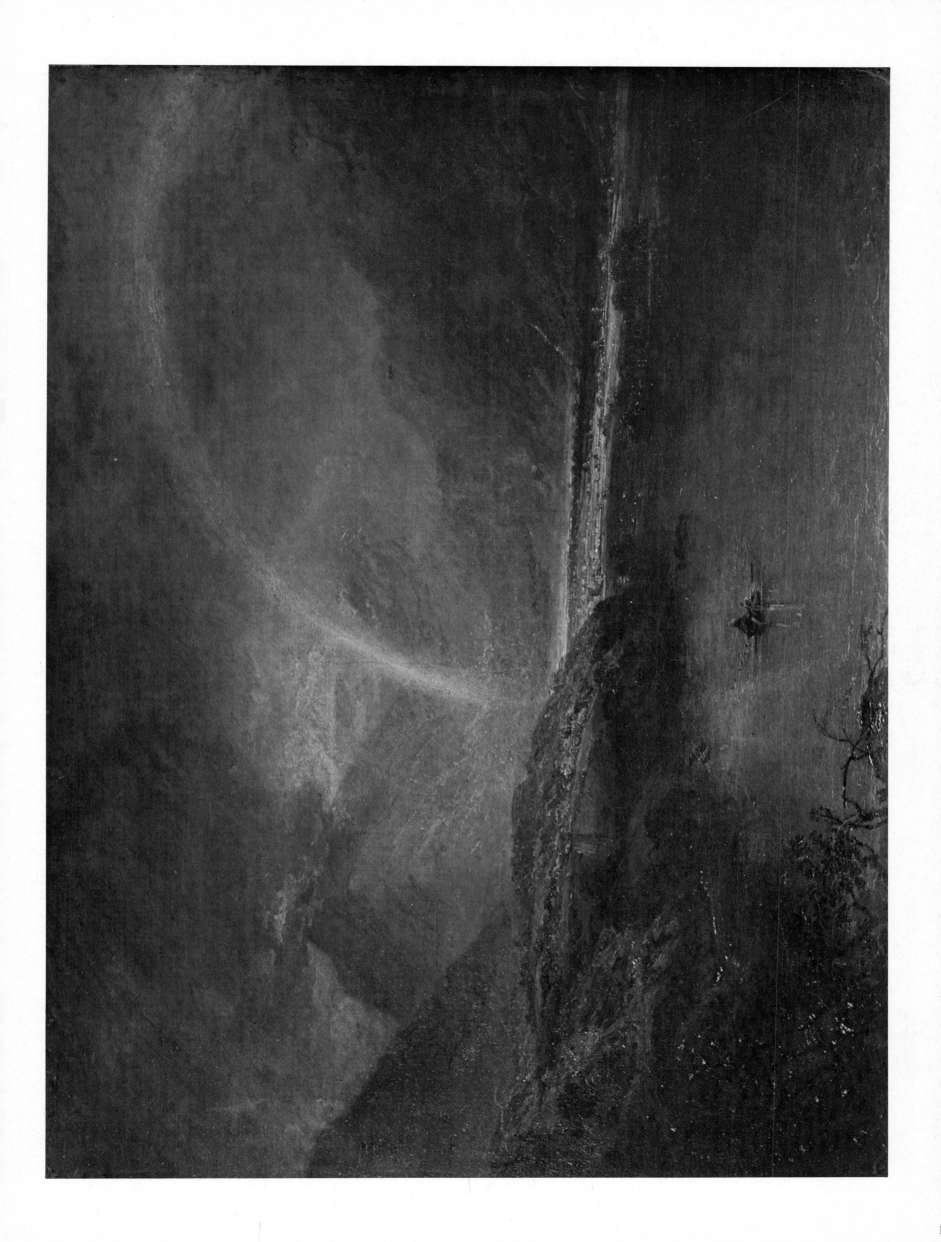

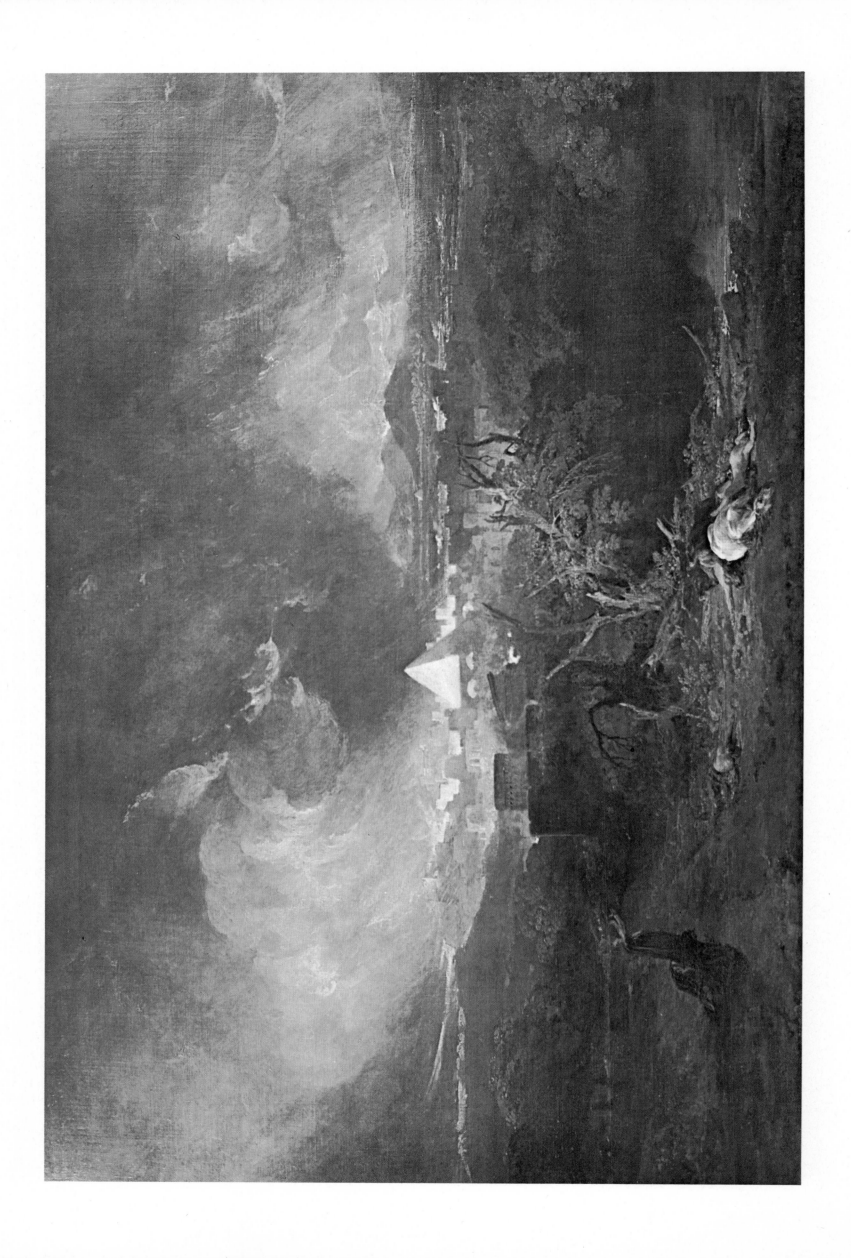

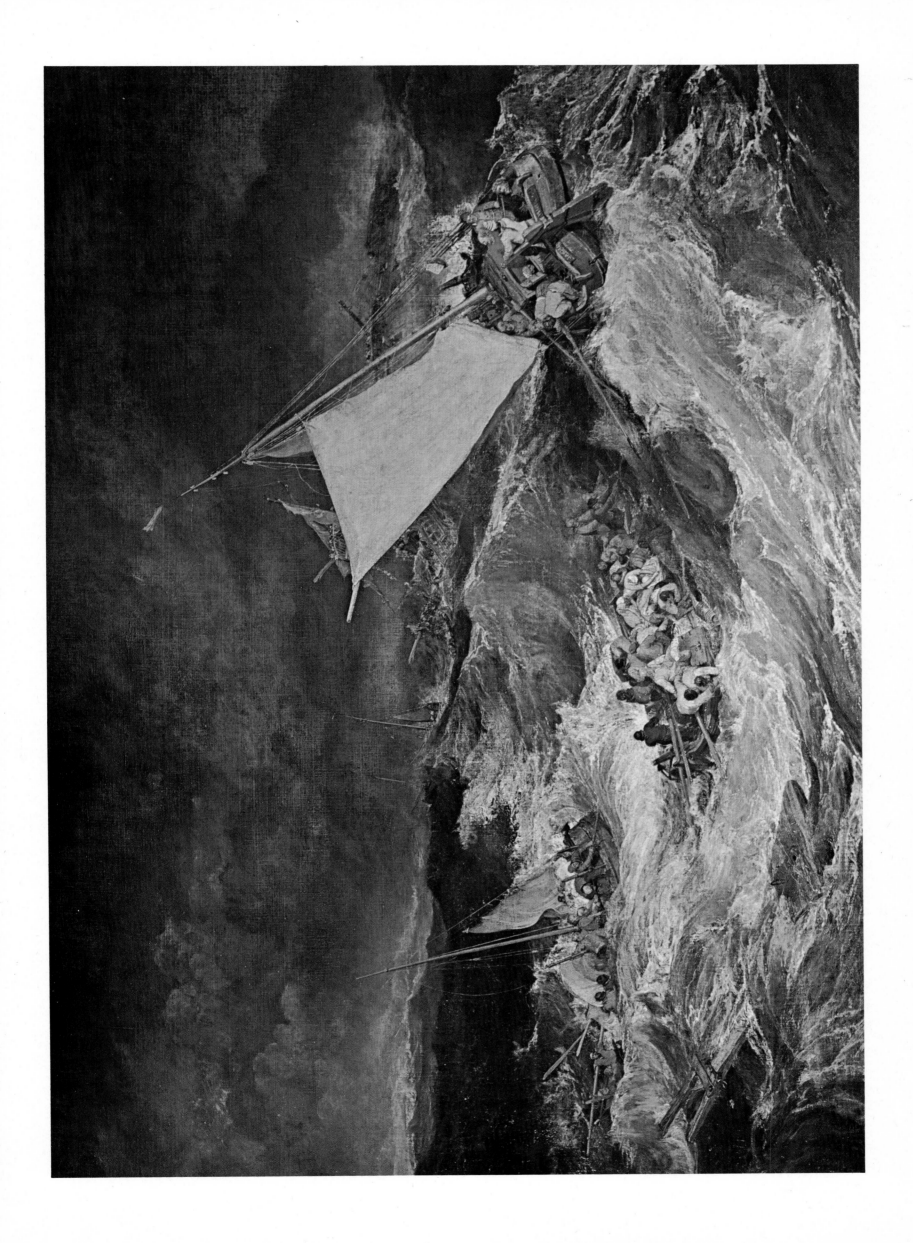

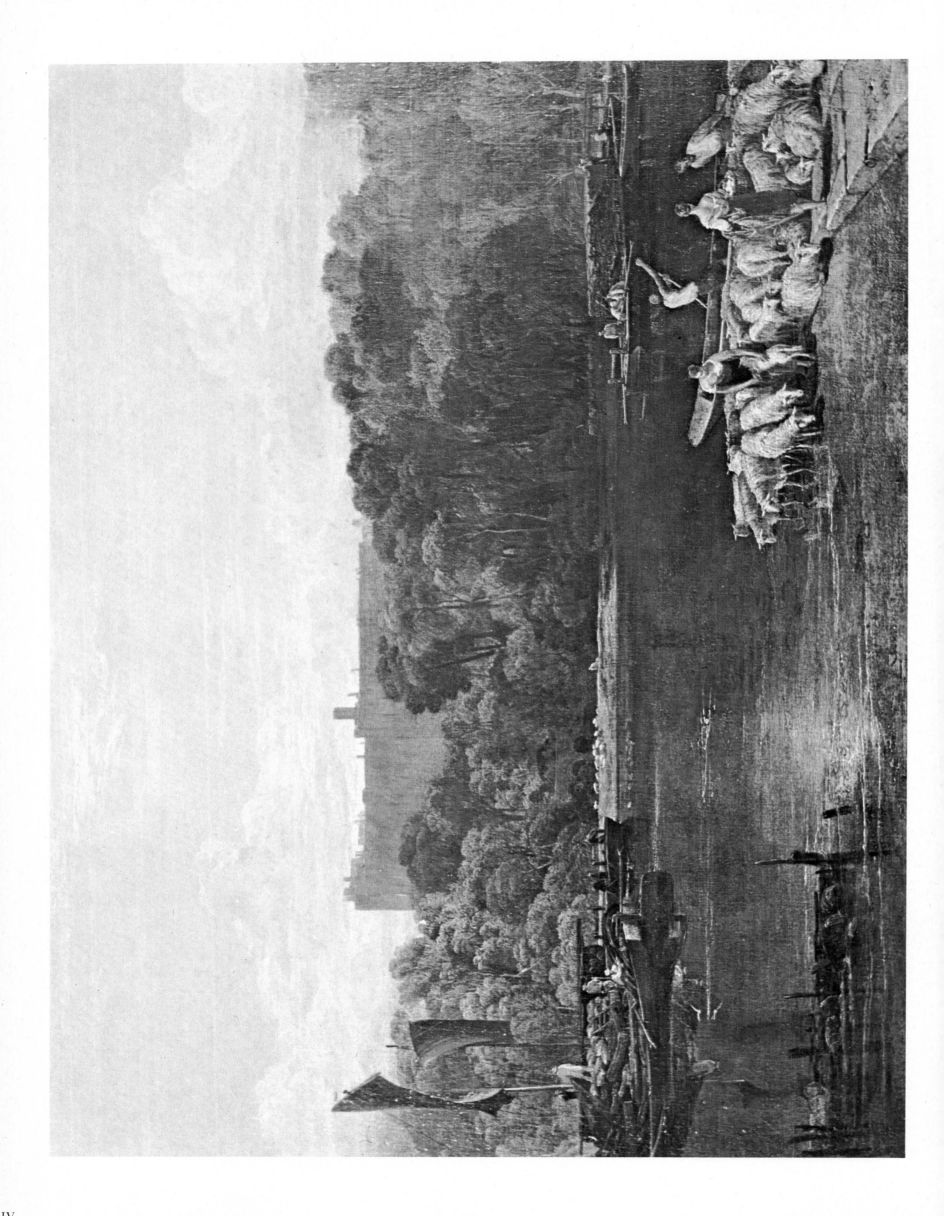

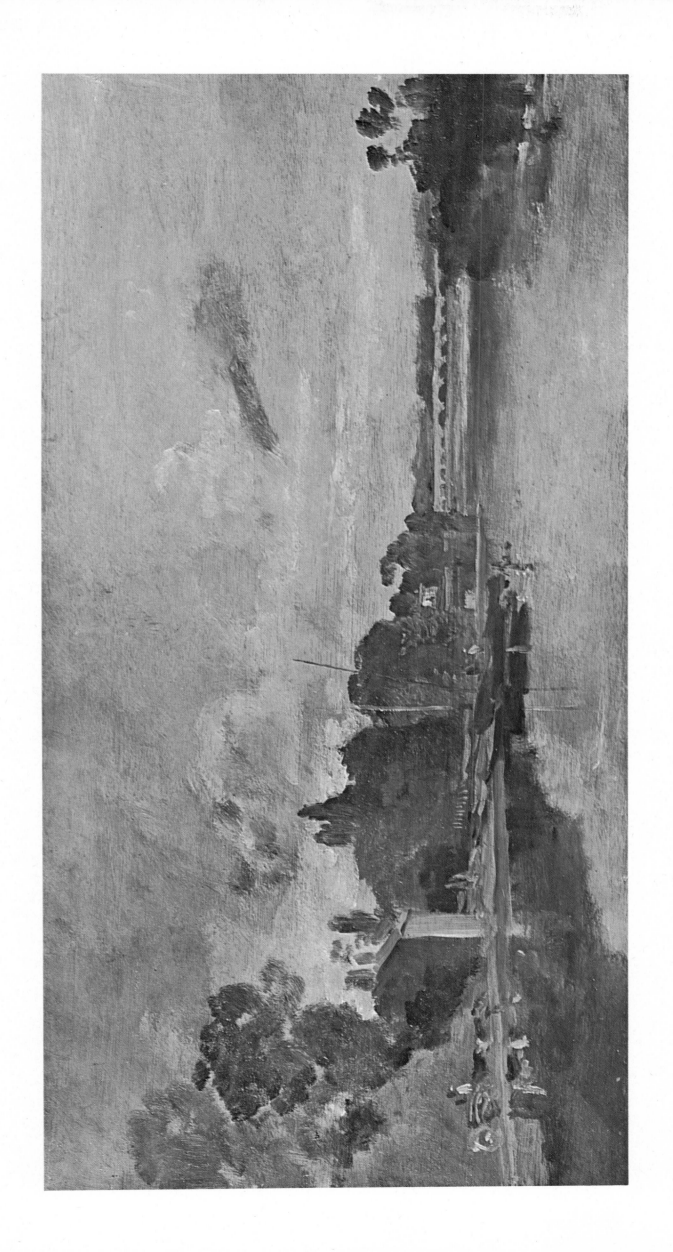

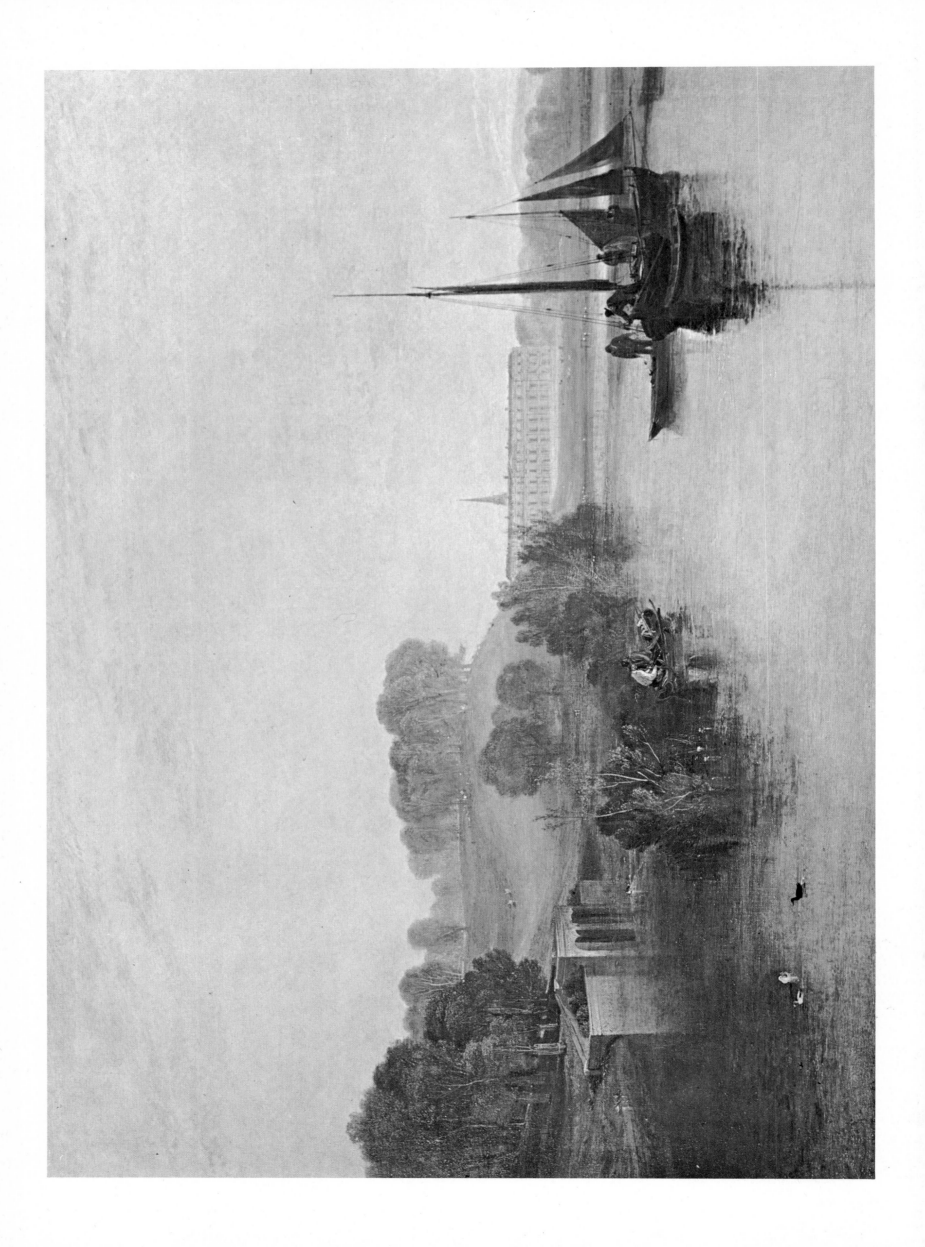

VI

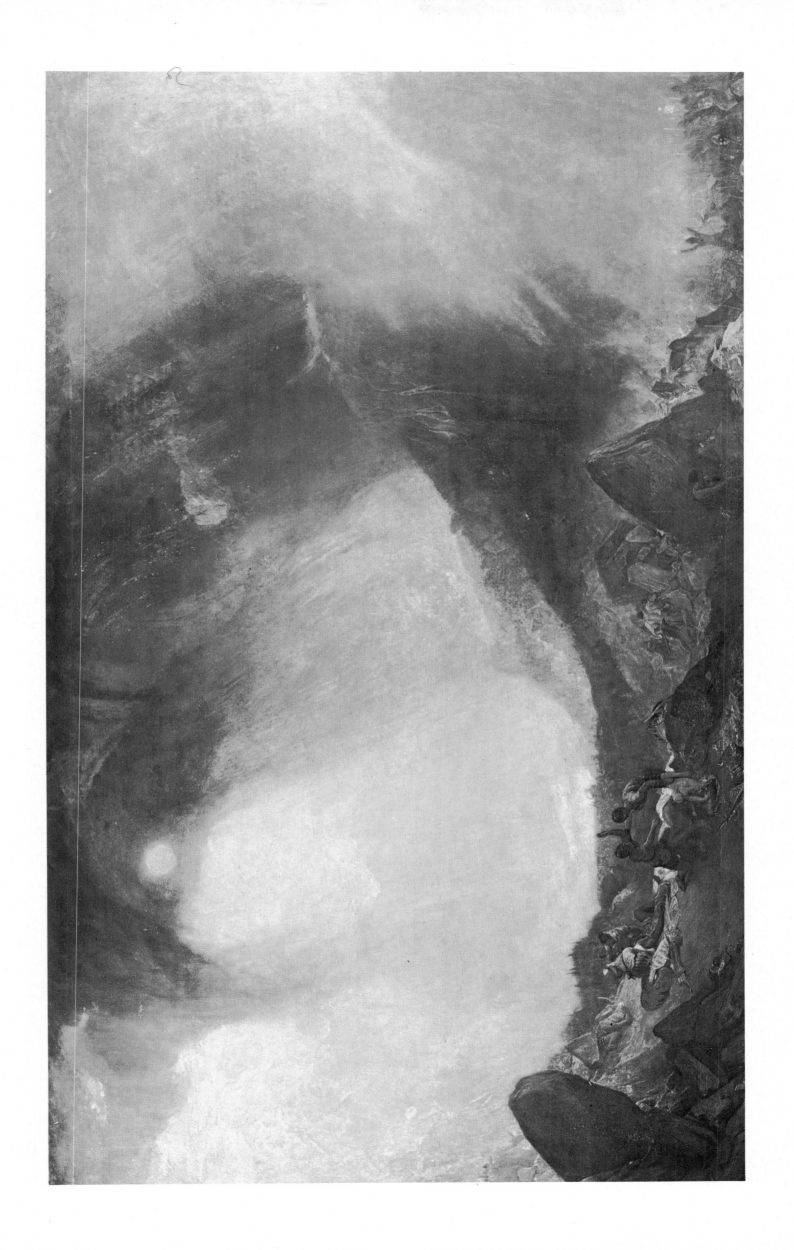

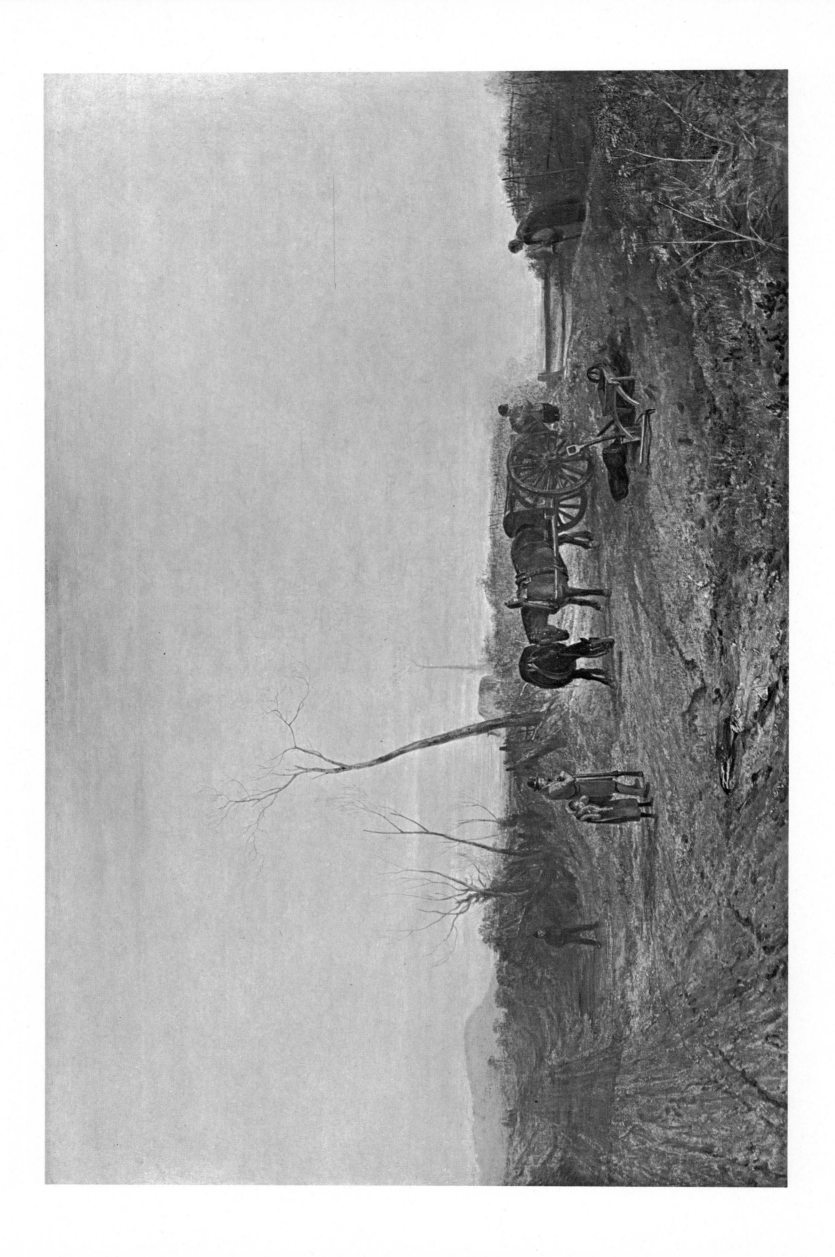

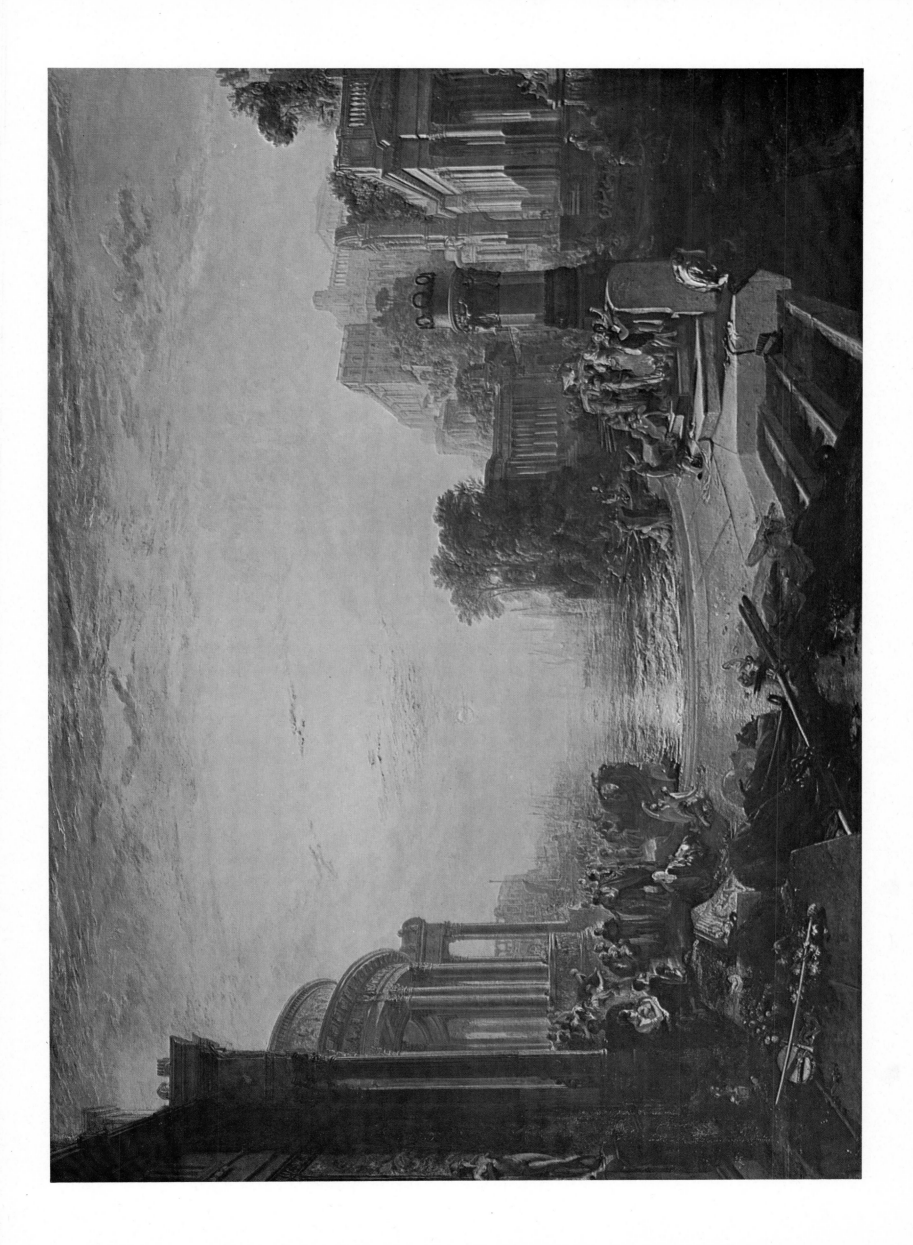

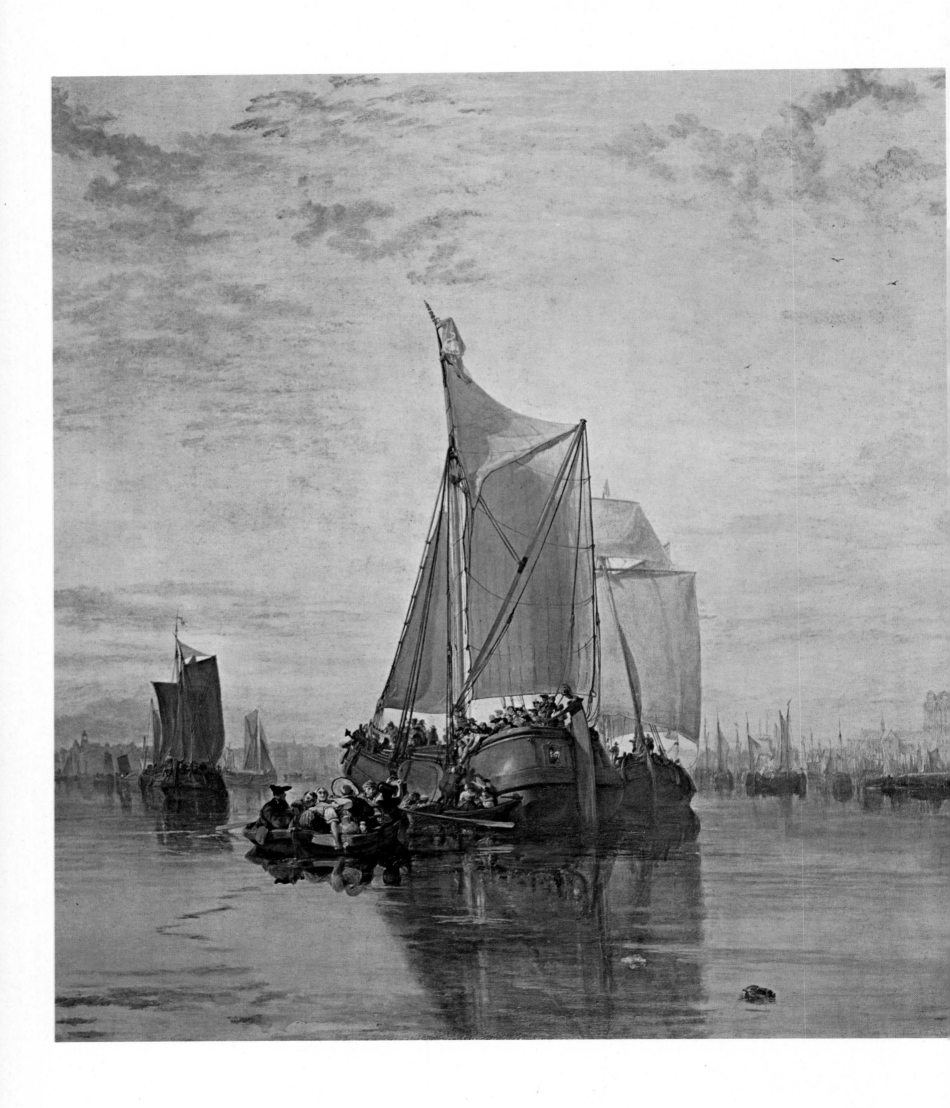

X

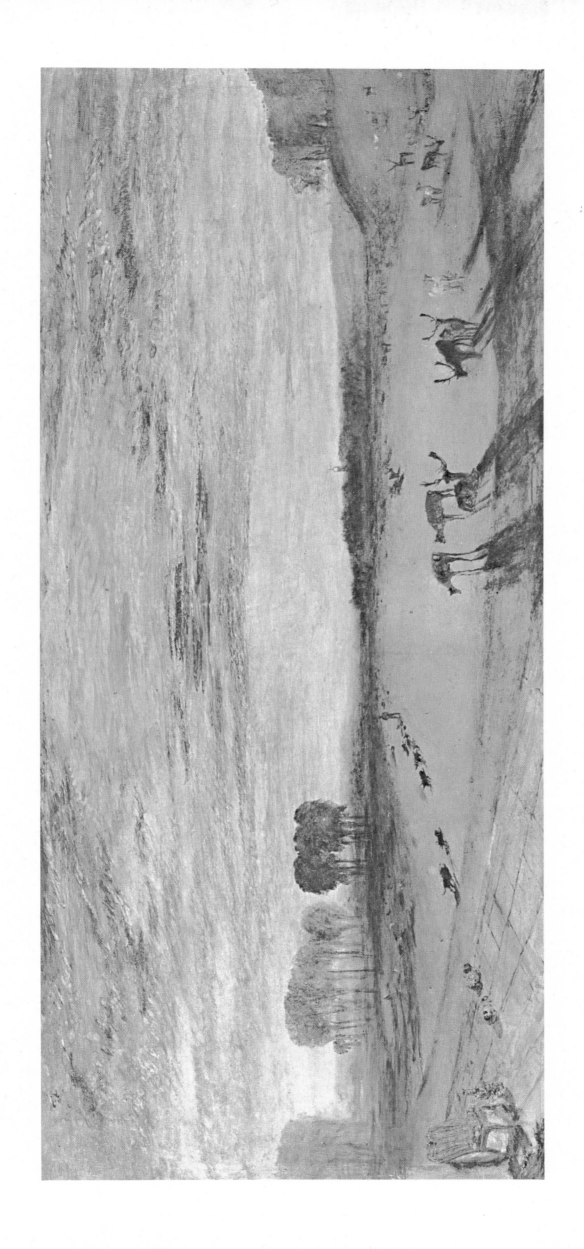

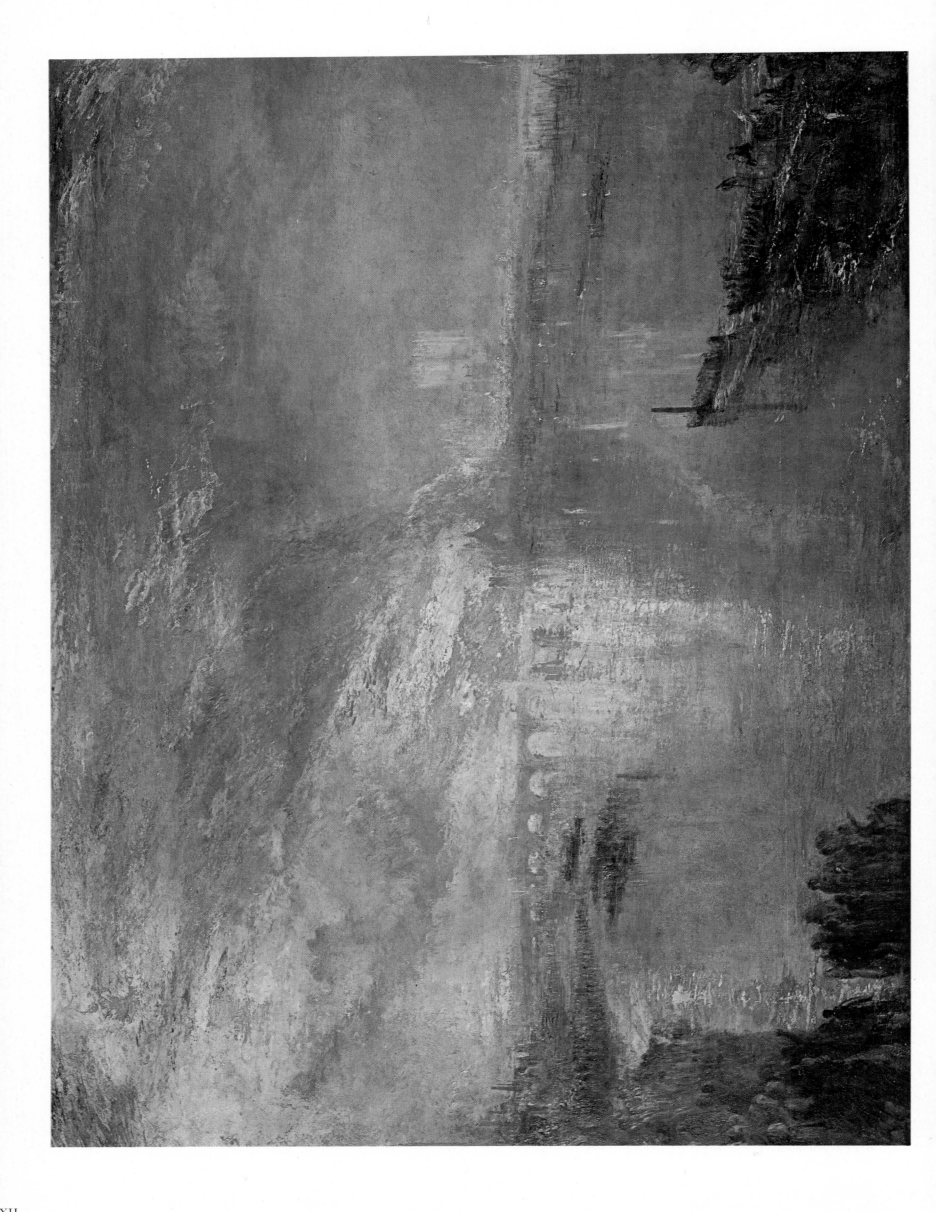

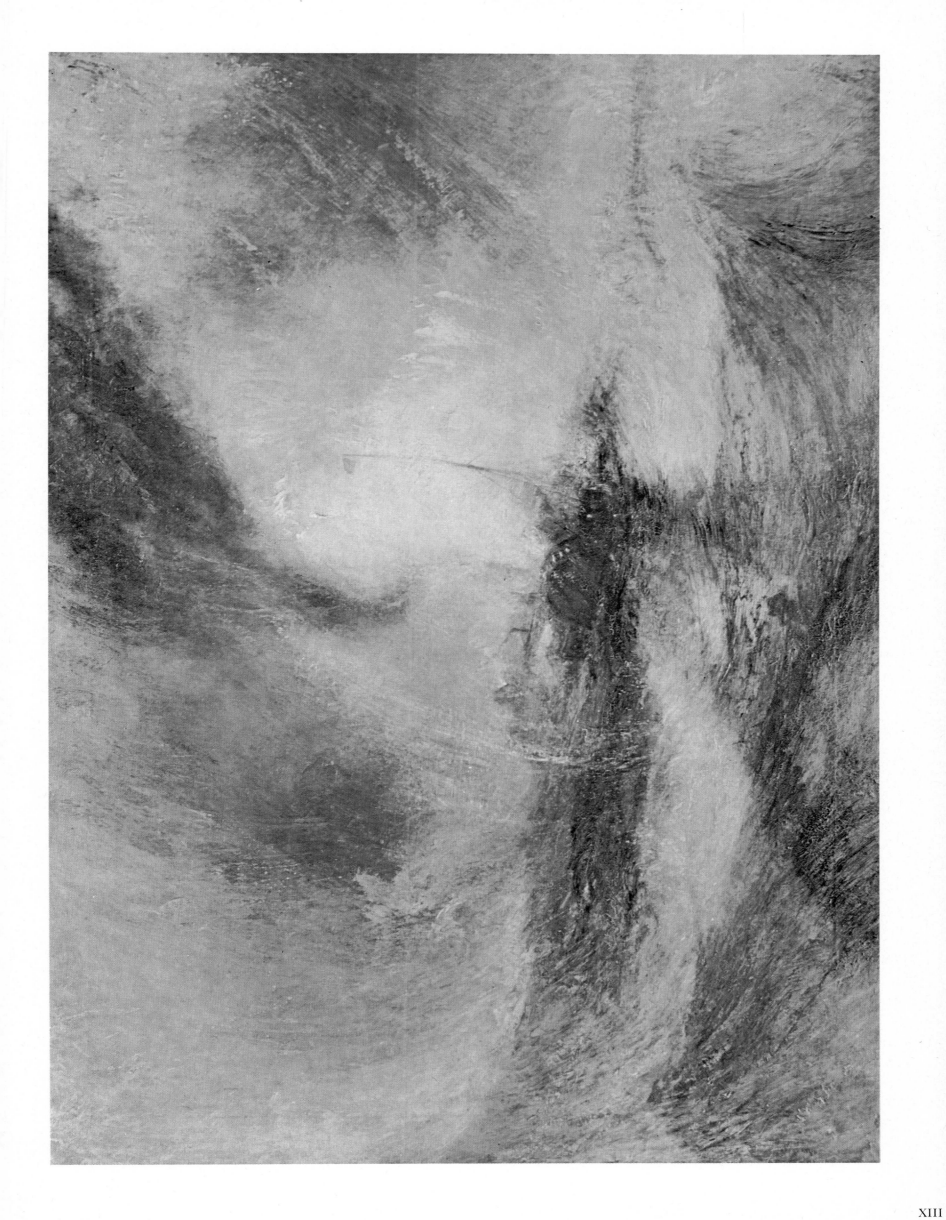

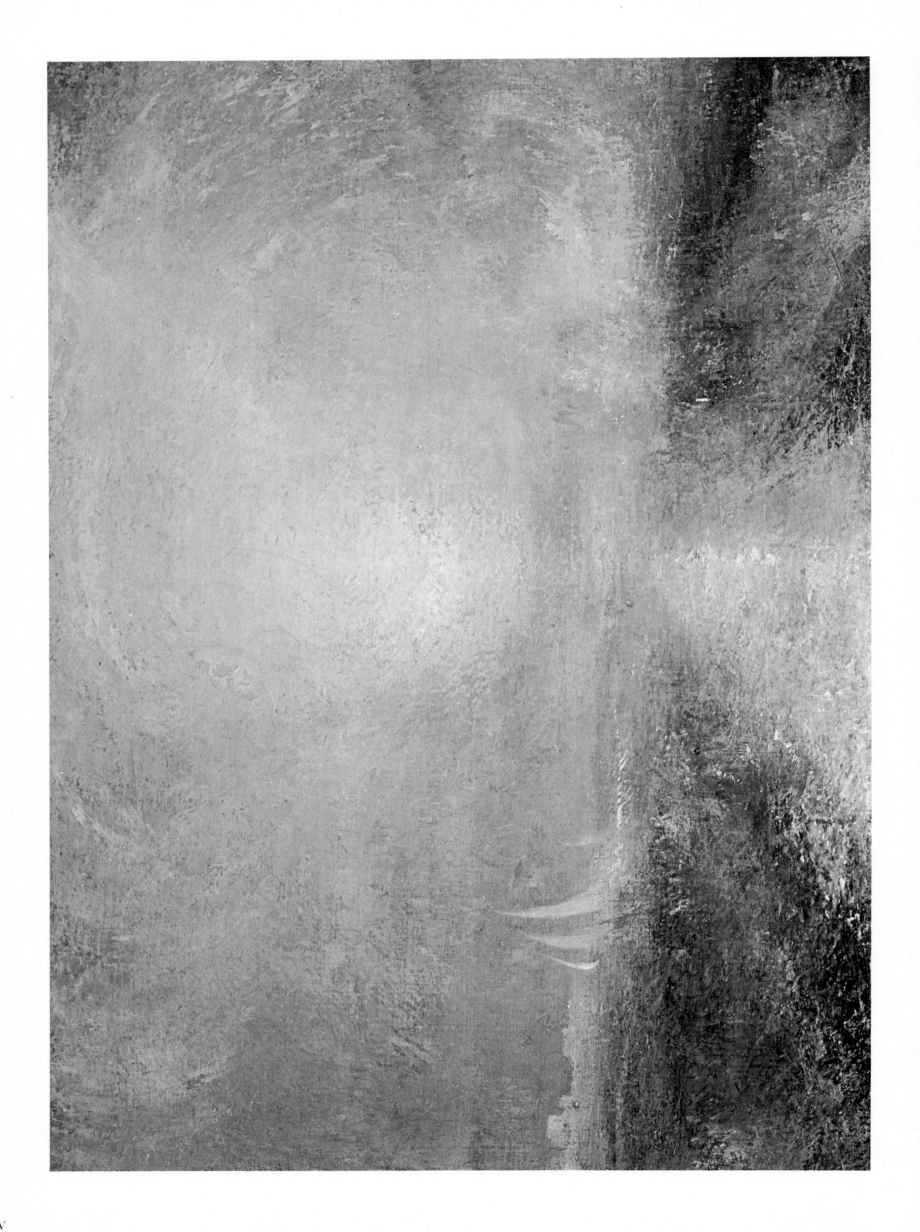

XIV

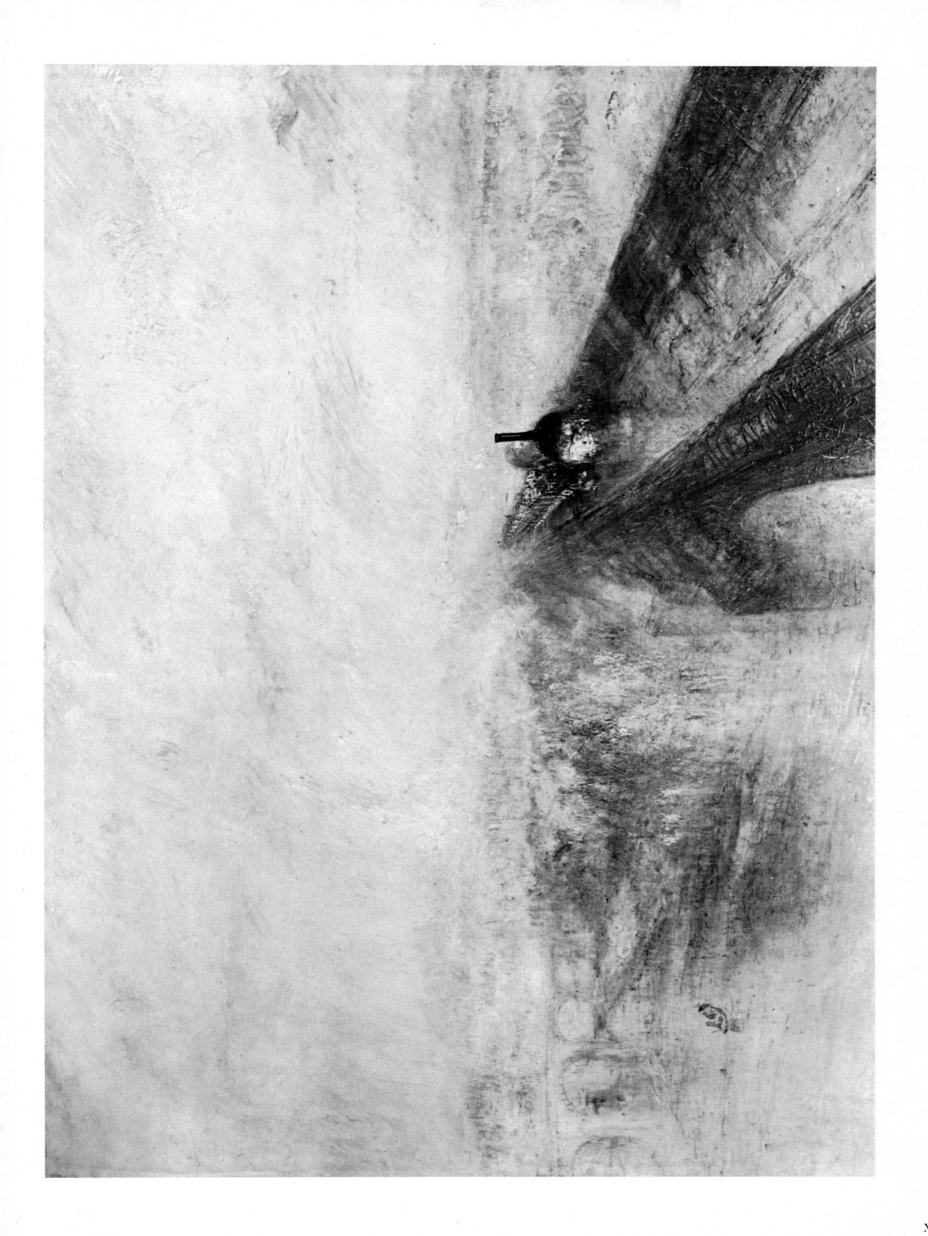

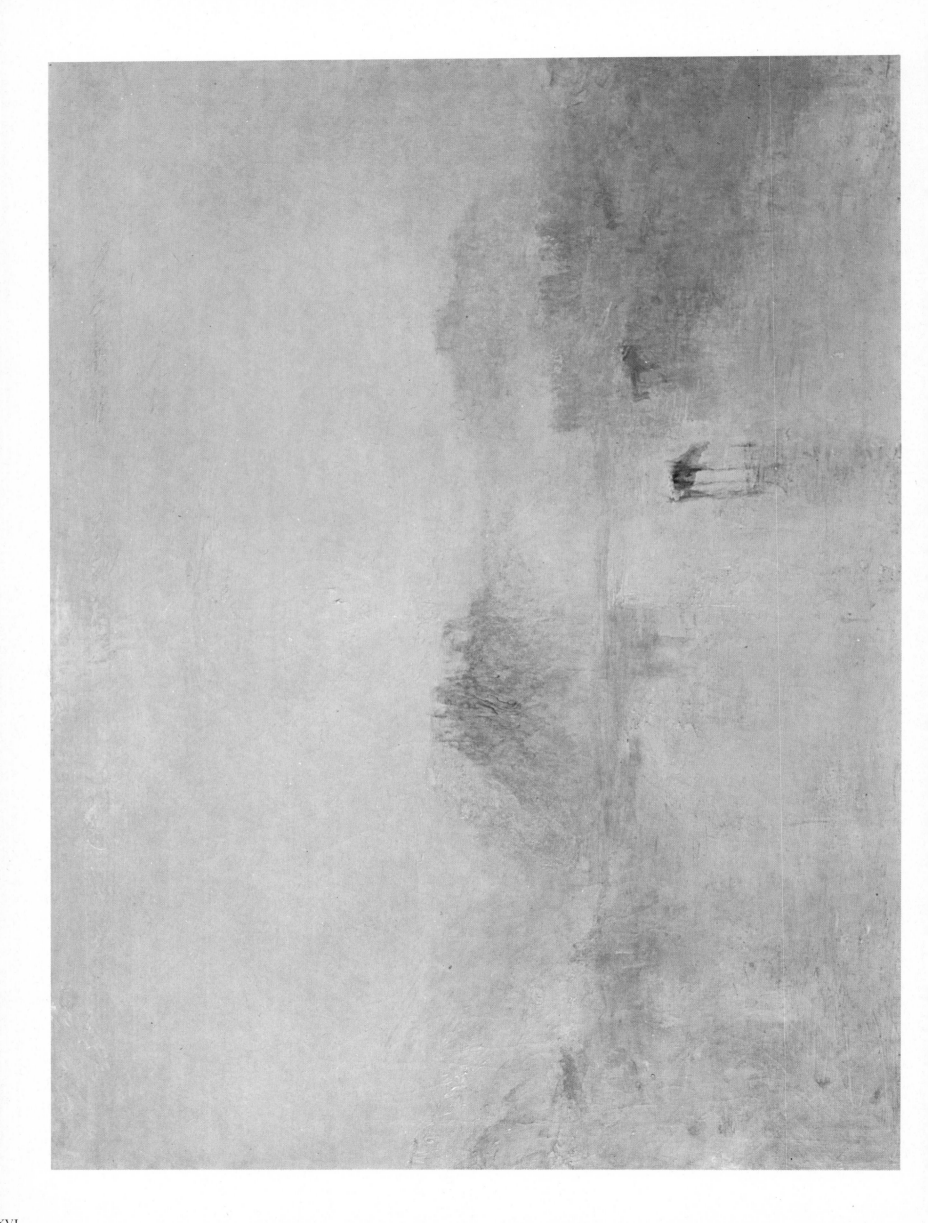

Edouard Manet

Edouard Manet 1832-1883

Edouard Manet was born in Paris on 23 January 1832, the son of an official at the Ministry of Justice. When he left the Collège Rollin in 1848 at the age of sixteen he already wanted to be a painter. His parents, however, wished him to become either a lawyer or a naval officer. Manet failed the entrance examination to the Naval College and went instead as a cadet on a ship bound for Rio de Janeiro. Whenever he had the opportunity on the voyage he spent his time drawing and on his return to France he persuaded his family to allow him to study painting.

From 1850 to 1856 Manet worked in the studio of Thomas Couture, a good although now under-rated academic painter. He received here a thorough training in technique which is always apparent, even when his technical innovation is at its most daring. During this period Manet travelled in Italy, Holland, Germany and Austria, copying works that impressed him by Titian, Tintoretto, Veronese, Giorgione, Velázquez and Goya.

In 1858 Manet met Baudelaire. Their friendship resulted in a constant exchange of ideas and Baudelaire's influence can be seen in the subjects of such early works as The Absinthe Drinker (1858-59) (Ny Carlsberg Glyptothek, Copenhagen). Manet submitted this work to the Salon, but it was refused.

Although he did not visit Spain until 1865, he was fascinated by the country and its artists. There was a strong interest in Spanish culture in Paris at this time and there were many troupes of Spanish musicians and dancers performing in the theatres and music-halls (see Fig. 3). Manet's father died in 1863, leaving him with a comfortable income. He was thus in the fortunate position of not having to depend on sales to earn a living, although he always wanted to be accepted by the critics and the public, and regularly submitted his work to the Salon. After his father's death he married Susan Leenhoff, a

Dutch girl who had become Manet's piano teacher in 1853, when he was twenty-one. She was a talented pianist and her brother Ferdinand was a sculptor and engraver. In 1853 she had a child who assumed the name of Léon Koëlla, but is thought to have been Manet's son. Manet used Léon in several paintings as a model, most conspicuously as the boy in the foreground of Lunch in the Studio (Plate X-XI).

Manet had received little official recognition, but now, with his considerable private income, he was able to organise his own show at the Galerie Martinet. By 1863 he had produced his first mature works, Music in the Tuileries Gardens (Plate I), Lola of Valencia (Plate IV) and Lunch on the Grass (Plate II-III). This last was exhibited at the Salon des Refusés and provoked a scandal. It was considered shocking (despite Renaissance precedent) to depict a naked woman in the company of fully dressed men, even though they are so obviously more engrossed in their discussion than in her nakedness.

Olympia (Plate V) was accepted by the Salon in 1865, probably with the intention of exposing it to ridicule. It had to be hung high over the door to protect it from outraged spectators. After the Salon closed, Manet, disgusted by the public reaction to Olympia, left Paris and paid a long-projected visit to Spain. He was disappointed with Goya; he found the country dirty and the food barbaric, but Velázquez fully lived up to his expectations, and remained an important influence on his work to the end of his life.

In 1866, The Fife Player (Plate VII) was rejected by the Salon. Emile Zola,.the novelist, defended Manet's work in an article in 'l'Evènement' and in a subsequent pamphlet. They became friends and Manet expressed his gratitude in Portrait of Emile Zola (Plate IX). Manet was much moved by the tragic death of the Emperor Maximilian of Mexico and painted three

large versions of the execution. The second version he cut up, probably because newspaper reports revealed that certain details were inaccurate. Some of the fragments are now in the National Gallery, London.

During the Franco-Prussian War of 1870-71 Manet was first a gunner, then second-lieutenant. He was in Paris during the siege, but during the civil war that followed he stayed in the country with friends, returning at the end of the Commune.

The first important exhibition of Impressionist paintings was held in 1874 at the studio of Nadar, the photographer. Manet had been friendly with Claude Monet and Camille Pissarro since 1868, but he had always avoided being associated with any particular group, even one so sympathetic as the Impressionists. In 1874 Berthe Morisot married Manet's brother, Eugène. Manet spent the summer at Argenteuil on the Seine, painting with Monet and Renoir. During this time he painted several pictures of Monet and his wife, whom he represented twice in Monet's boat studio (Plate XIV).

In 1877 Manet's naturalistic painting of a prostitute Nana (Kunsthalle, Hamburg) was refused by the Salon because it was considered immoral (Zola's novel of the same name was not published until two years later). In 1879 the first symptoms appeared of the locomotor ataxia which was to cause Manet's death four years later. This disease of the central nervous system made it increasingly difficult for him to paint, and in his last years he worked mainly on a small scale or in pastel. In 1882 he completed A Bar at the Folies-Bergère (Plate XVI); in the same year he was decorated with the order of Chevalier of the Legion of Honour, so gaining the official recognition he had long hoped for.

In 1883, in a last effort to save his life, Manet's leg, which had become gangrenous, was amputated, ten days later, on 30 April, he died in Paris at the age of fifty.

1. LA RUE DE BERNE ART INSTITUTE, CHICAGO

'A confirmed taste for modern truth, an imagination that was rich and lively, sensitive, daring'
— CHARLES BAUDELAIRE

Manet is often mistakenly identified with the Impressionists. Although he was on friendly terms with several of them, influenced their work (and was in turn influenced by them), he never participated in their joint exhibitions and did not consider himself of their number. Manet was one of those revolutionary artists who, as innovators, stand at the very beginning of a new tradition and are also the last great masters of the old.

AT FIRST glance the subjects of *Lunch on the Grass* (Plate II-III) and *Olympia* (Plate V) may seem very far from the depiction of ordinary people in ordinary situations—a classically derived group of a naked woman picnicking with two fully clothed men, a naked prostitute being presented with a bunch of flowers by a Negro maid. Yet despite the bizarre character of these subjects, they are painted so convincingly that we do not question them. Courbet had stated his aim 'to represent, according to my judgment, the customs, ideas and aspects of my time; to be not only an artist, but a man!' Manet stated his programme less ambitiously: 'One must be of one's time and paint what one sees,' but even more than Courbet he succeeded in representing the customs, ideas and aspects of his time. It is this penetrating judgment that enabled Manet in *Lunch on the Grass* and *Olympia* to see the way things were in France in the 1860's and to present this with complete honesty. For Manet had, as Baudelaire said, 'a confirmed taste for modern truth'.

Manet's tendency to stress shape and form, almost for its own sake, is at times as marked as that of Piero della Francesca, for instance, in the strong geometry of the ironwork and shutters in *The Balcony* (1868, Louvre, Paris). 'Nature,' he said, 'will only provide you with references,' but nevertheless he considered these references essential in providing a source of visual interest: 'Nature is like a warden in a lunatic asylum. It stops you from becoming banal.'

The influence of Manet's teacher, Thomas Couture, is apparent in an early work like *Boy with Cherries* (c. 1858, The Gulbenkian Foundation, Lisbon), with its precisely graduated tones. Its sentimental reminiscences of Murillo show his interest in Spanish art. In *The Absinthe Drinker* (1858-59, Ny Carlsberg Glyptothek, Copenhagen) Manet's academic training still dominates his technique with its 'opaque blacks and dull paint', despite the Baudelairean subject.

Soon Manet began to eliminate half-tones—the academic device of graduating the whole tonal structure of the paintings so that there are no sudden transitions from light to dark, from warm colours to cold. Manet realised that the eye did not see colours in this way, it was merely a convention designed to give an 'old-masterish' appearance to a painting, in imitation of that quality which is mainly due, not to the intention of the Renaissance masters, but to chemical changes in the pigments they used and the yellowing of the varnish with which they, or subsequent 'improvers', coated their works. Manet said that the use of half-tones was unnecessary. 'Light,' he said, 'has such unity that a single tone suffices to render it.'

However, Manet saw that to set light against dark, warm colours against cold in every passage in a painting would produce an expressionistic effect that he did not want. So he devised a marvellously subtle scale of grey tones, running from a transparent black through dark greys to soft greys and off-whites. Against these he set small touches of cobalt blue, indian red, yellow ochre and viridian green, arriving at a much closer approximation to visual reality than either the Academics or the Impressionists. Here he was helped by the relatively recent invention of photography. *Lunch in the Studio* (Plate X-XI), in particular, owes a great deal to photography in its wide range of subdued grey tones, as well as in its method of composition.

MANET'S first major work is *Music in the Tuileries Gardens* (Plate I). It depicts a fashionable crowd attending an open-air concert. The painting is built up from the rhythmic contrasts of black, off-whites and oyster greys of the figures and the curving forms of the trees. It has an extraordinary cohesion (most crowd scenes painted with such seeming verisimilitude fall apart visually). This is achieved by the juxtaposition of carefully finished passages with others which are summarily sketched. Manet's naturalism is the product of a most intelligent and sensitive selection of just as much detail as catches our eye when we are in the middle of such a crowd. Our eye does not move carefully from object to object, from precise outline to precise outline, but darts about, falling on an irrelevant detail here, a significant detail there. The scale of the composition is panoramic, as though photographed through a wide-angled lens; the tree trunks seem to curve outwards from the centre of the painting as though optically distorted. This panoramic effect is heightened because the central parts of the picture are painted in a somewhat sketchy fashion, the outside figures in detail. Compared with the figures, the tree trunks are deliberately flat and insubstantial, like a nineteenth-century photographer's backdrop.

2. *SEATED WOMAN* PRIVATE COLLECTION

Later in 1862 Manet painted the work which first made him notorious among the bourgeois public, *Lunch on the Grass* (Plate II-III). This is an extraordinary work, one of the great masterpieces of nineteenth-century art, in which we find elements of Manet's academic training (his fondness for black and brown set against luminous greens, for example) combined with abrupt transitions of tone and a daring heightening of whites, classical composition with the deliberate flattening of perspective and elimination of recession. The three figures in the foreground are taken directly from an engraving by Marcantonio Raimondi after Raphael's lost *Judgment of Paris*. The subject itself derives from Giorgione's *Concert Champêtre*, although, as always with Manet, the initial idea for the painting came from life, suggesting to him the variation on a classical theme. He borrowed from the masters of the Renaissance in the same way that they borrowed from Graeco-Roman sculpture and from each other—*creatively*.

The idea for *Lunch on the Grass* was suggested by some women whom Manet saw emerging from bathing in the Seine at Argenteuil. They reminded him of Giorgione's painting which he had copied while working under Couture: 'It is black, that painting, the dark priming has come through. I want to do that over again in terms of transparent light and with people like these,' Manet told his friend, Antonin Proust. The whole tone of the painting is set by the 'transparent light' filtering through the leaves of the wood and falling on the naked flesh of the woman. The 'people like these' were Manet's favourite model, Victorine Meurent (who also sat for the *Olympia*), his brother Gustave and his future brother-in-law, Ferdinand Leenhoff.

The woman emerging from the water in the background has often been cited as an example of Manet's inability to handle scale and perspective. She appears too large and sharply defined for a figure who is apparently set in the middle distance; but Manet has deliberately painted her thus in order to flatten the whole composition, uniting the leafy, watery glades of the background with the foreground, so that the three central figures fit naturally into this shallow, foreshortened space, instead of standing out too starkly against the landscape, like actors against a backdrop. It is not the fact that the figure of the woman is too large that is disturbing, but that the outlines of her body and the modelling of her face are too distinct and sharp, instead of soft and blurred in accordance with 'atmospheric perspective'. Manet has painted her, in fact, in the way she would appear if the scene were recorded by the objective eye of the camera. What we see when *we* look at an actual landscape is what our visual mechanism allows us to see. Thus, focusing on the foreground group, we would see the woman in the middle distance as blurred. Manet paints the scene as though through a lens which can focus on objects at different distances from it at the same time. This is the opposite to what he had done in *Music in the Tuileries Gardens*. The effect of the woman emerging from the water, looming above the foreground figures, is rather like the strange foreshortening we get today in newsreel shots taken with a telephoto lens.

The effect of photography on painting has been crucial. If abstract art is partly a reaction against the easy representation of the camera, the attitude of nineteenth-century painters was more ambiguous, concentrating like the Impressionists on effects of light that the camera could not capture, but borrowing from photography a seemingly arbitrary method of composition, cutting figures off abruptly at the edges of the picture, as Manet does in *Lunch in the Studio*.

Manet has brought out very clearly the geometric structure of the group of three figures in the foreground of *Lunch on the Grass*. This is present in the original engraving after Raphael, but Manet has subtly altered, adapted and clarified. He has emphasised their structural unity by painting the figures in a series of flat planes, particularly the naked body of the woman where modelling is reduced to the absolute minimum compatible with coherence. In contrast to the triangular basis of the three figures, the background is broken down into a roughly rectangular pattern formed by the space enclosed between the tree trunks.

This tendency towards abstract form balances and modifies the naturalistic elements in the painting. The facial expressions are calm, beautiful and idealised. We have never come across expressions quite like these in life, but we feel we ought to have, and this is what makes them seem so real. The figures appear natural and relaxed, whereas in fact their positions are posed and awkward—the way the naked woman rests her elbow against her knee would soon become unbearably uncomfortable.

Manet's work is full of contradictions and ambiguities. His impassive, detached figures stare serenely out of the canvas like the figures of Piero della Francesca, and yet we feel that the naked woman in *Lunch on the Grass* and the maid in *Lunch in the Studio* have spotted us looking at them—the spell of objective detachment has been broken, yet, curiously, still remains powerful. The figures in *Lunch on the Grass* have the calm nobility and grace of their classical counterparts, yet they are so obviously of their time, so *bourgeois*. We know they will row their boat back after the picnic and catch the next train to Paris. They have a self-confidence in the rightness of their way of life, of the age in which they lived, so utterly removed from the anxiety of the later decades of the nineteenth century and of our own times.

Manet was himself a bourgeois, a cultivated dandy, in a period when the bourgeois were assuming the positions of influence, in a world embarked on 'inevitable progress'. Yet this great work does not represent an attitude of complacency, but a confident idealism. The past, alluded to in the classically based composition, is confronted by the present in the camera viewpoint, the self-consciousness of the figures and their consciousness of us, the spectators, looking at them. It was Manet's honesty in presenting his own age as it really was, remaking the past in its own image (neo-Gothic architecture with cast-iron pillars), that seemed so shocking to his conventional contemporaries, even more than his representation of a naked woman sitting with two fully clothed men.

AN EVEN GREATER outcry from the public was provoked by *Olympia* (Plate V), exhibited at the Salon in 1865. This too is based on a classical masterpiece, which Manet had copied as a student, Titian's *Venus of Urbino*. What was considered so disgusting was that Manet had painted, instead of a well-rounded woman of classical proportions, a girl with an adolescent body and a face expressing open invitation. Her body is painted in such a cold, revealing light and with such definite outlines that she appears more naked than any previous nude figure in art. The treatment of her body on the bed is a startling demonstration of Manet's absolute mastery of white tones—the subtle contrasts between the dense creamy surface of her flesh and the cold surface sheen of the fine sheets, set off by the dark browns and black of the background and the skin of the Negro maid.

Despite the intense realism with which the girl's nakedness is depicted, there are even more pronounced geometrical elements in this painting than in *Lunch on the Grass*. The background is firmly divided into black and brown rectangles across which the strong horizontals of the girl and the bed on which she lies are set. Against the sombre background and luminous whites of the foreground glimmer the small patches of ochre yellow, indian red and mid-green of which Manet was so fond.

In Manet's painting, unlike Titian's *Venus*, there is no recession, all interest is thrust forward, space is reduced to a shallow niche. The girl reclines in a more upright position with her head erect and fixes the spectator with a more intent gaze than Titian's Venus. She looks slightly surprised (although admirably composed) at suddenly being revealed naked on her bed, a surprise echoed by the arched back of the black cat at her feet. (At the feet of the Venus a small dog sleeps peacefully.)

The French poet, Paul Valéry, described Olympia as 'an animal Vestal, vowed to complete nakedness, she forces us to reflect on all the primitive barbarism and bestial ritual which is hidden and preserved in the habits and activities of prostitution in our big cities'. This is exaggerated, but the picture is certainly a comment on contemporary life although Manet's marvellous feeling for abstract form transforms it into something much more—and far greater—a masterpiece of organisation, a superb study in the transforming power of light. 'Human beings,' Manet wrote, 'are enveloped and etherealised by light.' The cold, objective white light transfigures the young prostitute.

Although based on a painting by Titian, the feeling of *Olympia* is far closer to Goya's *Naked Maja*. The Spanish influence remains strong in the works he painted during the next few years, but in *The Fifer* (Plate VII) of 1866, and *Portrait of Emile Zola* (Plate IX) of 1867-68, another influence becomes apparent; the flat colour tones and bold outlines derive from the Japanese colour prints which were much admired in Paris at the time. *The Fifer* has a flat, two-dimensional quality—the figure of the boy is almost like a cut-out—yet the softly brushed background suggests infinite undefined space circulating round the figure. The painting is full of this spatial ambiguity, the shadows of the boy's feet apparently fall on the ground, yet where does this ground end, and the background begin? The two-dimensional impression is cunningly distorted, without being destroyed, by the dark stripe running down the side of the boy's trousers. This serves as a thick, bold black outline, bounding the flat colour of the material, but in one or two places the material falls *inside* this outline so that there the area of red is not bounded, suggesting the other side of the garment.

PERHAPS *The Execution of Maximilian* (Plate VIII) is Manet's most curious work. The title does not seem to be strictly accurate. The three men are apparently being shot one at a time and the painting actually shows the six riflemen shooting the general on Maximilian's right, and not the Emperor himself. We can see the victim being knocked backwards as the bullets hit him. Maximilian and the other general quietly wait their turn. What are the spectators gaping over the wall standing on—it must be at least ten feet high? And, as many critics have pointed out, the uniforms of the firing-squad are French, not Mexican. This is often taken as an implied criticism of French interference in Mexico, which directly resulted in Maximilian's tragic death. It is, however, more likely that they wear French uniforms because Manet borrowed a squad of French soldiers as models! These peculiarities are certainly not due to carelessness on Manet's part, but deliberately planned to counteract the emotional impact of the scene, which a strictly realistic treatment would have over-stressed. The result is curiously dispassionate and gives the impression that Manet was more interested in painting the groups of figures and the way the folds fell in their uniforms than in trying to evoke the tragic character of the historical event, although no doubt he was equally interested in depicting both.

Lunch in the Studio (Plate X-XI) is the central masterpiece of Manet's career. This marvellous work is composed

3. *SPANISH BALLET* MAGYAR NEMZETI GALERIA, BUDAPEST

almost entirely of grey tones, from the velvety black of the boy's jacket to the glazed white of the pot holding the aspidistra. Against these are set the small subdued touches of colour; the yellow of the lemon, the indian red of the beer in the glass, the dark green of the aspidistra. The colours, insulated from one another by grey tones, give to the objects they denote an extraordinary isolation.

It is this sense of isolation and also a sense of timelessness that one feels so strongly in the painting. Timeless paradoxically because Manet has caught a single moment, like a camera shutter opening for an instant and recording that instant on the plate. The set-piece of armour on the left and the carefully arranged still-life on the table balance the extreme naturalness and casualness of the figures. The arrangement of armour is obviously artificial but the still-life is in fact no less so (why are the oysters uneaten when the meal is obviously over?). Manet has painted oysters rather than the empty shells because oysters are more interesting to paint than shells, since there are extraordinary subtleties of grey tones in an opened oyster. And Manet wanted to introduce into this naturalistic *genre* scene—epic in its breadth and scale—deliberate inconsistencies that would heighten its mysterious timelessness and isolation.

The space that Manet creates for his figures is shallow but not flat. The dense black of the young man's coat set against the creamy white of his trousers seems to project his figure beyond the picture plane. Yet although the figure is thrust forward it does not jump out of the picture, because the rest of the work is composed within the scale of grey tones between this black and white, and because the figure of the maid and the aspidistra in its pot are lined up to form a visual link which leads the eye back into the painting. The soft, misty, atmospheric greys suggest the air, laden with cigar smoke, which passes between the boy's figure and the two figures in the background. Manet wrote to Fantin-Latour in 1865 of Velázquez's *Pabillos of Valladolid*, 'The background disappears; the life-like figure dressed in black is surrounded by nothing but air.' In *Lunch in the Studio* Manet manages to make the figure of the boy appear to be surrounded by air and yet, unlike *The Fifer*, presents us with a background that is evidently real. As usual in Manet's work there are wide variations in the degree of finish throughout the painting. The boy's hand is very carefully painted whereas that of the man is sketchily, almost clumsily modelled. We often find passages in Manet's greatest works almost indifferently painted side by side with passages of consummate technical mastery. This is not because Manet was careless or slapdash, but because he knew that the eye focuses on some things and skates over others and because he realised that in order to create maximum interest and *tension* within a painting it is necessary to make the most significant passages stand out against those of less importance.

MANET first met the Impressionists in the late 1860's and shortly afterwards his work began to show their influence. His forms become freer, his composition more open, his technique more relaxed. Yet he continued to produce superb works, culminating in *A Bar at the Folies Bergère* (Plate XVI), the limpid masterpiece in which, more than in any other of his paintings, 'human beings are enveloped and etherealised by light'.

The portrait of *Berthe Morisot with a Bunch of Violets* (Plate XII), transitional between his earlier and his later styles, is a tour-de-force with its superb handling of black and off-whites. The Impressionist influence can be seen in the way the white and creamy flesh tones are suffused with a warmth that his earlier works had lacked. The Impressionists had learnt much from Manet in their treatment of open-air subjects, but they went further, banishing black from their palettes and juxtaposing complementary colours. Even in his work produced under their influence Manet never abandoned the black of which he was so fond, and although he painted pictures in which direct sunlight heightens the colour key, he still applied paint in broad areas rather than in the stippled technique of the Impressionists.

On the Beach (Plate XIII) is painted in the same loose and summary manner as *Berthe Morisot*, but the brush strokes have become even longer, loosely drawing the paint across the canvas. Unlike the Impressionists, the human figure is the basis of Manet's painting; light and landscape are used to heighten our awareness of its complexity. The woman on the beach is sketched in with deceptive simplicity; her dress is not very different in tone from the sand on which she sits, yet Manet gives it a vital quality derived from the human body it covers, although so briskly has the dress been brushed in that we are not aware of the exact form and contours of her body. The treatment of the man's figure is similarly perfunctory, but with equal economy Manet has given him a rock-like solidity as he gazes out across the sand to the sea. Against the figures are set the broad horizontals of beach and sea, punctuated only at the very top edge of the painting by the sails and masts of the boats.

PAINTED a year later in 1874 *Claude Monet in his Floating Studio* (Plate XIV) is a much more firmly structured composition than anything the Impressionists painted, however it may superficially resemble their works. It is composed of strong verticals and long rectangles formed by the masts of the boats against which are set the curve of the floating studio's bows and the canopy over Monet's head. In *The Barmaid* (Plate XV) Manet's technique is even more perfunctory than *On the Beach* except for the face of the waitress gazing serenely from the canvas which is carefully modelled. The paint seems to have been dragged hastily up and down to form the glasses full of beer, and how clumsy, yet how right, seem the hand and the face of the man with the pipe in the foreground.

A Bar at the Folies Bergère (Plate XVI), Manet's last great work, is composed of long horizontal bands, superbly worked with paint, against which are set punctuating verticals. The standing form of the girl is echoed by that of the champagne bottles on her right which have something of her elegant figure in their shape and a hint of her lace-trimmed dress in the neat gold foil round their necks. The figures reflected in the mirror are Manet's most daring affront to visual expectations. The top-hatted customer stands presumably in front of the bar, in the position which we, as spectators, occupy, yet his reflection and that of the girl's back are painted on the far right of the picture. Once again Manet's distortion is deliberately designed to create a visual ambiguity that gives a mysterious fascination to what might have otherwise been too naturalistic, too obvious a work. It prevents us viewing this scene, marvellous in its realistic evocation, too subjectively. Instead we feel that we are observing it objectively from more than one viewpoint. It is a device as daring, and as successful, as Velázquez's use of mirrors in *Las Meninas*. This is the standard by which Manet would like to have been judged.

The Plates

I *MUSIC IN THE TUILERIES GARDENS* 1862
Oil on canvas. 30 in. × 46½ in.
NATIONAL GALLERY, LONDON

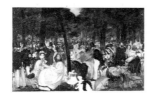

Baudelaire accompanied Manet when he made preliminary sketches in the Tuileries for this painting; he can be seen behind the seated woman on the left. Offenbach, Gautier and Fantin-Latour are also portrayed. Manet probably worked from photographs for these figures.

II-III *LUNCH ON THE GRASS* 1862-3
Oil on canvas. 84¾ in. × 106½ in.
LOUVRE, PARIS

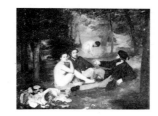

Manet made sketches for the landscape at Gennevilliers and Ile de Saint-Ouen. There is an earlier version in the Courtauld Gallery, London. This is not so highly finished; the naked girl is shown with fair hair and the boat in the background is piled with hay.

IV *LOLA OF VALENCIA* 1862
Oil on canvas. 48¾ in. × 36¼ in.
LOUVRE, PARIS

The best of Manet's 'Spanish' paintings, reminiscent of works by Goya. Lola of Valencia was the *première danseuse* of Mariano Camprubi's company of Spanish dancers which performed at the Hippodrome in a ballet entitled *Flor de Sevilla* from 12 August until 2 November 1862.

V *OLYMPIA* 1863
Oil on canvas. 51 in. × 73¾ in.
LOUVRE, PARIS

This painting is now regarded as one of the great masterpieces of nineteenth-century art, but when it was first exhibited at the Salon of 1865 a critic wrote, 'Nothing so cynical has ever been seen as this *Olympia*, a sort of female gorilla, an india rubber deformity, surrounded by black, lying on a bed, completely nude. . . .'

VI *PEONIES* 1864
Oil on canvas. 12½ in. × 18¼ in.
LOUVRE, PARIS

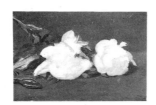

This work has a wonderful, instantaneous freshness in its juxtaposition of juicy green and creamy white paint against a neutral brown background. In the last years of his life Manet painted many flower-pieces, but, unlike this work of early maturity, they have a tragic, nervous intensity.

VII *THE FIFER* 1866
Oil on canvas. 63 in. × 38½ in.
LOUVRE, PARIS

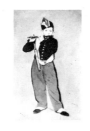

Spanish and Japanese influences are combined in this masterpiece executed shortly after Manet's return from Spain. Manet arranged for a young fife-player from the Garde Impériale to pose for him. For the boy's face he used the thirteen-year-old Léon Koëlla as a model.

VIII *THE EXECUTION OF MAXIMILIAN* 1867-68
Oil on canvas. 99¾ in. × 120 in.
NATIONAL GALLERY, LONDON

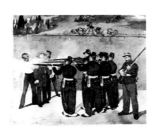

In 1864 French troops occupied Mexico and set up Maximilian, the brother of Franz Joseph of Austria, as Emperor. At the demand of America the French withdrew in 1866. Maximilian was captured by the republicans in 1867 and shot with two of his generals.

IX *PORTRAIT OF EMILE ZOLA* 1867-68
Oil on canvas. 57 in. × 43½ in.
LOUVRE, PARIS

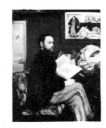

This portrait has a closer resemblance to Manet himself. Zola wrote in 1868: 'As I sat there, I looked at the artist standing at his easel, his features taut, his eyes bright, absorbed in his work. He had forgotten me; he no longer realised I was there.'

X-XI *LUNCH IN THE STUDIO* 1868
Oil on canvas. 47¼ in. × 60½ in.
BAYERISCHE STAATSGEM SAM, MUNICH

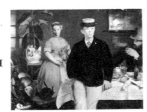

The three figures are Léon Koëlla, then aged fifteen; Auguste Rousellin, a painter Manet had known since his student days; and a girl from Boulogne, where the painting is set, in the house the Manets took for the summer of 1868.

XII *BERTHE MORISOT WITH A BUNCH OF VIOLETS* 1872
Oil on canvas. 21½ in. × 34½ in.
COLLECTION OF E. ROUART, PARIS

This is Manet's finest portrait of Berthe Morisot, who became his sister-in-law in 1874 when she married his brother Eugène. She was a pupil of Corot and a member of the Impressionist group. Manet was fascinated by her intelligence and vitality.

XIII *ON THE BEACH* 1873
Oil on canvas. 20½ in. × 28½ in.
COLLECTION OF J. DOUCET, PARIS

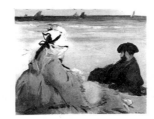

Painted at Berck, near Boulogne with marvellous economy of brushwork. Manet said: 'Conciseness in art is essential and a refinement. The concise man makes one think; the verbose bores. . . .' The woman on the beach is Manet's wife, the man his brother Eugène.

XIV *CLAUDE MONET IN HIS FLOATING STUDIO* 1874
Oil on canvas. 31½ in. × 38½ in.
BAYERISCHE STAATSGEM SAM, MUNICH

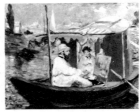

Monet had this boat specially built so that he could paint the banks of the Seine. It was usually anchored at Argenteuil, the Impressionists' favourite location, which can be seen in the background across the river. The woman is Monet's wife.

XV *THE BARMAID* 1878
Oil on canvas. 30¾ in. × 24¼ in.
LOUVRE, PARIS

The model was a waitress at the *Cabaret de Reichschoffen* who insisted Manet should include her boyfriend, the man smoking the clay pipe, in the picture. There is another version in the National Gallery, London, in which the man in the top hat wears a grey bowler instead.

XVI *A BAR AT THE FOLIES BERGÈRE* 1881-2
Oil on canvas. 37¾ in. × 51 in.
COURTAULD GALLERY, LONDON

Manet painted this masterpiece when he was already incapacitated by locomotor ataxia. 'The model, a pretty girl, was posed behind a table laden with bottles and victuals . . . I remember his sweeping simplifications; the tones were made lighter, the colours brighter, the contrasts of values closer.' (G. Jeanniot)

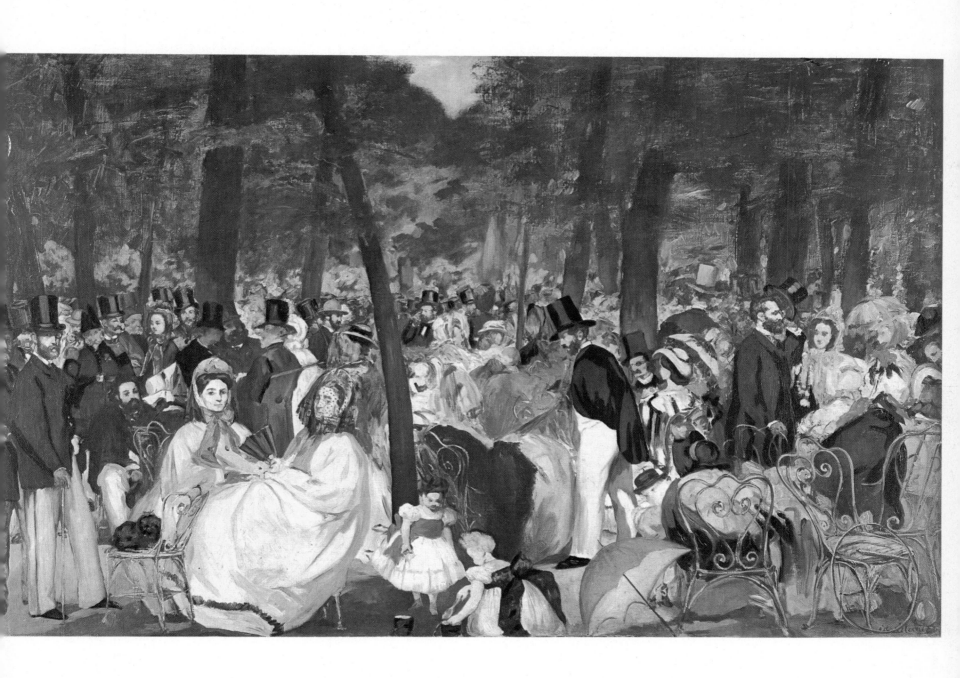

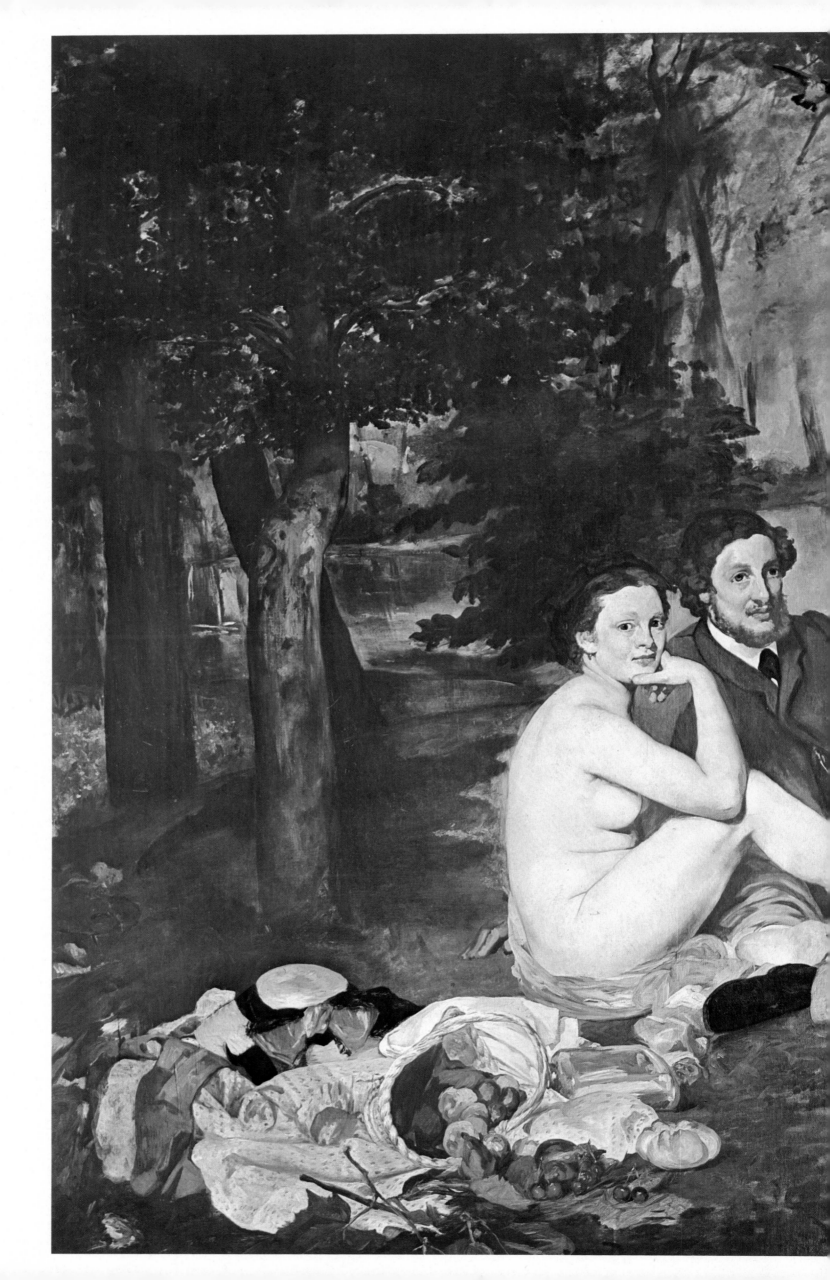

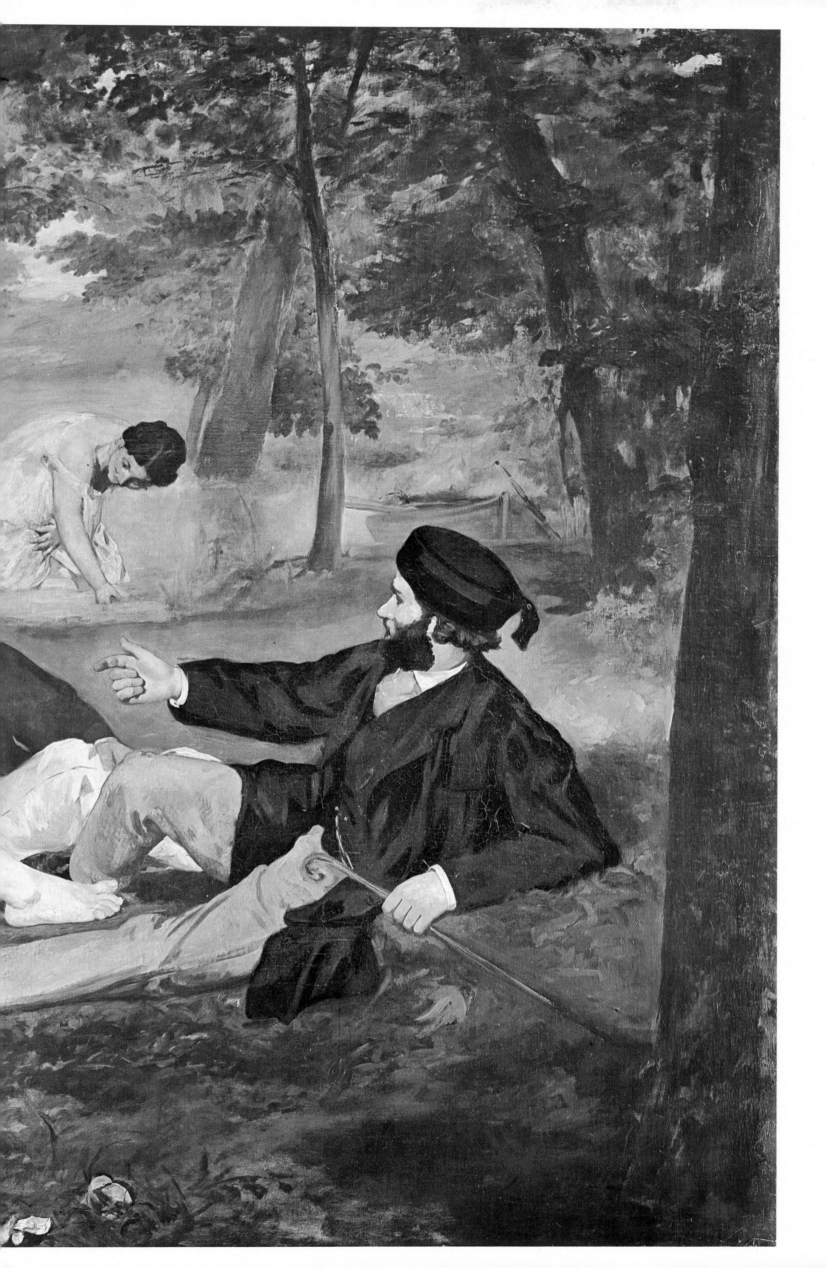

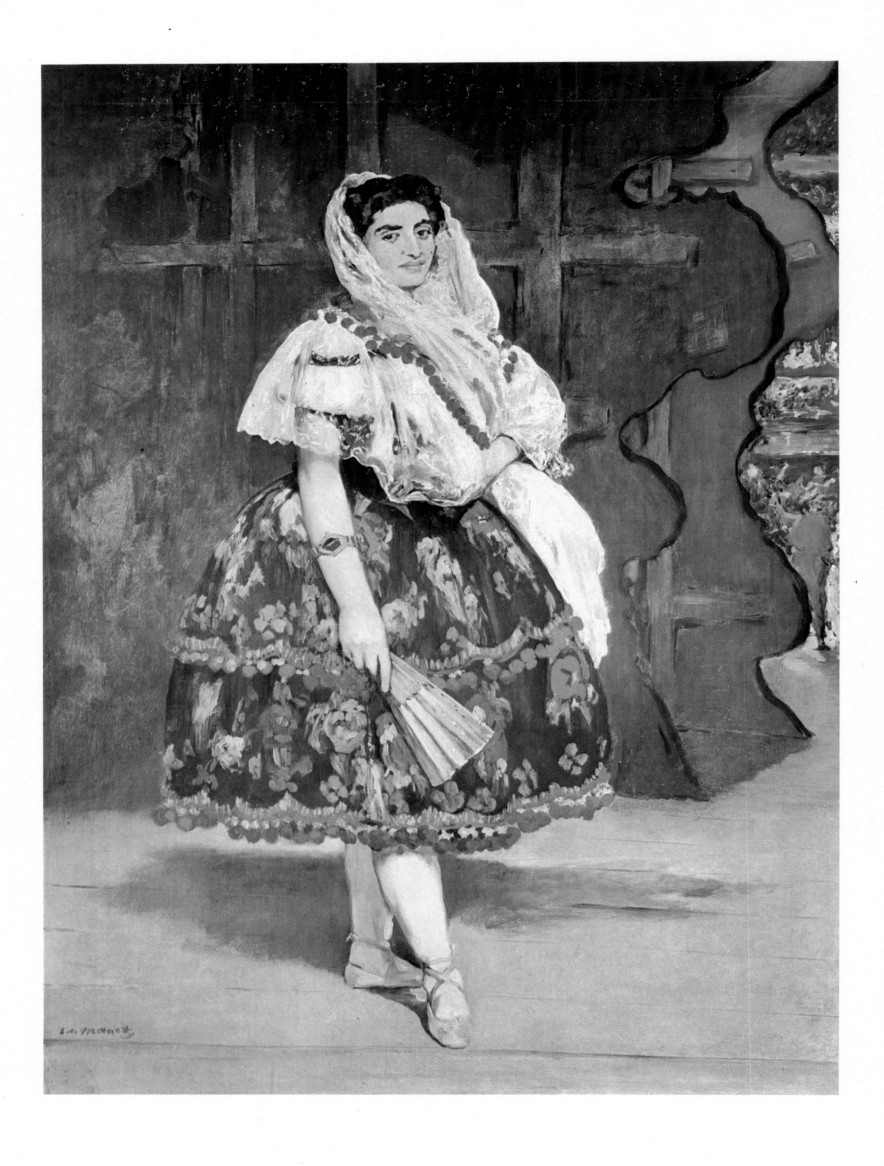

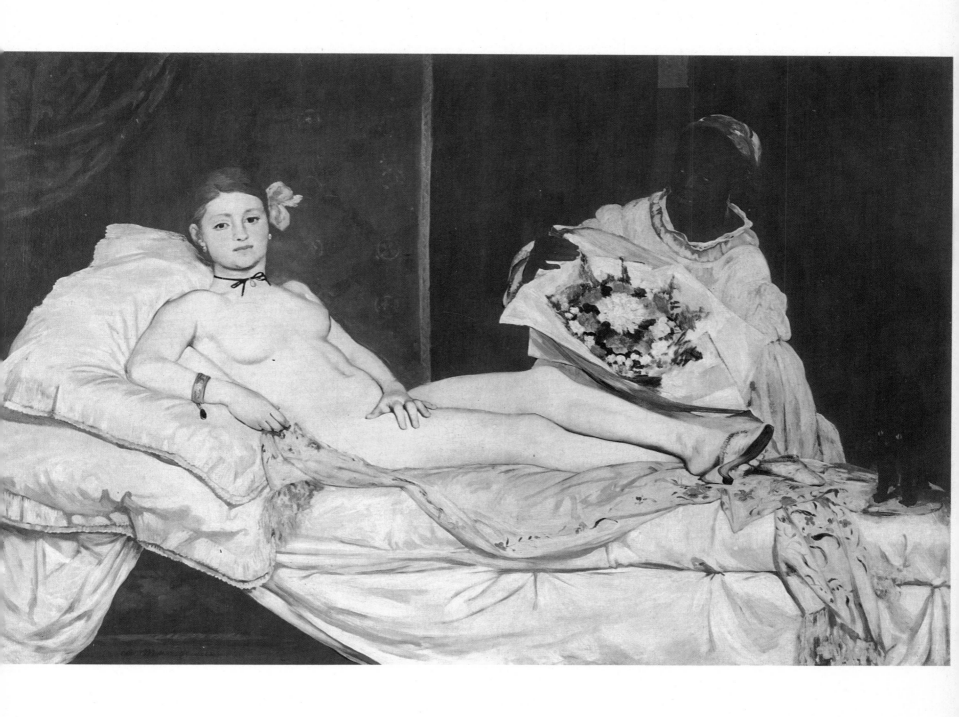

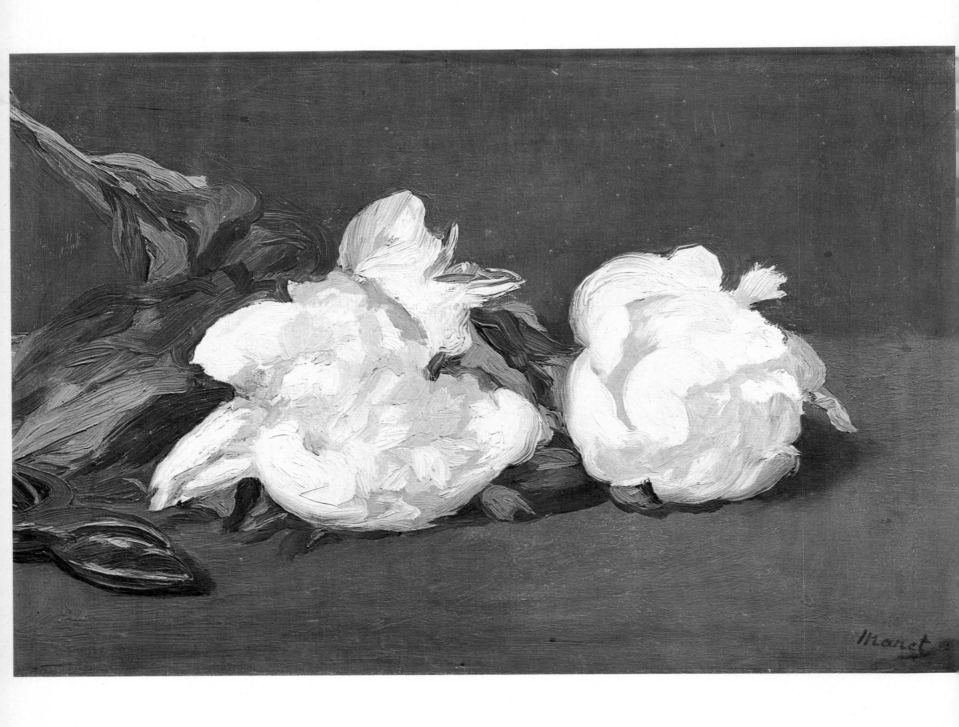

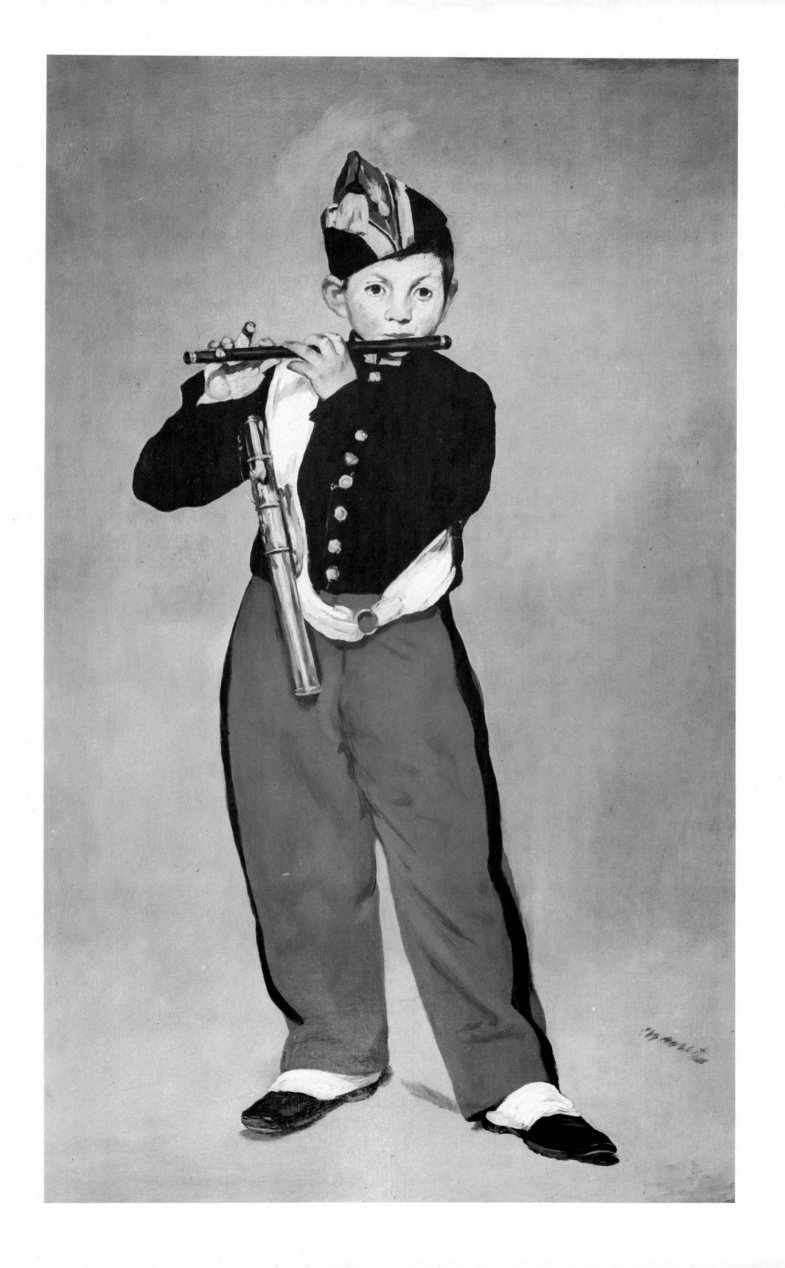

VII

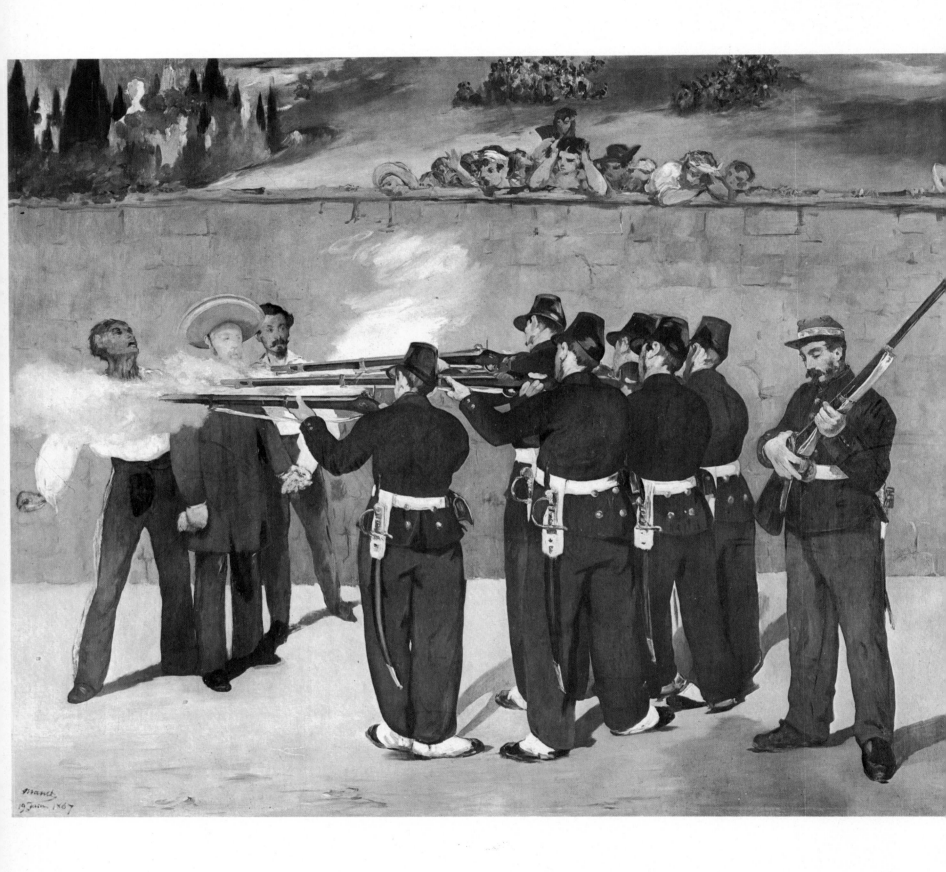

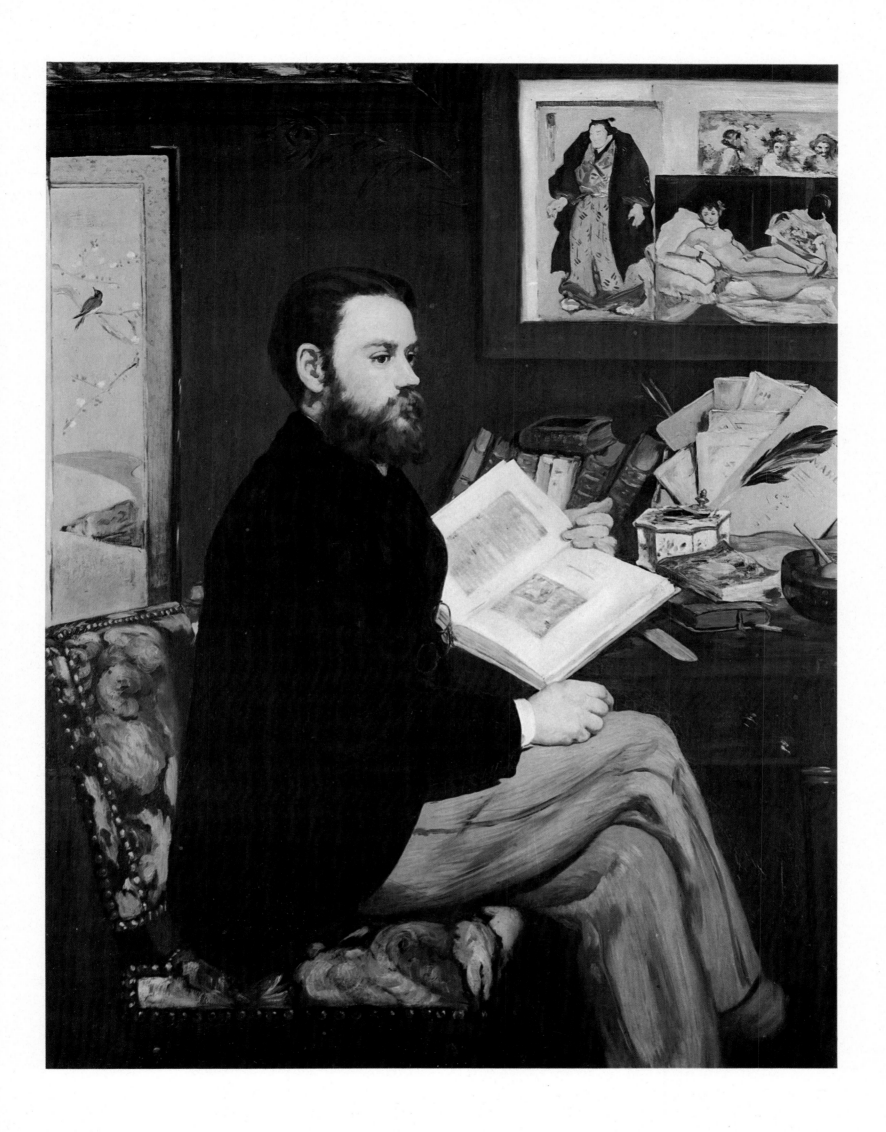

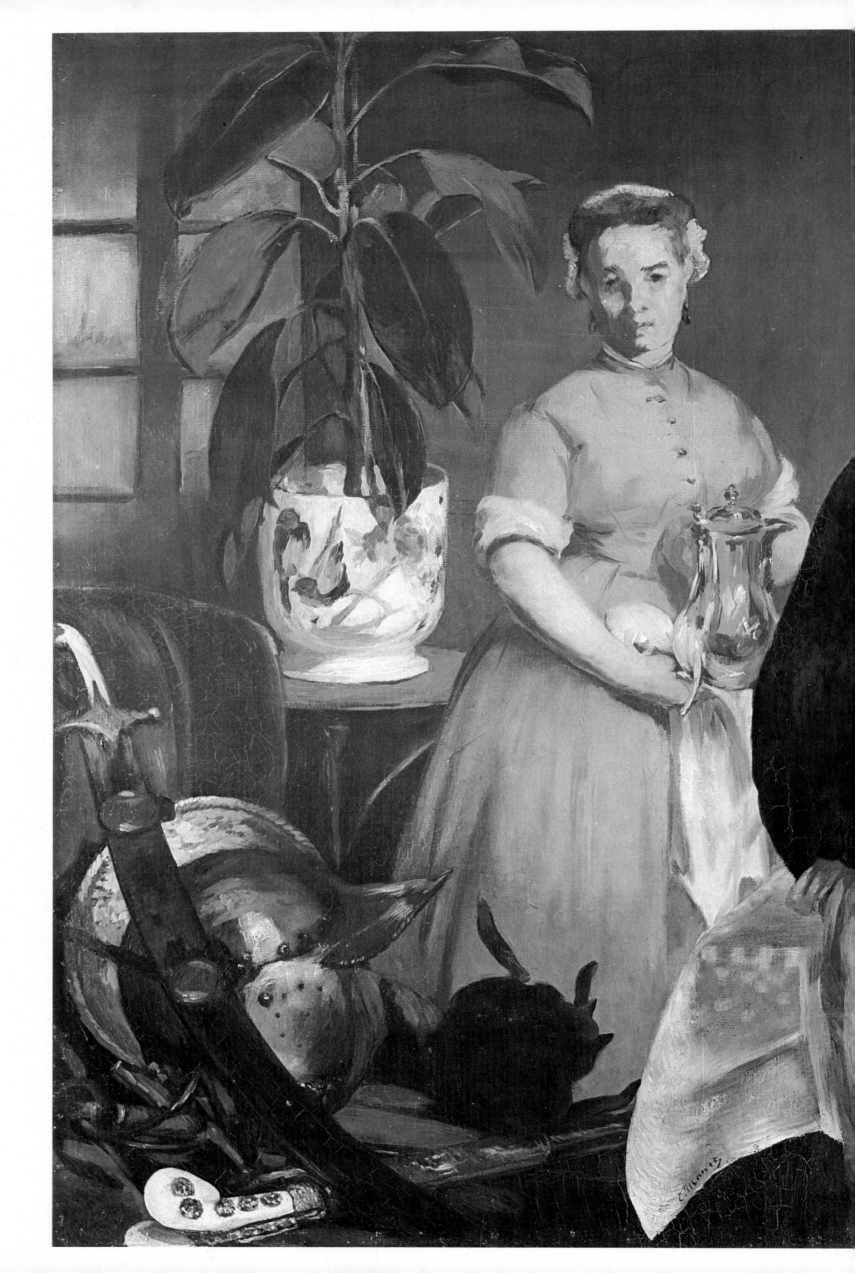

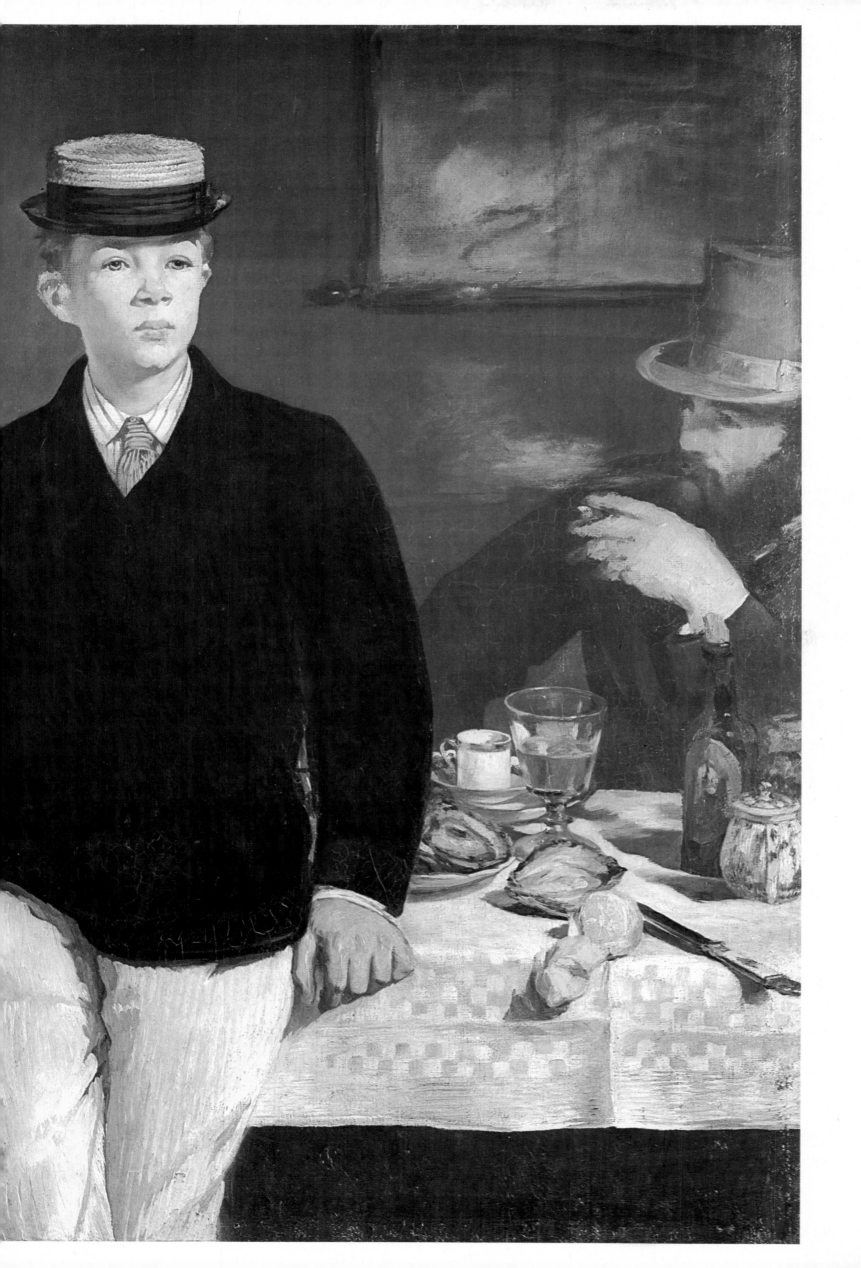

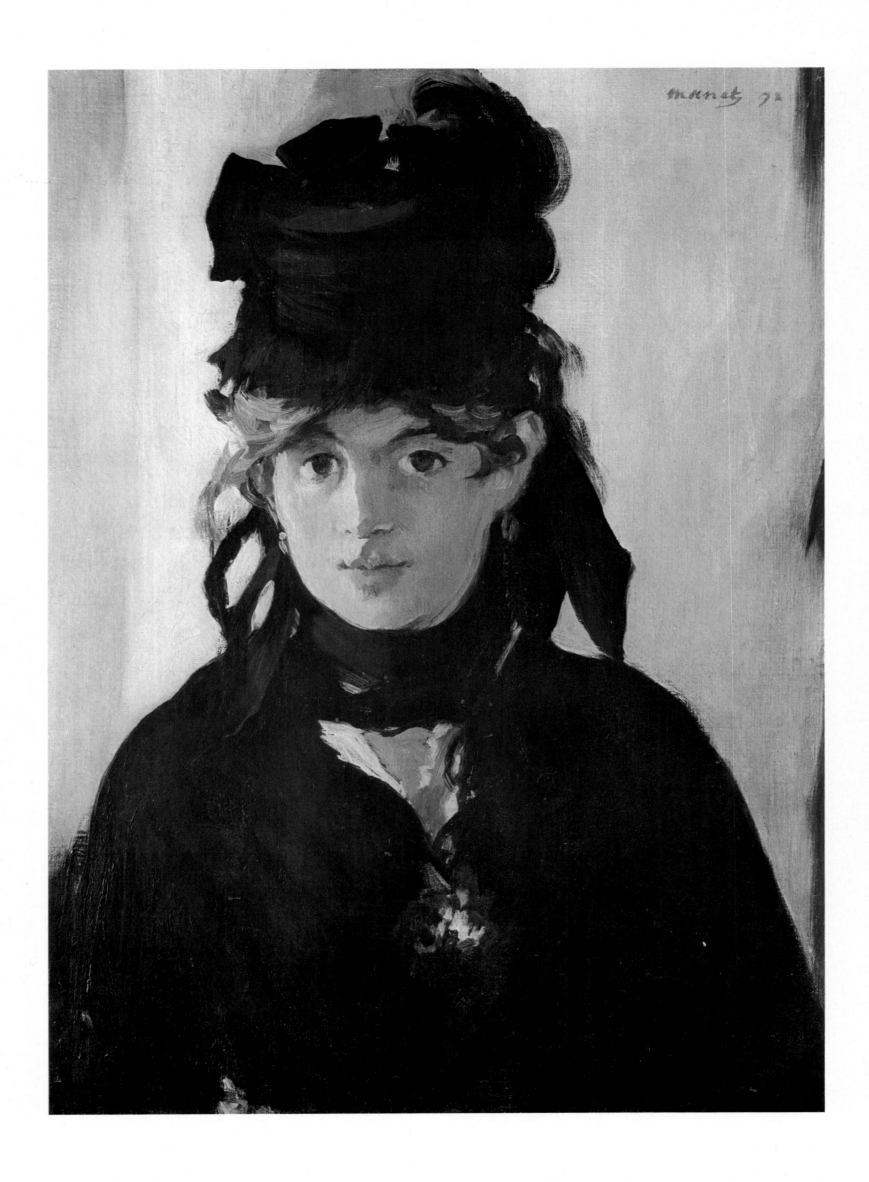

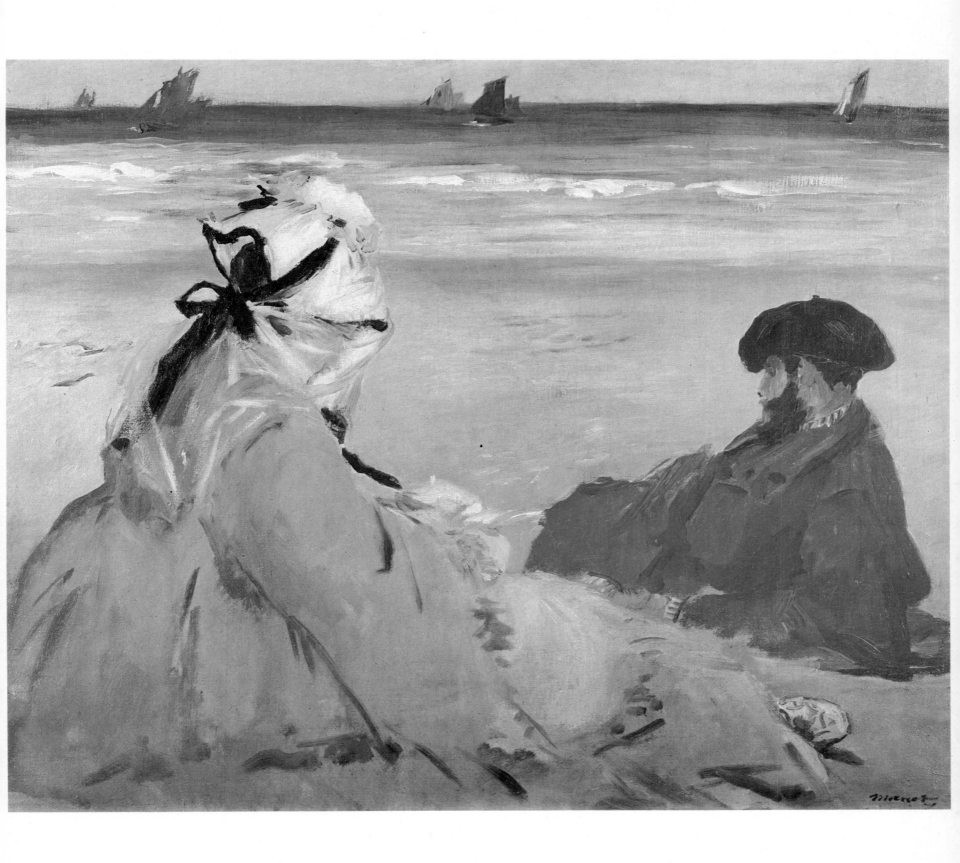

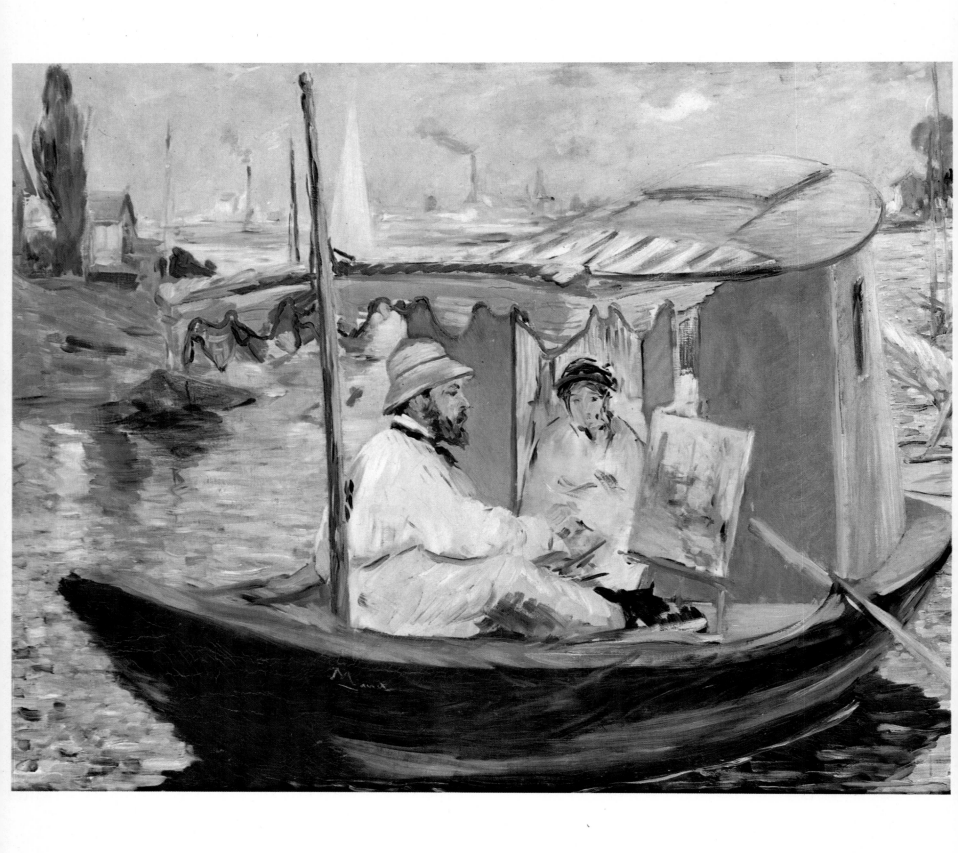

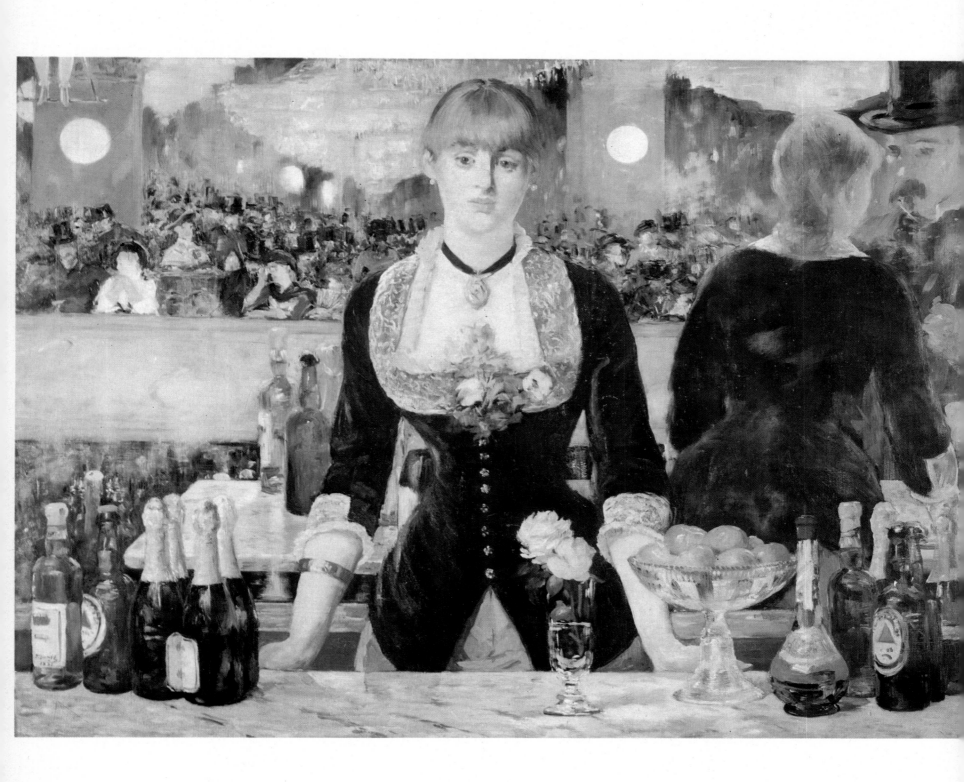

Edgar Degas

Edgar Degas 1834-1917

Edgar de Gas (later contracted by the painter to Degas) was born in Paris on 19 July 1834. He was the eldest of five children. Madame de Gas belonged to a French family that had settled in America. Degas worshipped his mother and her death in 1847, when he was thirteen, was a tragedy he never forgot. His father, a banker, was a man of cultivated tastes, devoted to music and the theatre, and he encouraged his son's artistic inclinations. From 1845 to 1852, Degas studied at the Lycée Louis-le-Grand, where he was given a good classical education; his best subjects were Latin, Greek, history and recitation.

In 1852, Degas was allowed to transform a room in the family home in the rue Mondivi into a studio, and in the following year he began to work under Félix Joseph Barrias. He took to making copies of Old Masters in the Louvre and studied the prints of Dürer, Mantegna, Goya and Rembrandt. In 1854 Degas studied with Louis Lamothe, who was an ardent disciple of Ingres, the great upholder of the classical tradition for which Degas, too, was always to retain the greatest respect.

In 1855, Degas began to study at the Ecole des Beaux-Arts; but he found the course unprofitable and the régime too restricting. To study the classical tradition on home ground seemed more profitable. With hospitable relatives in Florence and Naples, Degas was able to make long and regular trips to Italy between the years 1854 and 1859. He studied hard, making copies of Italian pictures he admired and filling sketchbooks with further copies, compositions and precepts. When in Rome, he enjoyed the lively and stimulating company of friends and acquaintances either living in or near the French Academy.

In April, 1859, Degas took a studio in the rue Madame in Paris. Portraiture and historical subjects occupied his time. Of these earlier portraits, The Bellelli Family (Plate III) is the grandest and most important, Edmondo and Thérèse Morbilli (Plate IV) among the subtlest and most penetrating. The Young Spartans (Fig. 1) is perhaps the most attractive example of the historical genre which Degas, with some reluctance, finally abandoned in 1866. It was a crucial decision in which a number of factors were involved.

In 1862, Degas had met the painter Manet, who was becoming increasingly interested in themes from modern life in preference to the more traditional kinds of subject matter. Degas also met Edmond Duranty, a critic, novelist and friend of Manet. Duranty was a passionate believer in 'realism', and was anxious to remove the barrier he felt existed between art and daily life. Degas soon became a familiar figure at the Café Guerbois, where many of the artists most closely associated with what became known, after 1874, as Impressionism, were accustomed to meet and talk in the evenings.

Degas' art began to reflect his changing views in the second half of the 1860's, when he turned for inspiration not to classical authors but to the racecourse and the theatre (Plates XI and XII). He continued to exhibit at the official Salon until 1870. In the Franco-Prussian War (1870-71), Degas served in the artillery; and it was after a severe chill contracted during military service that his eyes first began to give him trouble.

Between October 1872 and April 1873, Degas was in America, visiting his brothers in New Orleans. On his return he settled in a studio in the rue Blanche where he concentrated on themes from modern life, often connected with some form of professional skill: dancers (Plates IX, XI and XIV-XV), acrobats, singers, musicians, milliners, washer-women and so on. To this list he soon added the female nude which became, with dancers, his favourite subject-matter in later years.

To the group show mounted by the Impressionists in 1874, Degas contributed ten works—dancers, racing scenes, and studies of a washerwoman and a female nude, Après le Bain; and he exhibited at all the others, save for that in 1882. In 1881, he showed The Little Dancer of Fourteen Years (one of the bronze casts is in the Tate Gallery, London), the only one of his sculptures exhibited in his lifetime. After 1886, the year of the Eighth and last Impressionist group exhibition, Degas stopped sending his works to public shows. His eyesight was by now very poor; and he worked more and more in pastel, a medium he found susceptible to bolder effects than oils.

The last twenty years of Degas' life were wretched. His eyesight deteriorated still further in the 1890's; while in the first years of the new century he could only work, and then with difficulty, on large compositions or sculpture. In 1908 he more or less gave up art altogether. The blow was crippling. Degas' life was over; but he went on living, morose, irritable, pathetic, repeating endlessly his old maxims and anecdotes, and falling into terrible silences that were broken by a single utterance: 'Death is all I think of.'

In 1912, eviction from his home in the rue Victor Massé caused Degas further anguish. A new studio was found for him; but he never really settled there. He took to wandering the streets aimlessly, 'in his Inverness cape, tapping his cane, feeling his way', and on more than one occasion was compared to the blind Homer, or Lear deprived of his daughters. Long famous and revered, Degas died in Paris on 27 September, 1917.

'Ah, Giotto, don't prevent me from seeing Paris; and, Paris, don't prevent me from seeing Giotto' — DEGAS

AMONG THE MOST PROMINENT and admired features of the 1855 Paris World Fair was the gallery devoted to the work of Ingres (1780-1867), the most respected French painter of the age and the recognized leader of the French Classical School. At the planning stage Ingres expressed a wish that an early *Bather* of 1808 (now in the Louvre) should be included, but the owner, a friend of Degas' father named Edouard Valpinçon, refused to lend the picture. Degas was incensed that a mere owner should reject the plea of a great artist; and he was able to prevail upon M. Valpinçon to change his mind. Impressed by the young man's ardour, Valpincon took Degas to see Ingres, to whom he related the whole story. The old painter, then in his mid-seventies, was touched and, when he was told that the boy wished to become a painter too, gave him a piece of advice: 'Draw lines, young man, many lines, from memory or from nature; it is in this way that you will become a good artist.'

Like the advice so often meted out by the old and famous to the young and unknown, Ingres' words were sympathetic, rather vague and a shade patronising. But Degas was never to forget them; they formed the substance of his favourite anecdote. It had been an all too brief meeting but it was to play a symbolic role in his life. The plain words of Ingres assumed the character of magic cyphers implying, as far as Degas was concerned, a whole philosophy of art, exemplified in the thirty-seven drawings and twenty paintings by Ingres which he eventually owned.

It might at first seem strange that Degas—known to everyone who has ever been inside an art gallery as the painter, par excellence, of the ballet, the race-track, the café and the nude in domestic surroundings—should have revered the sayings and work of a painter seemingly so very different. Ingres was an exceptionally conservative artist who had set his face against nineteenth-century progress, worshipped at High Renaissance shrines and consciously borrowed ideas from the works of Raphael. Classical myths and episodes from religious and secular history were his preferred subject matter.

A little of the mystery evaporates, however, when we remember that Degas in his youth tried to paint in the Ingres tradition. Of these early history pictures, *The Young Spartans* (Fig. 1) is probably the most successful. The subject is a simple one: in ancient Sparta boys and girls exercised together and in this painting the Spartan girls have just challenged the boys to a contest. Degas spent a great deal of time on the work, he made preparatory drawings for the individual figures and altered the overall design more than once, but try as he might, he could never achieve the 'correct' classical tone. In its present form *The Young Spartans* is as little like a conventional history picture as it is possible to imagine. The colour is as delicate and understated as the drawing. There are no hard lines, no rhetoric, and little or no evidence of archaeological research; instead an impression of casualness, of everyday life and of adolescence, with its touching interplay of boldness, silliness, curiosity and shyness. There is an earlier variant of the painting in existence, however, and it is more traditional in character. There is a temple in the background and the girls have been given classical headgear and idealised profiles with straight noses, whereas in the final version in the National Gallery they have the snub noses of Parisian *jeunes filles*. What induced Degas, self-confessed admirer of Ingres and the classical tradition, to make this conspicuously informal alteration?

The simplest way of stating the answer would be to say an awareness of modern life. Ingres did his best to forget that he was living in Paris in the nineteenth century. It was precisely this fact that Degas could not forget. He may not have been pleased with the age in which he lived: 'they were dirty', he once said of the era of Louis XIV, 'but they were distinguished; we are clean, but we are common': yet he came to accept it. His eye for what was actual and real was too acute to be satisfied for very long with the trappings of the classical style. The toga, the Doric capital and the ageless legends of antiquity might stand for sublime values and a nobler mode of being, but there was something shadowy about them, and like the ghost at cock-crow they faded in the glare of the gas jets that illuminated the cafés, streets and theatres of modern Paris.

Degas'. attitude to modern life was never the arid token of a self-conscious philosophy, willing to see in every new-fangled piece of machinery the soul of the nineteenth century, but a natural and spontaneous effusion of his nerves, sense of humour, curiosity and imagination. An excellent mimic, he developed an insatiable interest in behaviour, the seemingly trivial detail, the child eating an apple (Plate V); a shabbily dressed woman at a terrace café (Plate XIII); the sudden need to adjust one's shoe (Plate XI). Degas was a brilliant, though dispassionate observer of ordinary life, and it is this as much as his compositional devices or his attitude towards light that marks him out as a true Impressionist, to be ranked with Monet, Pissarro, Manet and Renoir.

1. THE YOUNG SPARTANS 1860
National Gallery, London

THERE WERE TWO BASIC POLES around which Degas' mind, temperament and artistic personality revolved: the one this feeling for modern life; the other, a strong sense of artistic tradition. But far from dividing his talent into two and reducing him to creative impotence, the rival claims grew together; they nourished his abilities and clarified his perceptions; and like the different coloured lenses in a pair of toy glasses they enabled him to see both his own art and the artistic situation of the day with stereoscopic clarity.

In a letter to a friend, Degas regretted that he had not lived at a time when artists, unaware of women in bath tubs, had painted Susanna and the Elders. At the same time he sensed that the whole temper of the age in which he lived, with its materialism and stress on scientific investigation and the objective record, was subtly destroying the delicate balance between imagination and fact on which for centuries the success of history painting had depended. Religious art in the tradition established by Renaissance painters could never survive topographically accurate records of the Holy Land. Degas had a sharp and witty tongue and he spared no one, least of all his friends. He did not conceal from Gustave Moreau that he had no time for his highly detailed historical fantasies: 'he wants to make us believe the Gods wore watch chains', he was fond of saying. Under the pressure of a strong aesthetic feeling, would not a love of beauty combine with archaeological exactitude to form a philosophy of ornament? One day Moreau asked Degas: 'are you really proposing to revive painting by means of the dance?' Degas parried: 'and you, are you proposing to renounce it with jewellery?'

THE SAME DEGREE of perception was brought to bear on the problem of portraying modern life. Degas soon realised that it was not enough to paint people in their ordinary clothes, while adopting a highly traditional type of composition, as he had done in his *Self-portrait* of about 1855 (Louvre, Paris), which had been based on a romantic Ingres *Self-portrait* of 1804 (Musée Condé, Chantilly). The whole strategy had to be thought out anew. Changing only the details was rather like introducing colloquial phrases into a play that was still in verse and meant to be acted in the grand manner. Conversation in real life was full of half-finished sentences and overlapping talk.

And was not the same true of appearance? It became very clear to Degas that what gives so many of life's actions their final seal of triviality is that they occur simultaneously. If the world had stopped and held its breath while the woman in the café took a sip from her drink, it would indeed have become an act to set beside the crowning of kings. But the world does not stop. The woman drinks on unnoticed by the man smoking his pipe; one dancer yawns at precisely the same moment as another pats her hair (Plate XI); a clerk does his accounts oblivious of the man behind him reading the newspaper (Plate VIII).

Trivial events, gestures and movement, the sigh of the woman looking down at the carriage as it passes in the street below, the grip of the hand on the heavy iron, cigar smoke, the loose cover of an armchair—they were all real enough, but were they compatible with art? Degas thought they were, though the same analytic cast of mind that led him to probe deeply into the problems of naturalistic representation made him unusually conscious of the dangers to which naturalism so easily gives rise. Unlike certain modern artists, Degas did not imagine that one would achieve greater realism by breaking through the very barriers of style itself. 'One sees as one wishes to see,' he once remarked, 'and it is that falsity that constitutes art.'

Nor did Degas imagine that naturalism would immeasurably broaden the scope of art. The apparent variety which it seemed to imply was really a symptom of its greatest potential weakness, triviality. 'Instantaneousness is photography, nothing more,' we find him writing in a letter of November, 1872. A few days later, in a letter to his friend, Henri Rouart, he expressed the view that 'one loves and gives art only to the things to which one is accustomed. New things capture your fancy and bore you by turns'. He touched on the point again in a letter written in January, 1886, to Bartholomé: 'it is essential to do the same subject over and over again, ten times, a hundred times. Nothing in art must seem to be accidental, not even movement'. Always at the back of his mind was a precise combination of lines and colours, and arrangements of form, that would combine the firmness and inevitability of classical design with an impression of life that was immediate and spontaneous. Degas devoted the whole of his mature life to the difficult task of preserving the disciplines and poised effects of classical art while rejecting its time-honoured associations, props and subject matter. Nothing could be less idealised, less like the figures of Ingres in fact, than Degas' studies of the female nude (Plate XVI). The artist himself told George Moore that they represented 'the human beast occupied with herself, a cat licking herself', and they create an impression that is realistic because we are shown women who have undressed not for our admiration but to wash their bodies. The sense of actuality is increased by compositional devices that heighten the effect of spontaneity, a glimpse through an open door, perhaps, or the choice of an unusual angle. And yet, without sacrificing one jot of their day-to-day ordinariness, Degas was at the same time able to invest the forms with the monumentality of classical sculpture. Renoir compared these works to fragments from the Parthenon, the noblest creation of fifth-century Athens.

IN ART observation is nothing if it is not related to design. And it was the underlying discipline of classical design that Degas so admired in the paintings of Ingres. By

nature melancholy and disenchanted, not easily beguiled and always inclined to see the skull beneath the skin, Degas knew that there was a good deal more to the work of the great master than superficial observers and imitators perceived. Ingres' classicism was a matter not of archaeological details but of deeply pondered arrangements of form. Beneath the draperies and brightly coloured accessories, the plump flesh and waxen finish, was a wholeness and serenity, a pictorial equilibrium that would almost have made it possible to translate Ingres's paintings into harmonious geometry.

Degas never allowed himself to forget the lesson of Ingres. It was constantly, vitally relevant precisely because his own kind of naturalism was so radical, committed to depicting what is not only actual and unidealised (seventeenth-century Dutch painters had already done this) but also what *appears* to the eye (which few Dutchmen had attempted). So far-reaching a proposition raised, and still raises, the issue of what we mean by 'true to life' and how we should define 'casual' and 'significant'. When in daily life we notice something 'casually', it means that we have made a lightning judgement according to standards of what is significant. For any one of a thousand accidental reasons, other people's lives suddenly impinge upon our own; we are made aware of a gesture, a movement, a figure, and for a moment it occupies the forefront of our attention. But we dismiss it again if it does not pass the test of what is personally significant. A woman in black, kneeling in prayer, with tears streaming down her face, is likely to make a deep impression because she brings to mind profound associations of life and death and loss. And she might also stand, incidentally, for the type of recognizably emotive image favoured by the older and more traditional schools of art. But a girl merely yawning, or a man reading a newspaper are phenomena too ordinary to lodge themselves in the memory; and they take their place in that passing flow of impressions which make up the richly varied, yet curiously vague texture of daily life.

Degas' great achievement lay in his ability to render this texture in wholly pictorial terms. The life-like casualness of his 'impressions' is defined not by implicit appeals to our non-pictorial faculties of judgement, as it is in Victorian anecdotal painting where even the titles (*The Morning Gossip, A Passing Thought*) stress the story, but by pure design. On the right of *The Rehearsal* (Plate IX), the wardrobe-mistress is repairing or adjusting the skirt of a ballet-dancer. It is an action of no importance and that is what, by virtue of his art, Degas allows it to remain. The instinctive human process of attention, judgement and dismissal is transmuted into a pictorial device whereby the group is cut by the edge of the frame. Move the whole group to the centre of the painting and it would assume, because of its dominant position in the design, a 'non-casual' importance; the pictorial situation would become pregnant with just those narrative implications that Degas was at pains to avoid. Design, with all its implications of selection and emphasis, is at the centre of Degas' achievement. For it enabled him, at one and the same time, to re-create an impression of unaccented, flowing life and to preserve a purely aesthetic harmony that is not haphazard at all—and without which the very power of the vision would be lost. Degas created unforgettable images of unmemorable facts; and in this light his art, representing as it does a tolerant acceptance of life, takes on a moral character. In its way, it is more humane than many conventional religious paintings.

DEGAS WAS CONCERNED with the underlying structure of design and form from the very beginning. Already, in 1856, we find him writing in a note-book: 'It is essential, therefore, never to bargain with nature. There is really courage in attacking nature frontally in her great planes and lines, and cowardice in doing it in details and facets.' Even when copying as an exercise the great artists of the past, Degas was faithful to his maxim, blocking in the forms broadly and ignoring the minute details. The sketch of *Giovanna and Giulia Bellelli* (Plate II), which is an early study for *The Bellelli Family* (Plate III), reveals the same approach to form.

The final version of *The Bellelli Family*, the most ambitious and important of the artist's early portraits, is of great interest in that it shows the young Degas attempting to reconcile classical design with the conclusions he had drawn from his observation of actual behaviour. The husband and wife are shown with their two daughters in the sitting-room of their house. The overall effect is monumental, the stance of the mother, in particular, suggesting the influence of Ingres, and at first one does not appreciate the casualness of the grouping. For the central figure is not as one might expect, and as Ingres would have made him, the head of the house but the younger daughter wearing an everyday pinafore. A similar informality is to be found in the brilliant portrait of the

2. STUDY FOR THE PORTRAIT OF MADAME JULIE BURTIN 1863
Fogg Art Museum, Harvard University. (Bequest of Meta and Paul J. Sachs)

Morbillis (Plate IV), which again has an immediacy alien to Ingres, the suggestion of people suddenly asked, in the middle of the afternoon, to look in the artist's direction for a minute or two while he paints their portraits.

In working out formulae that would accommodate this spontaneous, fragmentary aspect of vision, Degas was influenced by Japanese prints, which had become both popular and fashionable in the early 1860s, and by photography. From the colourful prints of Japan, he learned how to cut off the figure abruptly (for example, the dancer at the left in Plate XI or the man on the right in Plate XII); how to achieve effects through calculated asymmetry (Plates XII, XIII and XIV-XV), as well as a bold use of the head in close-up. The sloped foregrounds in his work (Plates IX and XIII) and unusual sight angles (Plates VI-VII and XIV-XV) suggest the influence of photography, an art in which Degas was a proficient amateur.

Visual spontaneity, however, was not achieved at the expense of visual equilibrium. Again under the influence of Japanese prints, which do not conform to western traditions of box perspective, Degas learned to use void areas positively. The grass in *At the Races* (Plate XII), for example, or the table tops in *L'Absinthe* (Plate XIII), even the boarded floor in *The Rehearsal* (Plate IX) tell not only as surfaces receding into depth but also as flat shapes whose very simplicity is a counterweight to the figures.

THE CRUCIAL LINK between the flux of life and the unfluctuating sense of order that Degas felt was proper to art lay in drawing—in the lines, the many lines Ingres had urged him to make. Degas shared the general Impressionist interest in the effects of light, and he could render them with the greatest delicacy and precision (Plates VIII, IX and XIII); he knew the value of light, and how it could be made to reveal form (the arms, for example, in Plate XI) and emphasise movement (the stage area in Plate XIV-XV), but he would never allow the observation of light to undermine the importance of drawing. Even when the forms are seen under a powerful illumination, the outlines in Degas' paintings are always firmer than in those of Monet or Pissarro. And Degas would make preliminary sketches of figures which, in the final painting, might be subjected to entirely different methods of lighting. For *The Rehearsal* (Plate IX), four beautiful drawings survive; and in some a plumb-line was employed. To describe the painting as a 'slice of life' created with the patient subterfuge of the Old Masters is to underline what the artist told George Moore: 'No art was less spontaneous than mine. What I do is the result of reflection and study of the great masters; of inspiration, spontaneity, temperament, I know nothing.'

A feeling for order depends on having a sense of priorities arrived at through evaluation. Drawing was Degas' method of evaluation. Pastel always appealed to him since it enabled him to retain colour without giving up a linear emphasis. In one of his most illuminating remarks, he explained why it was important that the artist should not draw only what was directly in front of him. 'It is all very well to copy what you see,' he said, 'but it is much better to draw only what you still see in your memory. This is a transformation in which imagination collaborates with memory. Then you only reproduce what has struck you, that is to say the essential, and so your memories and your fantasy are freed from the tyranny which nature holds over them.' It is a measure of his seriousness that Degas assumed, automatically, that what would strike the artist would be what was essential. He was one of the greatest draughtsmen in the history of European art, but in the entire range of his work there is no hint of virtuosity exploited for its own sake.

The constant exercise of this great gift on a restricted range of subject matter enabled Degas to judge, with increasing sureness, what could and could not be eliminated in any sequence of forms. The girl combing her hair, on the extreme left of Plate X, is brilliantly observed; there is mastery in the placing of hands and arms, and in the way the head is forced slightly to one side by the downward pressure of the comb drawn through the hair. But the study remains, at the same time, highly simplified. The tiny irregularities, the bumps, veins and wrinkles in hand and arm have been suppressed. It is precisely this careful selection of forms which gives to those that are finally included their conviction and simple grandeur.

DEGAS ALSO VALUED DRAWING because line and outline are among the most satisfactory methods of creating an impression of movement—the movement on which he always concentrated because for him it vividly expressed the pulse-beat of life. True to the Impressionists' anti-literary doctrine, Degas always tried to achieve the maximum expressiveness of form and complexity of movement with the minimum narrative reference. The paintings from the ballet, the most popular category of his work, exemplify his aims; and a copy that he made in about 1870 of Poussin's *Rape of the Sabine Women* (the original is in the Louvre) helps to make the point even clearer.

In the Poussin copy, across a setting that is itself not unlike the stage of a theatre, carefully placed groups of figures display the whole gamut of emotions implied by a concerted attack of this kind. Degas himself, in his maturity, did not paint such a scene. But in the dancer, the laundress, the jockey, the acrobats, the milliner arranging hats, and the woman at her toilet, he found a corresponding range of bodily movement. He was particularly attracted by the exercise of a professional skill in which highly conscious, often severely disciplined actions were brought into play for professional rather than personal reasons. As she pirouettes and glides across the stage, and raises her expressive arms, the dancer is not Daphne eluding the amorous Apollo, or a Sabine woman resisting her earnest captor; but nor is she a dramatic character in a ballet; she is simply a dancer, doing her job. In one complex operation, Degas—like Daumier in his theatrical scenes—preserves the trappings of artifice while stripping away the pretence.

Of all the painters loosely grouped together under the name of Impressionists, Degas most deserved a great final phase of creative activity. But though he laboured on he was denied through failing sight an ultimate flowering of his great gifts. And the qualities of mind which helped to make his work so exceptional made his last years particularly tragic. As the once sure hand (Fig. 2), as sure as any since Leonardo da Vinci and Holbein, fumbled with the chalks, no wonder he railed at fate. He knew, so clearly, what he wanted to do. Unable to do it his life became barren, aimless, a terrifying fog illuminated by the faint glimmer of memories. And as he shuffled along the boulevards, oblivious to the sound of the motors, and frequently in danger of being run over, how often his mind must have gone back over half a century to that unforgettable meeting with another artist, then also old, and to the advice he had given: 'draw lines, young man, many lines. . . .'

The Plates

I. ACHILLE DE GAS c. 1857
Oil on canvas. 25¼ in. × 20 in.
*National Gallery of Art, Washington
D.C. (Chester Dale Collection)*

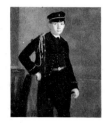

A portrait of a brother of the artist in the uniform of a cadet. Like Ingres, Degas concentrated, up to the mid 1860's at least, on portraiture and history painting.

II. GIOVANNA AND GIULIA BELLELLI 1859-60
Oil on canvas. 30½ in. × 24 in.
Gualino Collection, Rome

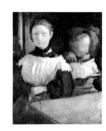

One of several studies for Plate III. The earliest were begun in Naples in 1856, and they were continued in Florence between 1857 and 1860, the final painting being carried out in Paris, 1860-62. This study dates from 1859-60 and the grouping used in it was not adopted in the final picture.

III. THE BELLELLI FAMILY 1860-62
Oil on canvas. 80 in. × 101⅛ in.
Louvre, Paris

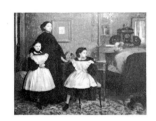

The most ambitious of Degas' early works and one which shows clearly his aim to reconcile classical precision of design with an impression of casualness and spontaneity. Laura de Gas (1814-1897) was the sister of Degas' father; she married Baron Gennaro Bellelli (1812-1864) in 1842. Giovanna (born 1849) and Giulia (born 1851) were therefore Degas' cousins.

IV. EDMONDO AND THÉRÈSE MORBILLI c. 1865
Oil on canvas. 46¼ in. × 35½ in.
Museum of Fine Arts, Boston

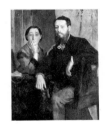

Thérèse de Gas (1840-1897), the painter's sister, married her cousin, Edmondo Morbilli (1836-1894), in Paris in 1863. A second portrait of the Morbillis, also dating from the mid-sixties, is in the National Gallery of Art, Washington (Chester Dale Collection). Degas could not get it right, and left it in a disfigured state.

V. PORTRAIT OF HORTENSE VALPINÇON c. 1870
Oil on canvas. 29¾ in. × 44¾ in.
Institute of Arts, Minneapolis

Hortense Valpinçon was the daughter of Degas' childhood friend, Paul Valpinçon. The painter used to visit the family regularly at their home in Normandy. In its sense of spontaneity, this portrait marks a further advance over Plates III and IV. The child leans casually against a table; and she seems to turn towards the spectator in a perfunctory manner, as though half her attention is still on the apple she is in the middle of eating.

VI-VII. THE ORCHESTRA c. 1869
Oil on canvas. 20⅞ in. × 13¾ in.
Louvre, Paris

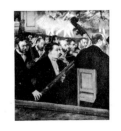

The bassoonist in the foreground is Désiré Dihau, a friend of the artist. It is typical of Degas' attitude to realism that when he painted a portrait of his friend, he depicted him at work. This realism is further revealed in the composition, with the figures cut by the frame, and in the lack of self-consciousness in the players.

VIII. THE COTTON MARKET, NEW ORLEANS 1873
Oil on canvas. 29⅛ in. × 36⅛ in.
Musée des Beaux-Arts, Pau

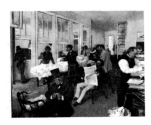

The first of Degas' paintings to be bought by a public museum (in 1878), *The Cotton Market* is a composite portrait of the men involved in the cotton business of the artist's uncle, Michel Musson, who is shown sitting in the foreground. The man on the extreme left, leaning on the partition sill, is Achille de Gas; while the man in the centre, reading the newspaper, is René de Gas. Both were brothers of the artist, who painted the picture on his trip to America in 1872-3.

IX. THE REHEARSAL 1873-74
Oil on canvas. 23 in. × 33 in.
*Art Gallery and Museum, Glasgow
(Burrell Collection)*

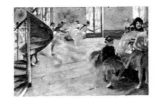

X. GIRLS COMBING THEIR HAIR 1875-76
Essence on paper, mounted on canvas. 13½ in. × 18½ in.
Phillips Collection, Washington D.C.

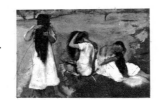

XI. THE REHEARSAL 1873
Pen, ink and *essence* on paper, mounted on canvas. 21⅛ in. × 28¾ in.
Metropolitan Museum of Art, New York (Collection Havemeyer)

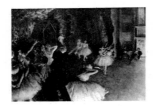

XII. AT THE RACES 1877-80
Oil on canvas. 26½ in. × 32⅜ in.
Louvre, Paris

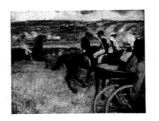

XIII. L'ABSINTHE 1876
Oil on canvas. 37 in. × 27½ in.
Louvre, Paris

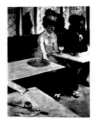

XIV-XV. DANCERS ON STAGE c. 1880
Pastel on paper. 22⅜ in. × 17¼ in.
Art Institute, Chicago (Potter Palmer Collection)

XVI. WOMAN DRYING HER FEET c. 1886
Pastel. 21½ in. × 20⅜ in.
Louvre, Paris

Degas had first become interested in theatrical subject matter in the second half of the 1860's (cf. Plate VI-VII); and in the early 1870's he began to study ballet dancers, both on stage and off, performing, rehearsing, resting. This picture, one of the most brilliant of a long series, was seen by Edmond and Jules de Goncourt when they visited the artist in his studio on the afternoon of Friday, 13 February, 1874.

Degas appreciated that naturalism demanded as much, if not more, discipline than classicism; and that the seemingly effortless pose could only be achieved by endless preparatory studies. These he made in oils (*essence* is a method of diluted oils) as well as pastel and pencil. The present painting is a fine example. Although vaguely suggestive of a beach scene, it is really a study of movement, and the three poses were drawn from the same model.

Plate IX shows a rehearsal in a classroom; Plate XI represents a rehearsal on stage. The impression of a 'slice of life' is conveyed by the unusual angle, from the wings; by the abrupt way figures — even musical instruments — are cut off by the frame; and by the great variety of simultaneous actions that are represented: one girl yawns, another adjusts her shoe, a group dances, a girl holds on to a piece of scenery and gazes into space, and so on.

The racecourse was one of Degas' favourite themes: it was a vivid and attractive aspect of contemporary life; and in the jockey he found, as he found in the ballet dancer and the laundress, a subject in which movement naturally played an important part. This movement gained in significance because it also represented the exercise of a professional skill.

Probably shown at the Second Impressionist Exhibition in 1876, as *Dans un Café*, *L'Absinthe* represents the actress Ellen Andrée and Marcellin Desboutin, a minor painter of the day, on the terrace of the Café de la Nouvelle-Athènes. *L'Absinthe* was for some time in England; though it was not then appreciated. When it appeared in a Christie's sale in 1892 it was hissed; and only fetched 180 guineas. Shown at the Grafton Gallery in March, 1893, it provoked a storm of abuse, being variously described as vulgar, sottish, loathsome, revolting, ugly and degraded.

After 1880 Degas used pastel increasingly, partly because it was easier to manipulate than oil, which he gradually abandoned as his sight deteriorated. This pastel is much freer in handling than his earlier ballet scenes (cf. Plates IX and XI); but by now experience enabled him to adopt a more summary treatment of form without any sacrifice of accuracy or vividness.

Exhibited at the Eighth and last Impressionist Exhibition, in 1886. This pastel is typical of Degas' whole approach to the nude, which he wanted to represent in domestic surroundings, devoid alike of self-consciousness and eroticism. It is,' he told George Moore, 'the human beast occupied with herself, a cat licking herself.'

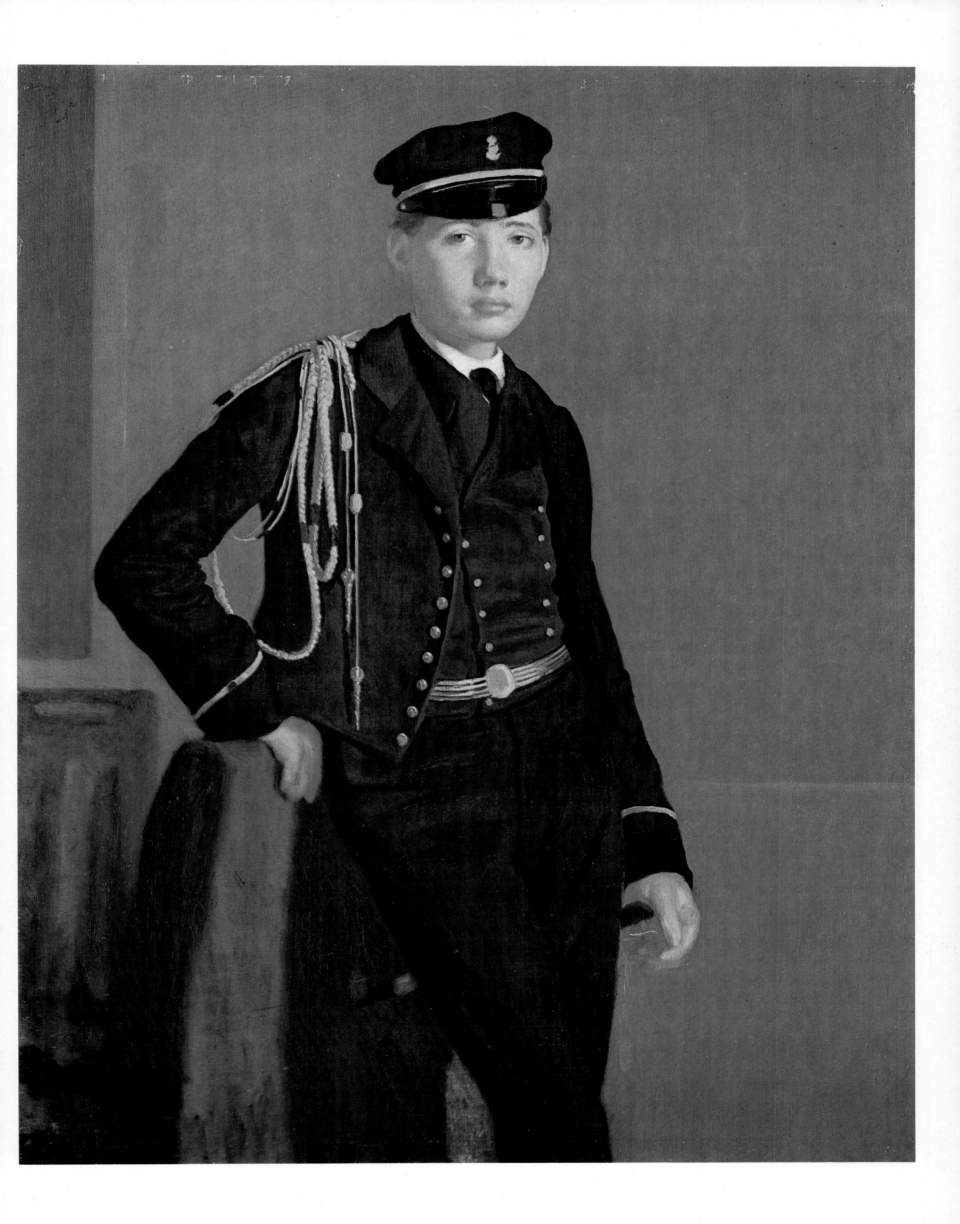

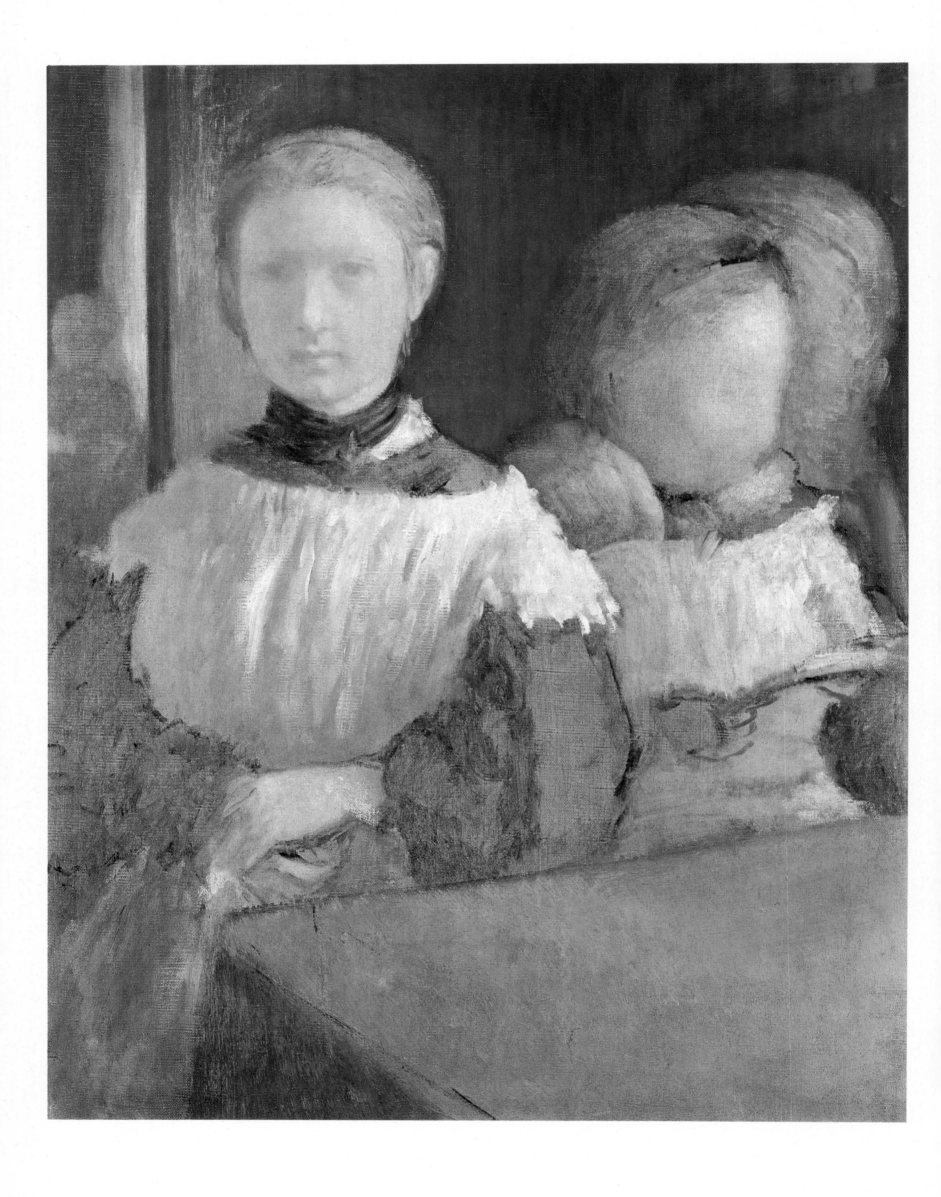

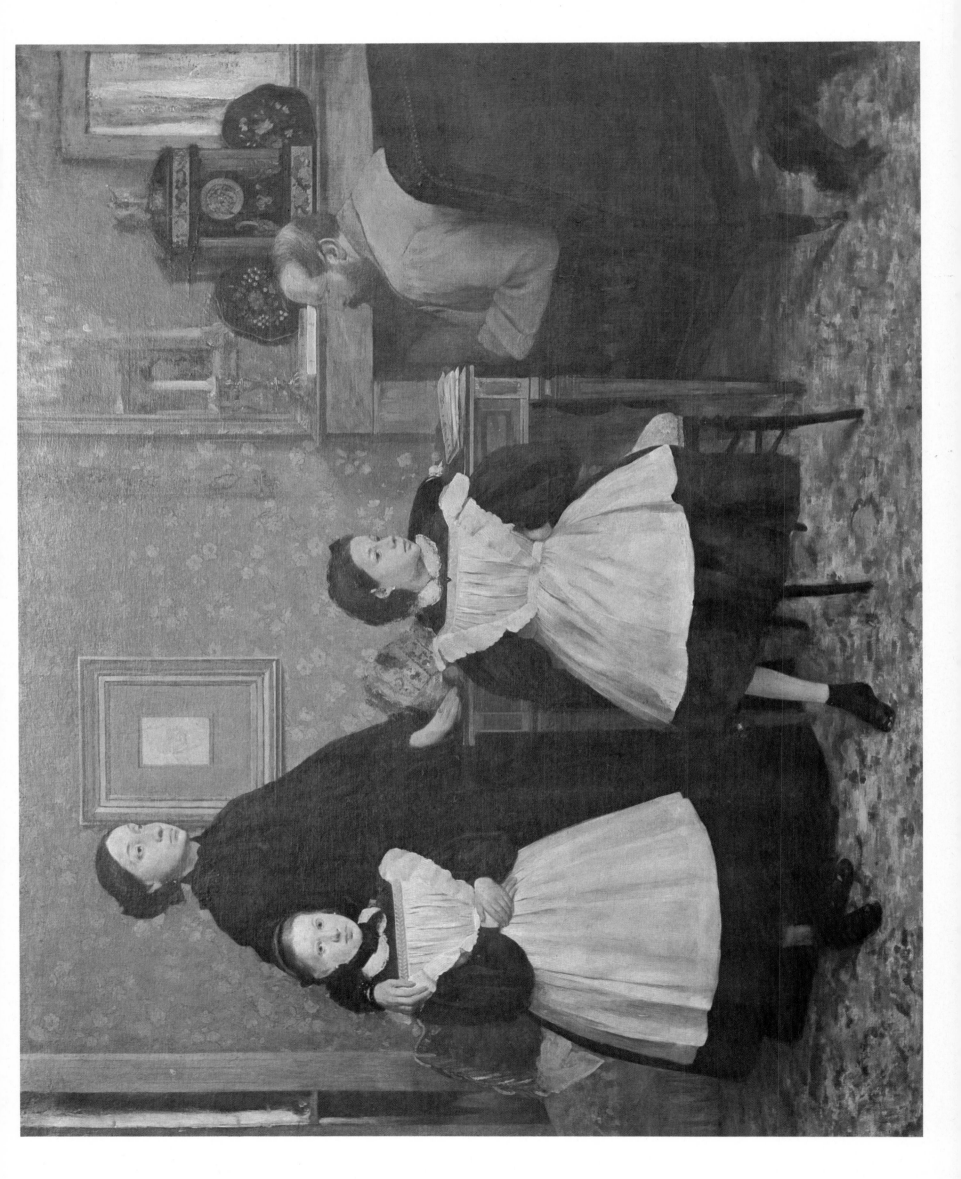

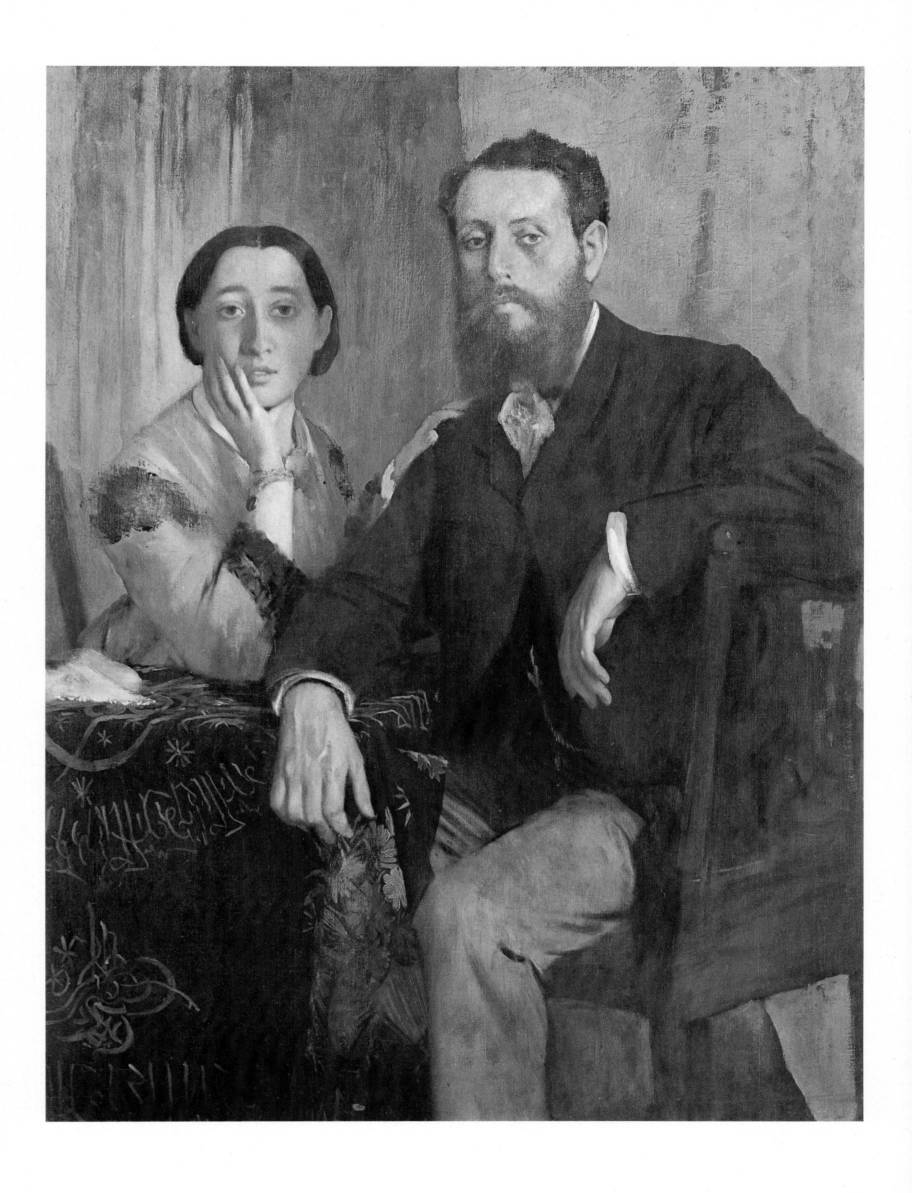

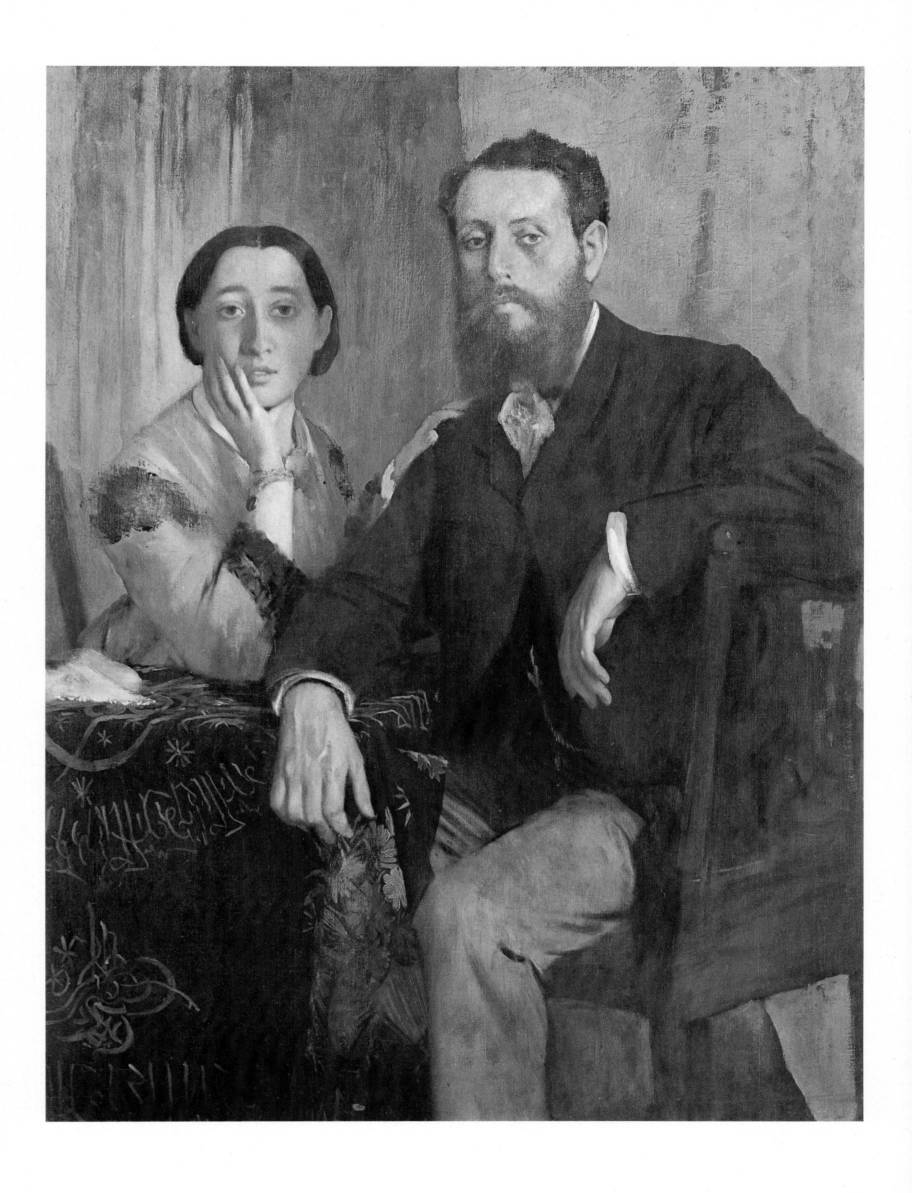

IV

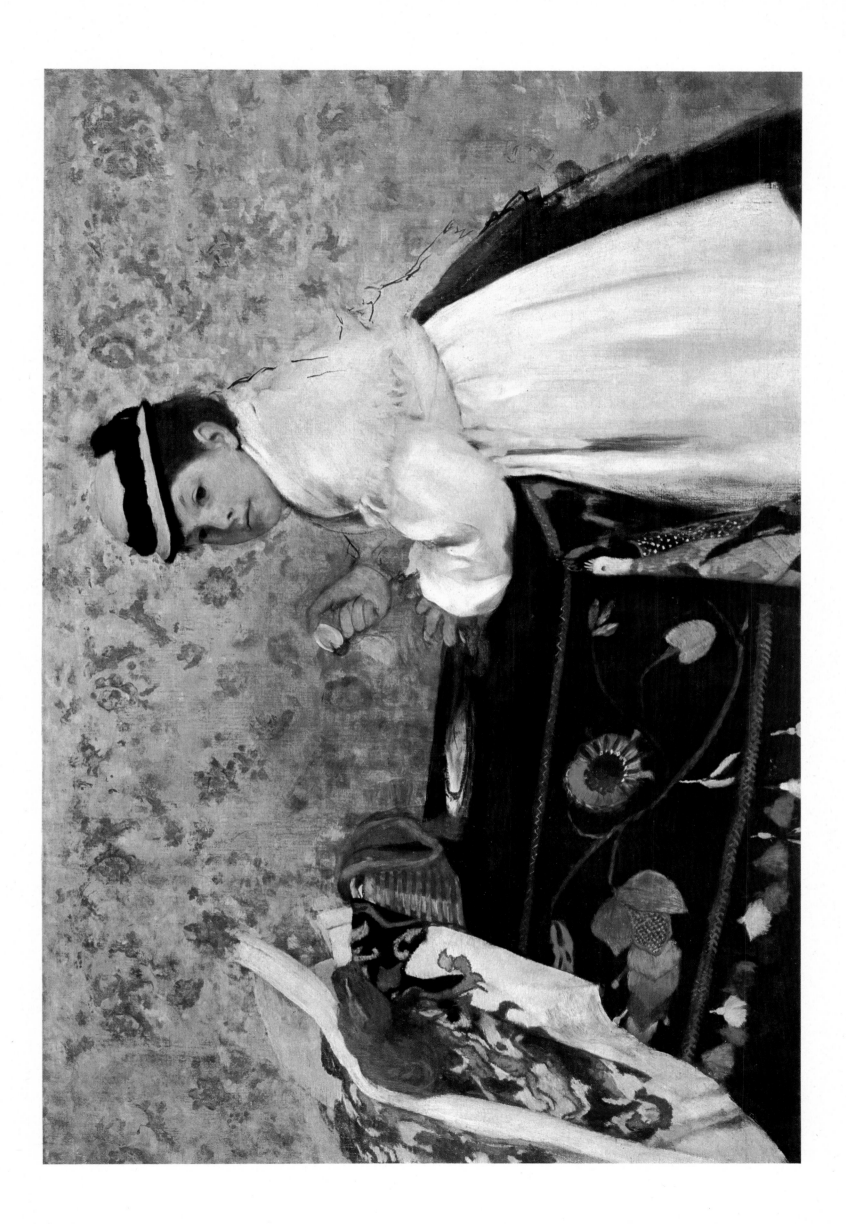

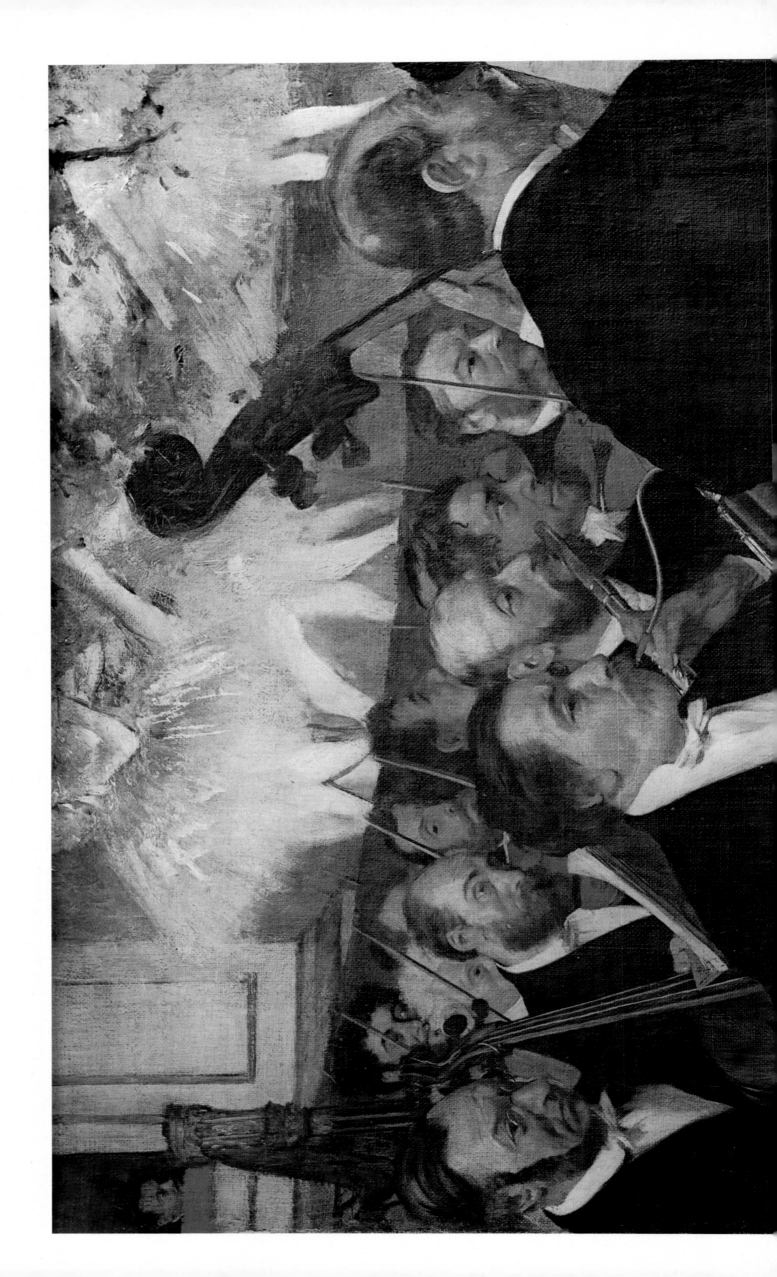

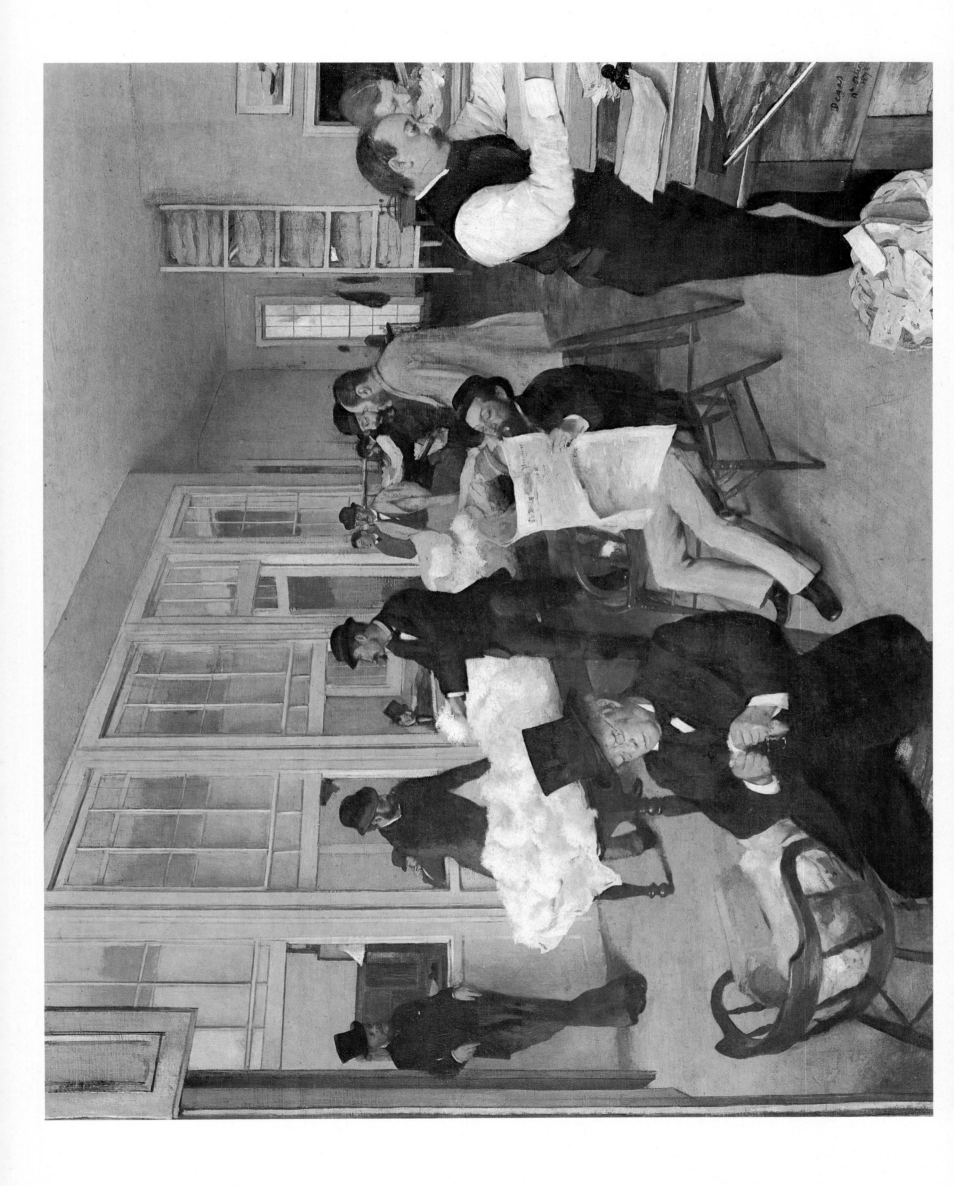

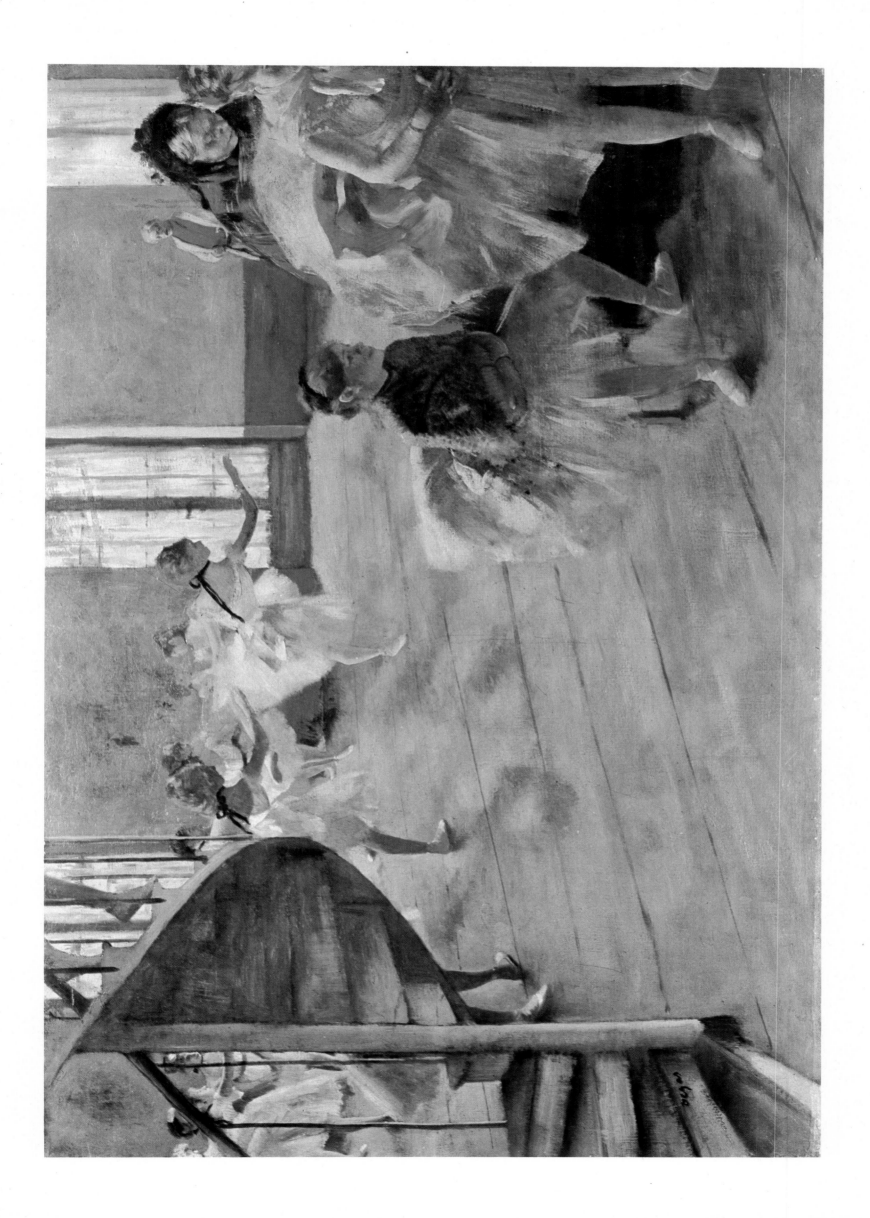

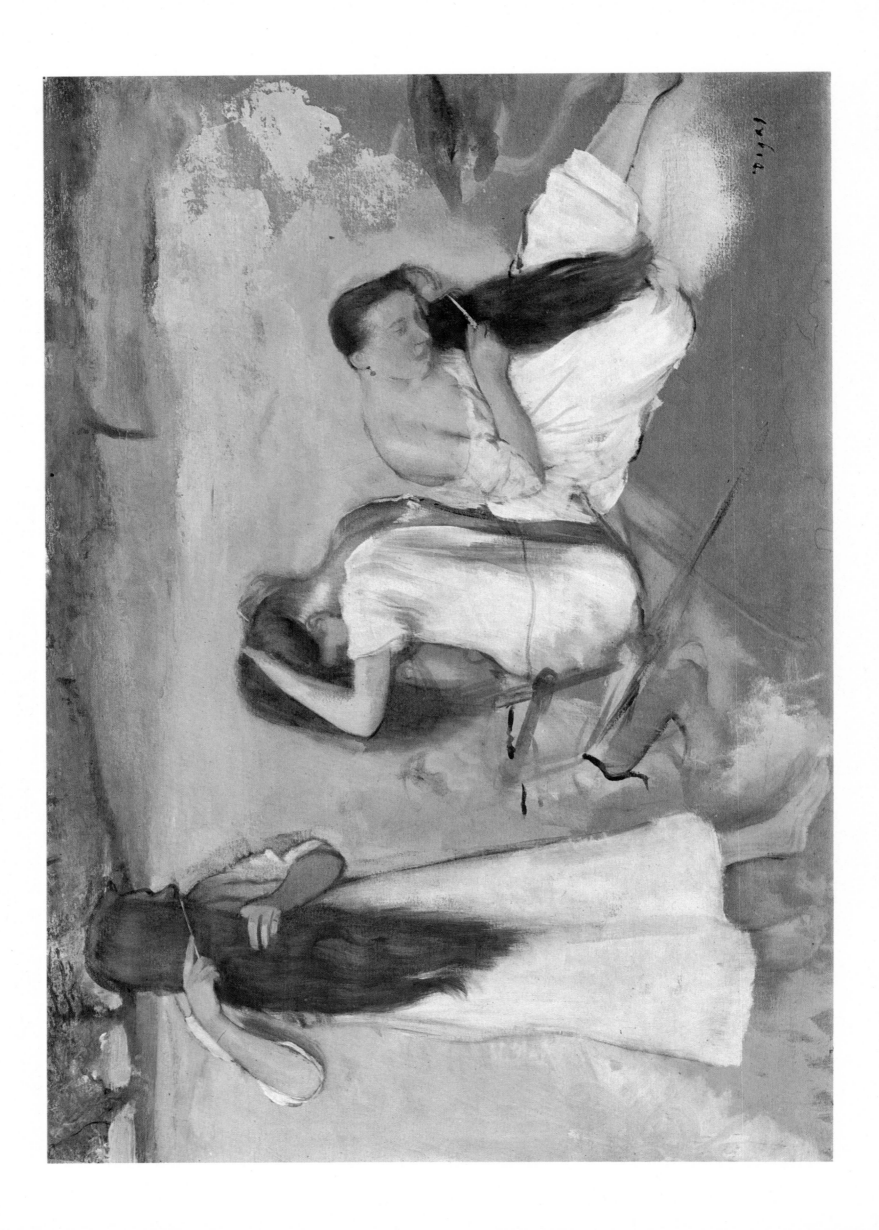

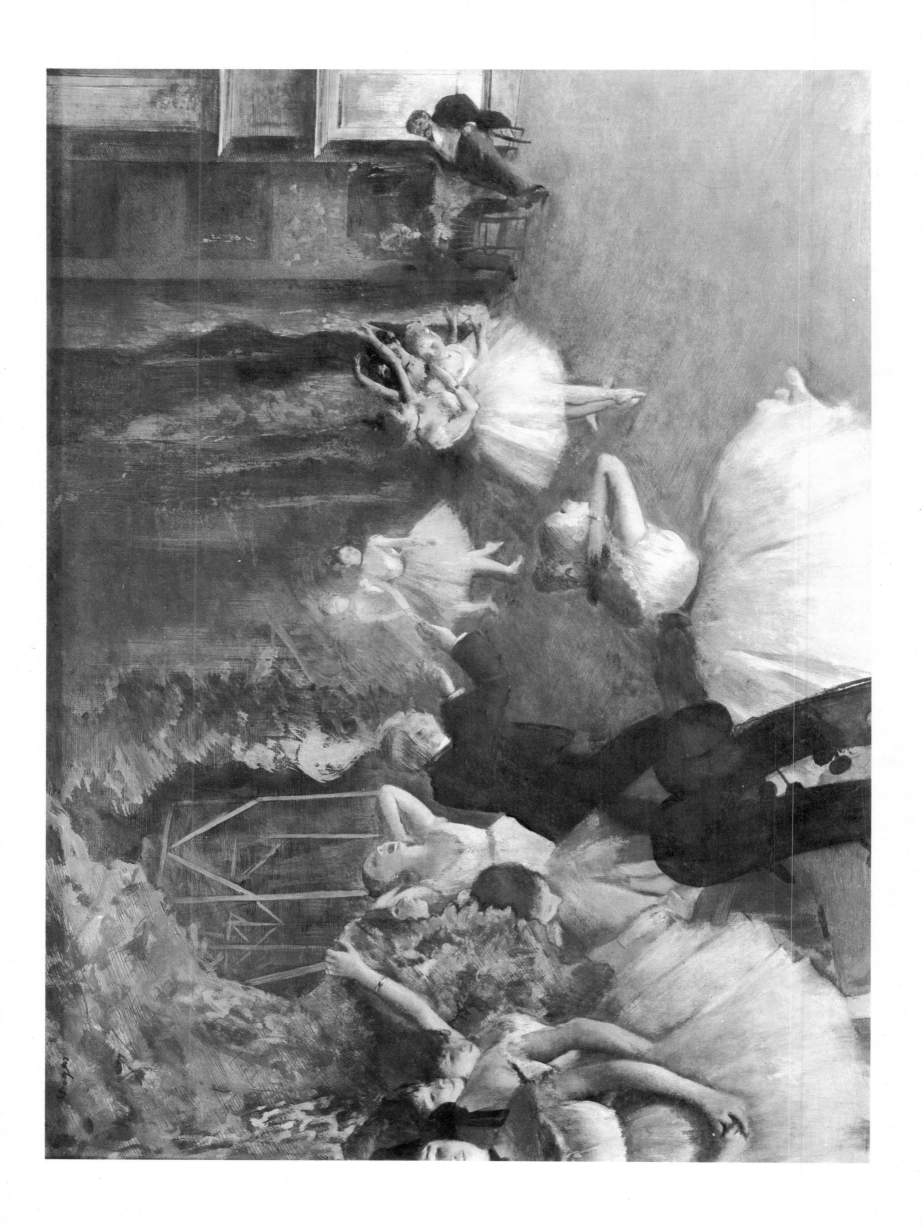

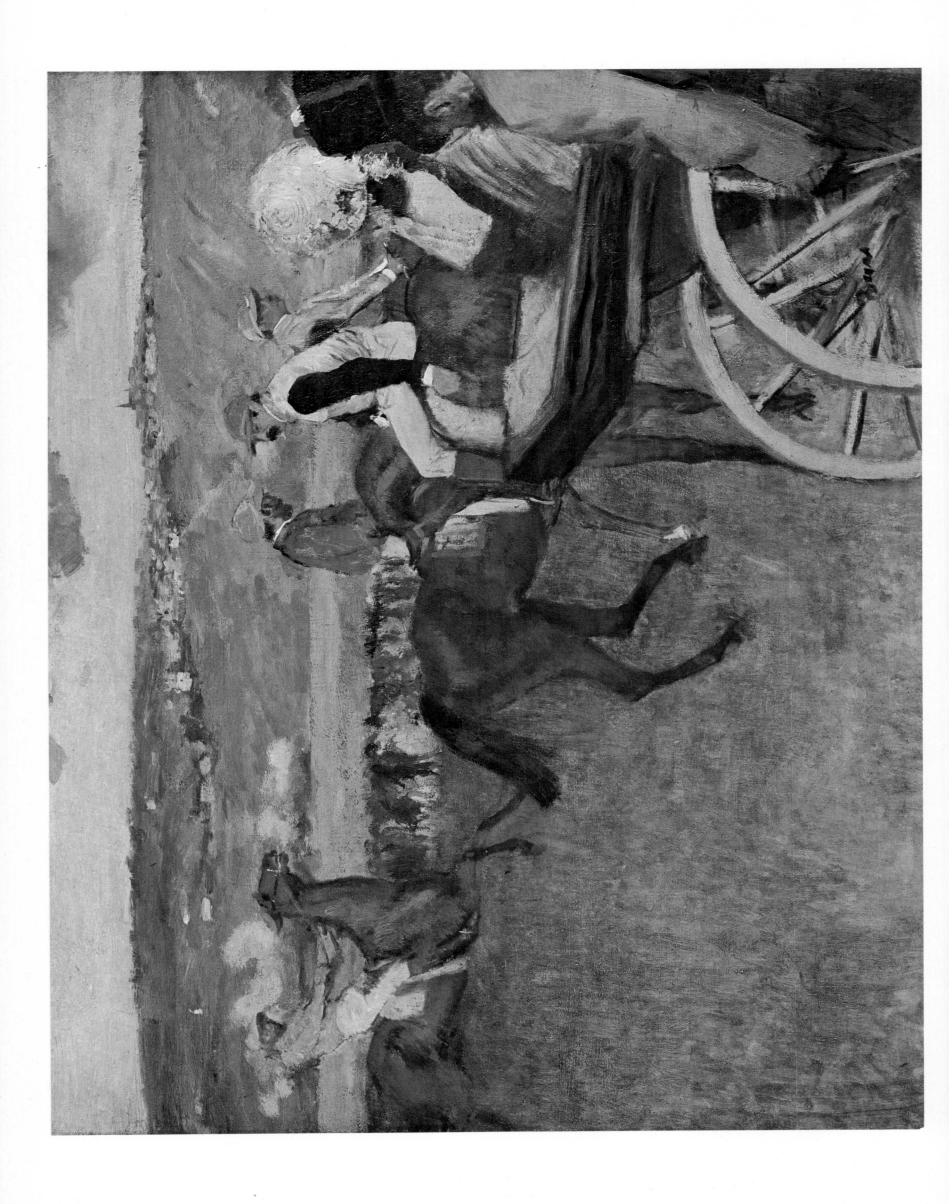

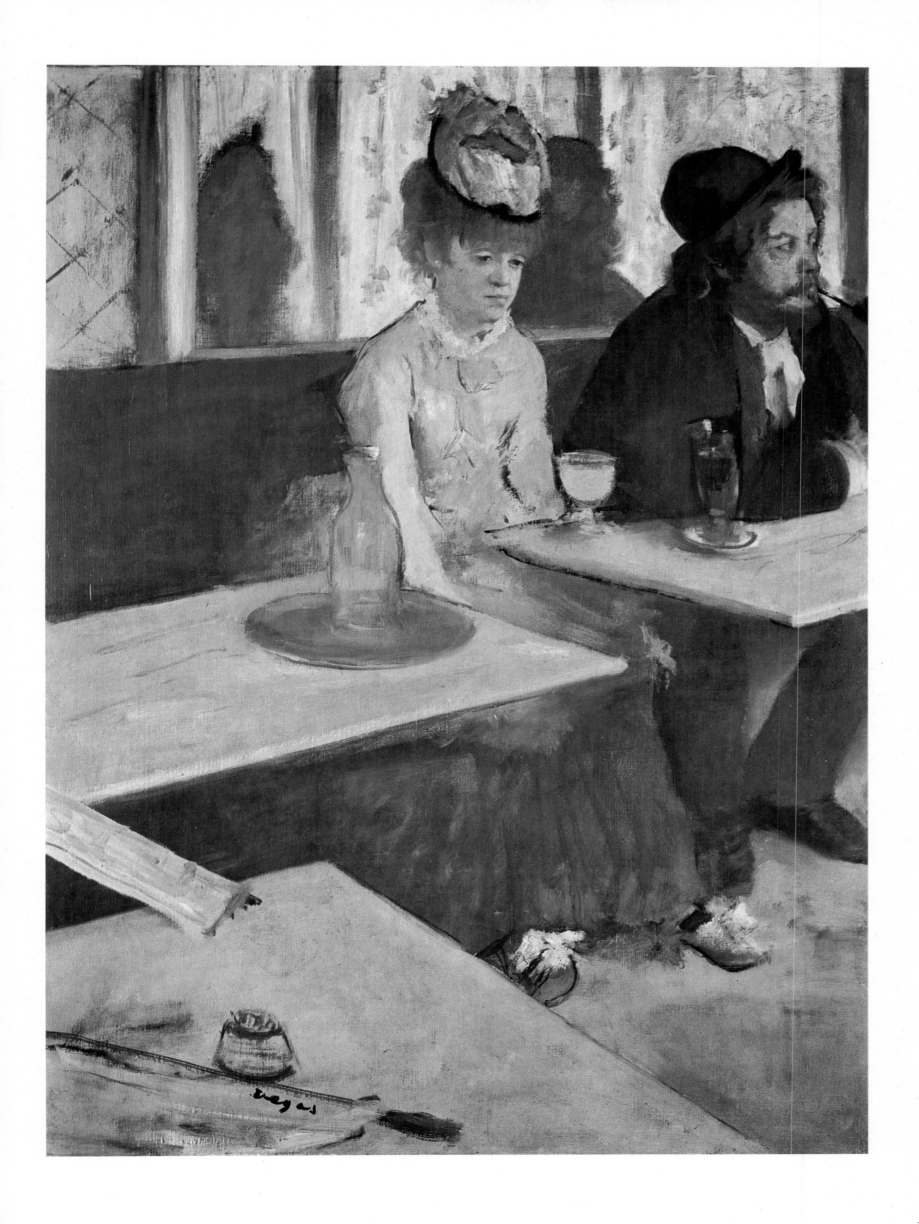

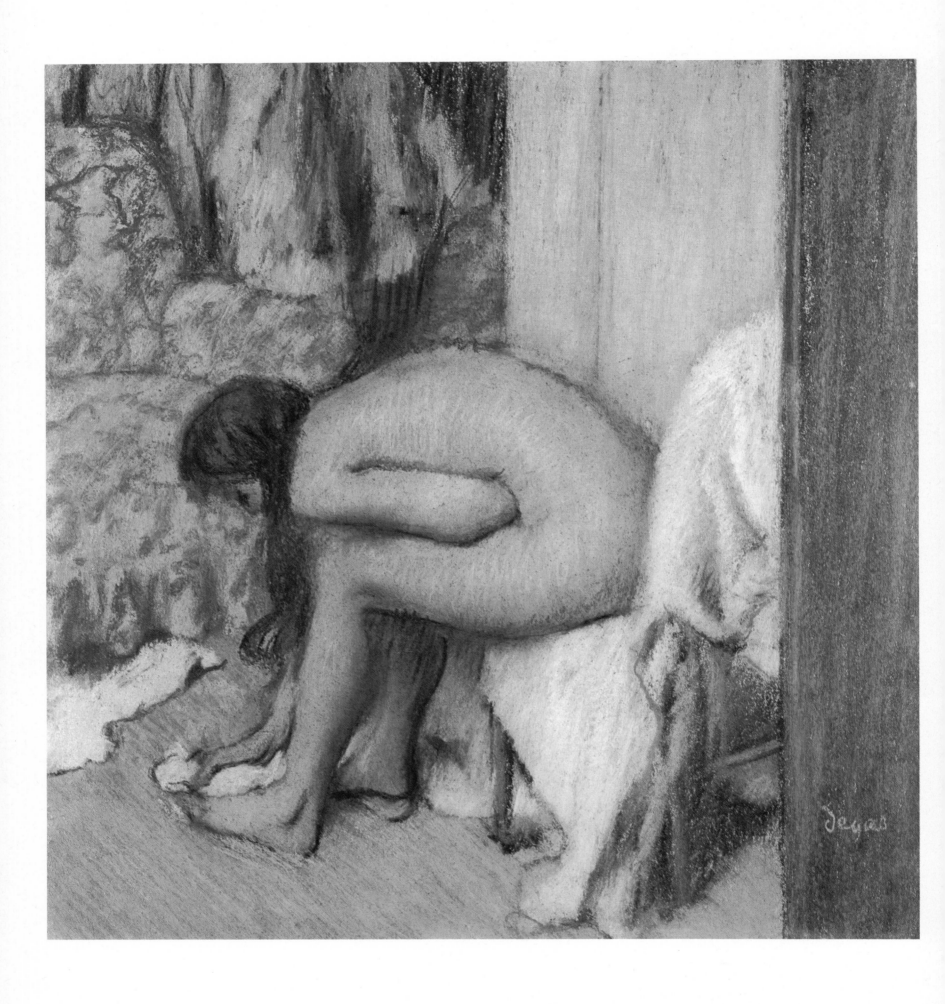

Paul Cézanne

Paul Cézanne 1839-1906

Paul Cézanne was born on 19 January 1839 at Aix-en-Provence, the son of Louis-Auguste Cézanne, a prosperous hat-merchant who later became a banker. In 1858 Paul graduated from the Collège Bourbon where he received a solid classical education and where he began his long friendship with Emile Zola. The two boys spent their summers reading, writing poetry and roaming the countryside together. Cézanne's love of the land remained with him, gradually maturing into a passionate devotion. While at school, he also attended classes at the Ecole des Beaux-Arts, which was connected with the municipal museum. Submitting to his father's wishes, Cézanne studied law at the University of Aix from 1859 to early 1861.

In 1859 his father purchased a country estate, the Jas de Bouffan, whose noble house and gardens often appear in Cézanne's mature paintings.

Cézanne's desire to prove that he could make a financial success of painting probably caused him at least as much anguish as did his father's early refusal to allow him to become a professional painter; and this need, still unfulfilled at his father's death in 1886, was related to Cézanne's lasting hope for official recognition. Year after year he continued to submit paintings to the Salon although he could only anticipate rejection of his shockingly unorthodox work. Partly through the intercession of his sympathetic mother but primarily through the patient and enthusiastic encouragement of Zola, who had moved to Paris in 1858, Cézanne persevered, until in April 1861 he finally gained permission from his father to go to Paris to study art. Apparently failing to qualify for admission to the Ecole des Beaux-Arts, he worked at the Académie Suisse, where he met Pissarro who became for him 'a man to be consulted—something like God'.

For the next twenty years he was active much of the time in and around Paris, although he never liked to stay too long away from his 'good sun of Provence' which even Van Gogh did not love more deeply than he. He continued his self-education by studying and copying at the Louvre and the Trocadéro. In 1863 he exhibited at the historic Salon des Refusés. Having become friends with Monet, Renoir and the other young rebels who revered Manet, he found himself a member of the avant-garde during the formative years of Impressionism. In 1869 he met Hortense Fiquet but she did not legally become his wife until 1886. His son Paul, for whom he always had the deepest affection, was born in 1872.

Between 1872 and 1882, he frequently stayed at Auvers and Pontoise where he worked with Pissarro, the Impressionist from whom he learned most and with whom he had the most in common. In 1874 the three paintings which he exhibited in the first Impressionist exhibition were cruelly ridiculed. However, even from the beginning his work was highly regarded by his colleagues and by a few far-sighted amateurs.

In 1877 Cézanne exhibited with the Impressionists for the last time, partly because the notoriety and persistently unfavourable popular criticism his work provoked were too painful and distracting. From 1877 until his first one-man exhibition at Vollard's gallery in 1895 his work was very little seen by the public who thought of him, if at all, as the mad hermit of Aix. Although Cézanne was in Paris less frequently and for shorter periods after about 1882, he continued to go there throughout his life to visit friends, paint portraits and study at the Louvre. Constantly moving about, up and down the country, he seldom remained long in Aix; but he always had his base there. His mother having died in 1897, Cézanne sold the Jas de Bouffan in 1899 and moved to 23 rue Boulegon in Aix. In 1902 he also had a studio built on the Chemin des Lauves looking out over the city and away to the mountain.

Apart from the paintings which knowledgeable critics and collectors could see at Père Tanguy's art shop, the occasions on which his pictures were included in public exhibitions from 1877 to 1895 were extremely few.

However, he came again to public notice—and again suffered abuse—in 1886 with the publication of Zola's 'L'Oeuvre' whose hero, a failed painter driven to suicide, was identified with Cézanne. Though the appearance of the novel may have played some part in his break with Zola, there were other causes. Cézanne felt uncomfortable and not altogether welcome in the home of Mme Zola; but, above all, the novelist never really understood the painter's work.

Very few of Cézanne's friendships could withstand his difficult nature: neurotically sensitive, he imagined insult or the violation of his privacy when neither was intended; he was profoundly ill-at-ease in society; and almost no-one was safe from his outbursts of temper. His irascibility was fundamentally linked to his need for solitude, not because he was a misanthrope but indeed because he was so painfully responsive to other people; and above all because solitude was essential for his work. As he wrote to his son shortly before his death, 'My life arranged in this way allows me to isolate myself from the lower spheres of life.'

Old and ill he continued to work incessantly. On 26 August 1906, in the 'stupefying' heat of the late summer, he wrote to Paul that he had stayed in bed late that morning, until after five o'clock, a time at which he was usually hard at work in his studio on the Chemin des Lauves. On 15 October, caught in a storm while painting, he collapsed and was brought home; but the next morning he was again at work. He died on 22 October, 1906.

In the last decade of his life critical acclaim increased and his work was more and more in demand for purchase and exhibition; several young painters and writers openly venerated him and came to him for advice. Nevertheless, he could not still his uncertainty and the dread that he would never, as he wrote in 1905, 'realize the dream of art that I have been pursuing all my life.'

This very doubt is at the heart of Cézanne's meaning for many of the painters who followed him. For Picasso, 'It's not what the artist does that counts, but what he is. Cézanne would never have interested me a bit if he had lived and thought like Jacques Emile Blanche, even if the apple he painted had been ten times as beautiful. What compels our interest is Cézanne's anxiety—that's Cézanne's lesson . . .' And Matisse, referring to a painting by Cézanne which he had owned since 1899, wrote in 1936, 'It has sustained me spiritually in the critical moments of my career as an artist; from it I have drawn my faith and perseverance.'

'I owe you the truth in painting.' — CÉZANNE

CEZANNE'S NEVER-ENDING, humble and heroic search for truth is the moral condition of his art and a primary source of its greatness. His truth, like Wordsworth's, is the truth of art 'in the keeping of the senses'. In his faithfulness both to nature and to art, his synthesis of minute visual sensation with a grandeur of formal construction, Cézanne stands alone. Austere and difficult of access as his work may be on first encounter, prolonged contemplation slowly reveals his delicate exactitude and the depth of his feeling for nature, which to him meant 'man, woman, and still-life' as well as landscape.

Although Cézanne almost never dated his paintings and it is difficult to assign dates to them with precision, certain crucial changes serve to divide his work into a few fairly distinct phases. The early paintings, of the 1860's, are violent expressions of his dark, tortured imagination, his unfulfilled eroticism, and the anxieties springing from the repressive hand of his father and from his own despair of realizing the grandeur of his dreams. Such themes as the temptation of St. Anthony, rape, murder and even the portraits, picnics, landscapes, still-lifes and the translations from other art, are painted with brutal power. They can also be as astonishingly elegant as the *Still-Life with Black Clock* (Stavros S. Niarchos, Paris). Crude and even grotesque as the youthful paintings have appeared to some critics, they are monumental pre-Expressionist images whose dramatic contrasts of black and white intensify the red, blue or green areas and whose dense surfaces, tempestuously built up with the brush and knife, harken back to Goya and herald De Kooning. Clearly Cézanne's early painting owes much to Delacroix, and the characteristically sensuous paint in *Man in a Blue Cap* (Plate I) even exceeds that of another of his masters, Courbet.

This *couillarde* technique, as Cézanne termed it, was abandoned in his Impressionist phase, which began in about 1872 when he made the first of several visits to Auvers and Pontoise. Here, in close association with Pissarro, he learned to relate his painting more to the evidence of his eyes and to register what he saw by means of short, separate strokes of fresh colour. That this shift in direction from interior to exterior vision was of decisive importance in developing what he called his 'own means of expression' was attested to when, exhibiting in Aix a few years before he died, he designated himself 'pupil of Pissarro'.

Although none of the *plein air* painters examined the relationship between colour and light more exhaustively than did Cézanne, his analysis never led him to abandon the full volume of objects and the firmly constructed space which he admired in the art of the past. These qualities are apparent in his earliest Impressionist paintings, notably *The House of the Hanged Man* (Plate III) of c. 1873, as well as in the work from the end of the decade, such as *The Château of Médan* (Plate IV), where the foliage and even its reflection in the Seine are as substantially constructed as the buildings. During the next few years he placed the little parallel blocks of paint with ever-increasing exacti-

1. SELF-PORTRAIT c. 1877
The Phillips Collection, Washington D.C.

tude to record his sensations of colour, volume and space, as they moved, series after series, in changing directions corresponding to and enforcing the structure and growth of the object and its directional force in the painting. Indeed, in several of the paintings from the early 1880's, he modelled volumes and thrust them out into space as securely as though he were chiselling them from rock. One would think that Cézanne might have been a sculptor, were it not that his mighty forms and the space they occupy are built up by means of colour in subtle inter-action.

LATER IN THE 1880's Cézanne had gained sufficient command of his *petites sensations* to be able to relax a little the stern regimenting of the colour strokes. The looser, thinner and more open painting of *Mont Sainte-Victoire* (Plate VI) brings an expansive space which allows the forms to breathe more easily. The mass of the mountain is constructed by subtle modulations of colour, from blue to violet to pink to orange to ochre to green. Each variation in colour creates a different indentation or projection of the form which corresponds so precisely to the actual contours

of the mountain that one can identify the exact angle from which each of the more than sixty pictures of Mont Sainte-Victoire was made. The fact that Cézanne could represent exactly the form of objects is of no importance in itself; but it is significant that he wanted to, and did, maintain the identity of individual objects at the same time as he adjusted and bent them to his creative will. In this particular painting he has made the form of the garden wall echo the slant of the fields which fan out from the house, and he has brought into rhythmic accord the arcs and angles of the branches of the tree, the mountain and the valley. He has almost completely dispensed with the texture of objects in favour of the unifying texture of the paint. In the valley the distinction between green and orange-ochre induces a sensation of different locations in space. At the same time, these green and orange planes are decisively shaped in relation to the rectangular format of the picture and, even though they are slanting rectangles moving in zig-zag directions to suggest the extension of the valley, they are also flat, conforming to the essential nature of the picture plane. Moreover, the green planes tend to move back while the recurring orange-ochre areas come forward and the colour intensity, unlike that in traditional illusionist paint-

2. STUDY OF A FIGURE (AFTER RUBENS)
Kunstmuseum, Basel

ing, diminishes very little, if at all, in the distance. By these and far more carefully contemplated means, the illusion of space and volume is firmly presented—and as firmly denied. The represented reality gives way to the created reality; but Cézanne never conceals the tension between the two in his insistence on the truth of both. Already here, in the 1880's, he laid down that premise of his art on which so much of twentieth-century art has been built.

Cézanne's insistence on the truth of feeling was no less strongly maintained. However, the emotions expressed, in keeping with the complexity and contradictions of his nature, his mind and his work, are neither simple nor single. In the *Mont Sainte-Victoire* painting, tranquil and buoyant as it is, one senses something of 'the struggle for life' which Van Gogh found in the 'living being' of trees; but trying to put words to such feelings is so hopeless that one can only conclude, as Cézanne did, 'it is better to feel them'.

CÉZANNE'S PAINTING is born of the senses and addresses itself directly to them. Looking at this picture of Mont Sainte-Victoire from Montbriant on his brother-in-law's estate 'Bellevue', one experiences again the sensation of the clear, dry air and burning sun of Provence and the trees whipping in the wind; and one vividly recalls the green fields and the orange earth which, from miles away, can be seen to move up into the blue and violet rock of the mountain. But Cézanne's art is also born of what he called 'the logic of organized sensations'. He is reported to have said that he wanted 'to make of Impressionism something as solid and enduring as the art of the museums' and that the kind of 'classic' effect which he sought was 'Poussin remade entirely after nature'. Comparing Cézanne's painting with that of Poussin, one recognizes a similar reasoning at work in the monumental simplification, the elimination of the fortuitous, the geometric decisiveness of forms and the precisely calculated distances between them. These are among the elements which contribute to the grave serenity which pervades the painting of both masters. However, Cézanne weds this idealism with the scientific materialism to which the Impressionists adhered more closely. Using their analytical method of perceptual painting, he created his profoundly intellectual and universal 'ideal of art' not outside of but within and from the framework of specific observation. To many of his contemporary critics Cézanne seemed to be the great destroyer of the classical tradition. In reality, as we now see, he, like Seurat, was one of its great restorers. There were, however, a few critics who responded to the classical quality of his work. Georges Rivière, as early as 1877, called Cézanne 'a Greek of the great period' and those who ridiculed his work 'barbarians criticizing the Parthenon'.

In his still-life paintings Cézanne achieved a similar harmony between the perception of nature and the logic of form. The painted apples, bottles, flowers, bread and even tablecloths appear as everlasting and unmoving as his mountain. One does not expect to find a still-life of ordinary objects so monumental and grave as the *Still-Life with Basket of Apples* (Plate VIII) unquestionably is. This quietude, however, is like T. S. Eliot's 'At the still point of the turning world'. The individual objects move, shift, expand and contract as though they lived a life of their own in a magical world.

THE PROBLEM of representing three-dimensional objects in space on a two-dimensional surface is as old as painting; but Cézanne's solution to that problem funda-

mentally questions the concept of space which for centuries had prevailed in western art. According to the laws of linear perspective formulated in the Renaissance, all the objects in a picture are represented as though seen from a single, fixed, static point. Cézanne, subjecting objects to the demands of their pictorial relationships, introduced multiple and moving view-points. In the *Still-Life with Basket of Apples* the biscuits appear as though seen from the left and above as well as *en face*. The top two biscuits are suspended beyond their support, curiously increasing the sensation of their amplitude of form. The oval of the plate is squared off like the biscuits, relating these shapes to other oval and rectangular forms; the basket and its handle, the apples and the colour planes which model them are pulled towards the shape of the picture itself in a complex oval-rectangle counterpoint. The left side of the table is completely flat, not viewed from any single position; it gives pictorial but no conceivable physical support for the swelling basket of fruit, within which the scale of the apples changes considerably. By enlarging, simplifying and flattening forms towards the outer parts of the composition, Cézanne accentuates, by contrast, the fuller volumes and more quickly changing colours, shapes and lines in the central parts (a compositional arrangement often followed in Cubist paintings). The left edges of the table do not correspond to those on the right; these discrepancies set up a pictorial tug-of-war concealed by the cloth and the bottle and basket. (The Cubists would remove the cloth.) We *feel* these tensions and we feel the slanting bottle straining away from the axes of the biscuits. Through this empathy we experience the life and evolution of the picture, and we marvel at the miraculously quiet but vibrant equilibrium which Cézanne creates from the conflicting forces in the still-life.

In compelling the objects 'to put up with', in Picasso's phrase, the pictorial life which the artist assigns to them, Cézanne prepared the way for the Cubist fragmentation of the object and its eventual elimination in abstract painting. At the same time, while impelling our perception of the painting as painting, he heightens illusion. Cézanne's departures from traditional perspective more nearly approximate to the way in which we actually see with successive, shifting focus than does the Renaissance 'rationalization of sight', as perspective has been called. His slow and deliberate painting presents the experience of space in time—not the moment of the Impressionists, but time itself—as duration. The tensions and continuous interweavings between space and surface, volume and plane, near and far, create a fluctuating and dynamic relativity which suggests a parallel with modern concepts of time/space as an entity, neither any longer separate and independent from each other.

BUT APART from these implications of Cézanne's work there is its sheer beauty. The *Still-Life with Plaster Cupid* (Plate XIII) is a perfect harmony of consonant and dissonant elements, of related and opposing colour and of pointed shapes and swinging curves. The complex and daring zig-zag rhythm up and back into space reaches its climax in the expanded apple shape suspended breathlessly over the upward sweeping tilt of the floor. The qualities of objects are modified in accordance with the demands of the painting: the canvas behind the cupid curves to receive and conform to its forms; the section of another painting on the upper right is treated like a piece of relief sculpture; the green foreground apple forces the plate to give way to its coloured shape; objects throw

3. COAT ON CHAIR c. 1890-1900
Mrs. Marianne Feilchenfeldt, Zürich

green, blue, red or violet transparent shadows; the freely moving line strikes an accent here, a full contour there, and sometimes forms the object in complete independence from it. This fresh and beautiful still-life is 'about' art: an actual cast of a piece of Baroque sculpture, a painting of another piece of sculpture, a canvas with no visible composition on it, the back of at least one more canvas leaning against the wall, and a section of a painted still-life, whose cascading drapery spills out over the 'real' table. The new reality of painting which Cézanne creates, transcends and shatters the traditional distinctions between real and unreal or the different levels of reality.

One might say that the *Still-Life with Apples and Oranges* (Plate XVI) is about opulence. Painted in Cézanne's last decade, it has the rich, saturated colour, the elaboration of design, and the grand Baroque movements which he could now allow himself. It also has a hint, perhaps in the smouldering intensity of colour, of the sombre mood which one often encounters in his late work. Sybaritic and forbidding, it bespeaks the abundance of the earth, and the terrors within it.

In his portraits Cézanne seeks and reveals the grave, silent dignity at the core of each human being. In spite of their basic immobility (to Vollard he shouted, 'You must sit like an apple! Does an apple move?'), his portraits have

a formal vitality akin to the still-lifes, but less complex. The immobility of Madame Cézanne's pose (Plate VII), as though she had been seated there forever, is qualified and enlivened by the slight but concentrated tension between the axis of her body and the slant of the chair on which she sits.

His portraits, and the figure compositions of card players and bathers, all have a solemn grandeur. This is particularly marked in *The Large Bathers* (Plate X-XI), a composition on which he worked for several years, painting three large versions and many smaller studies. The male bather groups, which he also painted but never in large format, are looser in their organisation with horizontal bands open at the sides in contrast to the usually closed-in, triangular disposition of the female groups. To paint an heroic-sized composition of bathers in the open air was a challenge which Cézanne's life-long devotion to nature and the grand tradition of art imposed upon him. Although his landscapes are almost invariably devoid of human figures, the theme of bathers in nature had preoccupied him since his student days. It was not, however, until the last decade of his life that he attempted to develop this theme on an imposing scale. He pursued it stubbornly in spite of great handicaps: failing health, the difficulty of moving the huge canvases out of doors and the impossibility of getting suitable models in provincial Aix. The idea came in part from his nostalgia for the days when he and his boyhood friends bathed in the Arc River under the large trees which, as he wrote to his son, 'form a vault over the water'. The sources of his figures were his student drawings and the studies he had made from Ancient, Renaissance and Baroque art, which he continued to copy even in his old age.

While the small bather paintings are more immediately appealing, each time one stands before *The Large Bathers* one responds anew to the majesty of its conception and the beauty of its execution. Both epic and idyllic, Olympian and Arcadian, it is Cézanne's dream of a pure state in nature. The sex of the figures has no more importance here than it has in Giotto's frescoes at Padua. Although the felicity of the actual painting may not be fully apparent from reproductions, its archaic grace is unmistakable. The severe architecture of its interlocking triangles is modified by sonorous arcs and more quickly changing curves; and the painting is extraordinarily complex and subtle in its trembling nuances of blue and ochre intermingled with many tints of orange, red, rose, lavender, green, brushed on in transparent and semi-transparent overlays of colour. The supple line ripples, curves, sharply squares itself off, disappears, multiplies itself, defines or slices across or runs outside the coloured shapes as it rides on its own free rhythm. The master has so fully conquered 'the knowledge of the means of expressing emotion' which, as he wrote in 1904, 'is only to be acquired through very long experience' that he is able to maintain in this monumental composition the lyricism and refinement of his less heroic painting and to endow it with a noble sentiment.

LIKE MONET, Cézanne gave full expression in his late landscapes to his deep feeling for the mysterious inner force of nature. The *élan vital* which Bergson celebrated animates each rock and tree, each sweeping line, each plane of colour as surely as it does in the more overtly Expressionist painting of Van Gogh. In *Cabanon du Jourdan* (Dott. Riccardo Jucker, Milan) the heaving earth, the chopping strokes of the brush, and the intense orange burning against brilliant blue convey his passion with equal eloquence. This compelling image has the strangely foreboding expression of which we caught a glimpse in *Still-Life with Apples and Oranges*.

A similar deepening of emotional expression occurs in the water-colour medium, which, from the middle of the 1870's, was closely related to the development of Cézanne's oil painting and is as richly varied. In some of the water-colours, by applying only a few transparent patches of colour over quick little pencil strokes he not only creates the illusion of palpable space occupied by solid volumes but he also makes a brilliantly coherent formal structure. Others are more densely built up, layer after layer like transparent sheets of coloured ice (Fig. 4). Line and colour weave in and around and under each other, setting in motion angular, curving and sweeping rhythms.

But even the freest water-colours hardly prepare one for the last *Mont Sainte-Victoire* oil paintings (Plate XIV-XV) which are almost abstract in their daring reduction and transformation of visual sensation to the pulsating life of colour, line and shape. The faceted planes collide and multiply 'like a shell bursting into fragments which are again shells' to use the image by which Bergson described life. If one covers over the mountain, the rest of the picture could be an Abstract Expressionist painting. However, the mountain remains in its abiding majesty; as one looks at it, the valley falls into place and the small blocks of colour again assume their dual role.

Although Cézanne's innovations anticipated Cubism and subsequent abstraction, he only opened the gate to a garden which he had no thought of entering. His spiritual as well as physical vision remained firmly anchored in nature. As he wrote in 1896, 'were it not that I love excessively the configurations of my country, I would not be here.' The pictures which Cézanne painted in his slow and probing contemplation of nature demand our unhurried study. They do not give up their wonders easily or quickly; but they never exhaust them.

4. RIVER AT THE BRIDGE OF TROIS SAUTETS 1906
Cincinnati Art Museum, Ohio

The Plates

I. MAN IN A BLUE CAP
(UNCLE DOMINIC) 1865-66
Oil on canvas. 31⅜ in. × 25¼ in.
Metropolitan Museum of Art,
New York

Cézanne painted nine portraits of his mother's brother in the 1860's. Here the solemn dignity of the figure, thick, sensuous paint built up like clay, terse vehement drawing and dramatic contrast of light and dark colours, whose predominant earth tones are brilliantly climaxed by bright green-blue and darkened red, unite in an image of hypnotic power. Cézanne's 'black paintings' recall Goya and anticipate Expressionism.

II. A MODERN OLYMPIA
1872-73
Oil on canvas. 18¼ in. × 21⅞ in.
Louvre, Paris

Inspired and challenged by Manet's *Olympia* of a decade earlier, Cézanne has presented his version of the theme as an erotic fantasy. With a sweeping Baroque gesture, the slave unveils the voluptuous, if uncomfortable, nude to the seated man who resembles Cézanne. This exceptionally free and relaxed painting was done at Auvers, possibly at the home of the art enthusiast Dr. Gachet, who lent it to the first Impressionist exhibition in 1874. An earlier oil painting and later water-colours are closer to Manet's composition.

III. THE HOUSE OF THE HANGED MAN c. 1873
Oil on canvas. 21⅝ in. × 26 in.
Louvre, Paris

Whereas *A Modern Olympia* (Plate II) appears effortless in execution, this *plein air* painting bears the traces of Cézanne's struggle, recording and modifying his sensations of colour. Purchased by Count Doria from the first Impressionist exhibition and later in Chocquet's collection, the painting has a density of surface, complexity of interlocking forms and sobriety of mood quite unlike the work of the other Impressionists, except perhaps that of Pissarro.

IV. THE CHATEAU OF MEDAN
c. 1880
Oil on canvas. 23¼ in. × 28⅜ in.
Burrell Collection, Glasgow Art
Gallery and Museum, Kelvingrove

Although this particular view along the Seine does not actually include Zola's house, it was painted on one of Cézanne's visits to Médan, where his friend had bought a property in 1878. The picture's organization into horizontal and vertical divisions is so emphatic that it calls to mind Mondrian's geometric abstractions. A water-colour study of this oil (which once belonged to Gauguin) is in the Kunsthaus, Zürich.

V. THE GULF OF MARSEILLES SEEN FROM L'ESTAQUE
1883-85
Oil on canvas. 28¾ in. × 39½ in.
Metropolitan Museum of Art,
New York (Havemeyer Collection)

When Mauclair described a view of L'Estaque 'which travesties that adorable panorama of gold and sapphire by making it a sullen swamp of leaden blue', he at least recognized the austerity which distinguishes Cézanne's work from that of his associates. This severely constructed painting with its careful modulation of green, yellow and orange against a broad expanse of blue, evokes the silent depth of the sea; its weight and volume rather than its shimmering surface.

VI. MONT SAINTE-VICTOIRE
c. 1887
Oil on canvas. 26 in. × 35⅜ in.
Courtauld Institute Galleries,
London

Cézanne painted four versions of this motif from his brother-in-law's estate at Montbriant. The pine branches, stretching gloriously out into space, set in motion a series of curves which roll through the mountain and down into the valley where the angular counterpoint grows stronger. In 1896 Cézanne gave this painting to the young poet, Joachim Gasquet, who published his reminiscences of the master in 1921.

VII. MADAME CEZANNE IN RED 1890-95
Oil on canvas. 35¾ in. × 27½ in.
Museu de Arte, São Paulo

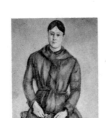

According to Vollard, Cézanne often said that 'the goal of all art is the human face'. In more than twenty-five oils and numerous water-colours and drawings the artist portrayed his wife with sober tenderness. Cézanne first met Hortense Fiquet in 1869 when she sometimes worked as an artist's model.

VIII. STILL-LIFE WITH BASKET OF APPLES 1890-95
Oil on canvas. 25¾ in. × 32 in.
Art Institute of Chicago
(Bartlett Memorial Collection)

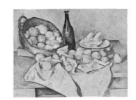

IX. THE OLD WOMAN WITH A ROSARY c. 1895-96
Oil on canvas. 31⅞ in. × 25¾ in.
National Gallery, London

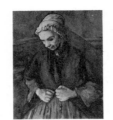

X-XI. THE LARGE BATHERS 1898-1905
Oil on canvas. 82 in. × 99 in.
Philadelphia Museum of Art
(W. P. Wilstach Collection)

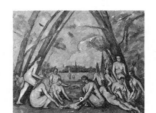

XII. ROCKS IN THE FOREST 1894-98
Oil on canvas. 20⅛ in. × 24¼ in.
Kunsthaus, Zürich

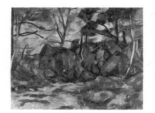

XIII. STILL-LIFE WITH PLASTER CUPID c. 1895
Oil on paper mounted on panel.
27½ in. × 22½ in.
Courtauld Institute Galleries,
London

XIV-XV. MONT SAINTE-VICTOIRE 1904-06
Oil on canvas. 28⅞ in. × 36¼ in.
Philadelphia Museum of Art
(Elkins Collection)

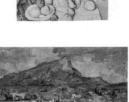

XVI. STILL-LIFE WITH APPLES AND ORANGES 1895-1900
Oil on canvas. 29⅛ in. × 36⅝ in.
Louvre, Paris

Although it is said that Cézanne sometimes used artificial flowers and fruits, no other artist has brought such pictorial life to *nature morte*. In 1907, when fifty-six of Cézanne's paintings were exhibited in the Autumn Salon, the poet Rilke wrote, 'It has never before been so demonstrated to what extent painting takes place among the colours themselves', and that, with Cézanne, fruits 'cease altogether to be edible' and become 'indestructible in their stubborn presence'.

Gasquet, who first owned this painting, identified the sitter as a 'nun without faith' who deserted the convent. Wandering lost and deranged, she was found by Cézanne and taken into his household. Working on the portrait over a period of eighteen months, he changed the position of the left shoulder several times to exaggerate the poignant stoop of her body. Her pathos and his compassionate portrayal bespeak Cézanne's kinship with Rembrandt and Van Gogh.

This is the most ambitious and fully realised of the three *Large Bathers*; the others are in the National Gallery, London and Barnes Foundation, Merion, Pennsylvania. Cézanne's newness is particularly striking in his very use of the traditional triangle; in his composition, the active areas (figures and trees) form the sides of a triangle framing nothing. This picture was exhibited in the Autumn Salon of 1907, the year of Picasso's *Les Demoiselles d'Avignon*.

The beautifully modulated colours convey a sombre tone against which plays a lyrical movement carried mainly by the two slender light trees as they reach outward and upward in buoyant grace. So far has Cézanne's painting developed in delicacy from the thick impasto of the youthful works that now even the dark colours are translucent, if not transparent. He told Renoir, 'It took me forty years to find out that painting is not sculpture'.

Cézanne owned plaster casts of the *Cupid* and the *Anatomy*, formerly attributed to Puget and Michelangelo respectively, and the two works appear separately in many of his oils, water-colours and drawings. His studies after earlier art were made principally from sculptures involving the figure in motion, such as these. In none of his paintings is his relation to the past, particularly the Baroque, more brilliantly synthesized with his unique power of invention than in this daring and beautiful composition.

Interlocking and overlapping in rapidly changing colour, the multiple parallel strokes and abrupt isolated dashes create a predominantly rectangular rhythm independent of the landscape which they still so miraculously convey. This is one of seven oil paintings of the mountain seen from above Cézanne's studio on the Chemin des Lauves (now open to the public). In these late works, he gave himself freely to his exaltation before nature.

In this glowing painting, once owned by the writer and art critic Gustave Geffroy, a single apple, more carefully modelled than any of the others, is startlingly placed in the exact centre of an otherwise completely asymmetrical design. On the far left, apples vanish into the drapery which in turn invades the three-dimensional objects by imposing its pattern on the pitcher.

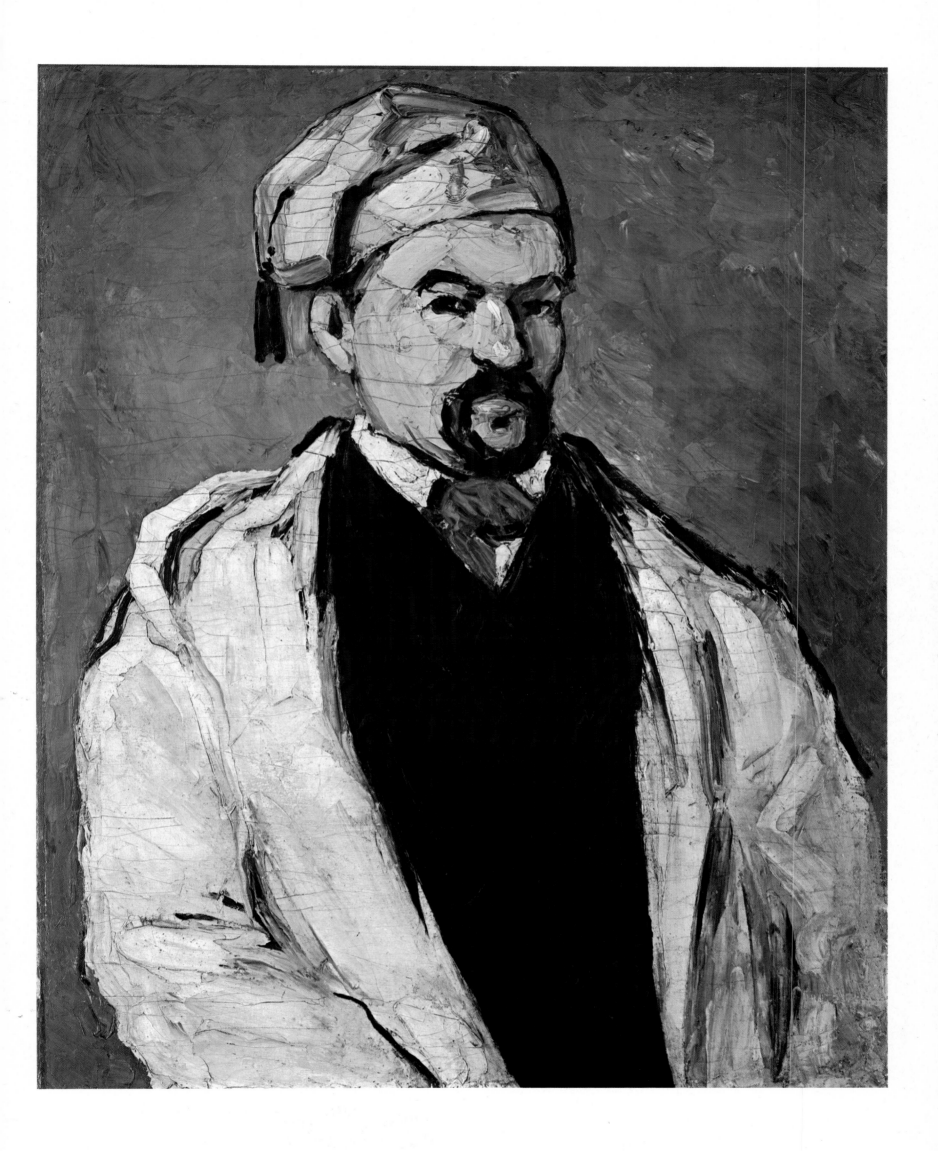

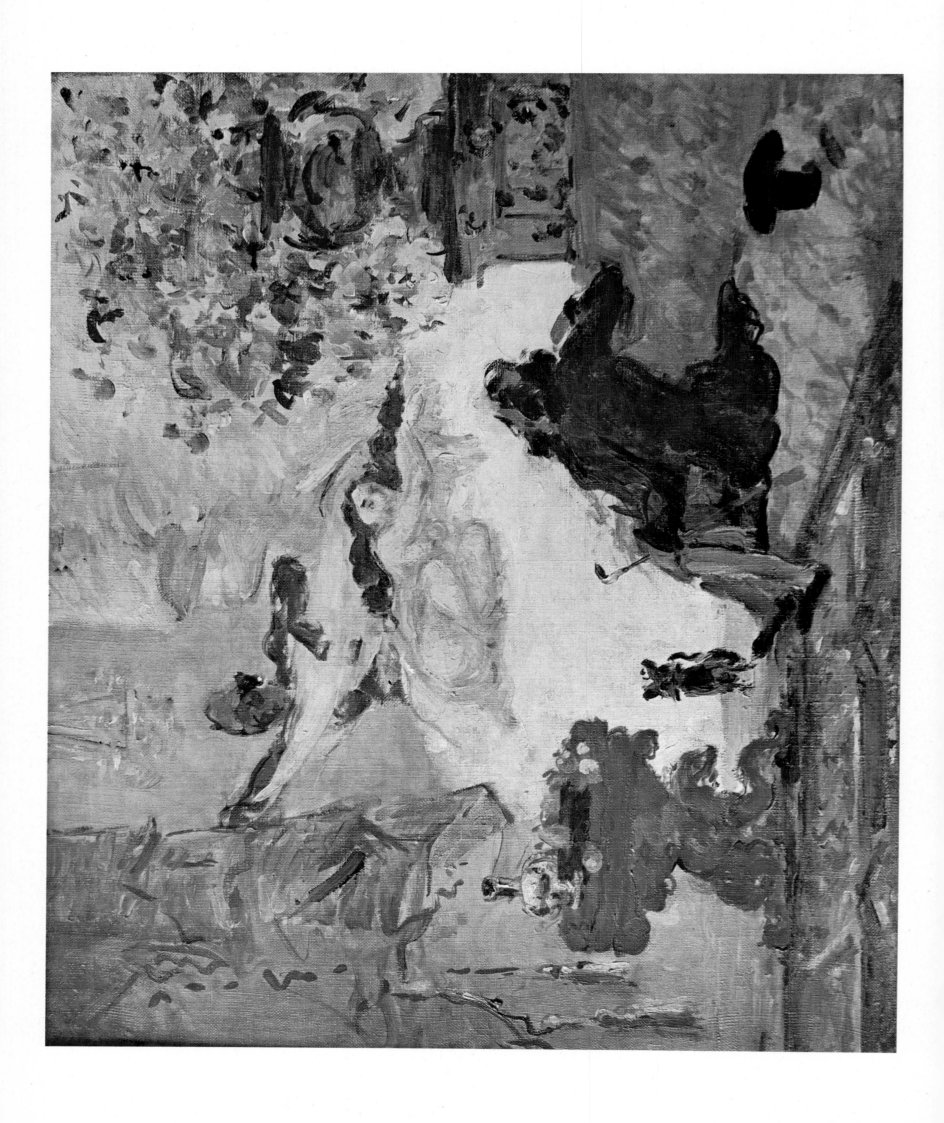

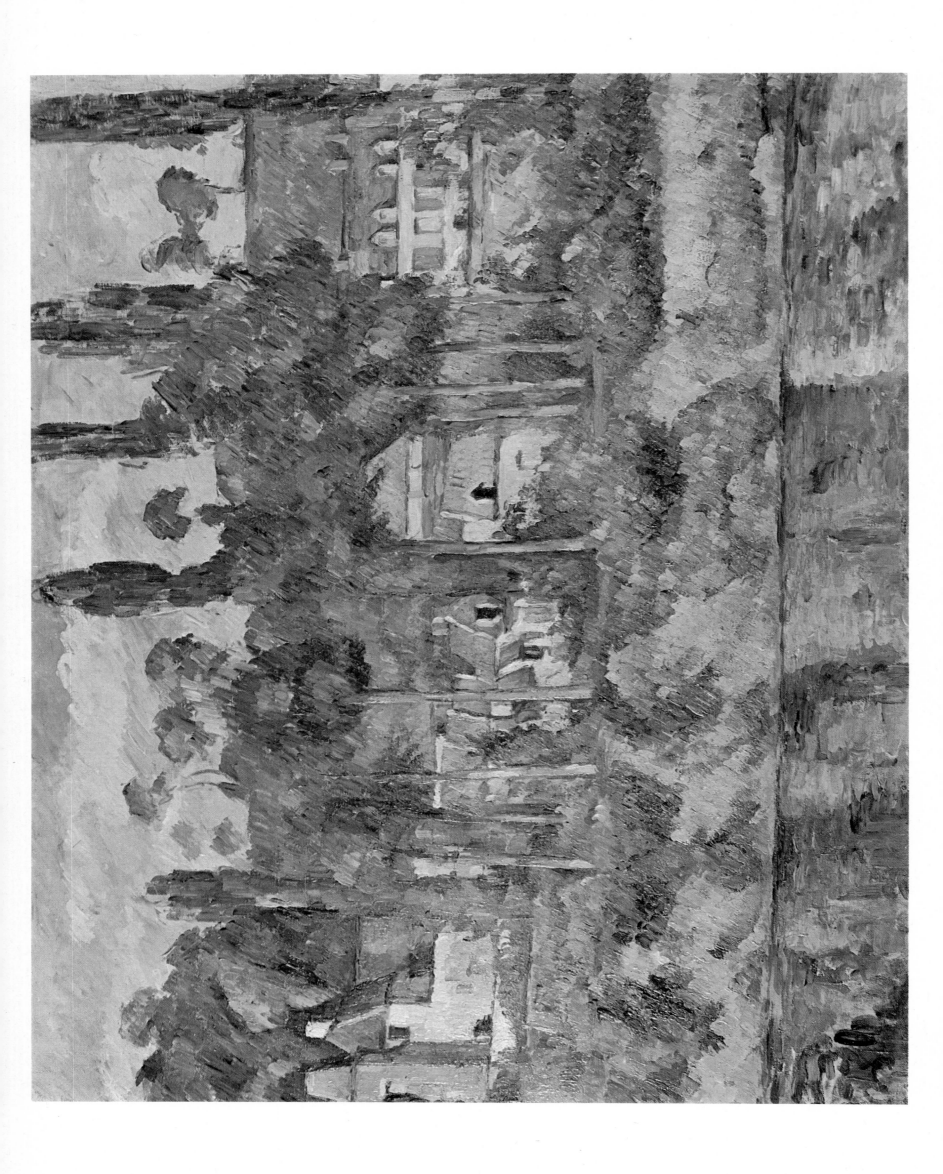

IV

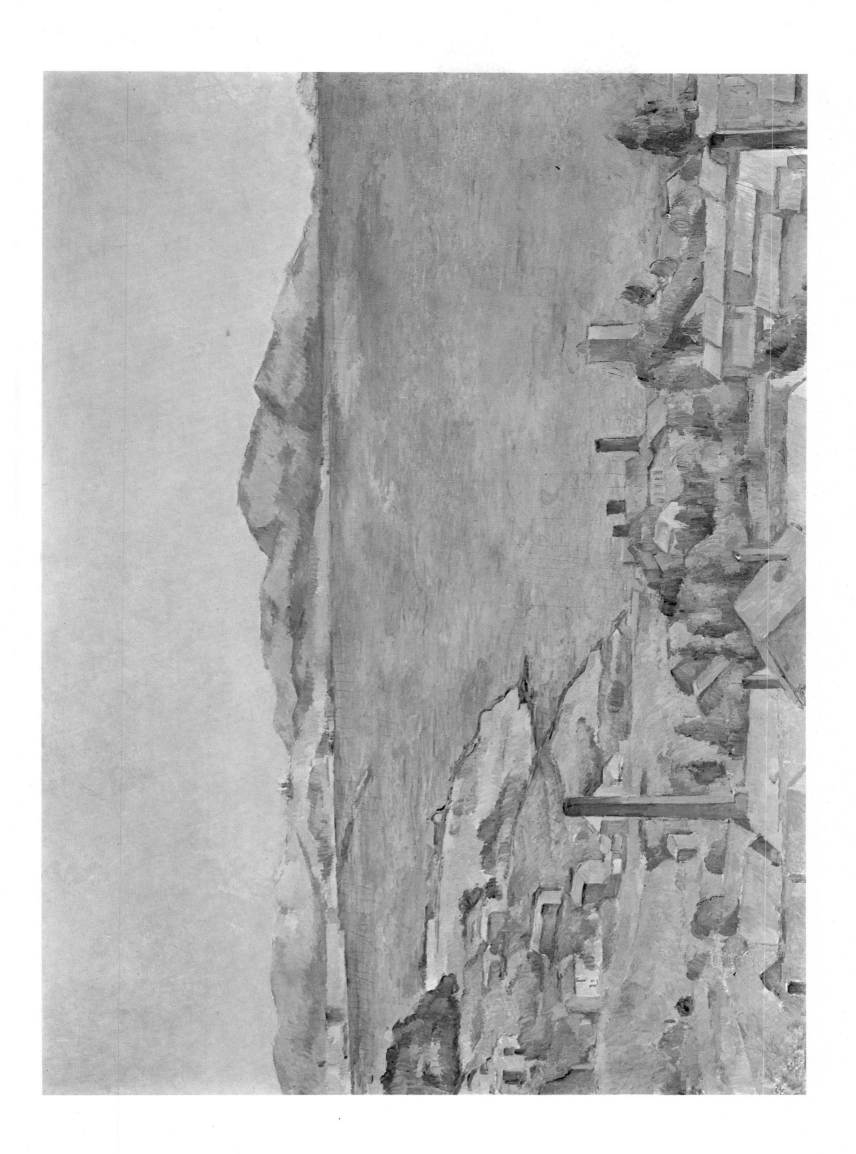

V

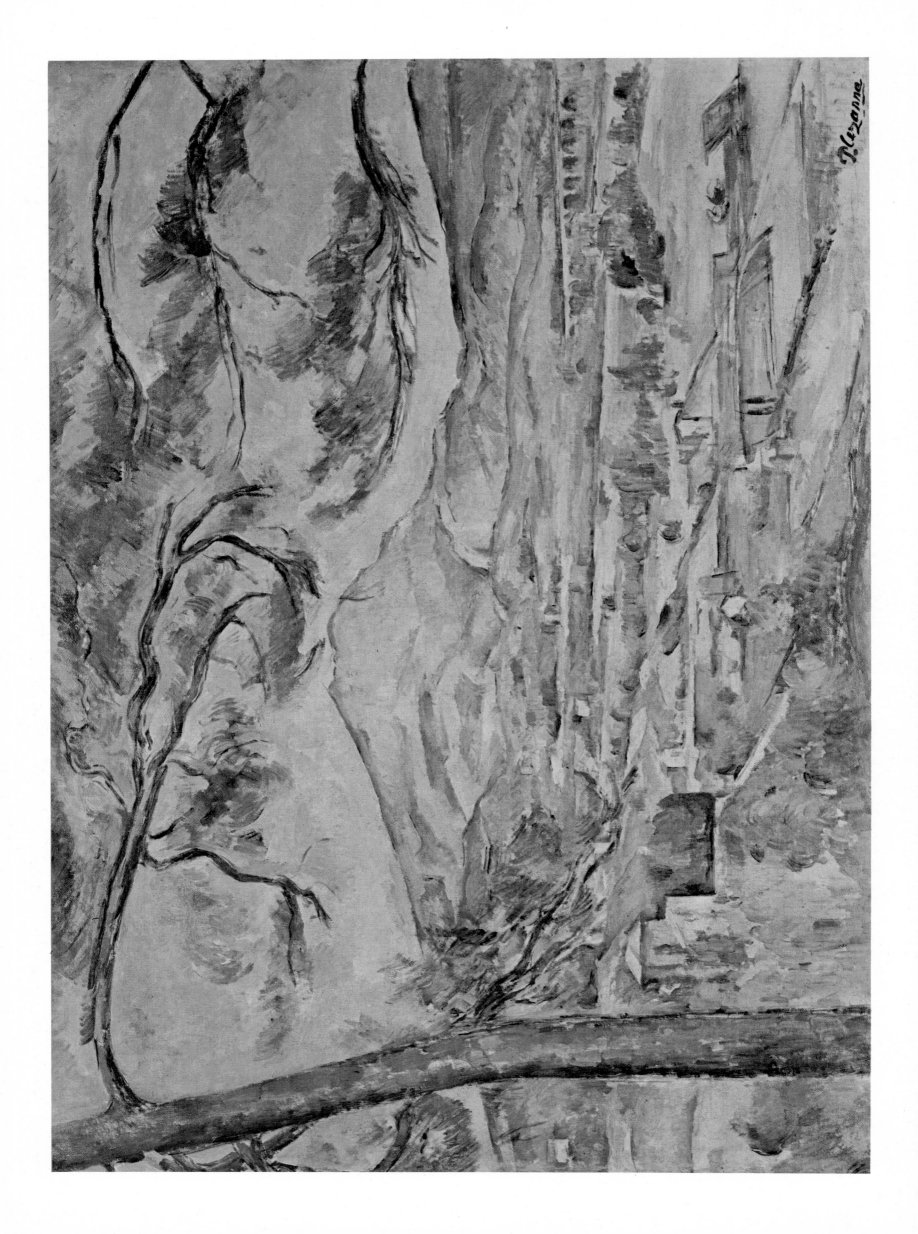

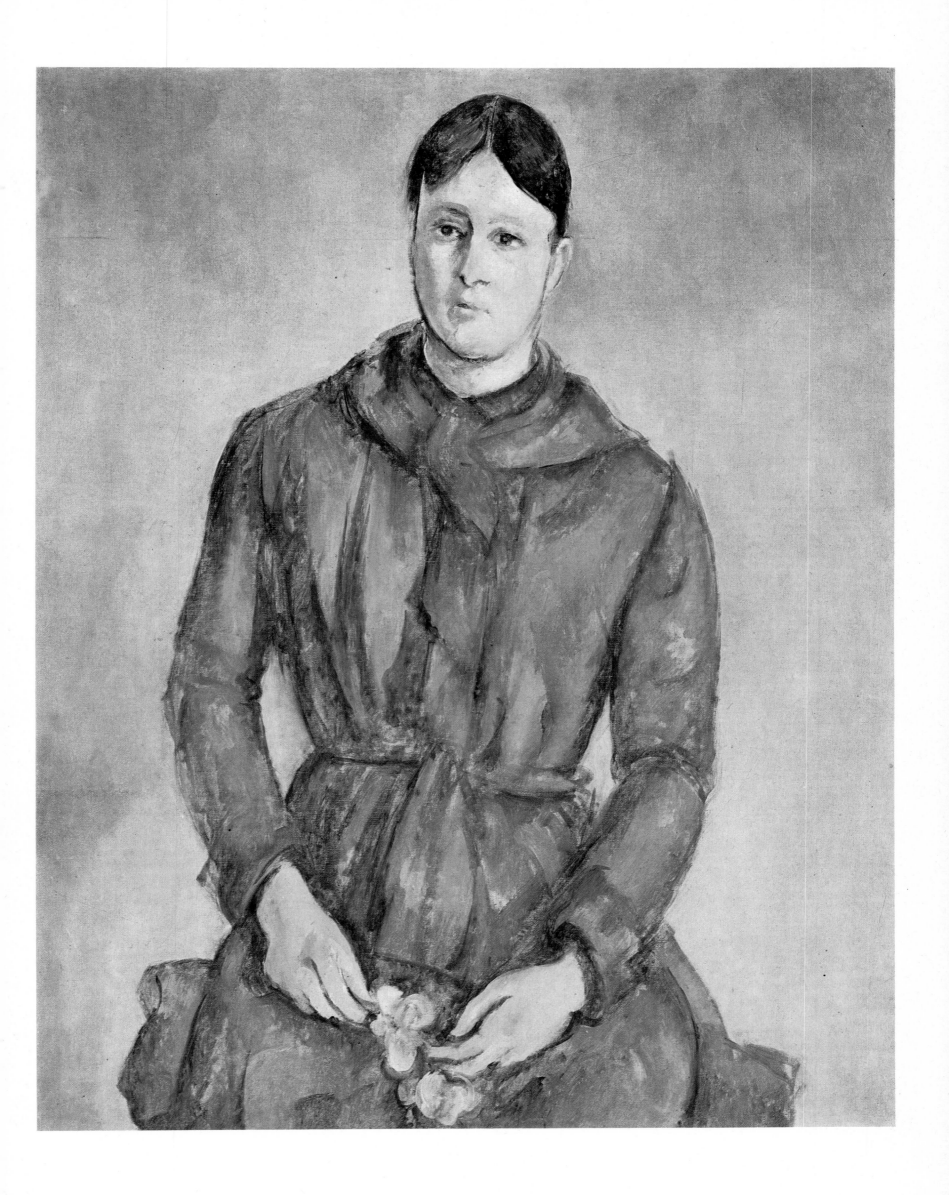

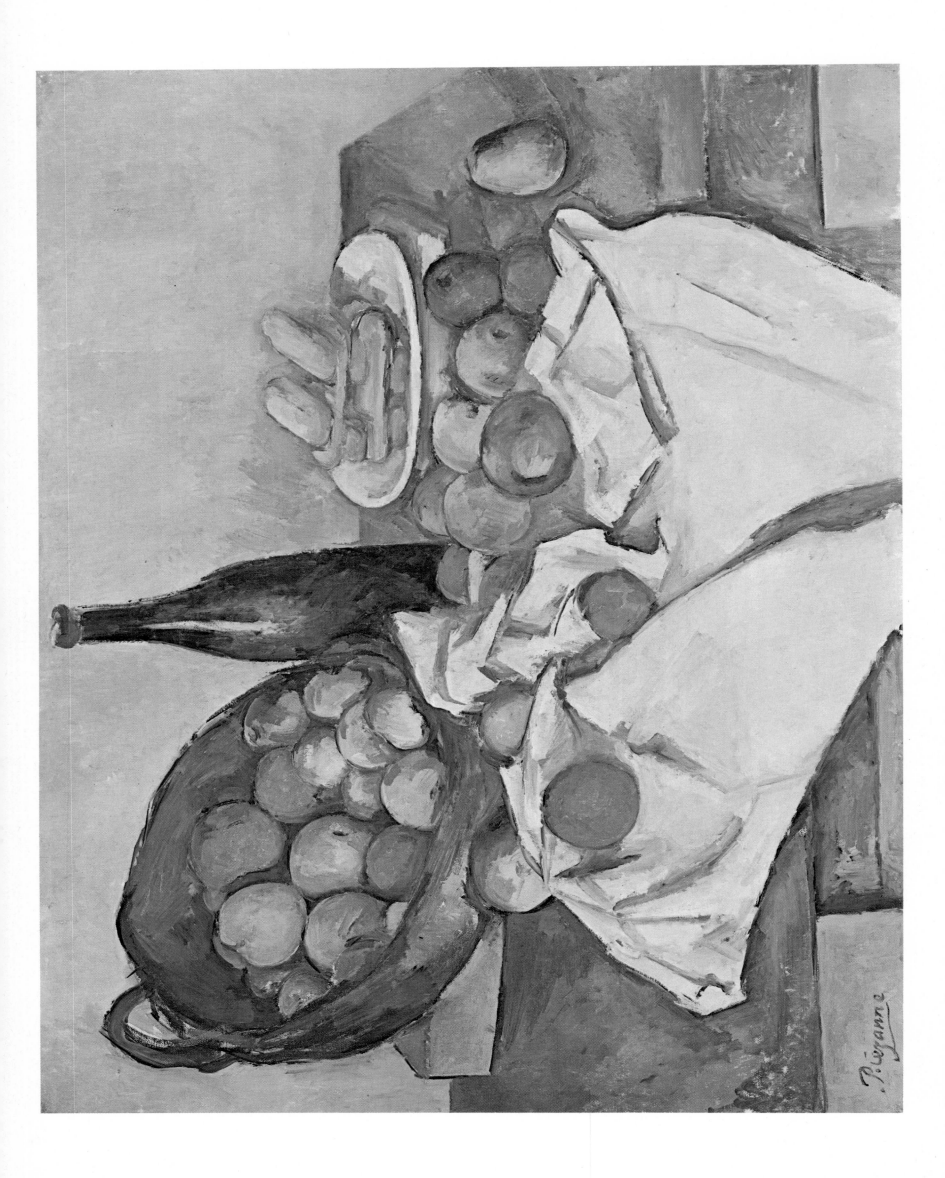

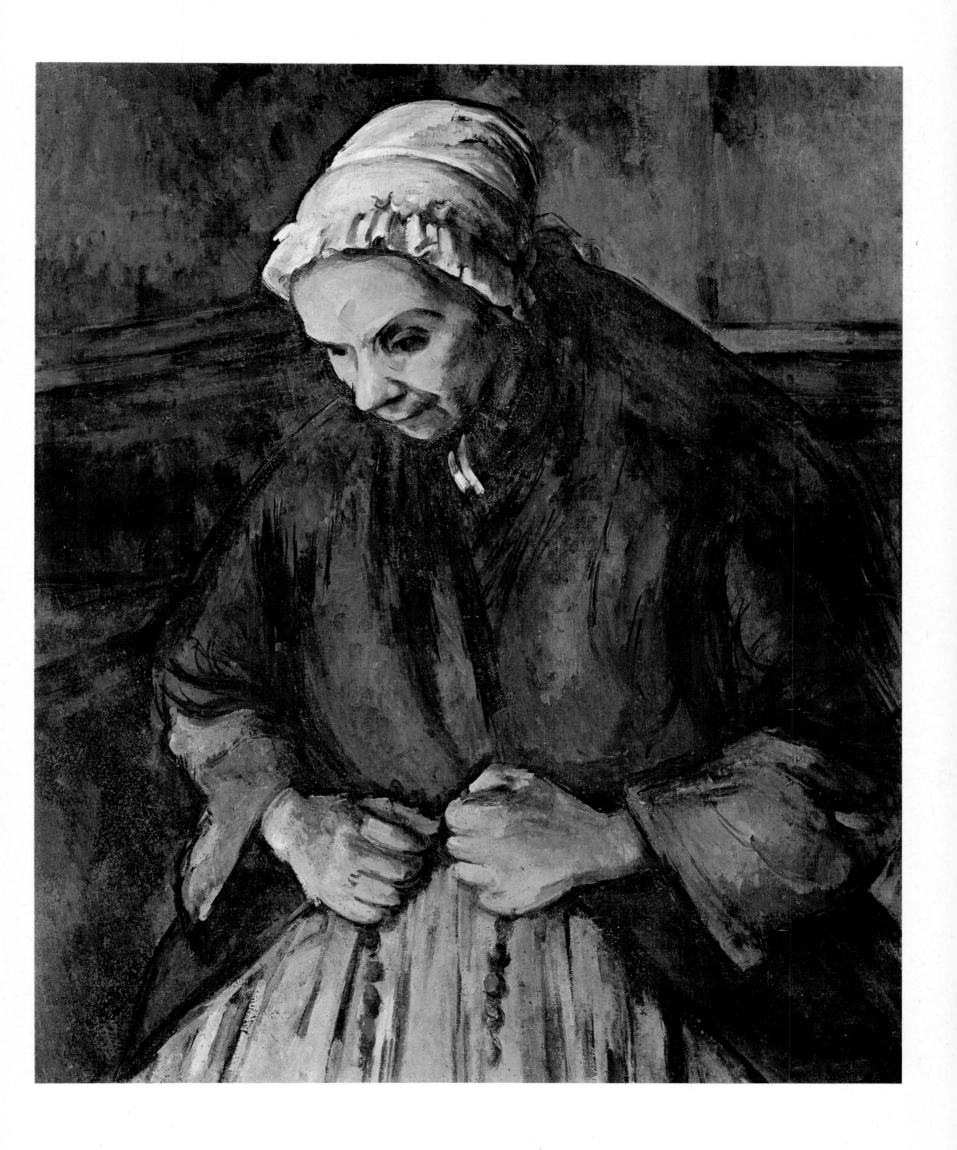

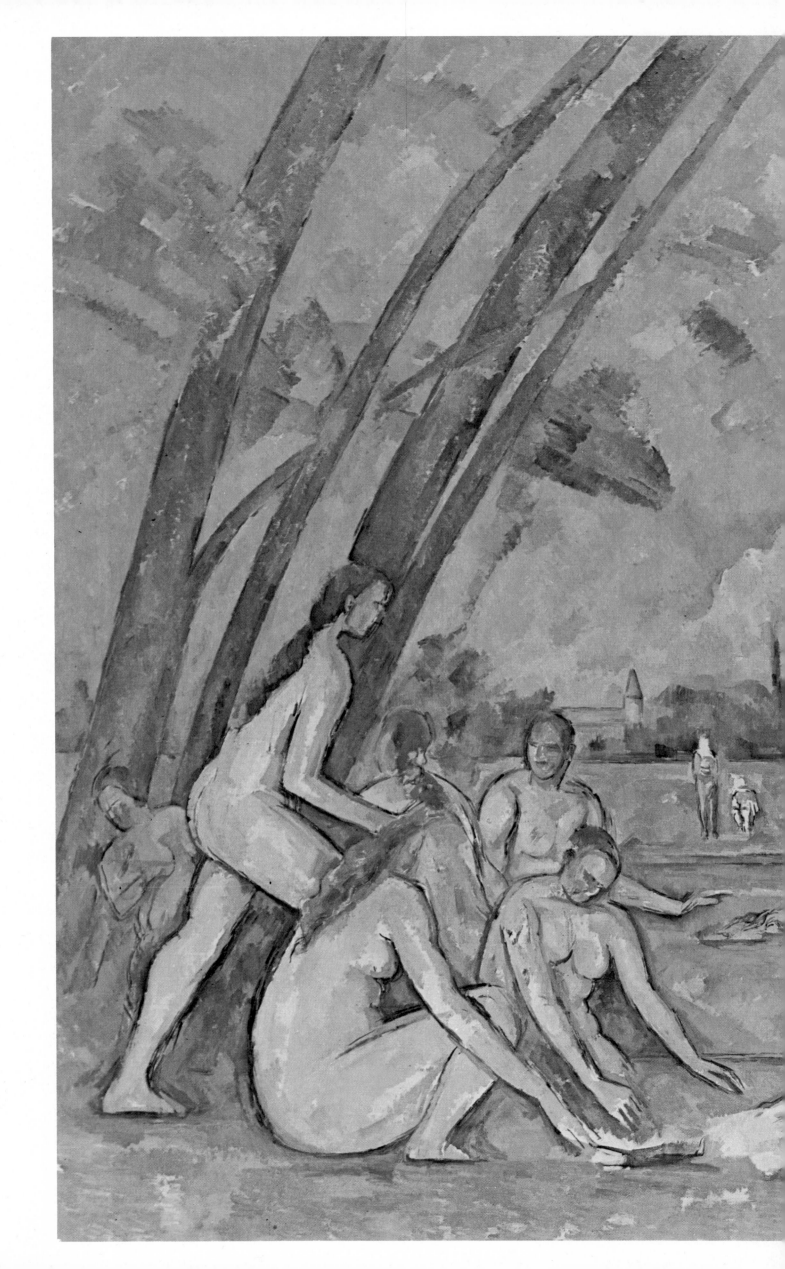

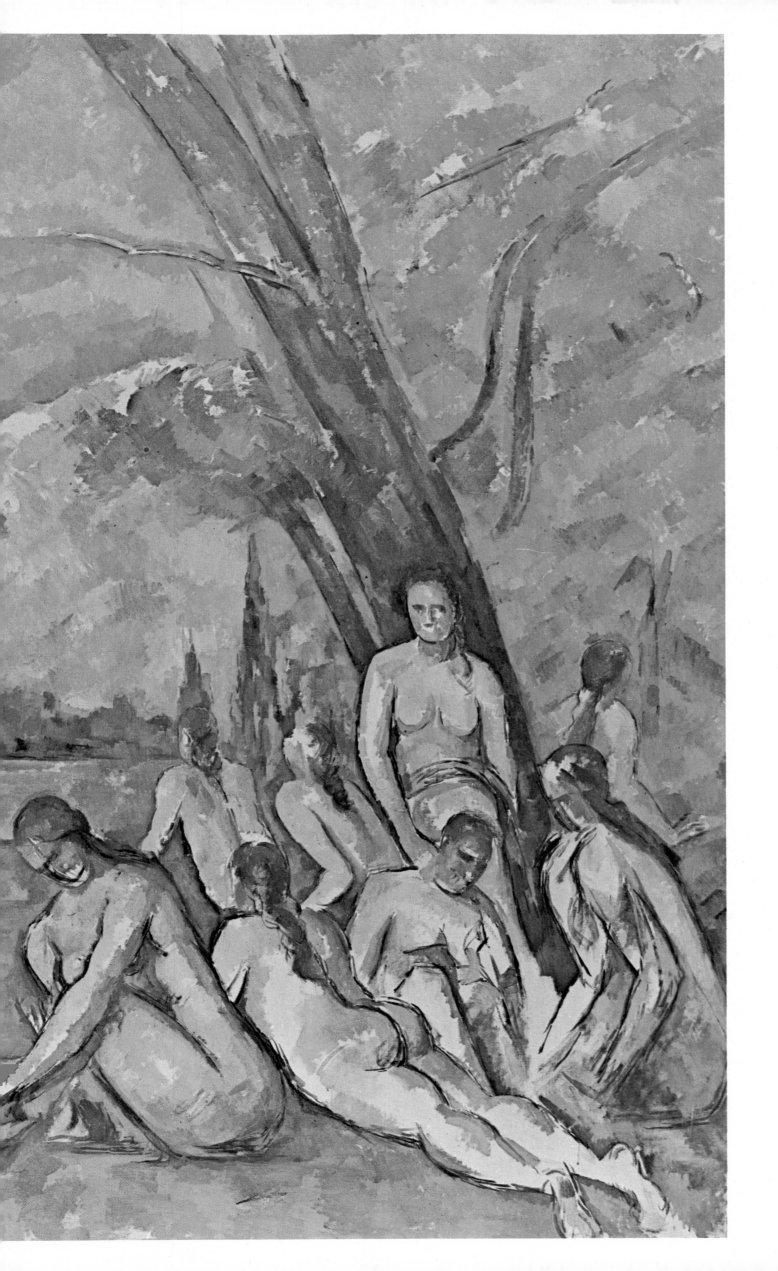

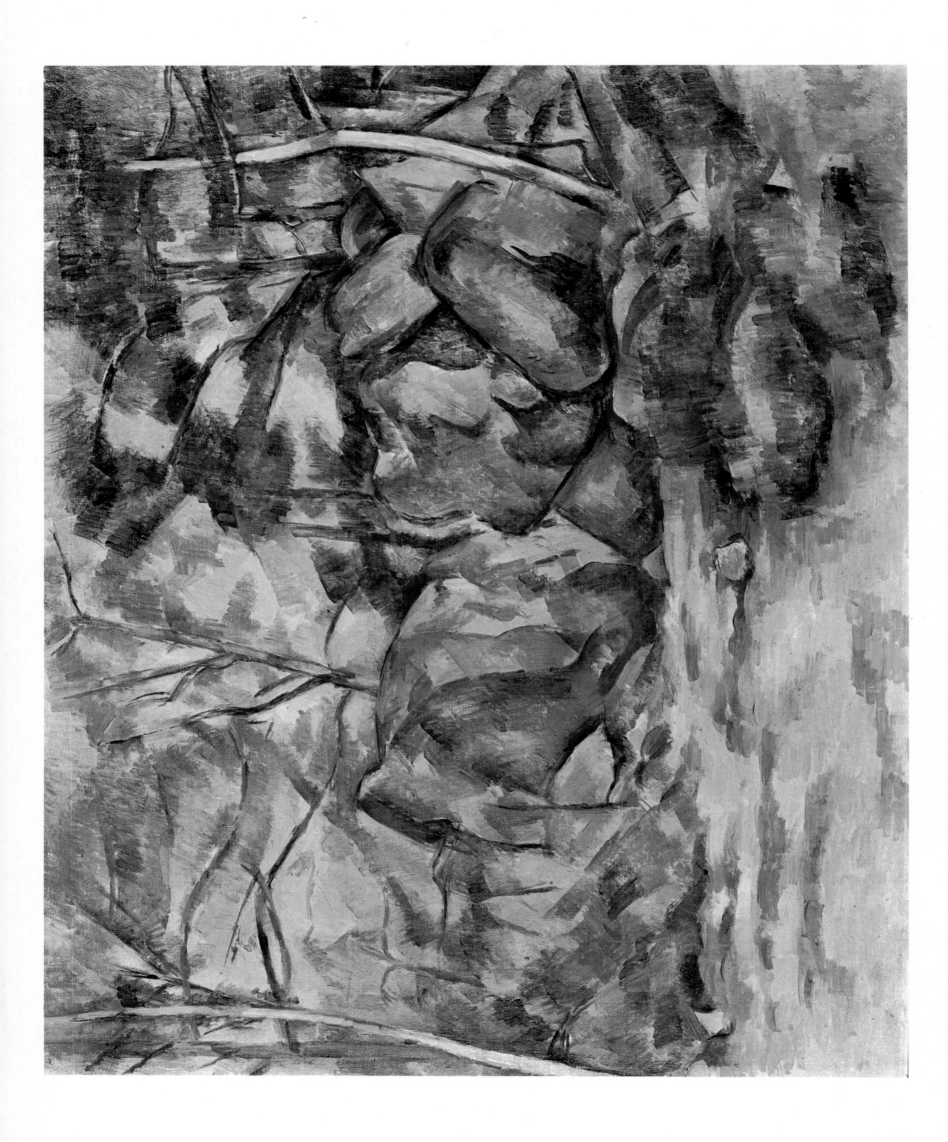

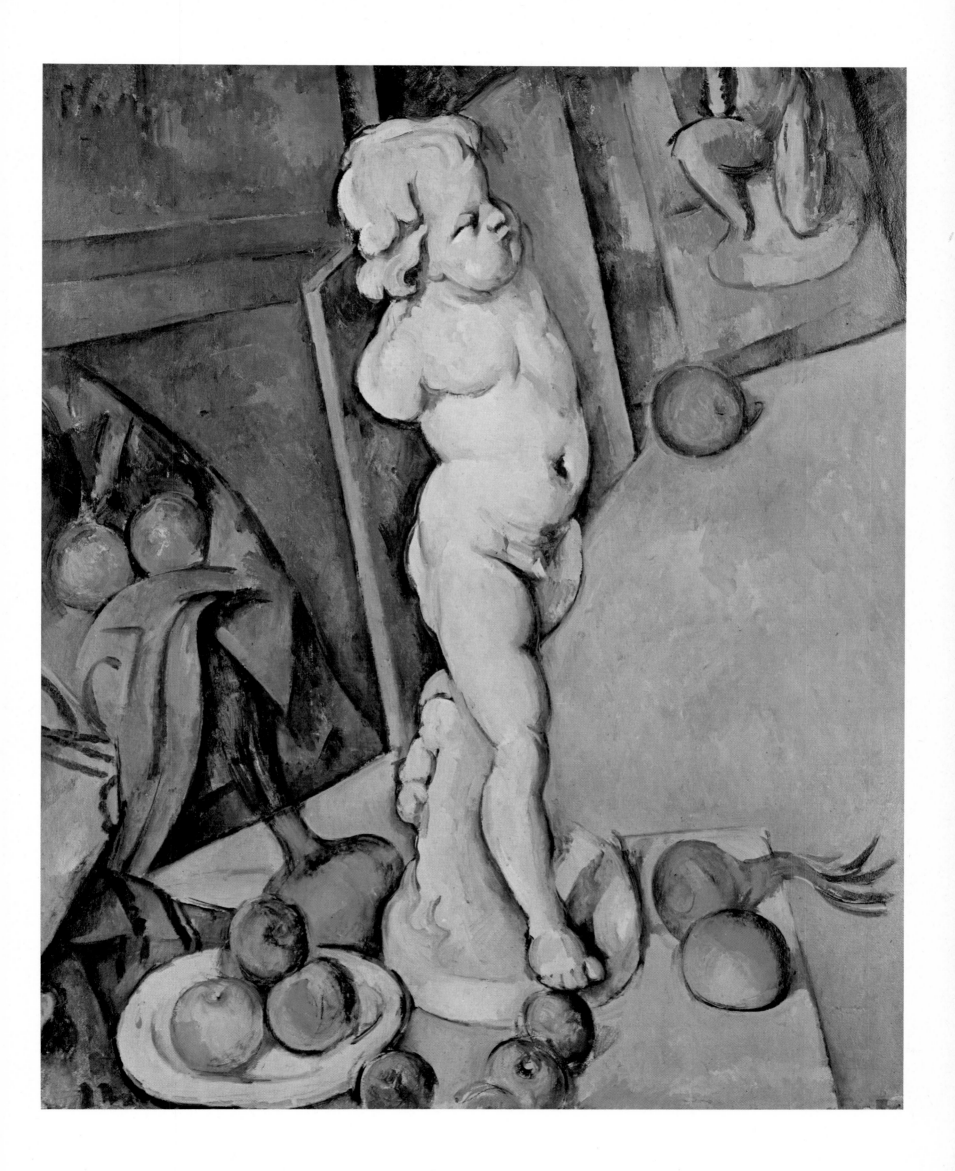

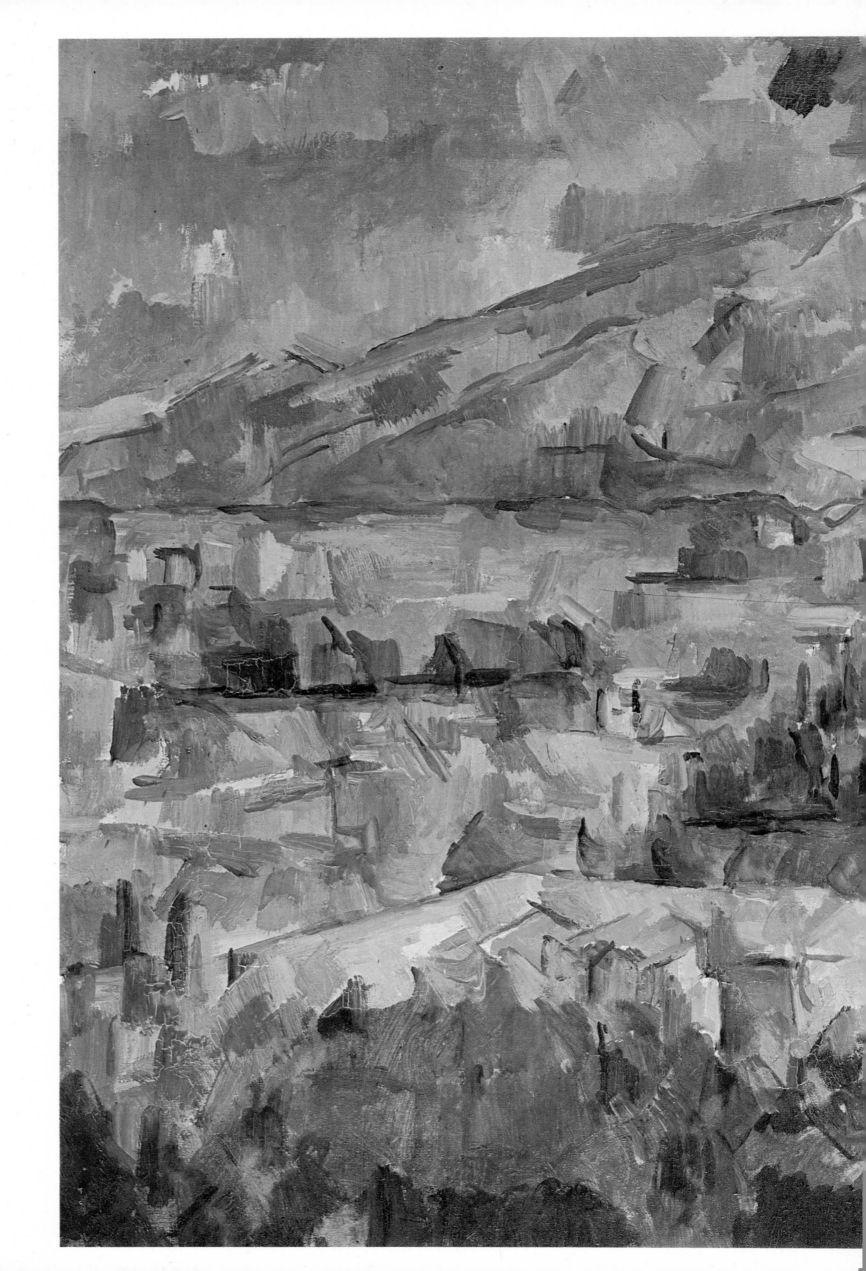

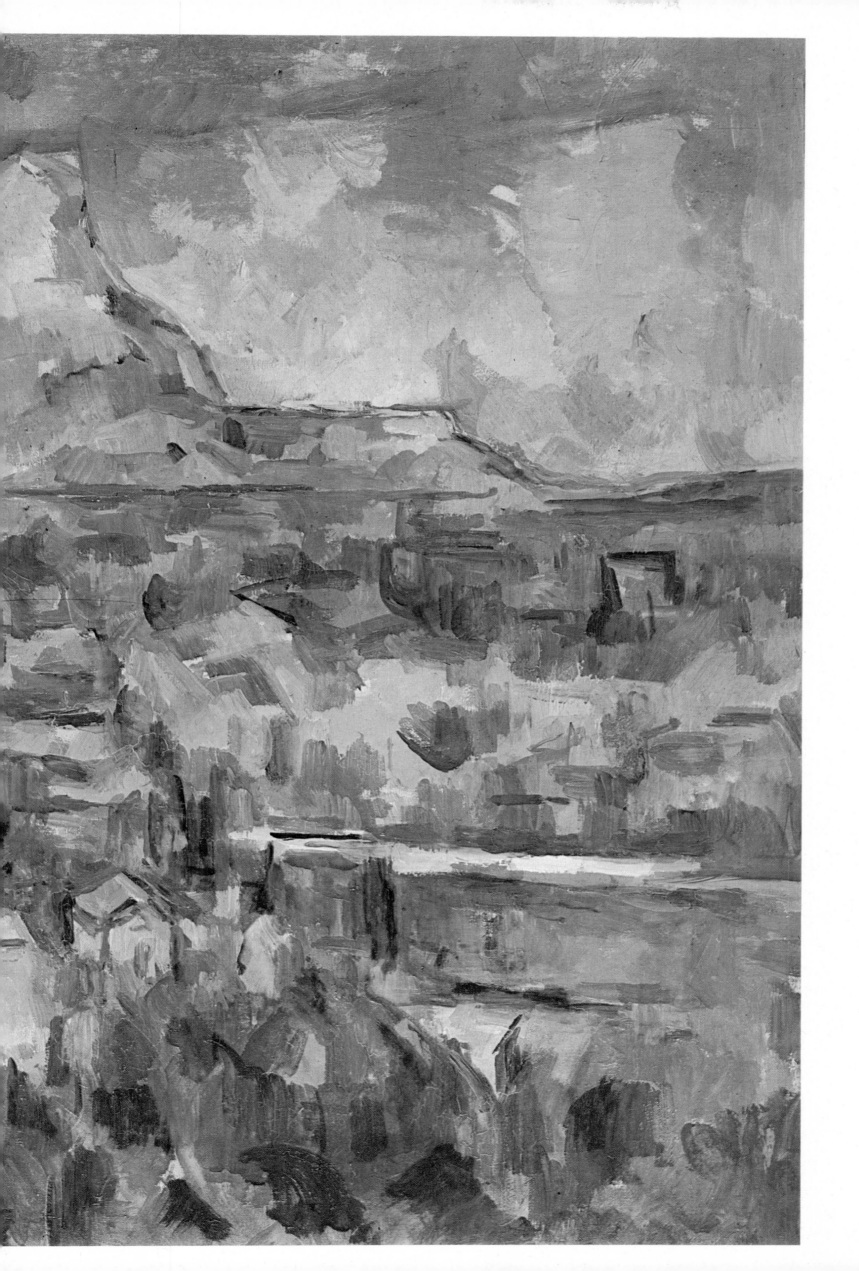

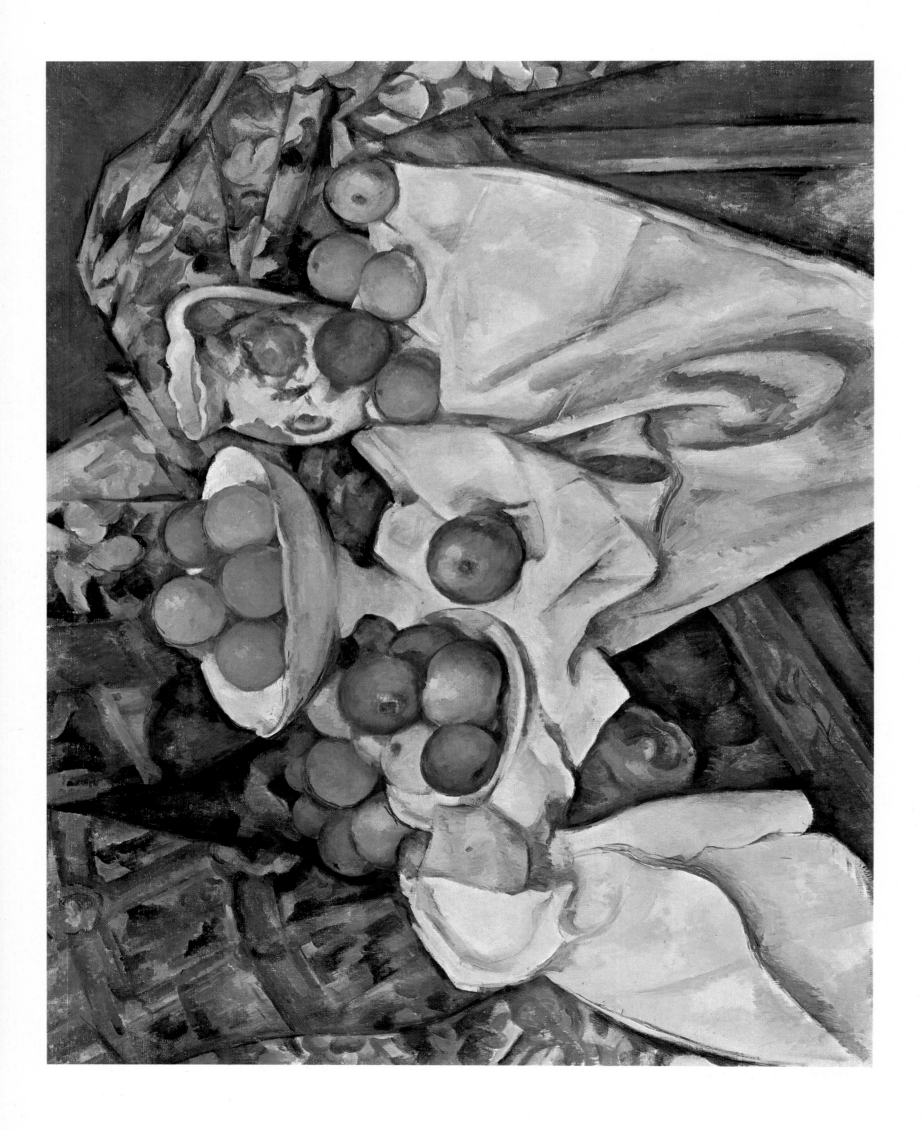

Claude-Oscar Monet

Claude-Oscar Monet 1840-1926

Claude-Oscar Monet, born in Paris on 14 November, 1840, was the elder son of a grocer. In 1845 the family moved to Le Havre, where Monet, in addition to the normal school curriculum, studied drawing—for which he had shown an early inclination—under François-Jacques Ochard, a pupil of David. As a youth he displayed a flair for caricature, but after 1858, under the guidance of the landscape painter Eugène Boudin, his first real teacher, he came to love painting out of doors.

In 1859 he went to study painting in Paris, where he was for a time a regular visitor to the Salon, attracted by the work of Daubigny and Troyon: the latter, to whom he had been given a letter of introduction by Boudin, showed interest in his work and gave him encouragement. Despite all advice to the contrary, Monet pursued his studies independently, both in the studio of Charles Jacque and in the free Académie Suisse, where he met Pissarro. Familiarity with the work of painters such as Delacroix, and discussions in the Brasserie des Martyrs (a favourite haunt of art students) no doubt played the most effective part in enriching his cultural heritage and widening his artistic experience. In the autumn of 1860 he was conscripted for military service and sent to Algiers with the Chasseurs d'Afrique. Early in 1862, however, he returned to Le Havre to convalesce after contracting anaemia, and his family eventually agreed to buy him out of the army, provided that he, in return, promised to enter the studio of a serious painter. This stay in Le Havre was a particularly happy one for the young painter.

On his return to Paris in the autumn he entered the studio of Gleyre, where he made the acquaintance of Bazille, Renoir and Sisley, who were to remain his lifelong friends. Around this time the most significant contacts which he established were those with Manet, whom he met at an exhibition in 1863, and Courbet, whom he met the following year, after the closure of Gleyre's studio. These were, however, extremely difficult and penurious years during which he was involved in constant wrangling with his family, who strongly disapproved of his independent and rebellious behaviour and accordingly denied him any financial support. Monet nevertheless painted unceasingly out of doors—in the forest of Fontainebleau, along the banks of the Seine, and in Normandy. The only help which he obtained came from his artist friends, from Courbet for instance, and in particular from the devoted Bazille.

After his full-length portrait of Camille Doucieux had attracted favourable comment when exhibited at the Salon in 1866, his family once again agreed to help him. Shortly afterwards, however, when he visited them and they learnt that he was living with Camille, they responded to his renewed pleas for financial aid by urging him to leave her. Monet had left Camille behind in Paris and while he was away she gave birth to a son, Jean. Completely destitute, Monet was unable even to raise the money to pay for his return to Paris from Sainte Adresse, where he was staying with an aunt. In 1870 he married Camille and in the same year he moved to London, France having declared war on Prussia (a war in which his friend Bazille was to lose his life). He later spent some time in Belgium, and returned to Paris towards the end of 1871, renting a small house at Argenteuil, on the banks of the Seine.

He was no longer hounded by the poverty which in his earlier years had driven him, fortunately without success, to attempt suicide, but he was still burdened with economic problems. Now, however, he was free to devote his energies almost entirely to painting, thanks especially to the support of Durand-Ruel, the only picture-dealer who had faith in the innovations of Monet and his friends—Renoir, Sisley, Pissarro and Cézanne. Together with Degas and Berthe Morisot they formed a group for whom Durand-Ruel organised an exhibition in 1874. This group was satirically accorded the name Impressionists on the basis of the title of one of Monet's works—Impression: soleil levant. Similar exhibitions were subsequently held in 1876, 1877, 1879, 1880, 1881, 1882 and 1886. Monet himself did not contribute to several of these because of a disagreement with the promoters. Early in 1878 he moved from Argenteuil to Vétheuil. Camille's state of health, for some time a cause of concern, had become precarious after the birth of her second son, Michel. She died in September 1879.

For some years Monet led an unsettled life, moving constantly between Poissy, Varangéville, Dieppe, Pourville and Etretat. Eventually, in 1883, he decided to settle in Giverny from where he often travelled southwards, alone or accompanied by Renoir. In the early 1880's his financial situation showed distinct signs of improvement. A number of the exhibitions held at the Durand-Ruel and Petit Galleries were favourably received by the critics and a considerable number of works sold. In 1890, Monet was finally able to buy the house in which he was living at Giverny. Two years later he married Madame Hoschedé, the widow of a collector, who had four children. His wanderings became less extensive, but he paid a brief visit to Normandy, and visits to Norway (1895), London (1899, 1900, 1901 and 1904), Madrid (1904) —to see the works by Velázquez—and Venice (1908 and 1909). The completion of his water garden and the care of his plants and flowers, which he constantly painted, became after painting his main preoccupation. He was indifferent to the reputation which he had gained as the greatest living French artist and to the glory attained after surmounting so many ordeals. He was conscious only of a despairing sense of failure, of a yearning to transcend his achievement, to draw nearer each day to a completely accurate representation of his impressions. Sustained by this singleness of purpose, undiminished even by the tragic failure of his sight, he continued to work on his last canvases until he died, in his house at Giverny, on 5 December, 1926.

Monet is just an eye, but my God, what an eye! — CÉZANNE

The name of Claude Monet is closely associated with the history of Impressionism, with its initiation, development and most characteristic achievements, but his primary claim to eminence resides in his role as an innovator. The Impressionist movement was, in effect, both the brilliant culmination of the 19th-century preoccupation with naturalism and the point of departure of modern art. Monet played a leading part in the creation of the new artistic ideals and in the evolution of new methods of representation. His portrayal of reality was effected in an audaciously original style. 'I paint as a bird sings,' Monet remarked to his friend Geffroy—a frank avowal of his spontaneity and the unequivocal character of his vocation as a painter. Yet, Monet, through his originality, revolutionised the course of modern painting and his works came to represent a radical turning-point in art history.

BEFORE HIS TIME, even in the work of those painters whose style most closely approaches that of the Impressionists, shadows were painted in neutral tones and pictures were composed of more or less clearly-defined areas of light and shade, often determined in preliminary sketches; light was treated as a phenomenon whose function is to reveal beauty and the contours of form.

From the time of Monet onwards form—defined by flickering vibrations of light—is merely the embodiment of light; the picture represents an arbitrary fragment of nature and its unity is dependent upon the atmosphere which pervades it; the representation of mobility is so effective as to arouse in the beholder a consciousness of the transitoriness of all appearance, especially of that of the scene before him. Even the most brilliantly coloured paintings by Delacroix seem dull and sombre in comparison with those by Monet, while many works by Corot and Manet, similarly compared, convey respectively the restricted atmosphere of the studio and virtuosity of an academic kind. In Monet's work colour predominates, and the canvas is often entirely covered by a myriad of swirling brush-strokes: light pervades the scene and gives colour even to the shadows. Here was a new way of perceiving and representing the visible world. The public was unable, at first, to concede that such works were more than formless sketches or arbitrary chromatic studies, and the painters themselves were perplexed by a style which violated even the most recent of traditional principles. A few discerning critics, after praising the originality of Impressionism, lamented the fact that it progressed no further than the stage of the preliminary sketch. This nevertheless provides an indication of the freshness and force of Monet's painting, since it is in fact the preliminary sketch which renders the true and spontaneous impression of the motif, being free from the dangers of subsequent re-working and from conventional methods of representation.

In the natural world there is no formal pattern of colours, and shadows are infinitely various in depth. A perpetually evolving atmosphere, created by the impalpable mutations of light, envelops the things we see, the colours of which are constantly modified by the effect upon them of other colours: water, for example, assumes the blue of the sky reflected upon its surface, and in the shadow of green foliage, faces assume a greenish tinge. Monet was the first painter to represent these visual permutations with such discrimination and to record the fact that seen from afar the trees in a forest or the houses in a city become an almost indistinguishable mass in the vaporous atmosphere. Experience has, of course, taught us that the branches of a tree are distinct from one another—whether close by or farther away—and that each house may be differentiated in innumerable ways from those surrounding it, but this fact is not immediately discernible. Monet declined to paint objects as he knew them to be, preferring to depict them, as accurately as possible, *as he saw them.*

In order to do so he found himself obliged to invent new methods of representation, since those traditionally used proved totally inadequate. Design, monochrome, linear perspective and preliminary sketches failed to serve his purpose and he therefore evolved a style of painting, consisting of small, curving brush-strokes, which heightens the intensity of colours, conveys the ephemeral character of atmosphere, and represents form and space tenuously in terms of shimmering light. Monet's intellect and perception led him to take into account the rational and sensory experience of the beholder, inviting him to participate directly in the interpretation and understanding of the work. The evolution from his first exploratory landscapes to his final and wholly liberated series of *Water-Lilies*—(Plates XIII and XVI)—which seem almost to dissolve in the atmosphere, derives from his constant exploration of his own visual capacities and of the problem of representing light. Although in his earlier years, harrowed by precarious economic circumstances and even by tragedy, he had been involved in an arduous struggle to win recognition for his innovations, by the end of the century, when he had gained the understanding and support of a group of critics and collectors, he was emboldened to venture even further. It was now appreciated that his new method of representation was not a bizarre and unwarranted experiment, but a true style which was likely to prove of value to other artists in extending their conception of reality.

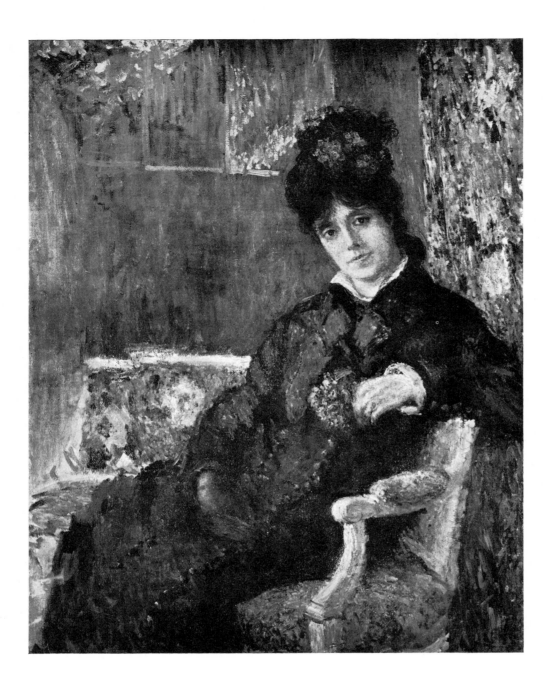

The fact that Monet's interest was centred primarily upon the problems of the representation of visual effects, and that he pursued his investigations without compromise, gave rise to many biassed criticisms and interpretations. By some he was regarded as a merely mechanical eye, a faithful but drily scientific recorder of optical impressions, by others as a systematic and intellectual revolutionary, a skilled sketcher who revealed his limitations in his final paintings which they considered splendid failures. Such judgements are unjust not only to the talent of the artist but also to his lyricism and delicate sensibility. While emphasizing the relevance of optical phenomena to Impressionism, one should not overlook the depth of the emotions which the artist used them to express. Monet loved, above all, sunlight and natural beauty, and he expressed in his work the personal exaltation which he felt in the presence of such beauty.

OWING TO THE strength and single-mindedness of his personality, the development of Monet's work followed an unvacillating course. His earliest works as a caricaturist at Le Havre were hung in the shop of a local picture-framer, and it was here that he had the good fortune to meet Eugène Boudin, who encouraged him to paint out of doors and to attempt many aspects of landscape. Boudin himself was not a major painter and his own small scenes are relatively conventional in style, but he was able to awaken in his young pupil an awareness of the infinite potentialities of less stylised painting executed in front of the motif: 'works painted directly on the spot,' he asserted, 'invariably have a force and vivacity which cannot be recaptured in the studio.' This dictum was treasured by Monet throughout his long life. Boudin, in addition, conscious of his inability to impart to his pupil more than his own love of landscape, wisely persuaded him to go to Paris, knowing that only in association with creative activity and through the exchange of ideas with fellow artists could the painter's education be effectively pursued.

WHEN HE ARRIVED in the artistic capital of Europe in 1859, Monet was only nineteen years old, yet his preference already lay decisively in the field of landscape painting, in which he admired the work of Corot and Troyon and in particular that of Daubigny. He was undeterred by the fact that the work of the latter was criticised even by devotees of landscape painting, and that the informed and discerning critic Théophile Gautier had derisively observed that his paintings 'offer little more

than juxtaposed patches of colour'. He was disinclined to heed the advice given by Troyon that he should enter the studio of a traditional painter such as Couture, or the continual exhortations of his family which were in the same vein, for he was already convinced that formal academic training encouraged a distorted representation of the initial impression gained in the presence of the motif. Accordingly he renounced academic disciplines which would have conflicted with his sense of vocation. His contempt for the Academy was so great that he made no attempt to resist the alternative, military service, and in the autumn of 1860 was sent to Algiers with the Chasseurs d'Afrique. This brief interlude ended early in 1862 on his return to his family to convalesce after an illness, and he eventually undertook to submit to formal study in the studio of Gleyre. Before returning to Paris Monet happened to meet the restless Dutch painter Jongkind, a pioneer in the search for the most effective means of representing the evanescence of light and atmosphere, who encouraged him to continue in the course he had already chosen.

During the year which Monet spent as a student of Gleyre he paid little attention to his formal instruction and worked, whenever possible, in the open air. He often persuaded some of his fellow-pupils to accompany him to Chailly, in the Forest of Fontainebleau, a place beloved of the Barbizon school of landscape painters, whom they greatly admired. Among these fellow-pupils were Bazille, still inhibited by academic conventions and ill at ease when painting out of doors; Renoir, still principally attracted by the vigorous painting of Courbet; and Sisley, at that time a disciple of Corot. Monet, the only member of the group who had had experience of painting in the open air, was the one who, unfettered by prejudice and attachment to traditional values, paved the way for modern realism with single-mindedness and conviction. From this time onwards, Monet assumed the leadership of the emerging movement. For over sixty years his adherence to his ideals was to remain constant, unaffected even by the tragic failure of his sight. Throughout these years he concentrated, in particular, upon the representation of sunlight, and its impact upon nature in general and especially upon the plants and flowers which he cultivated with such devotion.

DURING 1864 he experimented constantly with the style described as juxtaposed patches of colour, painting a series of landscapes along the banks of the Seine and around Honfleur—a series in which may be discerned the influence of Courbet.

1865 was the year in which he first secured favourable attention from the critics. In his large canvas Le Déjeuner sur l'Herbe (Plate I), painted during that year, he took up the theme of Manet's picture of the same title, using, however, a very different technique, and flooding the scene with sunlight. This work, painted in the open air, has a chromatic brilliance hitherto unapproached except by Manet and Courbet. Criticism of the picture offered by Courbet led Monet to make alterations, and it was never completed to his own satisfaction. Only two fragments survive of this enormous composition, in the Louvre and the Eknayan Collection, Paris, and they were possibly reworked at a later period; there is also a smaller version in the Pushkin Museum, Moscow, besides a study for the left side, in the E. Molyneux Collection, Paris. The painting in the Pushkin Museum, which bears the date 1866, is more luminous than the two large fragments. It is thought that this may have been a preparatory sketch for the larger work, and that it therefore gives a clearer notion of the original impression, having been executed on the actual scene but signed and dated the following year; or alternatively that it is a version painted by Monet as a record of the larger composition, since he was obliged at a later date to destroy its right half and cut the left into two sections as a result of deterioration in its condition. Le Déjeuner sur l'Herbe, the Femmes au Jardin (Louvre, Paris), and the tonal perfection of the landscapes painted around this time in Honfleur and Paris, marked a new stage in the development of Impressionism. On one occasion, when Renoir had persuaded Monet to accompany him on a visit to the Louvre to study the works of the masters, Monet had shown his preference for direct personal contact with nature by looking out of the window at the flowers instead. His attention had become focused

2. BEACH SCENE:
NORMANDY COAST
BY KIND PERMISSION OF
T. HANLEY, BRADFORD

upon the accurate reconstruction of visual sensations. Attracted by his enthusiasm and the efficacy of his innovations, the friends who had assisted in the evolution of the new techniques again came to his support. Chief among these were Renoir and Sisley, who early in their careers had abandoned their positions as devoted followers respectively of Courbet and Corot; Pissarro, who had grown away from the influence of Millet; Cézanne, whose repudiation of the turbid romanticism of his early years as a painter was given impetus by the new experiments; and Bazille, who died while still young and remained throughout his life under the influence of Manet. These artists constituted the famous group of Impressionists who, canvas, easel and palette in hand, explored the banks of the Seine, in search of subjects which accorded with their sensibility and temperament. Handfuls of flowers, dazzling light, reflections on water, the trembling of leaves, scurrying clouds, drifting mist or smoke; the most transient and ethereal aspects of nature were those which principally attracted these painters, and in particular Monet.

THE YEARS FROM 1870 until 1882-84 were those during which the Impressionist painters, now joined by the proud Manet, worked together in the closest association. After this time their paths diverged and each developed his individual style while retaining allegiance to the concept evolved from their interchange of ideas. Monet, who had undoubtedly made the greatest contribution to the evolution of the new methods of expression, followed his course along what he considered the only true path. His mature works therefore show enhanced devotion to the new representational methods and their expressive potentialities. Whereas in his earliest works the technique of light, fluttering brush-strokes was applied only in certain areas of the canvas, in later works it became the dominant element. In certain instances, notably the Normandy landscapes, the solidity of the cliffs is indicated merely by the effect of shimmering light, achieved by a flurry of small brush-strokes.

Eventually, having dissolved form almost entirely in atmosphere, Monet began to fear that he had abandoned his original aim of attaining an accurate rendering of nature and had allowed himself to be deluded by an unattainable goal, that by dint of aspiring to represent light he had come to underestimate the significance of matter. He accordingly ceased his wandering around the country in the manner described by Maupassant as that of a 'huntsman stalking impressions', and concentrated upon the observation of a single motif in a succession of different lights. This resulted in various series of paintings, such as those of 1891, devoted to haystacks and poppies, and that of 1892-94 devoted to Rouen Cathedral.

AS HE GREW older Monet lamented the loss of his faculty for immortalising an instantaneous impression and for capturing each swift modulation of sunlight. He became desolate at his inability to finish a picture to his own satisfaction and at the necessity for repeated attempts. In effect certain modifications were taking place in his own reactions to the visual world. Under the impact of Post-Impressionism, even Monet began to concede the part which imagination might play in the representation of nature. His devotion to the fundamental tenet of Impressionism—the intrinsic relationship between vision and emotion, between adherence to truth and lyrical transposition—was modified by the more scientific theories of Post-Impressionism. This change is apparent not only in the paintings executed by Monet in London and Venice, but also in the extensive output of the last twenty years of his life, devoted primarily to his water garden. In these works, the pool reflects the water-lilies on its surface, the sky and the perennial growth and decay of the natural world. It mirrors, also, the soul of the artist, at times deeply moved by the miracle of a blossoming flower or a growing plant, at others dejected and melancholy. The *Water-Lilies* series, rhapsodic in mood and kaleidoscopic in range, marks the climax of Monet's creativity.

The 'eyes of a pioneer who,' said Clemenceau, 'heightened our perception of the universe,' were finally closed at Giverny in December 1926 at the age of eighty-seven.

3. *TWO FISHERMEN*
FOGG ART MUSEUM,
HARVARD UNIVERSITY

The Plates

I *LE DÉJEUNER SUR L'HERBE* (Detail) 1865
Oil on canvas, 164½ in. ×59 in.
LOUVRE, PARIS

In the spring of 1865 Monet installed himself at the Auberge du Lion d'Or at Chailly, in the Forest of Fontainebleau, where he began work on a large picture inspired by Manet's *Déjeuner sur l'Herbe* (1862-3). Monet achieved a more naturalistic and convincing outdoor effect, but the work was never completed to his own satisfaction and at a later date was cut up and partly destroyed.

II *LA GRENOUILLÈRE* 1869
Oil on canvas, 29⅜ in. × 39¼ in.
METROPOLITAN MUSEUM,
NEW YORK

In September 1869 Monet, who was staying at Saint Michel, near Bougival, on the Seine, wrote to Bazille: 'I dream of painting a picture of the bathing-place La Grenouillère, for which I have made some poor sketches, but it is only a dream.' The heavily broken colours and effects of light upon the water in this picture are more typical of later Impressionism. Renoir, working beside Monet, also painted this popular restaurant and bathing establishment.

III *SAINT GERMAIN L'AUXERROIS* SUMMER 1866
Oil on canvas, 32⅖ in. × 39⅜ in.
STAATLICHE MUSEUM, BERLIN

Painted from a balcony of the Louvre. In order to achieve greater naturalism, Monet was beginning to vary the type of brush-stroke adopted in different areas of the canvas. The smooth even strokes used here for the buildings contrast strongly with the small irregular ones used for the chestnut trees.

IV *TERRACE AT THE SEA-SIDE, SAINTE ADRESSE* AUTUMN 1866
Oil on canvas, 38 in. ×51 in.
BY KIND PERMISSION OF
THE REV. T. PITCAIRN,
PENNSYLVANIA

To escape his creditors Monet left Ville d'Avray in the late summer of 1866 for Le Havre, where this work, which shows his father gazing out to sea, was painted. The use of unmixed colours to represent tonal brilliance in sunlight marked an important stage in the development of pure Impressionism.

V *THE FLOATING STUDIO* C. 1874
Oil on canvas, 19¾ in. × 25¼ in.
RIJKSMUSEUM KRÖLLER-MÜLLER,
OTTERLO

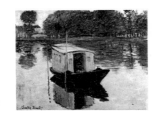

In the spring or summer of 1873 Monet acquired a floating studio, following the example of the Barbizon painter Daubigny who, in 1857, had constructed a special painting-boat which became known as *Le Botin*. Many of Monet's impressions of French river life were painted from his floating studio.

VI *REGATTA ON THE SEINE AT ARGENTEUIL* 1874
Oil on canvas, 24 in. ×40 in.
LOUVRE, PARIS

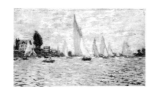

Painted during the year in which the first Impressionist group exhibition was held, and received with hostility by the press. By this time Monet's technique had become more delicate and supple and he was making more extensive use of small fluttering brush-strokes than in earlier works, such as Plates I-V.

VII *LA GARE ST. LAZARE* 1877
Oil on canvas, 29½ in. × 39½ in.
LOUVRE, PARIS

During the winter of 1876-7, Monet painted about ten views of this Paris station, eight of which were included in the third Impressionist exhibition in 1877. Each depicts different atmospheric condition and time of day. Together they constitute the first of the many series of variations on a single theme painted by Monet.

VIII *THE VILLAGE STREET, VÉTHEUIL* 1879
Oil on canvas, 24 in. ×32⅖ in.
KÜNSTMUSEUM, GÖTEBORG

Painted at a time when Monet was feeling particularly dispirited. Twelve major works, auctioned in June 1878, had fetched negligible prices, and by the winter he could afford neither food nor painting materials. This portrayal of winter conditions illustrates the persistence of the Impressionists in working out of doors in all weathers.

IX *THE RUE MONTORGUEIL DECKED WITH FLAGS* 1878
Oil on canvas, 24½ in. × 13 in.
MUSÉE DES BEAUX-ARTS, ROUEN

The first Fête Nationale after the war of 1870-71 was held on 30 June, 1878 (in honour of the highly successful Exposition Universelle). This is one of two views of the decorations painted by Monet, both of which were included in the fourth Impressionist exhibition in 1879. His brushwork had now become much bolder, and it is interesting to compare this picture with *La Gare St. Lazare* (Plate VII) painted less than two years earlier.

X *POPLARS ON THE EPTE* 1890
Oil on canvas, 36¾ in. × 29 in.
TATE GALLERY, LONDON

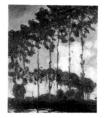

One of the earliest of a series of about 20 paintings of this group of poplars on which Monet worked in the summer of 1890, throughout 1891 and again in 1892. They were painted from a broad-bottomed boat, fitted with slots to hold a number of canvases: as the atmospheric conditions changed, Monet moved from one picture to another to capture the different effects of light.

XI *ROUEN CATHEDRAL: THE FACADE IN SUNLIGHT* 1894
Oil on canvas, 36 in. × 24¾ in.
LOUVRE, PARIS

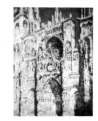

One of a series of more than 20 paintings of the Cathedral (almost all devoted to the west façade) at different times of day. Painted in Rouen in February-March 1892 and February-March 1893, they were later extensively reworked in his studio at Giverny. The heavily encrusted paint surface was intended to represent the texture of the stonework of the cathedral.

XII *CHARING CROSS BRIDGE, LONDON* 1902
Oil on canvas, 25¾ in. × 32 in.
NATIONAL MUSEUM OF WALES, CARDIFF (MARGARET F. DAVIES BEQUEST)

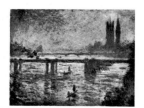

Since his visit in 1891, Monet had planned a series of London views; but he was only able to realise his ambition in the period from 1899 to 1901. Monet chose three motifs for these series: the view downstream with Waterloo Bridge; the view upstream with Charing Cross Bridge; and the Houses of Parliament which he painted from St. Thomas' Hospital. Many of the paintings were only completed later, in Paris.

XIII *WATER-LILIES, GIVERNY* 1905
Oil on canvas, 35¼ in. × 39¼ in.
MUSEUM OF FINE ARTS, BOSTON

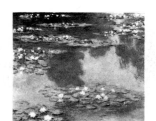

In 1890 Monet bought the house in which he was living at Giverny and made extensive alterations to the garden. The first series of paintings of his water-garden (1899-1900) are picturesque but rather naturalistic in style. From 1910 he concentrated almost exclusively on the more imaginative second series, begun in 1903-4.

XIV-XV *THE GRAND CANAL, VENICE* 1908
Oil on canvas, 29 in. × 36½ in.
MUSEUM OF FINE ARTS, BOSTON

Monet's first visit to Venice, in September 1908, was prompted by ill-health, failing eyesight and difficulty in representing his water-garden to his own satisfaction. He was delighted with the city: 'It is so beautiful!' he wrote to a friend, 'and I console myself with the thought of returning next year, for I have only been able to make a few tentative beginnings.' Monet paid another visit to Venice in the autumn of 1909.

XVI *WATER-LILIES* (detail)
C. 1910
Oil on canvas, 80 in. × 240 in.
KUNSTHAUS, ZÜRICH

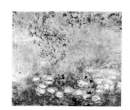

The increasingly broad brushwork and loose design of Monet's style in the *Water-Lilies* series was probably due primarily to his failing eye-sight. Work on the later paintings was frequently spasmodic and protracted, and they are often very hard to date.

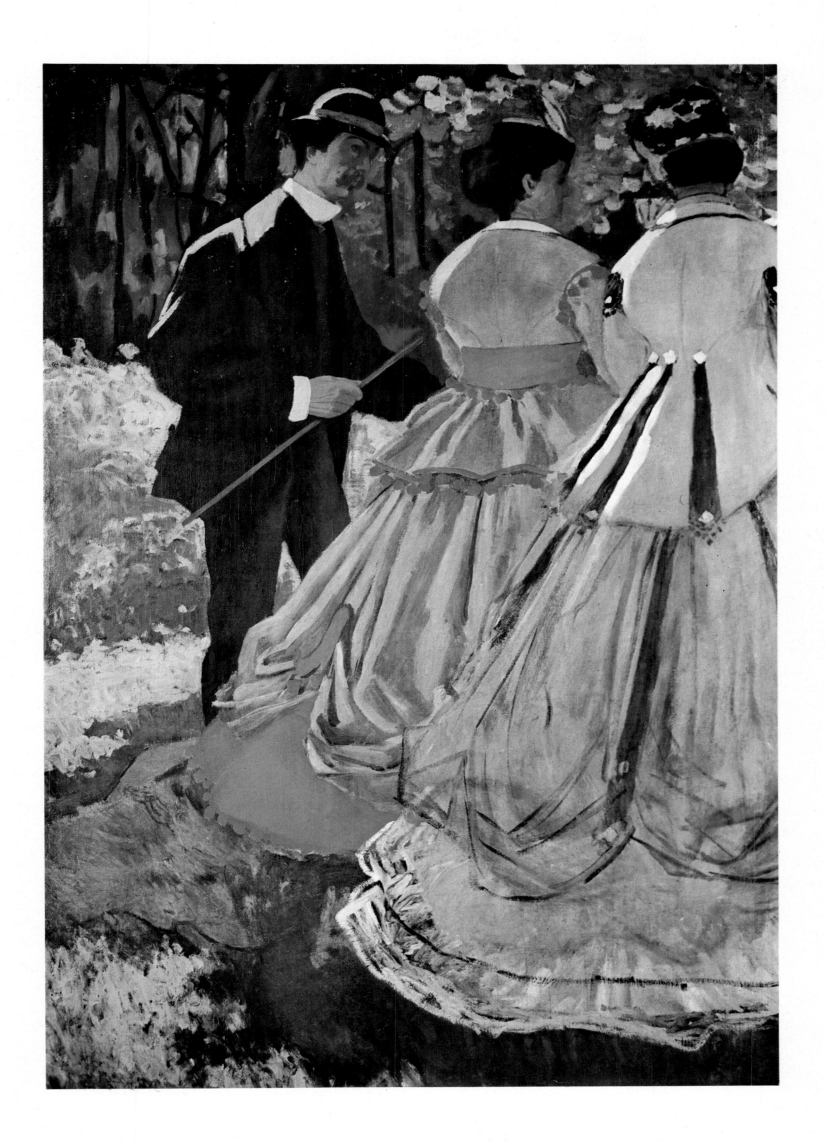

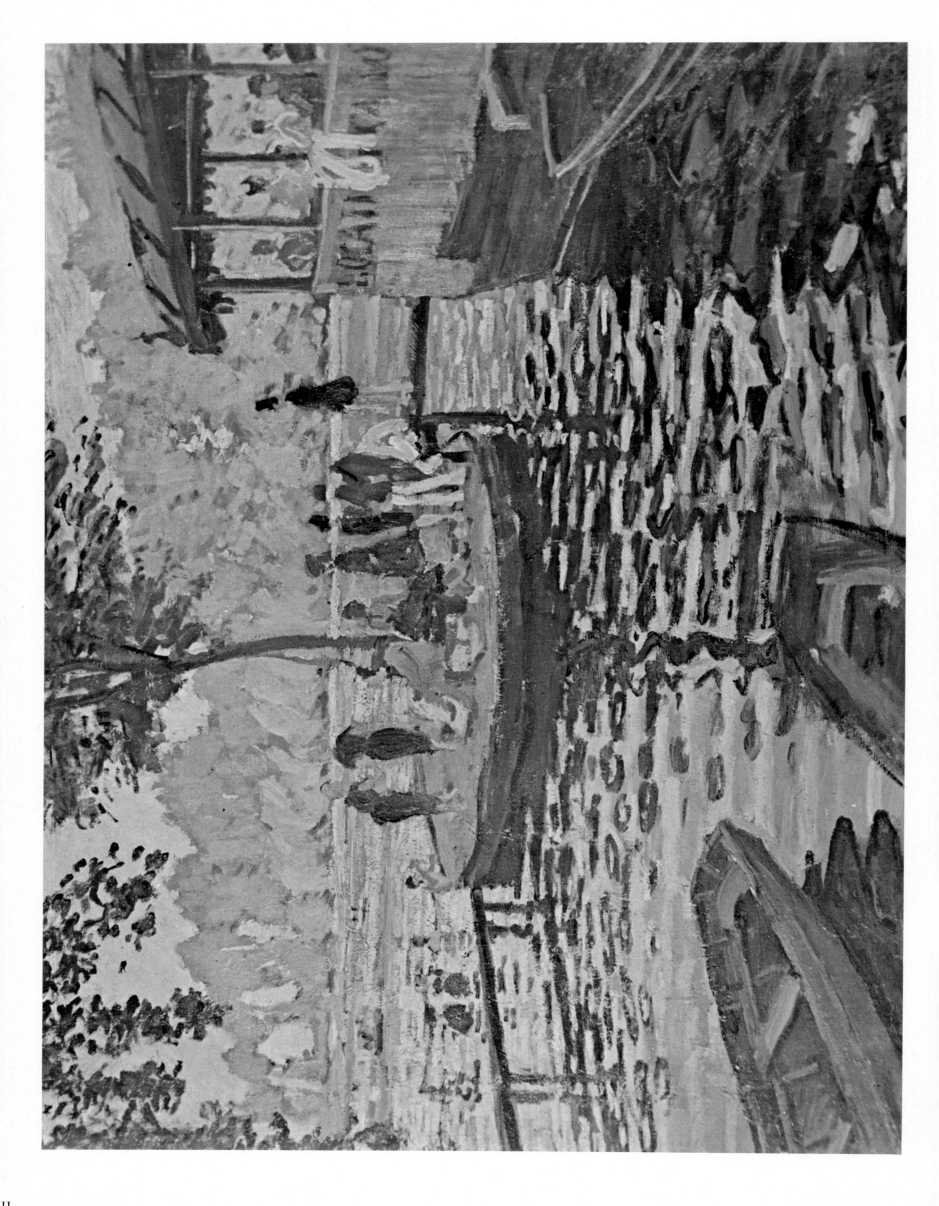

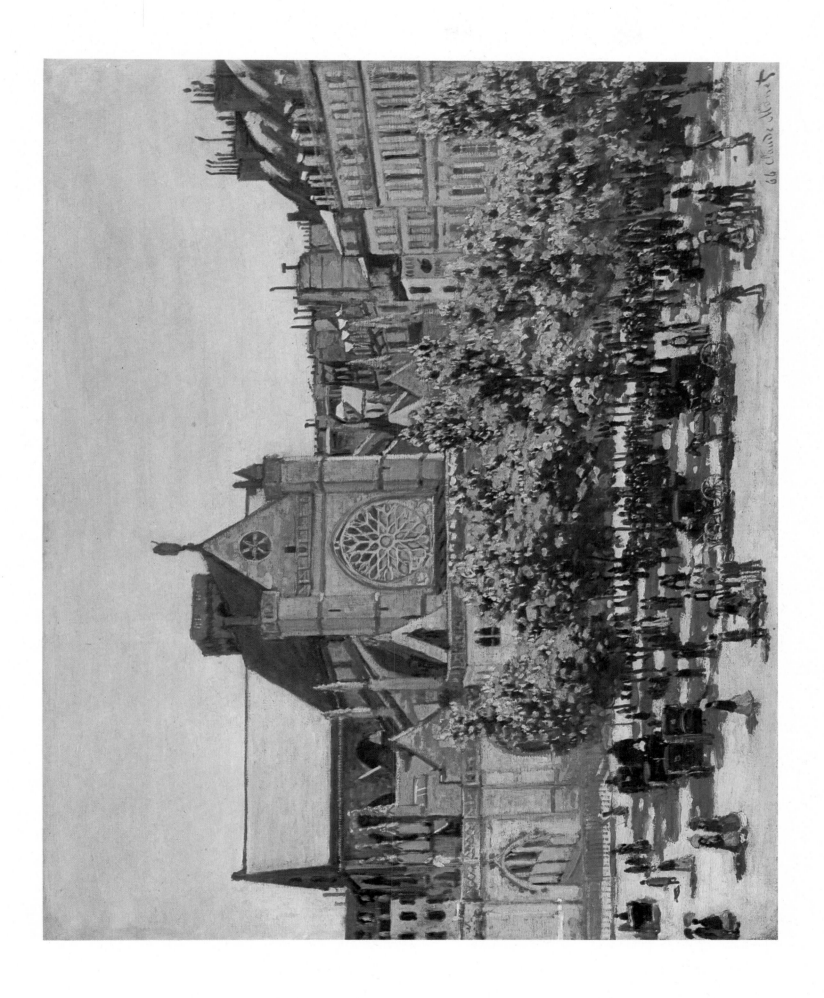

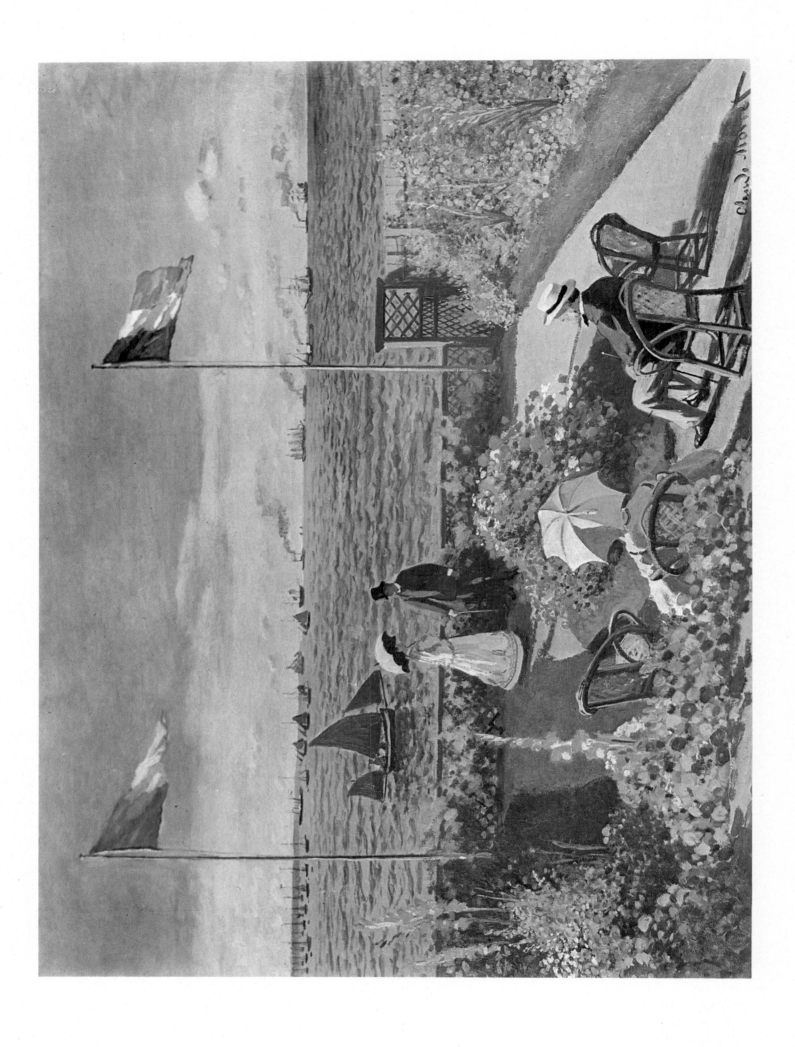

IV

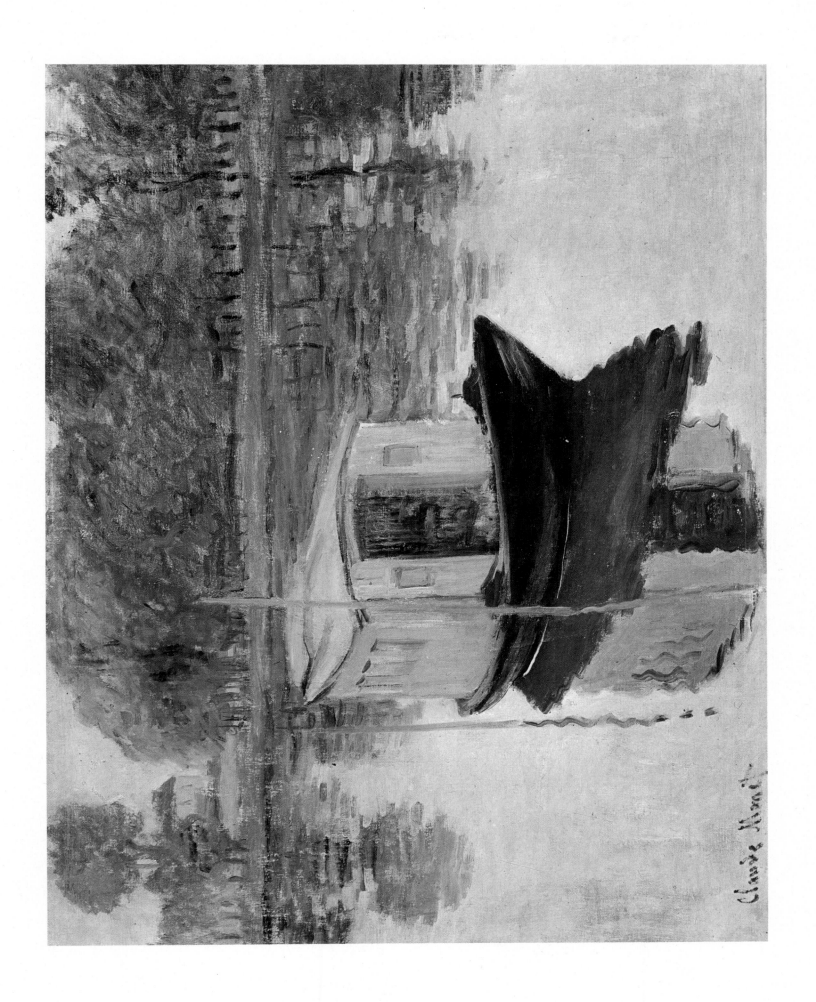

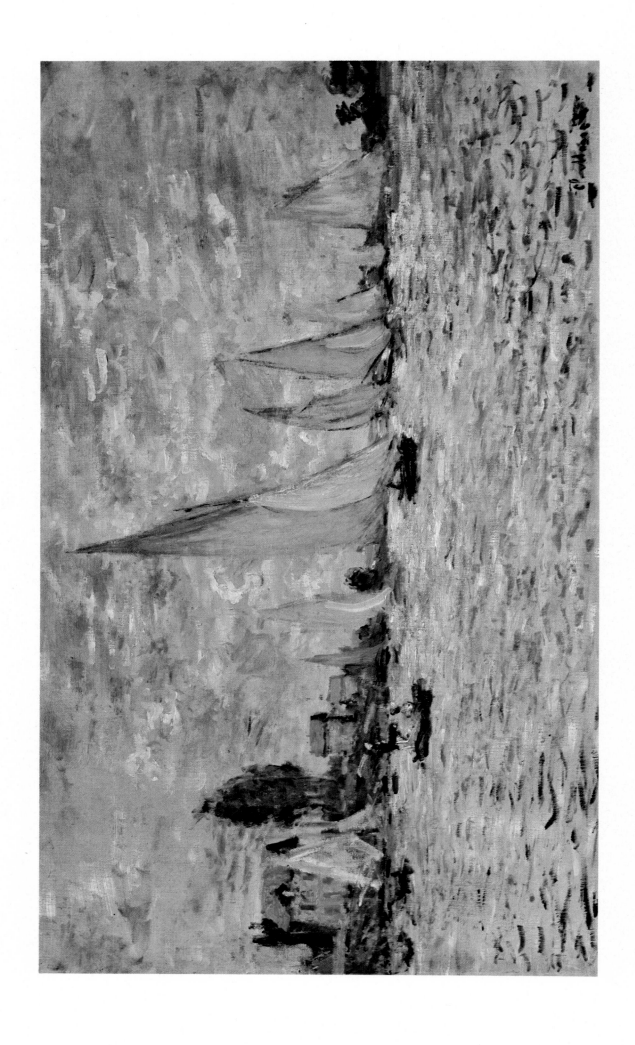

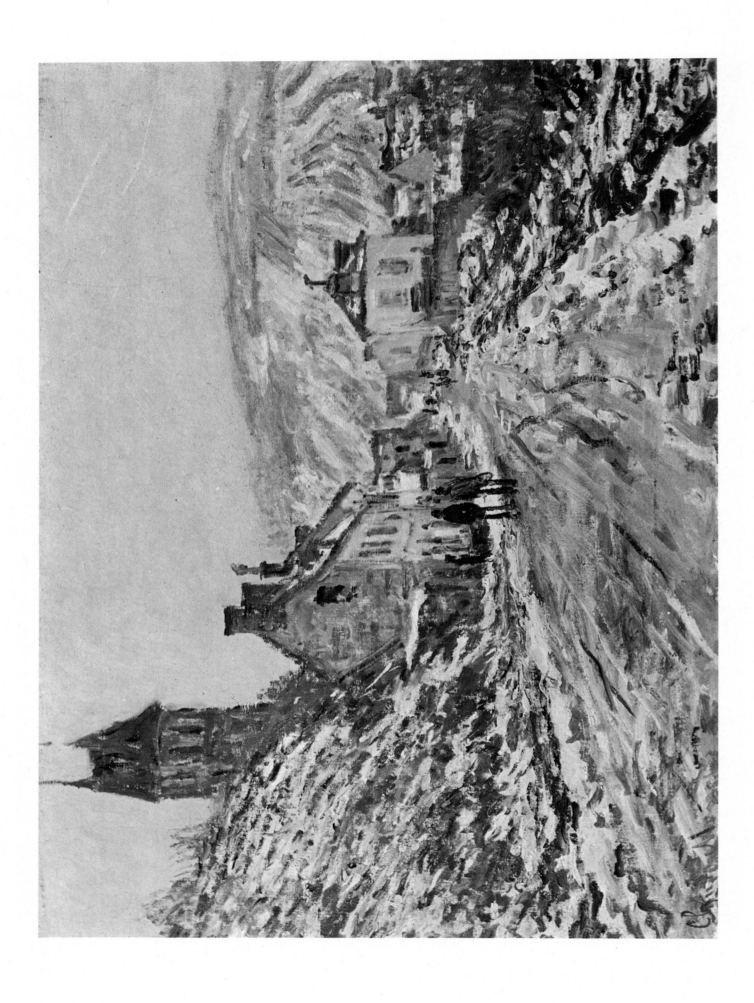

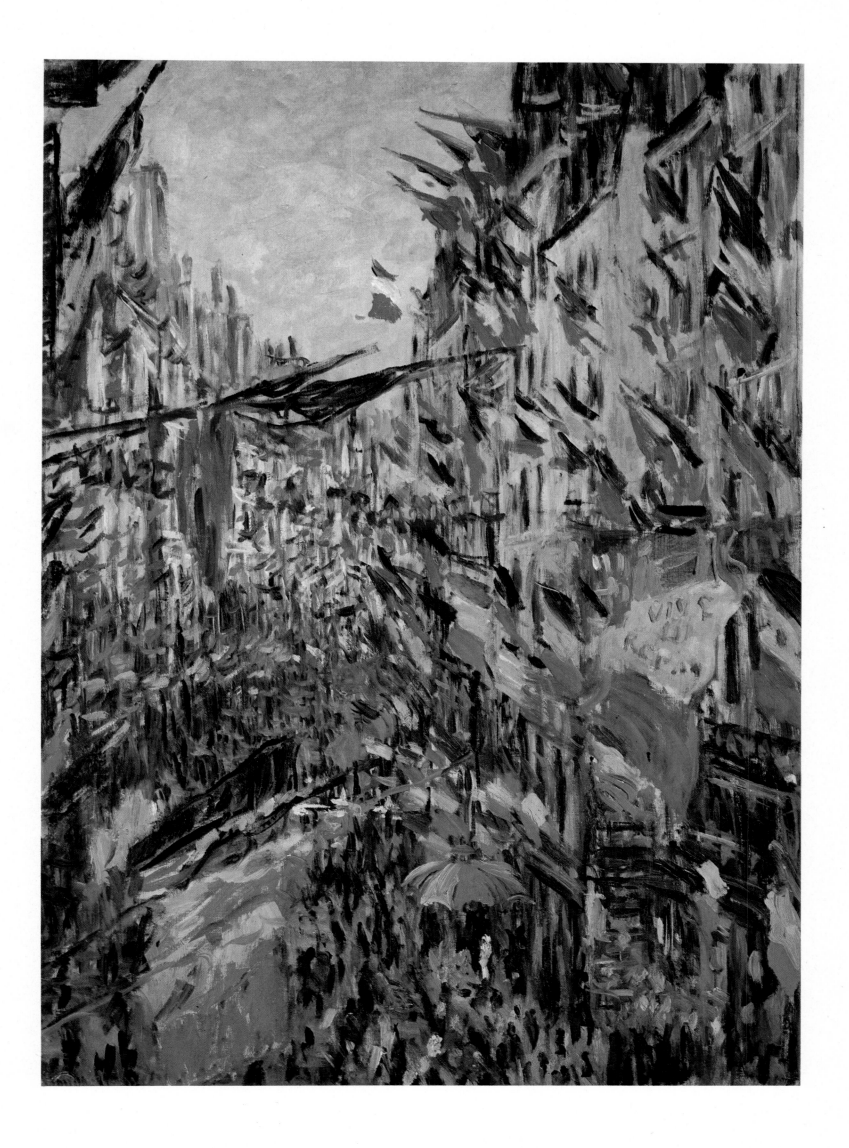

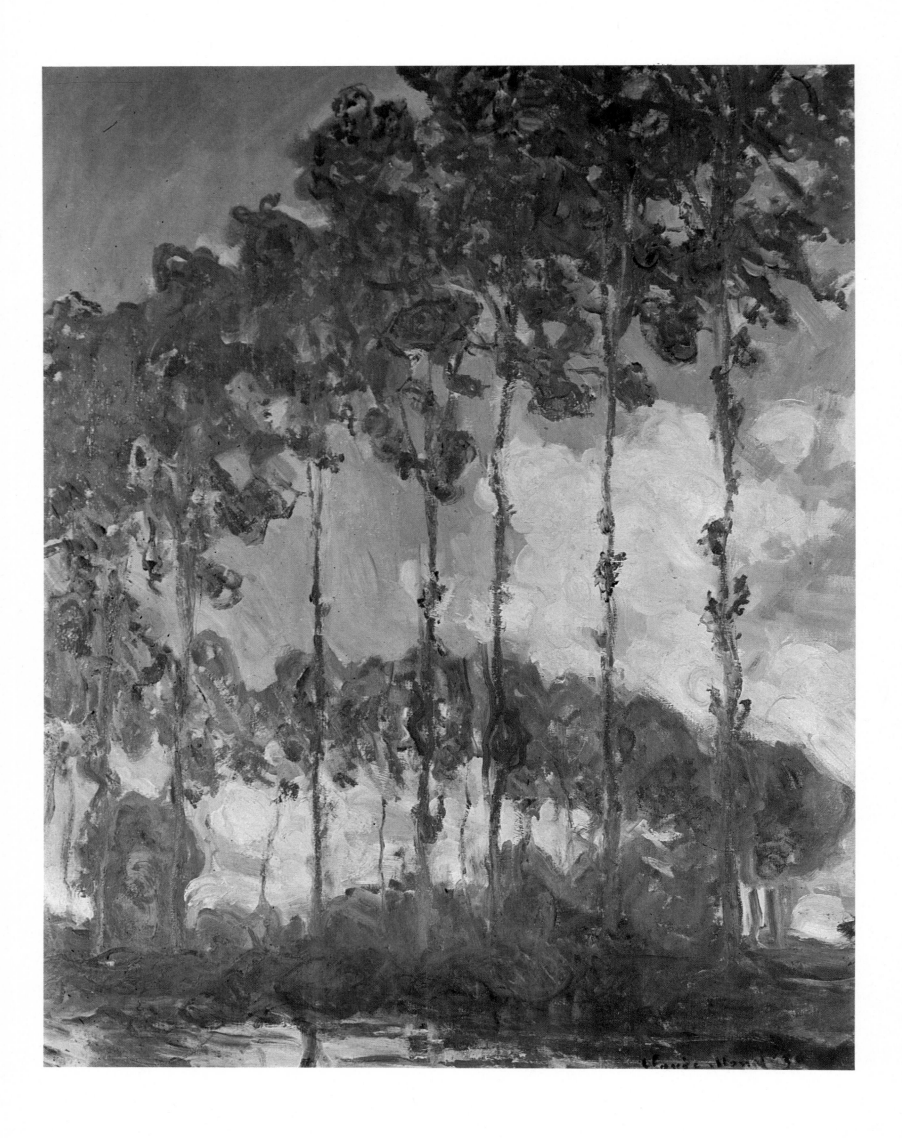

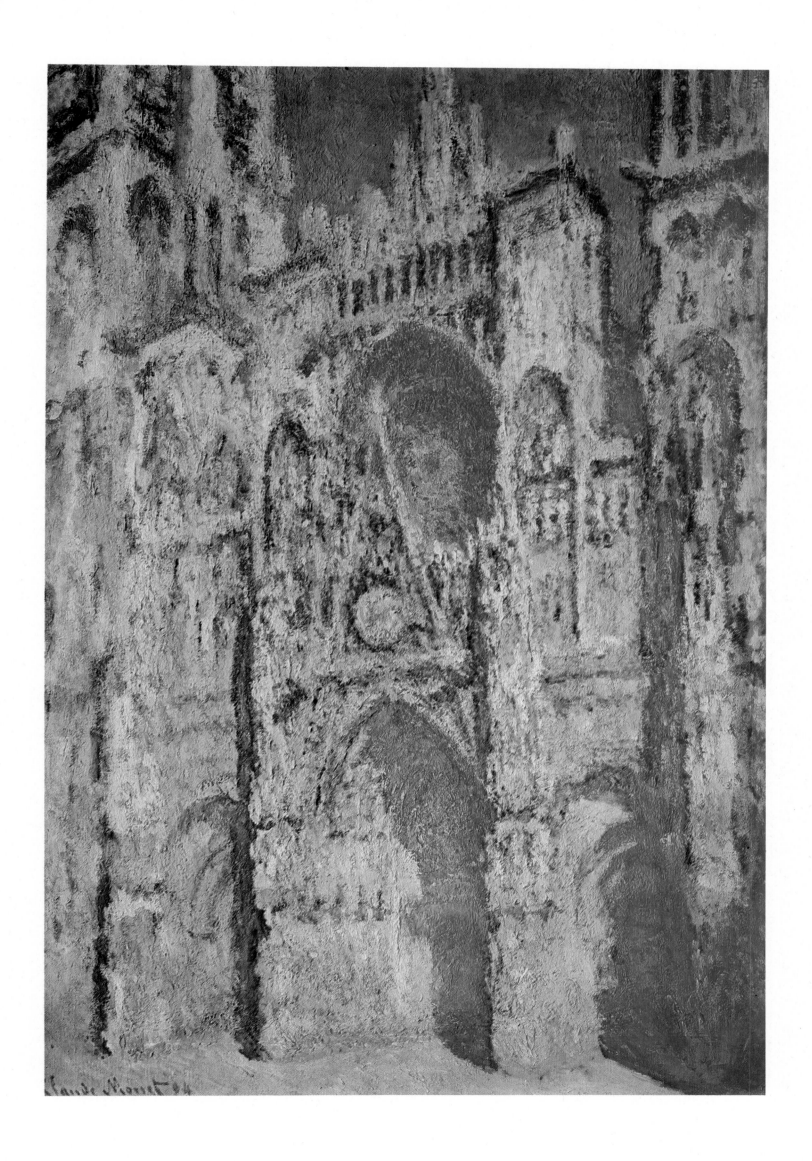

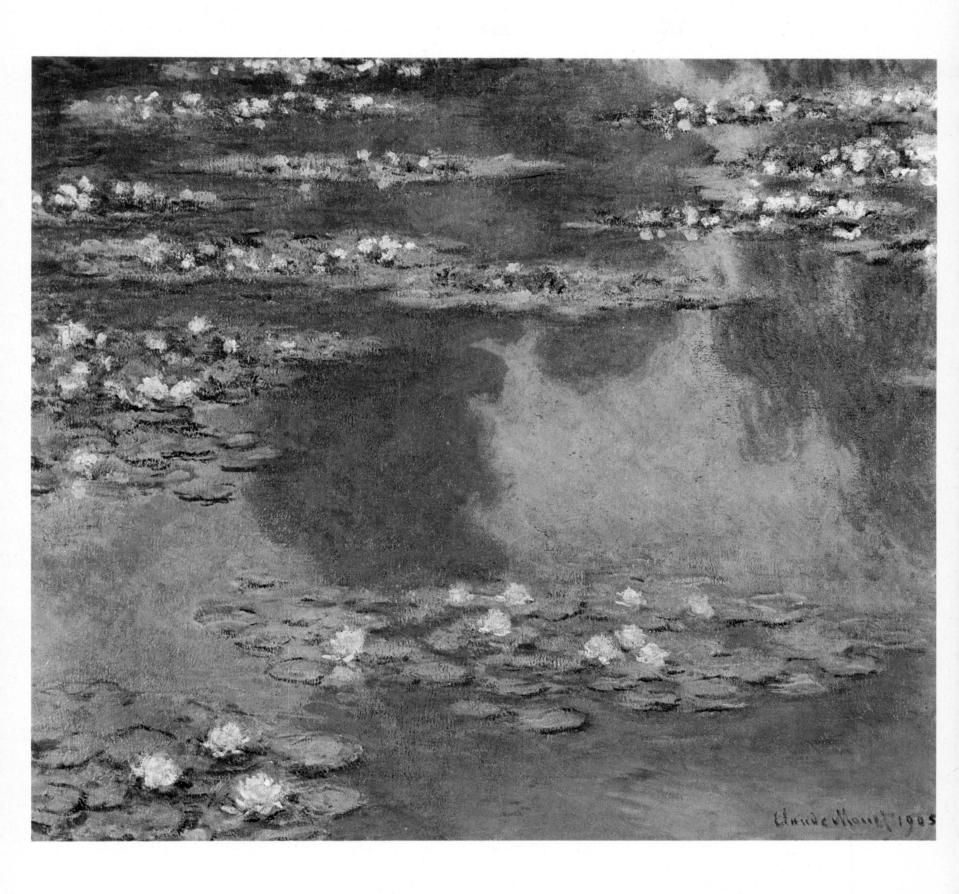

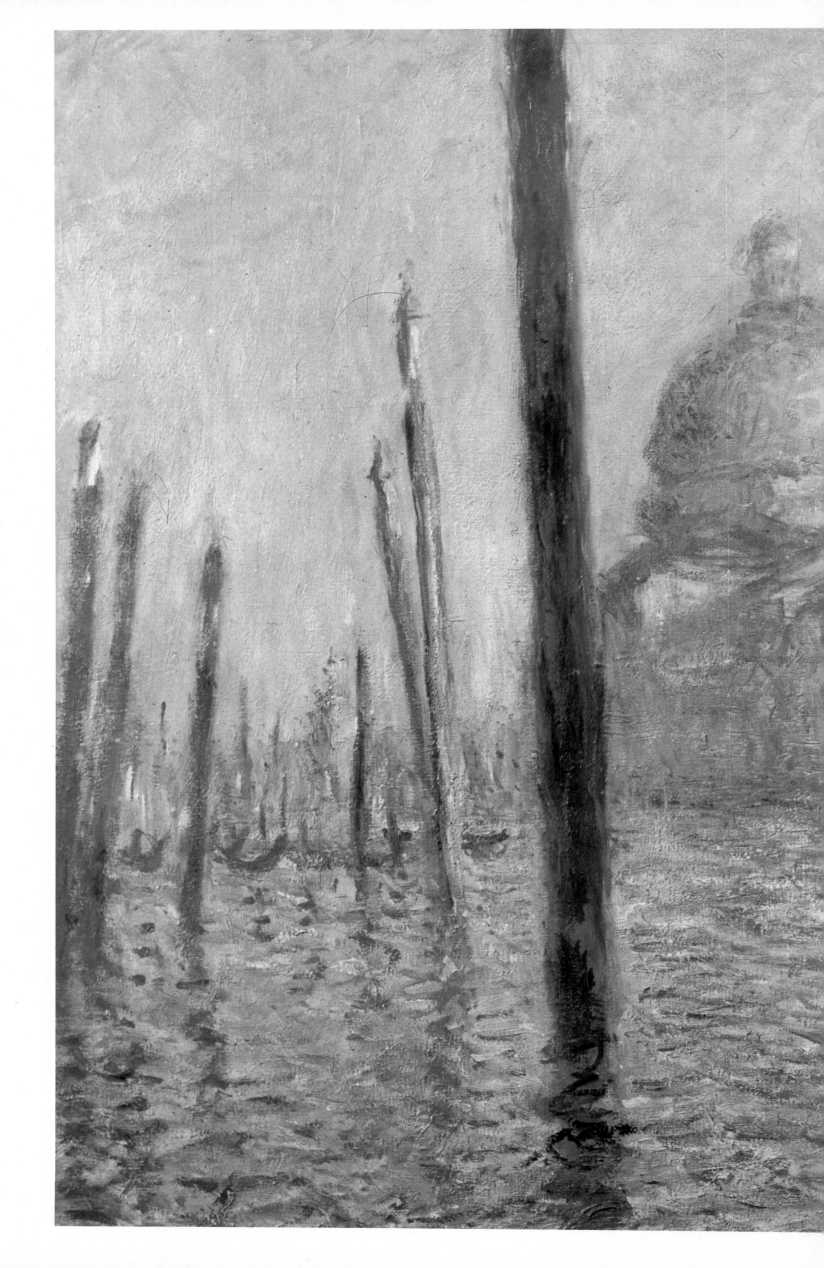

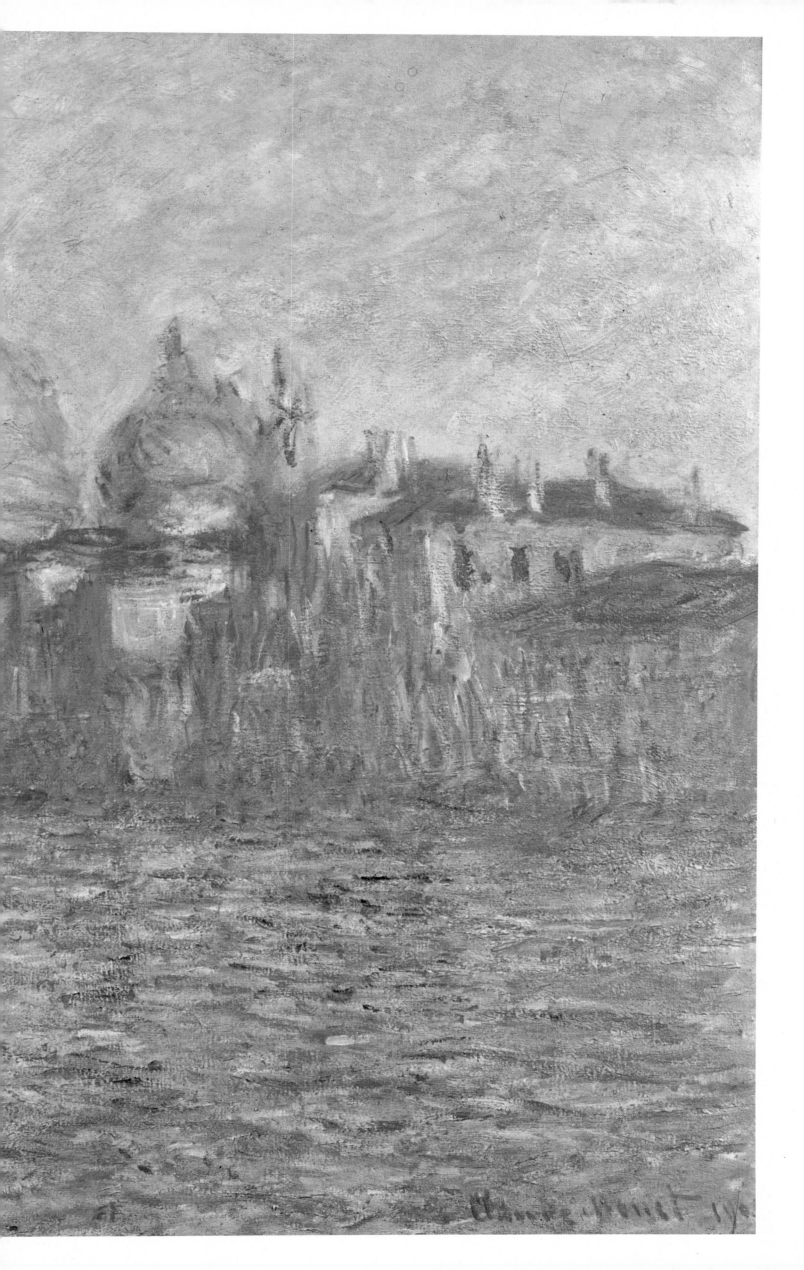

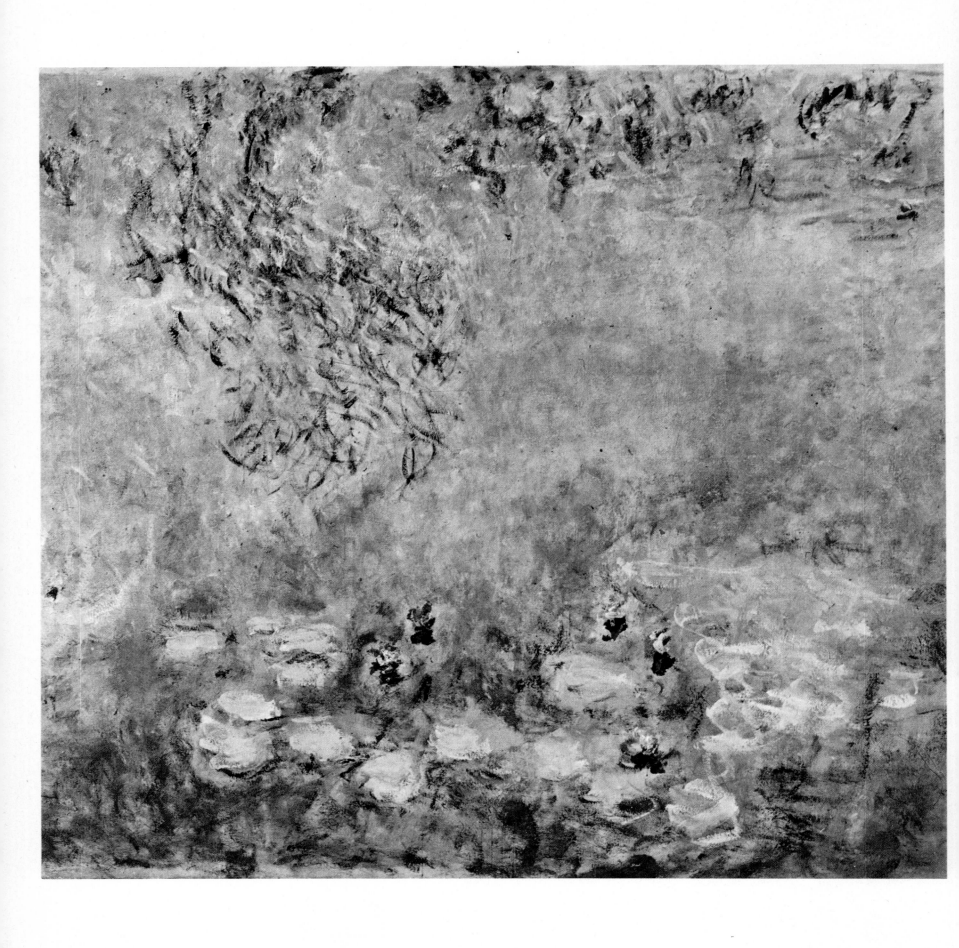

Pierre Auguste Renoir

Pierre Auguste Renoir 1841-1919

Pierre Auguste Renoir, born in 1841, at Limoges, was one of the five sons of a poor tailor. In 1845 the family moved to Paris. At the age of thirteen Renoir was sent to work, as an apprentice, in a porcelain factory, where he was kept busy decorating china. In his spare time, however, he would visit the Louvre, and sketch the works of art, in particular antique sculpture. It was not long before he came to the conclusion that he wanted to be a fully-fledged artist. But since there was no money in the family, Renoir was obliged to take on all sorts of odd jobs—such as the decoration of window blinds—so as to accumulate the necessary funds.

Finally, in 1862, Renoir was in a position to enroll at the Ecole des Beaux-Arts, where he studied under Gleyre, an academic artist whose rigidly orthodox views irked him as much as they did his fellow pupils, Monet, Sisley and Bazille, with all of whom he quickly became friends. During the 1860's, Renoir exhibited at the official Salon (in 1864, 1865, 1868 and 1870) but these showings brought him no financial rewards; and he was to remain, until the end of the 1870's, as poverty-stricken as Monet and Camille Pissarro.

Until the late 1860's, Renoir was greatly influenced by the work of Courbet, adopting his dark palette, with its blacks, greys and browns (Plate I); his technique of applying paint with the palette knife (for example, The Painter Le Coeur in the Forest of Fontainbleau, 1866, São Paulo Museum, Brazil); and even his rather heavy, earthy type of female nude (for example, La Baigneuse au Griffon, shown at the Salon of 1870 and now in the São Paulo Museum); but in the final years of the decade he was moving towards a full Impressionist style. Renoir had been painting out of doors since 1865, at least, and in 1869 was with Monet at Bougival, on the Seine. La Grenouillère (Plate III) was painted during this trip and it reveals the influence of Monet, in the lighter and brighter colour scale, in the free brush-work and in the concentration on rendering an impression of forms as they appear in sunlight.

Renoir served in the Franco-Prussian War in 1870, but returned to Paris the following year, during the Commune. Throughout the 1870's he continued to work in the Impressionist idiom, producing what are, without doubt, some of the most enchanting pictures in the history of European art (Plates V, VI-VII and XII). From 1874 to 1879, and again in 1882, Renoir exhibited at the group shows the Impressionists themselves organised. He gained his first important commercial success when the large, very carefully painted portrait of Madame Charpentier and her children (Metropolitan Museum, New York) was shown at the Salon in 1879; and in the same year, Renoir met (at the Charpentiers') Paul Bérard, a government official who was to become a generous patron.

But if the late 1870's brought Renoir his first taste of real success, they were also the beginning of a period of crisis in his life as an artist. He became restless and began to travel. In 1881 he visited Algiers and Guernsey; and in the autumn, Italy. The frescoes of Raphael and the Pompeian murals that he saw there definitely confirmed what Renoir had begun to feel about his own art; that it was becoming too amorphous in character and was weak in design. 'About 1883,' he later told the dealer Vollard, 'a kind of break occurred in my work. I had wrung Impressionism dry, and had come to the conclusion that I knew neither how to paint nor how to draw.'

During the 1880's, Renoir made a conscious attempt to remodel his style. His aim was to combine the linear precision of Ingres, whose works he had always admired, with the richness of colour that he had favoured in the 1870's. The key picture of this not altogether happy phase is The Bathers (Plate X-XI), on which he worked from 1884 to 1887 and for which he made many careful preparatory drawings.

In 1883, Renoir had a successful one-man show at Durand-Ruel's Paris Gallery. In 1892, he received the first token of official recognition when one of his canvases was purchased by the State. Although marred by poverty in youth, and by ill-health in old age, Renoir's life was, from the domestic point of view, an extremely happy one. His eldest son, Pierre, had been born in 1885. In 1893, his wife gave birth to the second son, Jean, who was to become a celebrated film director.

It was in the late 1880's that Renoir's health began to deteriorate. He suffered increasingly from arthritis, which became really serious after an accident in 1897, when he fell off a bicycle at Essoyes. In 1906 he settled for good in the south of France, at Cagnes-Sur-Mer, an idyllic spot he had first discovered in 1899. By 1908 his arthritis had become so bad that he could only walk with the aid of sticks. In 1912, he had an unsuccessful operation and subsequently could only paint seated in a bath chair. Holding a paint brush had become exceedingly difficult. Partial atrophy of a nerve in the left eye made the act of painting harder still for him in old age. But Renoir would not be beaten.

In 1908, he had modelled, with his own hands, two sculptures of his youngest son, Claude (born in 1901, and known as Coco). In 1913, he took up sculpture again. Only this time he could do no more than dictate and supervise forms created by assistants, notably Guino, an ex-pupil of Maillol, whose work Renoir greatly admired. Renoir died at his Cagnes home, Les Colettes, in December, 1919.

Although he continued to produce landscapes and flowerpieces and still-life, Renoir began to concentrate in the 1890's on single figures, invariably female, often nude or lightly draped, which he would always paint direct from a model. His favourite was Gabrielle, who had entered the household, as a maid, in 1893. Renoir's stylistic experiments of the 1880's gave way, in the following decade, to an idiom that was once more rich and painterly. He abandoned severity of line. But his attempts to master a form of classical drawing stamp his later figures with a monumentality and grandeur not to be found in his earlier, wholly Impressionist phase.

Renoir is probably the most popular of all the late 19th-century French painters. But he was far from being the most influential. He was not, and did not wish to be, in any way, a revolutionary artist. After the 1870's he withdrew into a splendid world of his own imagination; and after 1900 there is virtually no development in his style. Even though he lived until 1919, his entire oeuvre (and it is vast) belongs to the 19th century. Unlike Cézanne, Gauguin, Seurat or Monet, Renoir was to play no vital part in the evolution of modern art.

'My own form of madness has been to spend my whole life putting colour on canvas.' — RENOIR

In the middle of the 1870's, when Renoir used it as the setting for what is perhaps his greatest single picture (Plate VI-VII), the Moulin de la Galette was a combined dance hall and open air café, situated near the top of the hill of Montmartre, which in those days was still merely a semi-rural suburb of Paris. The neighbourhood had yet to acquire the unsavoury reputation that has since made it the synonym for a Good Time throughout the civilized world. The Moulin de la Galette was frequented by students, artists, and shop girls, and was especially popular on Sunday afternoons when dancing took place. It was out of this perfectly ordinary material that Renoir fashioned one of the most famous and deservedly popular master-pieces of 19th-century painting.

THE REASONS for the popularity of *Le Bal au Moulin de la Galette*—and, indeed, for the popularity of most of Renoir's work—are not hard to fathom. Like *The Swing* (Plate IX) or *La Loge* (Plate V), *Le Bal* has the instantaneous, irresistible appeal of a waltz by Strauss. No sooner do one's eyes light upon it in the Jeu de Paume (the branch of the Louvre where it is to be found) than the world seems flooded with joy; pure joy. The delicate patterns made by the sunlight as it softly falls through the tracery of leaves; the colours, golden yellow in the straw of the boaters, a sudden flash of scarlet in a hat, the infinitely varied shades of blue; and the figures themselves—especially the girl in the striped dress in the lower centre of the painting, a creature radiant yet somehow insubstantial, quite capable, one is sure, of disappearing into thin air through spells woven out of her own enchantment: everything about *Le Bal au Moulin de la Galette* is magical and, as in the best waltzes, the very simplicity of its appeal and the directness of its character are a source not of fast-growing weariness but of perpetual delight.

But to surrender to a picture's charms is not to explain them. And to understand more fully why Renoir's paintings look as they do, it is necessary to go deeper. *Le Bal au Moulin de la Galette* is not, of course, the first image of communal pleasure in European art; and in the Louvre itself it may be compared with works as different as Giorgione's *Fête Champêtre* (c. 1509), Rubens' *Kermesse Flamande* (1635-8) and Watteau's *Le Pèlerinage à l'Isle de Cythère* (1717). The relevant difference between them and Renoir's painting lies in the attitude to literary and social overtones. Giorgione's rural scene, sensuous though it is, is impregnated with the spirit of classical literature. Rubens' painting of dancing figures is boisterous, certainly, and fully communicates a sense of the life force, but it remains, for all that, the work of an aristocrat, who cannot but help remaining slightly aloof from the antics of the 'peasants'. In a far more obvious way, Watteau depicts the entirely fanciful diversions of a small, privileged class.

To both these issues Renoir reacted in a way that not only was in full accord with his character but is also particularly sympathetic to modern taste. 'Literary Painting'—the illustration of books, poems or plays, even the

1. PHOTOGRAPH OF RENOIR IN OLD AGE
RADIO TIMES HULTON PICTURE LIBRARY

Bible—Renoir certainly despised. 'What seems to me most significant about our movement (Impressionism)', his son, Jean Renoir, reports him as saying, 'is that we have freed painting from the importance of the subject. I am at liberty to paint flowers, and call them simply flowers, without their needing to tell a story.' Renoir had no wish to follow in the footsteps of Rubens, with his narrative preoccupations, nor was he interested in creating, like Watteau, a world of conscious fantasy. This anti-literary bias has helped to give his work an extra dimension of popularity in an age that does not care for sermons in paint—not because sermons and stories have lost their appeal, but because they can be done so much more effectively in the cinema and on television.

By ignoring illustration with narrative and moral implications, Renoir—like his fellow Impressionists—went against the established and official views of his day. This common rejection of artistic convention was one of the most important factors that bound this highly gifted group of painters together; and since it went hand in hand with a

direct and objective observation of nature. it created an art that was often a shared experience, and sometimes mutually regarding, in the most literal way. Monet painted the same view as Renoir, at the same time (as in Plates II and IV). Monet did a portrait of Renoir. Renoir painted Monet, Monet's wife (Plate VIII), and Sisley (on the extreme right in Plate I), not to mention Cézanne and Bazille. All the main figures in *Le Bal au Moulin de la Galette* were personal friends of Renoir.

Renoir's relationship to the subjects that he painted was influenced not only by personal affection and the desire to make a record free of academic prejudice but also by his complete disinterest in social overtones. Renoir was the least snobbish of men. His paintings invite the spectator, they draw him into the scene, as it were, on an equal footing. And part of the attraction of *Le Bal au Moulin de la Galette*, or of *The Swing*, even of a commissioned portrait such as *Madame Henriot* (Plate XII), is that they conjure up a vision not of a world to which we might aspire, but of a milieu to which most people could then, and still can belong. Like so much else in Impressionism, *Le Bal* is a masterpiece of democratic art.

The interaction of democratic and anti-academic feeling led Renoir to develop the view—shared by so many of his contemporaries in all the arts—that art itself should be a natural and authentic expression of the age in which it was created. He had no time for railway stations with sham Gothic façades or modern paintings carried out in a 17th-century style.

This doctrine of attachment to modern life, however, soon brought out one of the great contradictions in Renoir's character. He believed that everything should reflect the age in which it was created. The problem was that he lived in the era of the Industrial Revolution. Renoir always detested—and his hatred grew steadily stronger as he grew older—machine-made articles. Jean Renoir tells how he preferred candles to electricity; stairs to lifts; flagstones to asphalt. Even bread cut into slices annoyed him. It should, he felt, be broken. Always the artist first, Renoir went so far as to think that the ugliness of buildings towards the end of the 19th century and the vulgarity of machine-made articles represented a greater threat than wars. He would certainly have agreed with George Moore, who wrote in the 1880's that the world was dying of machinery. Like Oscar Wilde, he thought ugliness was immoral.

One side of Renoir's nature made him concentrate on the world about him. Yet he had an equally strong desire to escape from the ugliness and materialism of France in the second half of the 19th century. The subjects that he could bring himself to paint had to come within both of these conflicting frames of reference. What should—what *could* he paint? The subjects had to be posed before him, and they had to be, in the very fullest sense of the word, natural. Renoir had a deep and abiding love of all living creatures. He hated to see trees cut down or animals killed.

And so it was that he came to paint fruit and flowers (Plate XV), landscapes, almost without exception drenched in sunshine (Plates III and IV) and young people—especially girls (Plates II, V, X-XI, XIV, and Cover Plate). Subjects such as these were natural, and alive, and could be recorded without the need to introduce irrelevancies. They also conformed to Renoir's optimistic temperament. He always believed that a picture should be 'pleasing, cheerful and pretty—yes, pretty! There are plenty of dull things in life without creating any more.' The point needs no ela-

boration when we can see for ourselves the radiant colours with which he depicted a vase of chrysanthemums and the pearly lustre that he could impart to flesh (Plates X-XI, XVI and Cover Plate); and when we can sense, as we become increasingly familiar with the pictures, the sheer joy that seems to permeate not only the final character but the very technique of *La Loge* or *Madame Monet*. It is as if the strokes of the brush caressed the images in the very act of giving them tangible form.

Optimism, profound optimism coloured Renoir's taste in everything. Rembrandt's work he admired but found depressing. He disliked Baudelaire's deeply pessimistic collection of poems 'Les Fleurs du Mal', hated the realistic novels of Zola—but loved 'The Arabian Nights'—thought the sad tale of 'La Dame aux Camélias' rubbish, and although friendly with Guy de Maupassant felt that they really had nothing in common since the writer always looked on the darker side of life. Whatever was unfortunate, such as the disruptions of the Franco-Prussian War, or the poverty that Renoir endured until the end of the 1870's, found no emotive expression in his work. He lived through the First World War but his pictures give no hint of catastrophe. Even in the works of 1915, the year in which his son, Jean, was wounded, and his wife died, there is no hint of despair.

It was this optimism of spirit, and the delight he took in what was living and natural, combined with the desire to record what was literally in front of his eyes, that helps to explain why Renoir was such a great painter of the female nude. Almost no other painter—save for Rubens and Titian—has been able to preserve so well a balance between the body as a succulent, ripe fruit and the body as a human form, or been able to combine, in his imagery, the suggestion of unselfconscious sensuality, that belongs to animals, with a human connotation. This extraordinarily difficult feat was a triumph of temperament and sensibility even more than of technique. When he heard that one of his female studies had been given a title, *The Thinker (La Penseuse)*, Renoir was annoyed. 'My models,' he remarked tartly, 'don't think.' His nudes do not represent, like Lord Leighton's *The Nymph of the Sands* (Fig. 3), the female body, translated, with nervous and selfconscious tact, into a work of art. They present the body immune to tact, or, indeed, any other attitude of mind.

Renoir's nudes may awaken desire in the spectator but they are not deliberately erotic in character. Eroticism would have introduced that creation of a conscious attitude that he was always at pains to avoid. He once remarked that 'the artist who uses the least of what is called imagination will be the greatest.' A corresponding sense of the directly painted model is apparent in all Renoir's work. We do not really believe that the girl is actually playing a guitar (Plate XIV) or that Nini is in a theatre. Both are pretty girls in the studio, dressed up.

Renoir's attitude towards the pictorial image was always fundamentally direct and guileless. This is implicit in *Le Bal au Moulin de la Galette* and helps to explain both its charm and character. It is also implicit, in a more complex and somewhat detrimental sense, in *The Bathers* (Plate X-XI). Initially, this elaborately wrought painting might seem to contradict everything so far claimed for Renoir. Although not a literary illustration of a classical myth, *The Bathers* makes, nonetheless, a very artificial impression, of a kind one associates with academic art in which the literary element plays an important part. This streak of artifice in *The Bathers* reflects yet another, and

in many ways the most fundamental of the contradictions to be found in Renoir's character.

Though he believed that an artist should work in an idiom in tune with the age in which he lived, Renoir retained, throughout his life, a love and respect for the art of the past. Asked where one should learn to paint, he replied: 'In the museums, parbleu!' He was particularly fond of 18th-century French painting. 'Boucher's *Diana Bathing* is the first picture that caught my imagination,' he said, 'and I've loved it all my life.'

THIS PROFOUND sympathy with the art of the past, and a sense of tradition—which, in all aspects of life, he felt was being tragically eroded in the France of his own day—influenced his career in a number of important ways. Unlike his fellow Impressionists, Renoir became, if only marginally, a society portrait painter; and whereas the Impressionists tended to reject the nude as a subject, because it was too academic, Renoir made it one of the main themes of his art. It is this sense of tradition that gives some of his work a startling similarity to pictures produced in the high academic circles that he scorned. Though different in spirit, Renoir's *Bather* of 1881 is, as a formal design, surprisingly close to *The Nymph of the Sands*, which Lord Leighton—an academician of the most orthodox kind—had shown at the Royal Academy in London the year before.

Contrary to the general Impressionist trend, Renoir was never profoundly interested in landscape. The human figure was, for him, the essential subject of art; and it is worth noting that the artists he most admired (Titian, Rubens, Velàzquez, Ingres, Raphael, and the 18th-century French masters) were primarily figure painters too. His landscapes, though numerous, often charming, and occasionally arresting, represent the least interesting part of his work.

Renoir's deeply engrained sense of tradition hastened the artistic crisis through which he passed in the early 1880's and from which he never wholly recovered. Impressionism, to which one side of his nature responded whole-heartedly, implied painting directly from what was in front of one—a course obviously easier to follow if the subject matter was restricted. The single figure, the isolated *motif*, such as a vase of flowers, the 'snapshot' view, these were among the ideal solutions that Renoir, along with his contemporaries, always willingly accepted (Plates II, VIII, XIII, and Cover Plate).

But there was another side of Renoir that yearned for elaboration, for extension, for a whole tradition of large scale figure painting—with a pleasing, decorative emphasis—that the Impressionists had rejected but which remained enshrined in the work of those artists whom Renoir most admired. It is hardly surprising that his favourite early Renaissance painter should have been the great master of Venetian pageantry—Carpaccio. To earn money, in his youth, Renoir himself had painted murals in cafés (long since destroyed) and this was a tradition he was always trying to re-create, subconsciously, perhaps, in *Le Bal au Moulin de la Galette*, and selfconsciously in *The Bathers*, which he painted in a style that was for him, he told the dealer, Durand-Ruel, 'the old painting, soft and gracious. . . . It is nothing new, but it is a continuation of the pictures of the eighteenth century.' Even in works prior to *The Bathers*, echoes from 18th-century art are often to be found. *Le Bal au Moulin de la Galette* could legitimately be described as an Impressionist answer to Watteau's *Pèlerinage à l'Isle de Cythère* and Fragonard's *Fête at St. Cloud* (Banque

de France, Paris); a drastic modification of a tradition that is still subtly upheld.

By the early 1880's, Renoir had come to the conclusion that he did not know how to draw properly. From the academic point of view, this self criticism was perfectly valid. In *Le Bal*, the forms are boneless, the figures lack substance, and their relationship to the space they inhabit is only summarily stated. Under the influence of Renaissance and Antique painting, Renoir sought to correct these defects. And, up to a point, he did. In *The Bathers*, the figures are drawn with greater precision and exactitude; and their location in space is more precisely suggested. If something is still missing, it is an indefinable air of conviction. But then, in his heart of hearts, Renoir himself was still not completely convinced.

Artistic creation of the kind implied by *The Bathers* demands imagination and vision—and Renoir was suspicious of both. 'The trouble,' he once said, 'is that if the artist knows he has genius, he's done for. The only solution is to work like a labourer, and not have delusions of grandeur.' Imagination, he always claimed, was more a hin-

2. THE DANCE IN THE COUNTRY. PRIVATE COLLECTION

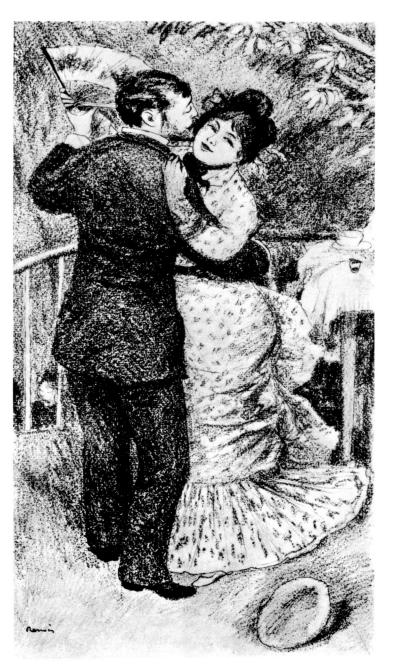

drance than a help. His art reflects his view that life should be a state of being, not of striving.

WITH the passage of time, it is now possible to see that Renoir was really a great decorative painter committed, if only partially—but sufficiently to make escape impossible—to a vision that did not require, and had, indeed, rejected the stylistic disciplines and intellectual apparatus necessary for the creation of elaborate decorative art. An examination of his character emphasises the difficulties of his position. He lacked the resources of character and intellect that Cézanne possessed, and which might have enabled him to build up a style of the requisite flexibility. On the other hand, his whole nature was too rich and warm, he was too much of a humanist to be satisfied either with the endless repetition of Impressionist principles that was to diminish Sisley's stature in the 1880's and 1890's, or with the kind of recherché optical effects that were to occupy an increasing amount of Monet's time.

After the rigorously linear phase of the 1880's, Renoir returned once more to a style in which the colouring was rich and the strokes of the brush self-evident. But he was never able to quite recapture the perfect balance that makes his work of the 1870's so beautiful. The experience of the 1880's gave to all his subsequent work a quality of remoteness, to which his growing infirmity eventually added a conspicuous streak of coarseness. The subjects of his later pictures seem to exist in a vibrantly coloured and sensuous limbo, that has neither the delicate sense of actuality to be found in his earlier work nor the poetry of an imaginative transformation. His late nudes seem to belong to a world of mythology—but a mythology, so to speak, that has no myths.

Though denied fulfilment as a decorative painter, Renoir never lost the ability to strike, exquisitely, the decorative note. His earliest artistic experience had been the decoration of china; and it is not fanciful to see this as a crucial phase in his life. Behind all his work, through his work, one can discern the youthful Renoir applying luscious strokes of pure colour to gleaming, translucent porcelain. This experience must have heightened his awareness of the purely decorative element in art, just as it lies behind his perennially masterful rendering of the skin's own glowing, translucent surface. And the Impressionism of the 1860's, with its increasing use of bright colours, must have attracted him all the more as being a reassertion of the colourful world he had known as a youth.

Le Bal au Moulin de la Galette is more than a masterpiece of non-literary, democratic art. It is also a supremely optimistic vision of life achieved through a profound regard for the decorative, sensuous properties of paint itself. The other Impressionists might fully understand the value of colour, for its own sake, but no one, not even Manet, knew so well as Renoir the sensuous power of the paint stroke itself.

The picture's optimism, like that of the artist himself, is self-evident and unquenchable. *Le Bal* conjures up a mythical world, far removed in time and space, 'when to be young was very heaven', where poverty is without squalor, and where the inhabitants are carefree but not careless, committed to a life of the senses and yet immune, as if in a fairy story, to the consequences of sensuality.

Viewed cold-bloodedly, *Le Bal au Moulin de la Galette* is also a masterpiece of deception, like so much Impressionist painting, which introduces us to the paradox of artists committed, more radically than ever before, to, painting directly from life and yet creating one of the greatest forms of escapist art in the history of European culture. But Renoir's art was never intended to deceive; it was an expression of a style that was, for him, personal and necessary. If, in looking at his work, the spectator is deceived, it is he, not the painter, who is also the deceiver. The enormous popularity of Renoir's paintings depends on a high degree of wish-fulfilment. For the purely artistic adjustments that Renoir made to a basically naturalistic idiom, his emphasis on what is pleasing, his awareness of what is decorative, his concentration on the optimistic element in life, these coincide, very precisely, with the practical adjustments that we would all like to make to our own lives. Who would not prefer to be younger, slimmer and more attractive?

The danger of Renoir's popularity as an artist is that it will slowly undermine the authority of his art. In austerer circles, his reputation has already suffered, partly on account of the disastrous influence he has exerted on subsequent painting. For it cannot be denied that he has indirectly fathered more chocolate box pictures than any other artist one might care to name. But his best work will always remain untouchable. For unlike the productions of his imitators, who have merely combined opportunism and skill, Renoir's own painting, in both its faults and its virtues, sprang from an unassailable alliance between genius and conviction.

3. THE NYMPH OF THE SANDS.
BY LORD LEIGHTON (1830-1896), SHOWN AT THE ROYAL ACADEMY, 1880. BY KIND PERMISSION OF THE TRUSTEES OF THE LADY LEVER COLLECTION, PORT SUNLIGHT, CHESHIRE

The Plates

I AT THE INN OF MOTHER ANTHONY 1866
Oil on canvas, 76 in. × 51 in.
NATIONALMUSEUM, STOCKHOLM

The Inn of Mother Anthony was situated at Marlotte, on the edge of the Forest of Fontainebleau, and was a favourite haunt of the Impressionists, who liked to work out of doors in and around the forest. There is some disagreement about the identification of the people in this painting. The girl on the left is Nana, daughter of Mother Anthony, who is just visible in the background to the right. The man standing next to Nana is probably the painter Le Coeur, while the man seated in the right foreground is almost certainly Sisley. The large scale and rather sombre tonality of this picture hint at Courbet's influence.

II LISE 1867
Oil on canvas, 71½ in. × 44½ in.
MUSEUM FOLKWANG, ESSEN

This famous portrait, which was shown at the Salon of 1868, was painted entirely in the open air and is one of Renoir's first wholly individual works. The monumental, even heavy character of the composition still link the picture with Courbet, but already (as the critic Bürger noted at the time) Renoir was depicting the colour to be found in shadows—a practice that reflects one of the key aspects of Impressionist doctrine.

III LA GRENOUILLÈRE 1869
Oil on canvas, 26 in. × 31 in.
NATIONALMUSEUM, STOCK-HOLM

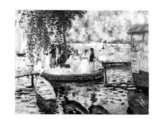

A partial view of the restaurant and bathing establishment at La Grenouillère, on the Seine, which Renoir and Monet painted during the summer of 1869. Their paintings are very similar in composition and general character; and in the broken colours, interest in the play of light on water, and in their bright, clear tonality—all of which combine to produce an effect of gaiety—they already presage the fully developed Impressionist idiom of the '70s.

IV SAILBOATS AT ARGENTEUIL 1873-4
Oil on canvas, 20 in. × 26 in.
PORTLAND ART MUSEUM, OREGON

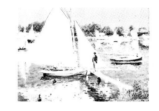

As in the case of Plate III, Monet painted the same view at the same time. What particularly distinguishes Renoir's treatment is the silky texture of his paint, which gives to the scene, over and above its status as an objective record, a purely decorative character.

V LA LOGE 1874
Oil on canvas, 31½ in. × 25 in.
COURTAULD INSTITUTE GALLERIES, LONDON

This particular canvas, of which Renoir painted other versions, was shown at the first Impressionist Exhibition in Paris, 1874 (142). A well-known Montmartre model, Nini, posed for the main figure. The man behind her is Edmond Renoir, the artist's brother.

VI-VII LE BAL AU MOULIN DE LA GALETTE 1876
Oil on canvas, 58⅝ in. × 68⅞ in.
LOUVRE, PARIS

The first, and most successful of the three compositions with many figures that Renoir produced in the 1870s and 1880s and to which he devoted special care and much thought. The second is Le Déjeuner des Canotiers, another scene from contemporary life, dated 1881, and now in the Phillips Memorial Gallery, Washington. The third is reproduced as Plate X-XI. Two other versions of this picture are known. Both are smaller in scale and were almost certainly painted earlier.

VIII MADAME CLAUDE MONET LYING ON A SOFA C. 1874
Oil on canvas, 21 in. × 28¼ in.
GULBENKIAN FOUNDATION, LISBON

The wife of Renoir's friend and fellow painter (who married her in June, 1870) is shown reading 'Le Figaro'. Comparison with Plate I emphasises the very light tonality that Renoir favoured in his full Impressionist phase.

135

IX *THE SWING* 1876
Oil on canvas, 36½ in. ×28½ in.
LOUVRE, PARIS

Very close in style, notably in the dappled effects of the sunshine, to *Le Bal* (Plate VI-VII). Both were shown in the third group exhibition, mounted by the Impressionists in 1877.

X-XI *THE BATHERS*
1884-1887
Oil on canvas, 45¼ in. × 67 in.
MUSEUM OF MODERN ART,
PHILADELPHIA

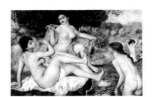

The key work of Renoir's linear phase, which lasted from the early 1880s until the early 1890s. Renoir made many preparatory drawings for this picture; and based his design on bas-reliefs by Girardon at Versailles. The finished work, on which he had laboured intermittently for more than two years, was shown at the Galerie Petit in 1887 and was well received by the general public. Pissarro and the writer J-K Huysmans, however, were less happy about the painting. Van Gogh, on the other hand, admired the artist's 'pure clean line'.

XII *PORTRAIT OF MADAME HENRIOT* C. 1877
Oil on canvas, 27⅞ in. × 21⅝ in.
NATIONAL GALLERY OF ART,
(LEVY FUND), WASHINGTON

One of the most enchanting and delicately executed of Renoir's portraits.

XIII *GIRL READING* 1875-6
Oil on canvas, 18⅘ in. × 15⅕ in.
LOUVRE, PARIS

The use of various colours in the shadows, noticeable in the hands, is typical of Impressionist methods. Although it does not in any way affect the charm of the work, the summary treatment of anatomical detail helps to explain Renoir's own feeling, which grew stronger in the late 1870s, that he 'did not know how to draw properly'.

XIV *WOMAN PLAYING THE GUITAR* C. 1890
Oil on canvas, 32⅖ in. × 26 in.
MUSÉE DES BEAUX-ARTS,
LYONS

From the beginning of the 1890s, a progressive thickening of the forms is apparent in Renoir's work, which also becomes hotter and richer in tonality. Although, in part, the result of a change in attitude towards his painting—this development cannot be divorced from Renoir's arthritic condition, which made the manual act of painting increasingly difficult.

XV *VASE OF CHRYSANTHE-MUMS* C. 1895
Oil on canvas, 32⅘ in. × 26⅖ in.
MUSEE DES BEAUX-ARTS,
ROUEN

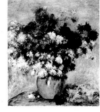

Renoir had always painted still-life, but in his later years he produced an increasing number, usually small in scale, and often depicting fruit. His love of painting directly from the model, from what was in front of him, had not diminished. As his illness imposed an increasing restriction on his movements, however, fruit and flowers, which could be placed in front of him, offered material that was not only relevant to his art but ideally suited to his habits.

XVI *THE BATHER* 1881
Oil on canvas, 33 in. × 25¾ in.
PRIVATE COLLECTION, TURIN

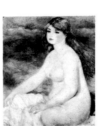

One of Renoir's most perfect nudes, painted when he was just beginning to remodel his style, and placing more emphasis on line, but before he had abandoned the extreme delicacy, both of colour and touch, that characterises his best work of the 1870s.

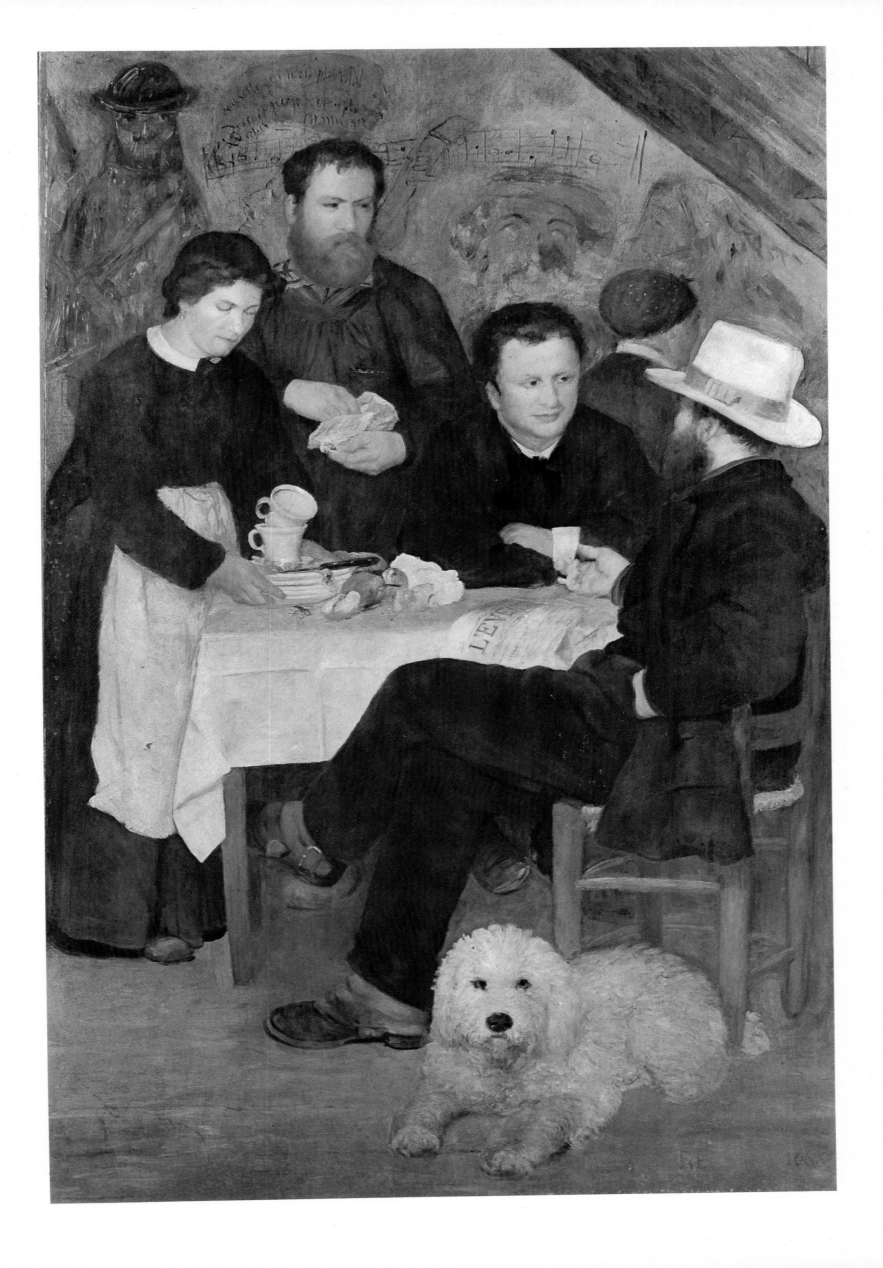

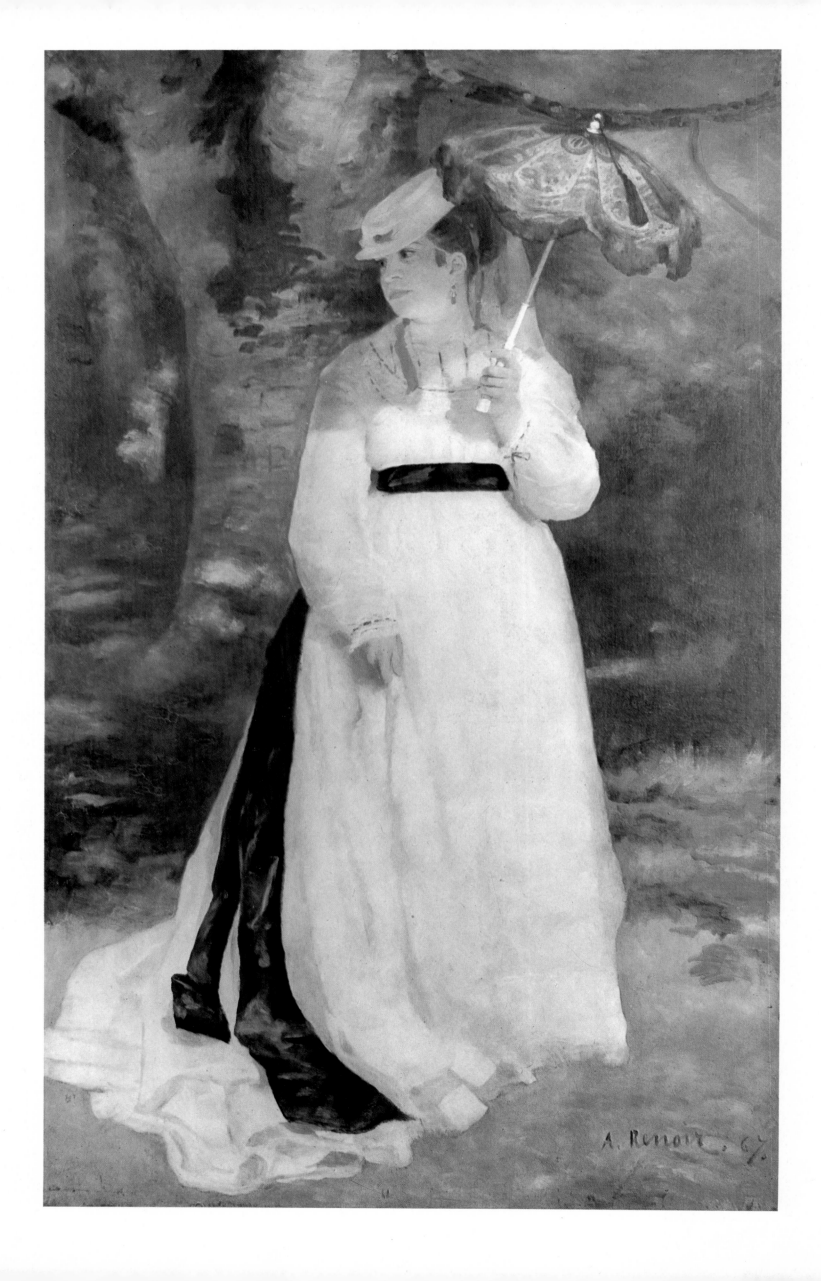

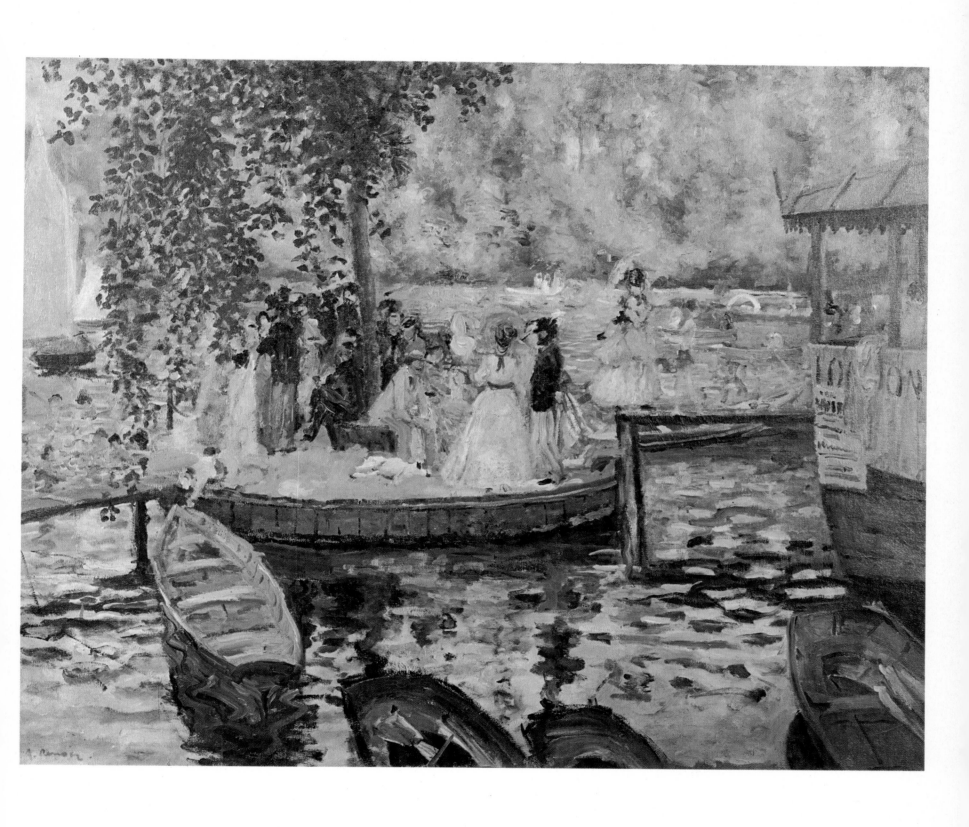

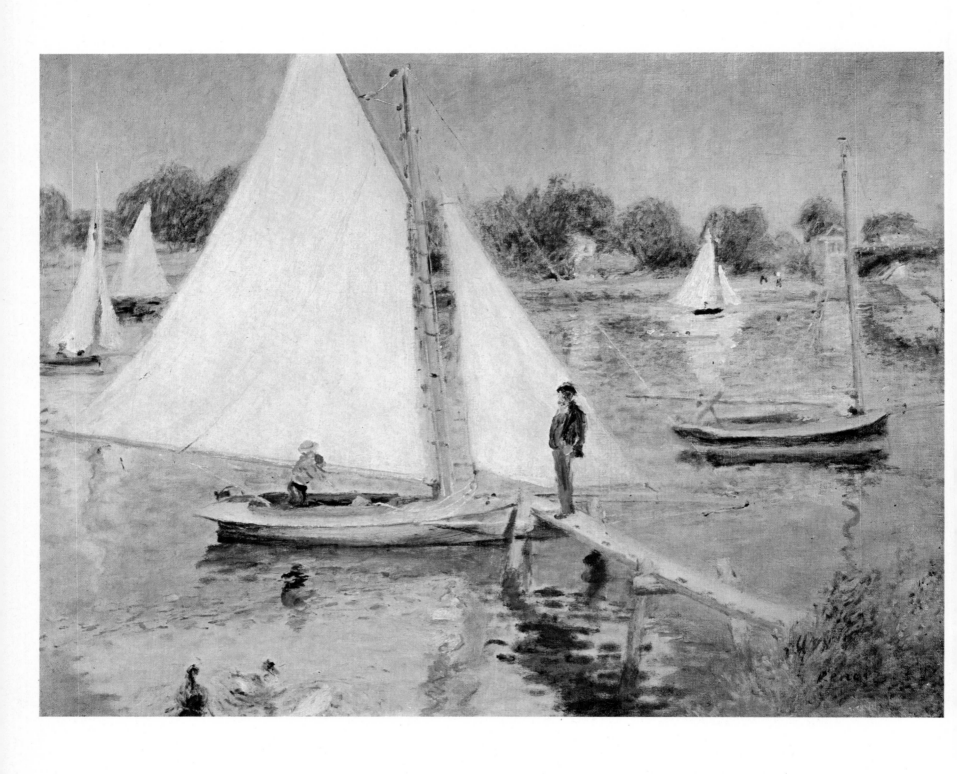

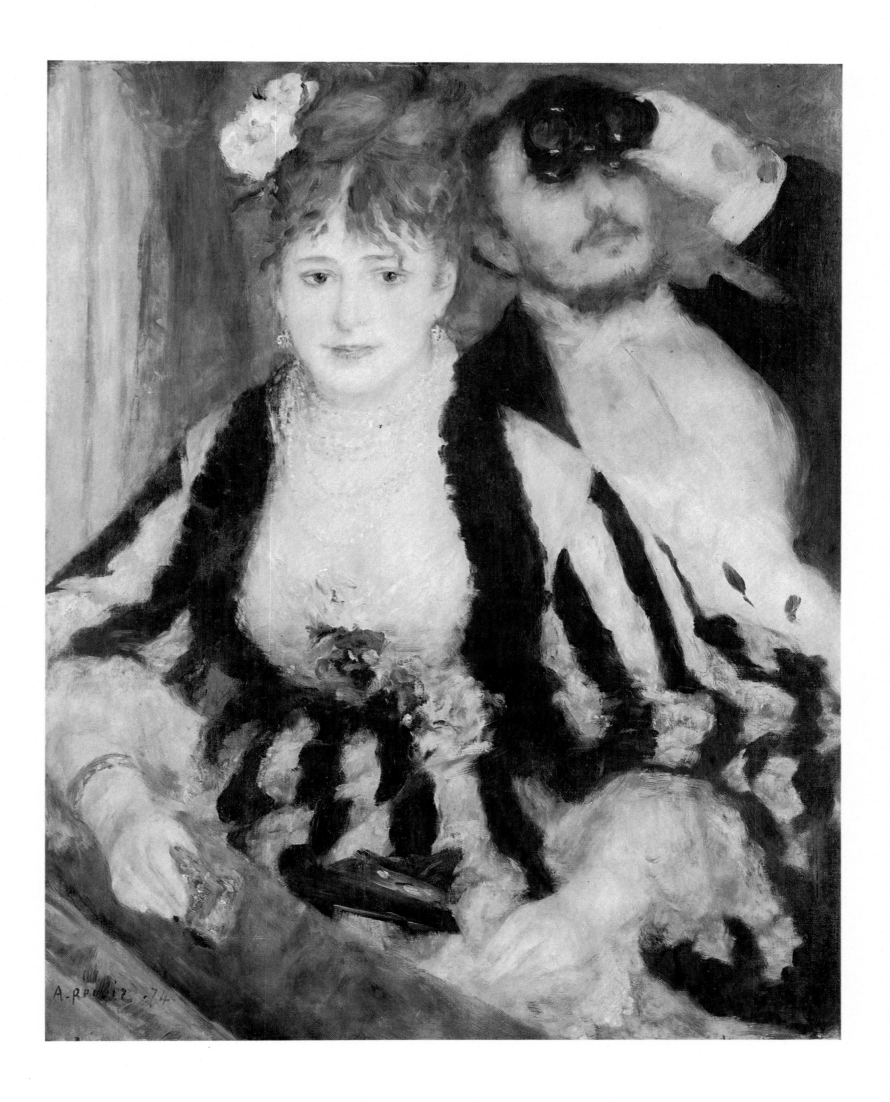

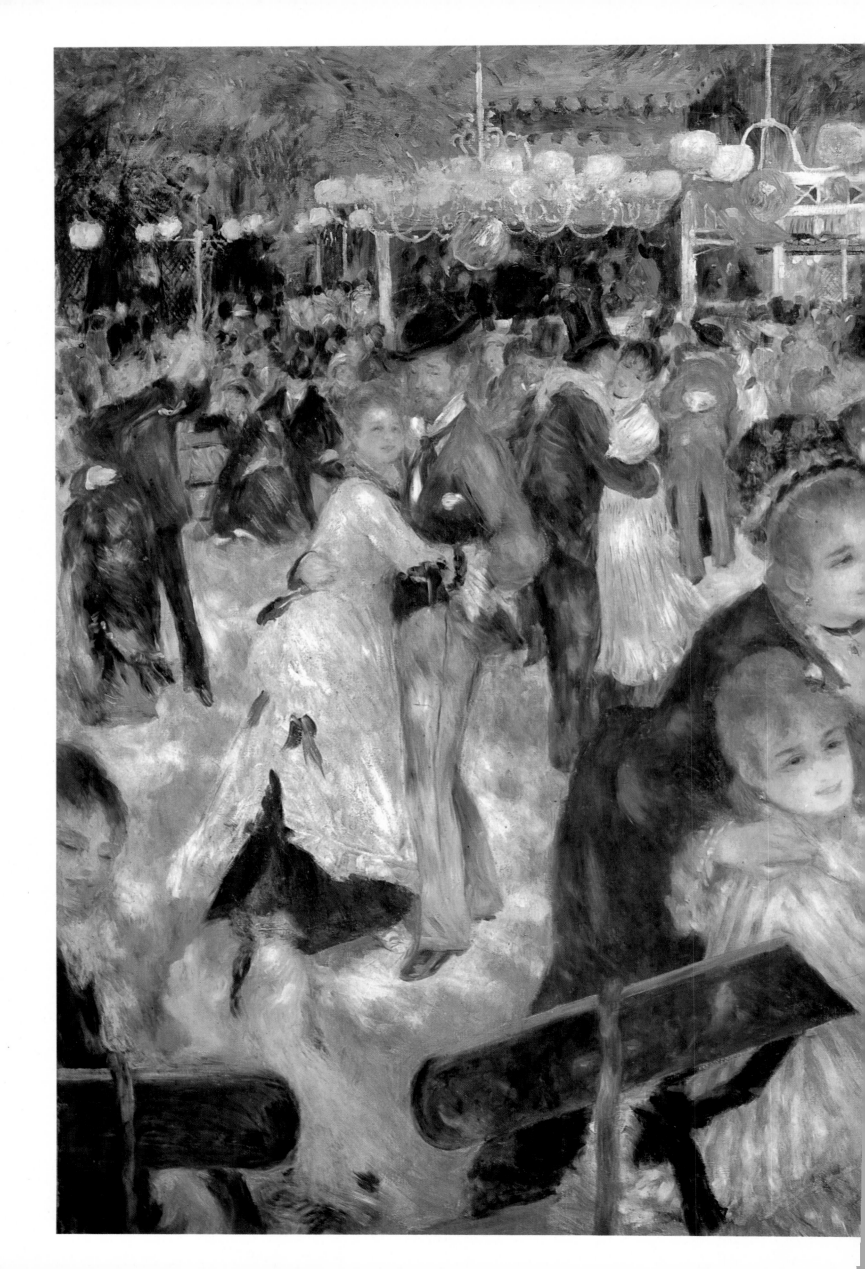

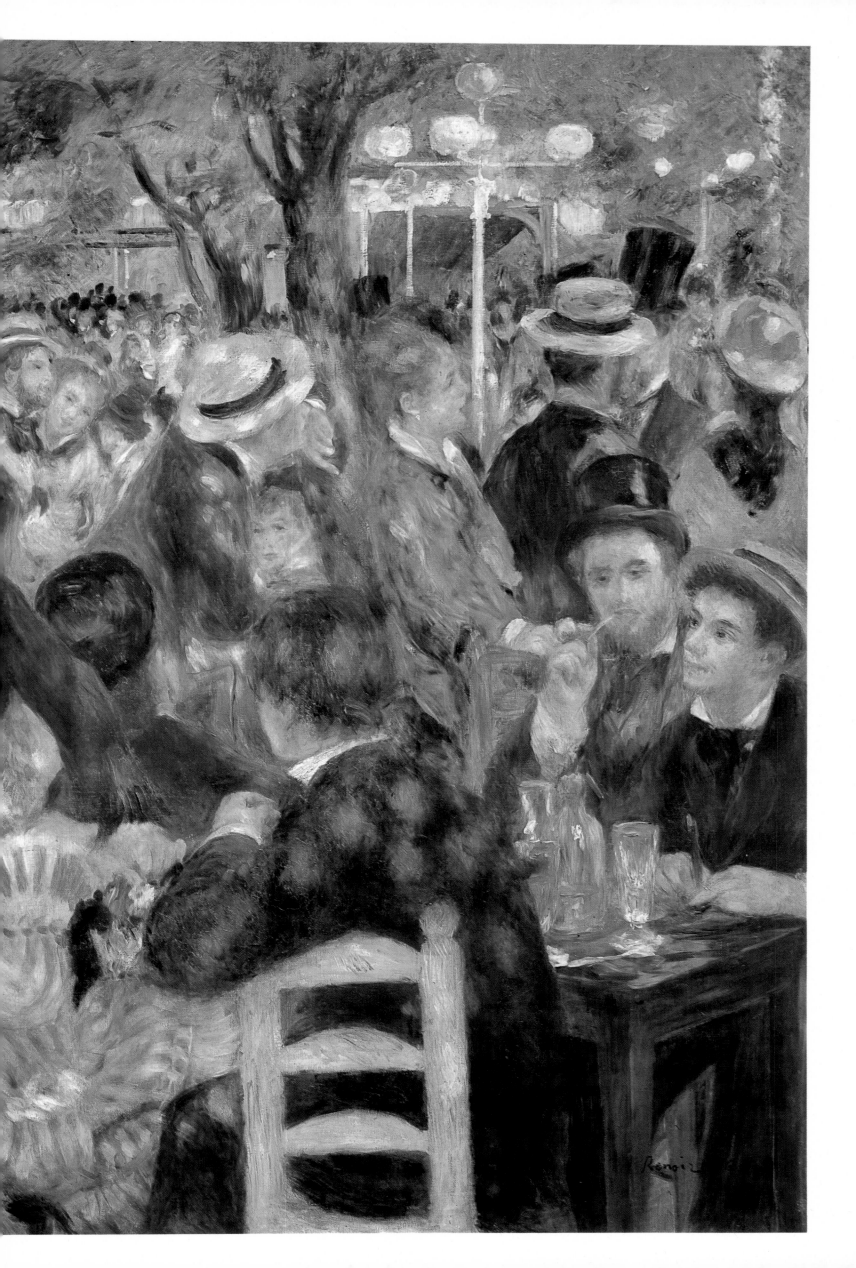

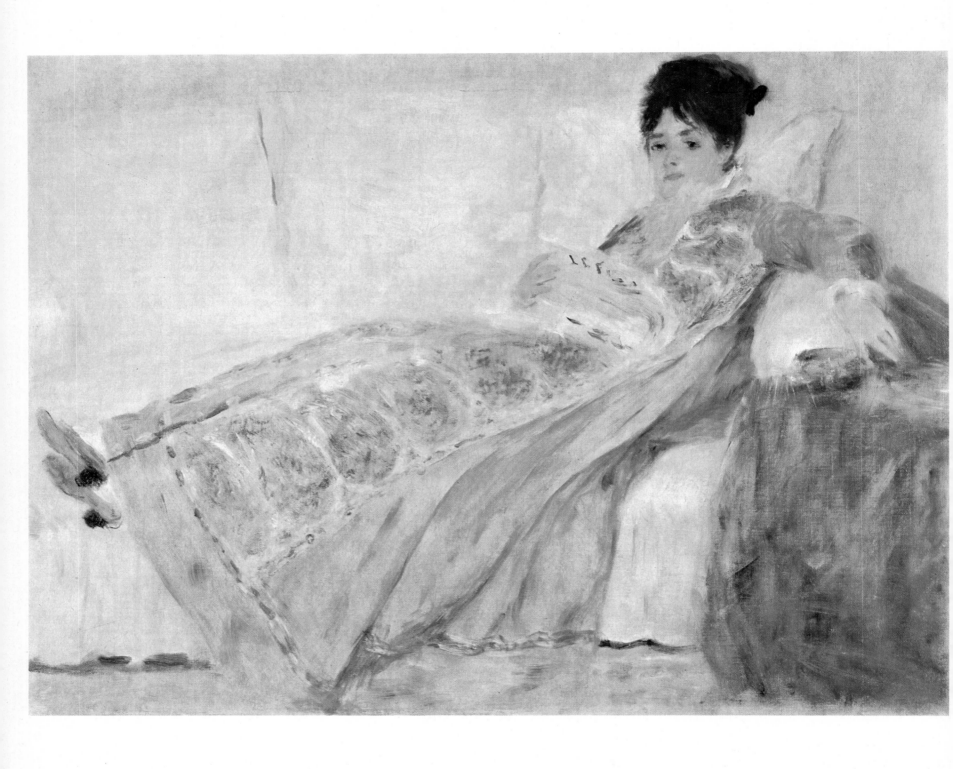

VIII

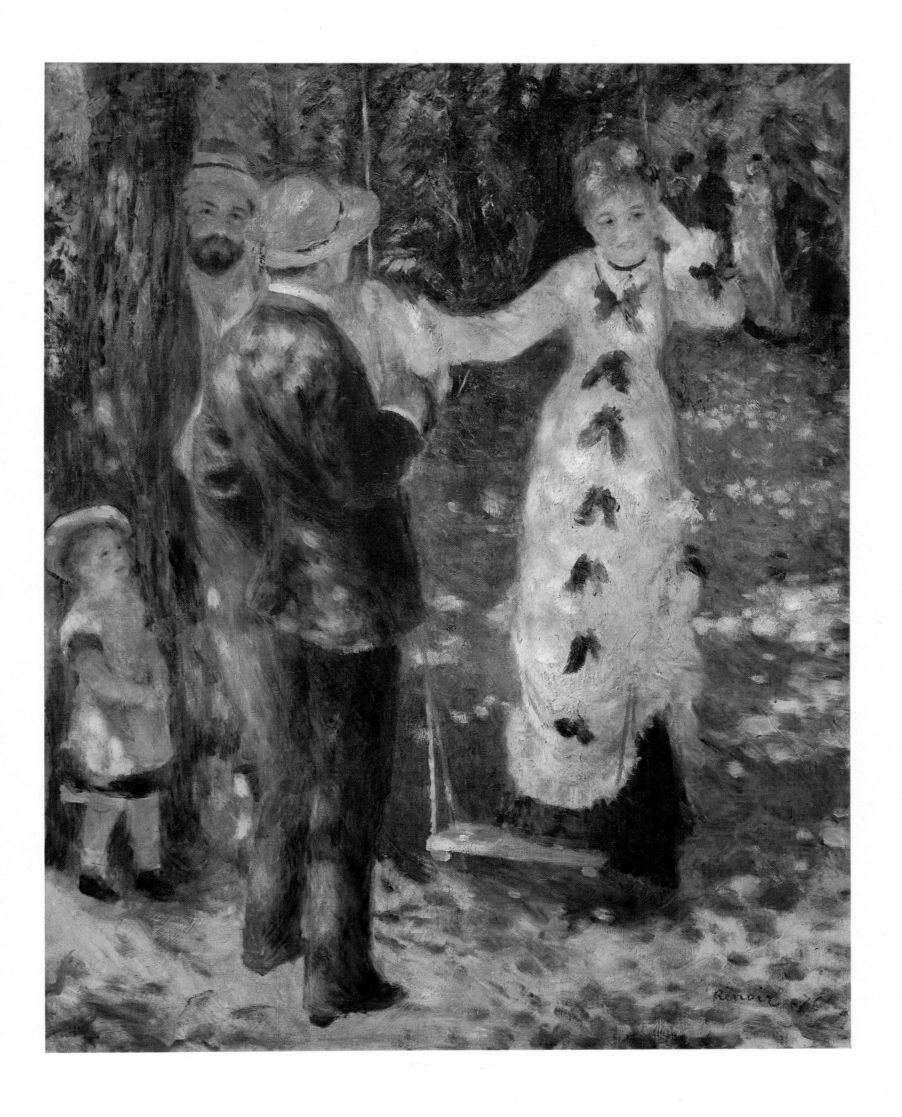

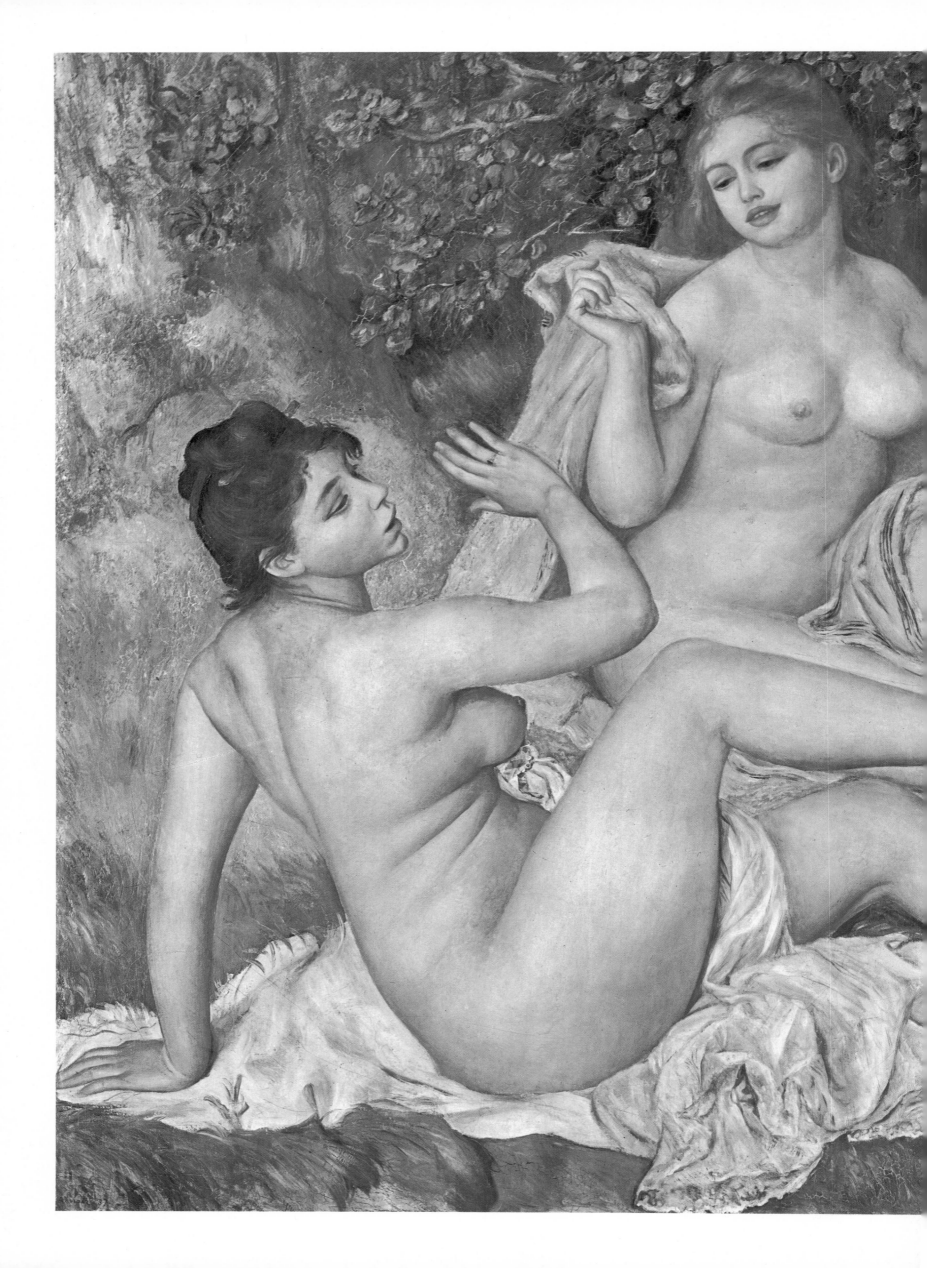

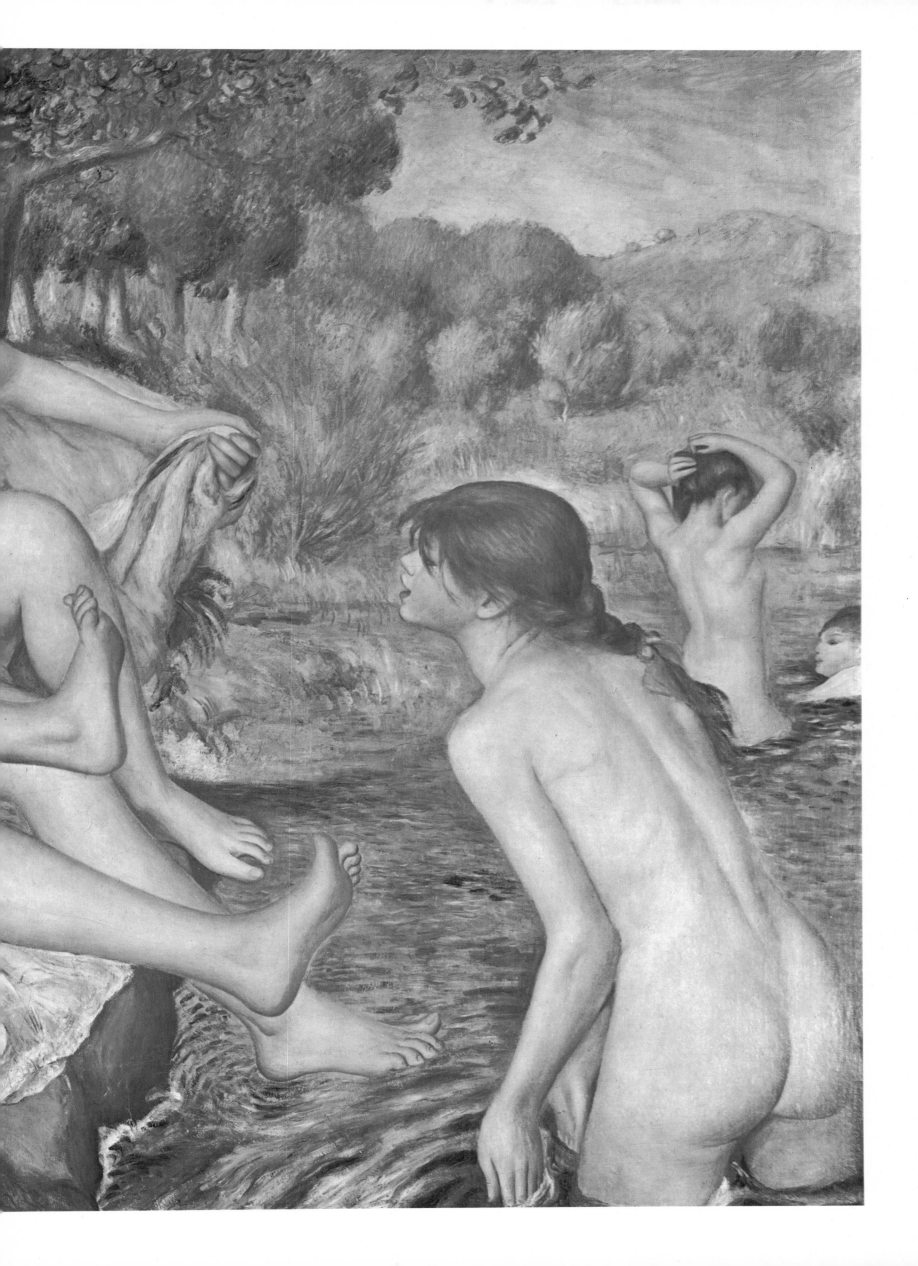

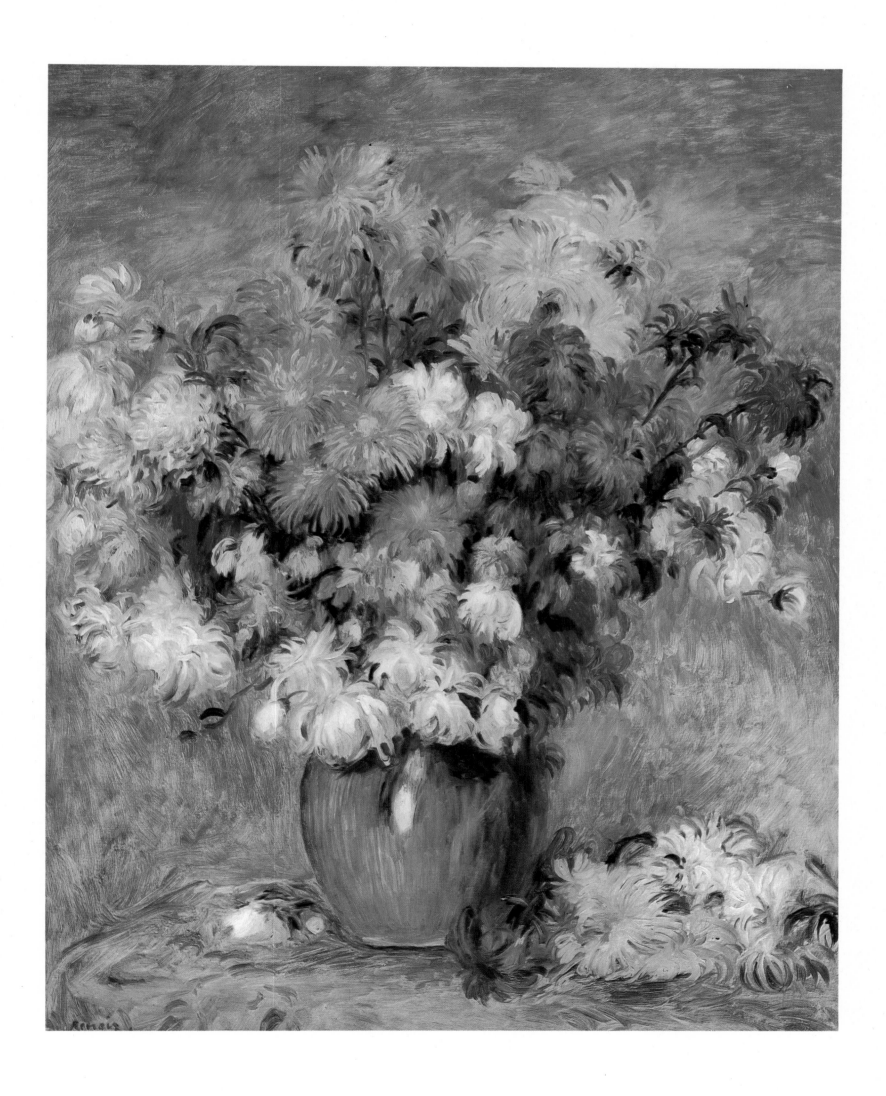

XV

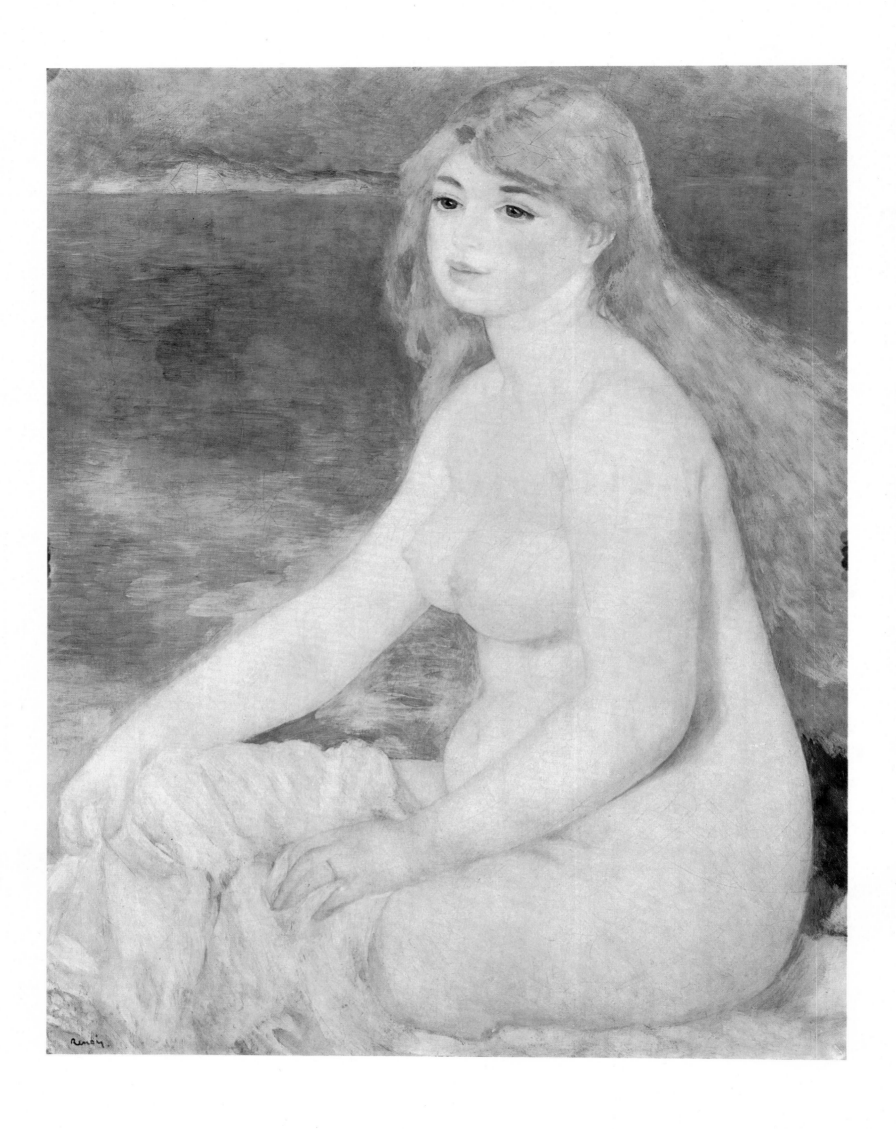

Paul Gauguin

Paul Gauguin 1848-1903

Paul Gauguin was born in Paris in 1848; his father was a radical journalist and his mother, Aline Chazal, the daughter of a feminist and socialist. In 1851, after Napoleon's Coup d'Etat, the family embarked for Peru where Aline had influential relations; unfortunately, however, Paul's father died on the way. Mme. Gauguin and the children stayed in Lima for four years and then came back to live in a family house at Orléans, where Paul went to school until they returned to Paris in about 1860. When he was seventeen Gauguin joined the merchant navy, sailing between Le Havre and South America; later he became a Second Lieutenant and served in the French Navy.

However, on his return to Paris in 1871 Gauguin managed to enter Bertin, a firm of stockbrokers, where he had sufficient luck and ability to make a very comfortable living. His guardian Arosa collected pictures and a fellow employee, Emile Schuffenecker, encouraged him to paint on Sundays and, as he became keener, to attend one of the free studios at night where he drew from the model. In 1873 he married a Danish girl, Mette-Sophie Gad, who came from a somewhat conventional bureaucratic family. She afterwards said she had no idea that he was painting at all when she married him, and apparently he did not tell her when he had a landscape accepted at the Salon of 1876. The success of this picture, Paysage à Viroflay (Kaplan Galleries, London), encouraged Gauguin to spend more of his time painting. The year before he had met Pissarro, who, as usual, was generous and encouraging. He took the younger painter with him on outdoor painting expeditions and also helped him to form a good collection of Impressionist pictures, including works by Cézanne. Pissarro even managed to persuade his friends to allow Gauguin to contribute works to the last four Impressionist Exhibitions, although there were protests from the Impressionists proper (Renoir was particularly incensed). Such works as a Winter Scene (Ny Carlsberg Glyptothek, Copenhagen), showing his garden in the rue Carcel, are somewhat like earlier snowpieces by Pissarro and Sisley.

In 1881 Huysmans praised his picture of a nude sewing; in the summer he painted at Pontoise with Pissarro,

Cézanne and Guillaumin. In 1883 Gauguin abandoned his work as a stockbroker in order to devote himself entirely to art. He made no sales and was forced in the following year to join his wife and children in Copenhagen where he was again unsuccessful in earning a living. Leaving his family, he returned to Paris; that winter his poverty was so acute that he was forced to earn his living as a bill-poster. In 1886 he first went to Brittany attracted by its archaic customs and the prospect of living cheaply. Here he met Emile Bernard and other painters, but was not closely associated with them until two years later. He also exhibited at the Eighth, and last, Impressionist Exhibition and is said to have organized a celebration dinner. In 1886 he began to make ceramics in collaboration with a sculptor, Ernest Chaplet. He now greatly admired Degas, but was avoiding Pissarro and the Neo-Impressionists.

In April 1887, attracted by ideas of an 'earthly Paradise' and still cheaper living, he went with the painter, Charles Laval, to Panama and afterwards to Martinique. This journey had an enriching effect upon his colour but both men became ill and destitute and were forced to work their passage back to France. 1888 was a vital year in the genesis of 'Synthesism'. Gauguin was at Pont-Aven in Brittany from February to October and it was here that the young Emile Bernard showed him his Breton Women in a Meadow with its areas of flat, unbroken colour surrounded by strong dark outlines, somewhat like those in mediaeval stained glass. He spent from October to December in Arles with Van Gogh; their violent discussions on painting revealed profound disagreement, and probably contributed to the despair which led Van Gogh to cut off his ear. For the next two years Gauguin moved between Brittany and Paris, where he frequented Symbolist circles and took part in an unsuccessful exhibition of Impressionists and Synthetists at the Café Volpini. He sailed for Tahiti in April, 1891, and on arrival in June soon left the capital to live amongst the natives, taking a young native girl to live with him. He became very interested in Tahitian lore and mythology, to which he often alludes in his pictures (e.g. The Moon and the Earth in the Museum of Modern Art, New York),

and after reading Moerenhout's book on the subject Gauguin began to compile his own 'Ancien Culte Mahorie'.

At this time Gauguin was painting some of his best Tahitian pictures, but he was extremely poor and lived almost entirely on roots and fish. He asked the Director of Fine Arts in Paris to repatriate him but this was not done until 1893. Back in Paris, he was able to rent a studio on account of a bequest from an uncle. Here he lived amongst exotic objects with a Javanese woman called Annah. He held weekly receptions and his pictures were given a show by Durand-Ruel. This attracted curiosity but little was sold. In 1894 he went briefly to Copenhagen to see his wife and children, to Bruges to see pictures by Memling, and from April to December he was in Brittany, where he broke his ankle in a brawl with some sailors.

In July 1895 he arrived back in Tahiti suffering from poverty, syphilis and the after-effects of his broken ankle. His health gradually improved, and he was hard at work when he was struck down again in April 1897 by the news that his favourite child Aline had died. He decided to paint a last great allegory, D'où venons-nous? (Plate XIV-XV), and then to commit suicide. He took arsenic but recovered. In April 1898 he began work as a clerk in the Bureau of Public Works at Papeete; this continued until at least March 1899 and by that time Vollard was buying his works, although at prices Gauguin considered too low. In 1900 he was able to obtain a monthly contract from Vollard, but he was very ill and forced to enter hospital. The money from Vollard enabled Gauguin to live less precariously, but the cost of living in Tahiti was rising so sharply that he decided to move to the Marquesas Islands, where he also hoped to find new subject matter. In Atuana, the chief village of La Dominique, he bought a house surrounded by enormous tropical plants. In 1903 his house was damaged by a cyclone and he suffered from painful eczema. As a result of denouncing the corruption of a gendarme on a neighbouring island and complaining about the administration of justice to the natives he was found guilty of libel and sentenced to three months' imprisonment. Before he could appeal against this sentence he died on 8 May, 1903.

'The public owes me nothing since my work is only relatively good; but the painters of today who profit from this liberty owe me something.'
— PAUL GAUGUIN

ONE SOMETIMES FEELS that if Gauguin had not existed it would have been necessary to invent this perfect embodiment of the reaction against Naturalism and Impressionism in the late eighties. Here was a painter who did not believe in the humble and passive submission to nature practised by his master Pissarro, still less in the immediate sensation of the eye, dear to Monet; for Gauguin's art was a reflection of the mind, of the 'centre mystérieux de la pensée'. This was in harmony with the new anti-Positivist philosophical ideas such as those of Schopenhauer, who saw nature as a projection of the mind, and of the anti-realist writers who met at the Café Volpini. This group, often, if loosely, known as the Symbolists, in fact admired Gauguin and gave a dinner in his honour before he went to Tahiti in 1891. Like these writers, and unlike Courbet and the Impressionists, Gauguin was interested in carrying on the ideas of analogies between art and music put forward by Delacroix and Baudelaire, whose 'Curiosités Esthétiques' he owned. A letter written to his friend, the painter Emile Schuffenecker, as early as 1885 shows that he had read or anticipated Charles Henry's theories about the psychological effects of line. Still more unlike the robustly secular Impressionists, Gauguin had a baffled feeling for religion although he sometimes expressed this in Satanism or in giving Christ his own features.

More than any of his contemporaries Gauguin embodied a dissatisfaction with industrial civilization and a love of the primitive, the archaic and the unspoiled which had been growing steadily ever since the time of Jean-Jacques Rousseau. In Courbet's circle this feeling had led to a cult of old popular songs and broadsheets. Gauguin first put the attitude more consistently and directly into practice by living in Brittany, where, he said, he found the savage and primitive: 'When my wooden shoes reverberate on this granite soil I hear the muffled, heavy and powerful note which I am seeking in painting.' Later, in 1887, the voyage to Panama and Martinique, which so radically liberated Gauguin's sense of colour, was not all disappointment. He was idealist enough to describe Martinique as a paradise, and he never entirely lost his belief that the 'earthly paradise' existed somewhere. In the South Seas this belief prompted his departure to the more remote Marquesan island where he died.

Gauguin's love of distant and exotic lands may also owe something to the actual voyages which he made to Peru as a child and to Valparaiso as a sailor. Like the Douanier Rousseau, he was enraptured by the reconstructed villages, the Javanese dancers and other primitive attractions which formed part of the Exhibition of 1889. He loved all links with the savage past and his records and illustrations of ancient mythology in 'Ancien Culte Mahorie' are enlivened by a conversation with a cannibal about the gastronomic merits of human flesh.

Gauguin was also the perfect leader for the anti-realist painters; he had a natural clarity of mind and believed (as he wrote from Denmark to Schuffenecker as early as 1885) in simplicity of expression: 'A powerful sensation may be translated with immediacy; dream on it and seek its simplest form.' The young painters at Pont-Aven were impressed by his physical strength and ribald flippancy;

as he said, he wanted to establish the right to dare anything. He must have been a good teacher, judging from the accounts of Sérusier painting under his direction the evocative picture which they called *The Talisman*. Gauguin also had the great virtue of shrewdness, both about his own work and that of others. He was probably right and certainly not arrogant when he wrote at the end of his life: 'My capacities were not capable of great results, but the machine has been launched. The public owes me nothing since my pictorial oeuvre is only relatively good; but the painters of today who profit from this liberty owe me something.' His admiration for Rembrandt did not preclude a strong attachment to Ingres whose portraits, he told a Danish friend, showed 'la vie intérieure' and whose apparent coldness, he rightly observed, hides great ardour and passion.

TEMPERAMENTALLY, too, Gauguin needed to be iconoclastic—to break and invent. Strindberg told him he was fortified by the hatred and antipathy of others. Like Van Gogh he was far more deeply at odds both with himself and with society than were the Impressionists. His suffering and isolation led him to seek for the meaning of life far more deeply than they, and one may perceive incomprehension as well as smugness in Renoir's comment on Gauguin's departure to Tahiti: 'On peint si bien aux Batignolles' (One paints so well at Batignolles: i.e. locally, in Paris).

As a stockbroker and under Pissarro's direction Gauguin made a fine collection of Impressionist pictures as well as works by Cézanne, who was still considered a bad joke by most collectors. He was one of the first artists educated by the influence of Delacroix and the Impressionists without undergoing an academic phase of apprenticeship to the Old Masters, to whom even Degas and Renoir submitted. It is extremely difficult not to view the early art of Gauguin and Cézanne in the light of the revolutionary pictures to come, but contemporary critics such as Fénéon and Emile Bernard did not have this disadvantage, and they too noticed non-Impressionist elements in the early works of Gauguin, observing that his colour tones were mixed rather than divided, and that he used close rather than contrasting harmonies. He never was primarily interested in delicate effects of light; his great gift was for strong, hard and pungent colours, and he was far more concerned with line, rhythm and arabesque than were the Impressionists. He had not their taste for the momentary and moving; the great figures of his maturity are often statuesque and impassive. Like Delacroix he was interested in analogies between painting and music and in the overall musical effect of his canvas. In a note book for his favourite daughter Aline he analyses the genesis of his picture *Spirit of the Dead Watching* (Albright-Knox Art Gallery, Buffalo) into 'the musical' and 'the literary' parts.

Like Seurat and, again, unlike the Impressionists, Gauguin had no distaste for lofty or semi-literary subjects and for chef d'oeuvres. Courbet and the Impressionists had derived their horror of the latter from the *grandes machines* with high-faluting subjects which adorned the fashionable salons. But, since the 'sixties, the younger generation might

155

well have considered that they had been deluged with the casual and the immediate, not to say sometimes the trivial. This feeling lay at the root of Degas' opposition to the Impressionists; he felt too that the hero of Zola's 'L'Oeuvre' should not have failed from attempting the grandiose, but from sketchiness and triviality. In the early 'eighties it was a similar dissatisfaction which made Renoir, Monet and Pissarro all come to recognize that Gauguin's aestheticism was the negation of their own realism and the two former refused to exhibit with him.

GAUGUIN BEGAN to paint, as the Impressionists themselves had done, in the tradition of Corot, Daubigny, Jongkind and Courbet. His guardian Arosa had a good collection of pictures which included works by Delacroix and Courbet, and Arosa's daughter took him out to paint in the open air in the outskirts of Paris. In 1876, the course of his artistic development was changed and accelerated by meeting Pissarro. Works of the next few years, such as the *Cows at the Watering Place* (Plate I), employ Pissarro's colours and the characteristic Impressionist handling, although—as the critics observed—in a somewhat diluted form.

Gauguin soon came to have a deep admiration for both Degas and Cézanne; the multiple perspectives of Degas began to appear in the seascapes painted on his first visit to Brittany in 1886. The influence of Cézanne's simplifications and flat areas of colours surrounded by definite outlines, which he used roughly between the years 1879-81, becomes equally apparent in some of Gauguin's still-lifes of about 1885. He bought a still-life of Cézanne's for his collection and refused to sell it even when he was in extreme poverty; it appears in the background of his portrait of Marie Lagadu (Plate VIII). The art of Degas and Cézanne, more powerful and concentrated than the somewhat diffuse and contemplative manner of Pissarro, was probably more sympathetic to Gauguin; but although Degas bought at least two of Gauguin's pictures, Gauguin's real benefactor was Pissarro, and at the end of his life he acknowledged this debt: 'He looked at everybody you say? Why not? Everyone looked at him too, but denied him. He was one of my masters, and I do not deny him.'

Already in some of the paintings executed at the time of his friendship with Pissarro, which are more or less Impressionist in colour and handling, there are signs of flattened space and sharper, more simplified and continuous outlines. Even in the nude of his children's nurse sewing, so highly praised for its realism by Huysmans when exhibited in 1881, many of the colours seem chosen for their decorative rather than their naturalistic qualities. In Martinique this process was intensified; Gauguin's colours became much brighter, his natural forms more schematic. The effect of tapestry anticipates to some degree the more magical harmonies in some of the last works such as the *Woman and the White Horse* of 1898. At this time, Gauguin himself wrote: 'I have never before made paintings so clear, so lucid.' Before they fell ill Gauguin and Laval lived in a negro hut, painting natives and palm-trees; for a short ecstatic time they believed that they were living in paradise. In spite of the material failure of this expedition, Gauguin returned to Paris with greater confidence in what he wanted to do. It was then that he wrote to his wife about the two natures within him—the 'Indian', or the harder side of his nature, and the sensitive. 'La sensitive a disparu, ce qui permet à l'Indien de marcher tout droit et fortement.'

According to Gustave Kahn, the pictures which Gauguin brought home disappointed both the critics and his usual admirers when shown in Theo Van Gogh's gallery. 'This was neither pointillism, nor even optical mixture, nor was it exactly an art which broke with all Impressionist ideas . . . He simplified the colours, contrasting them violently.' Pissarro was apparently one of the few to defend him, pointing out that in hot countries forms were so swallowed up by light that one was forced to proceed by violent oppositions.

BUT GAUGUIN was soon to have plenty of disciples. The art which did break with Impressionist ideas now found a suitable and concrete form through the friendship of the young mediaevalising writer and painter Emile Bernard with whom Gauguin spent the summer of 1888 at Pont-Aven. (They had in fact met briefly in Brittany before but made little contact.) Gauguin, who had read less and talked less than Bernard, became excited by the younger man's ideas and still more by his method of enclosing flat areas of paint by means of heavily stressed contours as in mediaeval enamels and stained glass. Louis Anquetin, friend of both Bernard and Seurat, had been experimenting with a similar technique, apparently inspired by the stained glass door of his father's house. All three artists had been attracted by Japanese prints and by Cézanne, and Gauguin had begun to use forceful and simplified lines in the

ceramic work which he had been doing in the winter of 1886-7. Attempts to establish one of the participants as the true founding father of Cloisonnisme are not very valuable since the success of their encounter was partly due to the many individual impulses which had been tending in the same direction. Seurat and Van Gogh had also wished to render feeling directly by the abstract means of line, shape and colour, for example the 'terrible greens and reds' of Van Gogh's *Night Café* were intended to express the sinful nature of the place.

There is little doubt that Gauguin was very much impressed when Bernard showed him his *Breton Women in a Meadow* with its absence of modelling and strong, generalized outlines. He exchanged it for one of his own paintings, and later took it to Arles, where it was copied by Van Gogh. It was during this time of close friendship with Bernard that Gauguin wrote to Schuffenecker: 'One piece of advice, don't copy nature too much. Art is an abstraction: derive this abstraction from nature while dreaming before it, but think more of creating than the actual result.' Bernard may also have had some influence on the religious themes chosen by Gauguin at this time since the younger man was becoming increasingly pious. 'Brittany had made me a Catholic ready to fight for the Church . . . I became intoxicated with incense, with organ music, . . . stained glass, hieratic tapestries. Little by little I became a man of the Middle Ages.'

Neither in content nor colour had Anquetin or Bernard broken with realism. *The Vision after the Sermon* (Plate V) was far more original and daring, notably in the use of an improbable, brilliant red background for the wrestling figures. The picture represented the apparition of Jacob wrestling with the Angel which the congregation saw in a vision after the Sermon. 'I believe,' Gauguin reported to Van Gogh, 'that I have attained in these figures a great rustic and superstitious simplicity . . . The landscape and the struggle exist only in the imagination of those praying people . . . that is why there is a contrast between these real people and the struggle in the landscape which is not real and out of proportion.' Gauguin has here used a curving rhythmical contour which seems to herald Art Nouveau, and everything is painted in flat colours, emphatically separated by thick contours, in contrast to the unified atmosphere of the Impressionists. The wrestling figures are probably derived from those in a Japanese print— Hokusai's *Mangwa*.

Gauguin continued to use stylized form and arbitrary colours in a self-portrait which he painted for Vincent Van Gogh in the same year. The reference to Hugo's book 'Les Misérables' actually on the picture and the decorative use of flowers, mark the distance which he had travelled from Impressionism. He wrote of this picture to Schuffenecker that it was 'one of my best things; absolutely incomprehensible of course, being so abstract . . . The drawing is quite special (complete abstraction). The eyes, the mouth, the nose are like flowers in Persian carpets, thus personifying the symbolical side.' When Gauguin went to stay with Van Gogh in Arles at the end of 1888, the role of reality and the outside world in painting was one of the many subjects for those bitter and violent disputes which must have played some part in deranging Vincent. Of their differences Gauguin wrote: 'He admires Daumier, Daubigny, Ziem and the great Rousseau whom I cannot stand. And on the other hand he detests Ingres, Raphael, Degas, and all those whom I admire . . . He is romantic while I am rather inclined towards a primitive state. As to colour, he is interested in the accidents of thickly applied paint, as with Monticelli, where I detest the worked-out surface.' Curiously enough Gauguin's colour did not change very much under the bright southern sky—he had probably travelled too far from the observation of outside appearances; and whereas some of Vincent's pictures show signs of Gauguin's flat areas and curvy lines, it is difficult to trace any of Van Gogh's traits in Gauguin's work.

AT THIS TIME Gauguin had many admirers amongst the younger painters and the Symbolists, including the critic Maurice Denis who later said that in this corrupt era 'Gauguin stood out as a sort of Poussin without classical culture.' It was probably after seeing Sérusier's *Talisman*, painted as we have seen under Gauguin's direction, that Denis formulated his celebrated definition, that a picture before being a battle-horse or a nude woman is primarily a flat surface decorated with colours.

Back in Brittany in 1889, Gauguin painted some of his most uncompromising works in the new flat and stylised idiom. Amongst these was his portrait of the Mayor of Pont-Aven's wife known as *La Belle Angèle* (Plate III). It is a decorative, non-naturalistic work divided into two parts, each with its own space. The human figure is enclosed in a semi-circle and balanced against a Peruvian idol and the whole is brought together by the relations of colour. It is reminiscent at once of tapestry, Breton folk art, Cézanne and Holbein. The sitter herself disapproved of it but the picture was bought by Degas. *The Yellow Christ* (Plate IV), painted at about the same time, has a very simplified formal construction; it seems intentionally rough and naïve, no doubt to harmonize with the simple piety which it represents. The lines round the figures appear deliberately crude; the curved figures of worshippers are set in contrast to the straight lines, vertical and horizontal, of the cross and of the field. It is a very flat picture (Gauguin often said that flat planes were honest, in contrast

2. TAHITIAN WOMAN CROUCHED
THE ART INSTITUTE, CHICAGO

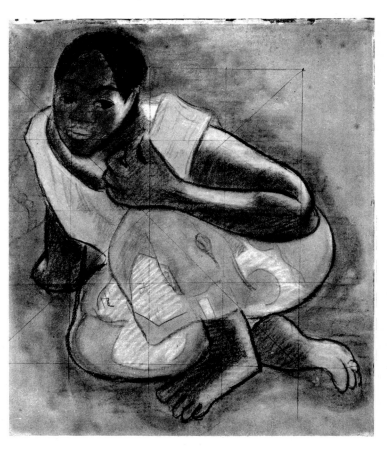

with the subterfuge of modelling), and the colours are almost nursery-like in their bright simplified patterns. The Christ was based on a wooden sculpture in the ancient Chapel of Trémalo near Pont-Aven.

The curving Art Nouveau characteristics of *The Vision after the Sermon* were continued in the wood sculptures such as *Soyez amoureuses, vous serez heureuses* (formerly collection of Emile Schuffenecker) where Gauguin in the form of a monster is seizing an unwilling woman's hand; beside her is a fox—the Indian symbol of perversity. The fox appears again in Gauguin's most consciously 'Symbolist' painting *La Perte du Pucelage* (Chrysler Collection, New York), where it represents the physical desires to which a nude girl is yielding. Art Nouveau curves are most extreme in the curving backview of *Ondine* (Collection of Mr. and Mrs. W. Powell-Jones, Gates Mills, Ohio).

GAUGUIN OFTEN declared, 'My artistic centre is in my own head and nowhere else.' It might therefore seem unnecessary for him to have undertaken the great journey to Tahiti in 1891. But he believed that barbarism was essential to rejuvenate him, and in fact the South Sea Islands were extremely important to his art in that they supplied him with new subject matter—the religion and customs of the natives—which seemed to him both mysterious and poetic. He was still sufficiently influenced by the doctrine of Manet and his friends to distrust the rather faded literary and classical themes of Puvis de Chavannes, although he admired his execution. The importance to Gauguin of the subject matter in his Tahitian works is apparent in the meticulous listing of translations for the native titles which he sent to his wife when she was arranging an exhibition. He no longer had to distort reality as harshly as he had done in Brittany since this new land seemed sufficiently magical and full of symbols in itself; there was no need for Gauguin to impose them on his work: as he wrote to Daniel de Monfreid: 'Ici la poésie se dégage toute seule.'

The style of the Tahitian pictures differs considerably from the cruder stylization of the works he produced in Brittany. The forms are far more sinuous and graceful, and fully modelled, the outlines are less heavy, the colour blends and harmonizes with greater subtlety, the laws of perspective are not so violently overthrown, the foreground and middle distance are generally more clearly established and the figures are no longer cut by the canvas in the manner of Degas. The influence of Japanese prints was now waning. The composition is less flat; instead it is often arranged like a frieze—Gauguin had brought with him from Paris photographs of Javanese and Egyptian friezes. In one of his early Tahitian pictures, *Ia Orana Maria* (Metropolitan Museum, New York), the figure adoring Mary and her Child comes from a sculptured frieze on the Javanese temple of Barabondour, photographs of which Gauguin had bought in Paris during the Franco-Prussian War.

According to M. Henri Dorra, this new manner, with its greater plasticity and less aggressively Synthetist contours, had been initiated in France, particularly in some pictures of a naked Eve, a dream of what Gauguin hoped to find in the South Seas. Gauguin had apparently been very much dissatisfied with *La Perte du Pucelage* and sought for a way out of this style by copying Manet's *Olympia* and by introducing into his work elements taken from the sculpture of the Far East. This view is given some substance by the fact that both Van Gogh brothers write of Gauguin's new manner before he went to Tahiti.

Some of the Tahitian pictures represent scenes from everyday life such as *Parau, Parau* (Conversation) (Hermitage Museum, Leningrad). Others derive from a specific incident such as the terror inspired by the spirits of the dead in Gauguin's young Tahitian wife when she had been left alone in the dark. Some are concerned with the traditional religious beliefs and practices of the Polynesians such as the legendary dialogue between the Moon and the Earth, which Gauguin had learnt about from 'Voyages aux Iles du Grand Océan' by Moerenhout, a former American consul. Gauguin was now highly eclectic in blending his sources; some figures in *The Market* (Plate VI-VII) are seated in the stiff conventional attitudes of Egyptian wall-paintings. Other works make use of Buddhist or Hindu figures which had impressed him in the Louvre. Manet's *Olympia* is detectable in some of the nudes such as *Nevermore* (Courtauld Institute Gallery, London) and there are undertones of Degas in the beautiful late *Riders on the Beach* (Plate XVI). Although Gauguin often said that the greatest error was the Greek and that he wanted to go back beyond the horses of the Parthenon, various poses, for example in *The Call* (now lost) seem reminiscent of the Parthenon. Other compositions apparently owe something to Puvis de Chavannes although Gauguin was inclined to mock his academic neo-classicism and his habit of drawing careful preparatory cartoons.

For years Gauguin had been insisting upon the musical role of colour in painting and on the need to suggest rather than to describe. His late works, such as the sombre and poetic *White Horse* of 1898 (Louvre, Paris), come nearest to fulfilling these ideals. The range of his colour was now immensely rich and varied; his palette held more mixed colours than primary—oranges, violets, pinks, which in their clashing juxtaposition often anticipate Matisse. In his most ambitious picture, *D'où venons-nous? Que sommes-nous? Où allons-nous?* (Where do we come from? What are we? Where are we going?) (Plate XIV-XV), painted before an attempt at suicide, all the landscape is blue and veronese green. As Gauguin said, he worked day and night at this painting, in an incredible fever, without studies from nature or preparatory cartoons. In it he makes use of themes and figures from earlier pictures, but refuses to tie down the allegory, quoting Mallarmé: 'It is a musical poem and needs no libretto.'

GAUGUIN'S originality and his contribution to later art can scarcely be over-stressed. His interest in oriental and primitive sources was highly infectious as was his cult of suggestion and poetry as opposed to the comparatively objective *rapportage* of Manet and his friends. Frequent criticism had been directed against the Impressionists before 1888, but until Gauguin painted *The Vision after the Sermon*, this opposition had never produced a concrete stylistic alternative. It is also too rarely pointed out that Gauguin's brevity and simplifications were very new developments in comparison with the more contemplative, detailed art of even Courbet and the Impressionists. His swift, rhythmical use of line lies behind the epigrammatic styles of Picasso and Matisse. The intentional broadness and crudity of his wood-blocks deeply affected the formation of Munch and the German Expressionists. The Nabis, the Fauves, Derain, the artists of the 'Blue Rider' Group, the English Camden Town painters, Kandinsky, Braque and Modigliani were among his debtors. In his escape from the literal he did not plunge straight into the literary as Moreau and Redon had done; the new themes supplied by life in the South Seas provided him with a poetic and fruitful alternative.

The Plates

I *COWS AT THE WATERING PLACE* 1885
Oil on canvas. 25¼ in. × 31¾ in.
GALLERIA D'ARTE MODERNA, MILAN

This is a good example of Gauguin's Impressionist style of painting with broken brush-strokes and colours akin to those of his master Pissarro, for example, in the latter's *Red Roofs*. Seurat's friend, the critic Félix Fénéon, however, noticed that Gauguin's early colours were more often close than contrasting in the Impressionist manner.

II *ST. PETER'S BAY, MARTINIQUE* 1887
Oil on canvas. 21¾ in. × 35⅘ in.
NY CARLSBERG GLYPTOTHEK, COPENHAGEN

In Martinique Gauguin's colours became bolder and his work acquired a somewhat decorative effect like tapestry. He himself said, 'I have never before made paintings so clear, so lucid.' The composition of this work looks far from haphazard; the curving tree trunks and the position of the figures seem to have been carefully worked out in the manner of Puvis de Chavannes or even Seurat, rather than that of the Impressionists.

III *LA BELLE ANGÈLE* 1889
Oil on canvas. 36⅘ in. × 28⅘ in.
LOUVRE, PARIS

This very stylized portrait once belonged to Edgar Degas. It seems to derive stylistically both from Cézanne and from Breton folk-art, and resemblances have also been found to Holbein. Angèle Sâtre's husband was later to become Mayor of Pont-Aven.

IV *THE YELLOW CHRIST* 1889
Oil on canvas. 36¾ in. × 29¼ in.
ALBRIGHT-KNOX ART GALLERY, BUFFALO

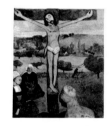

Here Gauguin is using both distortions of anatomy, as in the arms, and an arbitrary use of colour. Gauguin was interested in the simple religious cults of the Bretons as later of the Tahitians and the figure of Christ was based on a wooden crucifix in the Chapel of Trémalo near Pont-Aven. This picture appears in the background of a later self-portrait.

V *THE VISION AFTER THE SERMON (JACOB AND THE ANGEL)* 1888
Oil on canvas. 29¼ in. × 36⅘ in.
NATIONAL GALLERY OF SCOTLAND, EDINBURGH

Historically speaking this is probably Gauguin's most important work. It is painted in the technique called 'Cloisonnisme', that is in flat areas of unbroken colours surrounded by heavy outlines somewhat like mediaeval stained glass. Emile Bernard claimed to have invented Cloisonnisme and this picture in fact owes something to his *Breton Women in a Meadow* which he had shown to Gauguin immediately before the latter began *The Vision*.

VI-VII *THE MARKET (TE MATETE)* 1892
Tempera on canvas.
28¾ in. × 36¼ in.
KUNSTMUSEUM, BASLE

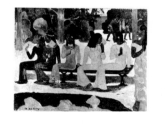

The title has sometimes been translated as 'We shall not go to market today'. It is characteristic of Gauguin's early work in Tahiti in that the subject is taken from everyday life and the figures invested with the hieratic qualities and rigid gestures of an Egyptian temple relief. Soon afterwards Gauguin was advising his friends, 'Have always before you the Persians, the Cambodians and a little of the Egyptians'.

VIII *PORTRAIT OF A WOMAN (MARIE LAGADU)* 1890
Oil on canvas. 25¾ in. × 21¼ in.
THE ART INSTITUTE, CHICAGO

Marie Lagadu owned the inn at Le Pouldu where Gauguin used to stay. Behind the sitter is a still-life by Cézanne which Gauguin refused to part with. The portrait is influenced by Cézanne in the diagonal composition of the sitter and the bulk and weight of the body. Cézanne disapproved of Gauguin's art chiefly because it was so flat and unmodelled.

IX *SELF-PORTRAIT* C. 1897
Oil on canvas. 16 in. × 14 in.
COLLECTION OF MME. L. HUC DE
MONFREID, BÉZIERS

Gauguin painted several self-portraits in the South Seas including the better-known one with a palette. This one was sent in 1896 to his friend Daniel de Monfreid; more than any other it is marked by his suffering and the poverty which compelled him to live on roots and fish and to apply for repatriation to France.

X-XI *SIESTA, TAHITI* 1893
Oil on canvas. 35¼ in. × 45¾ in.
COLLECTION OF MR. AND MRS.
IRA HAUPT, NEW YORK

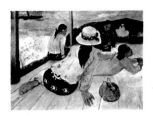

This work, probably derived from an actual scene, has been composed with such spaciousness and decorative harmony that it makes *The Vision after the Sermon* (Plate V) seem rigid and schematic in comparison.

XII *TAHITIAN WOMEN WITH MANGO BLOSSOMS* 1899
Oil on canvas. 37⅔ in. × 29¼ in.
METROPOLITAN MUSEUM OF ART,
NEW YORK

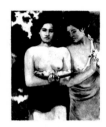

This painting is also called *Les Seins aux Fleurs Rouges* in the Wildenstein catalogue. These young girls seem like the realization of the imaginary Eves of which Gauguin dreamed in the year before he came to the South Seas. It was probably of such figures that Gauguin wrote to Strindberg, 'The Eve I have painted—and she alone—can remain naturally naked before us. Yours, in this simple state, could not move without a feeling of shame.'

XIII *ET L'OR DE LEUR CORPS* 1901
Oil on canvas. 26⅘ in. × 30⅝ in.
LOUVRE, PARIS

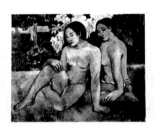

The rhythmical poses of these figures have been said to owe something to Ancient Egyptian art. The work seems near the mood Gauguin describes in a letter to André Fontainas: '. . . the odour of an antique joy which I am breathing in the present. Animal shapes . . . indescribably antique, august and religious in the rhythm of their gesture, in their singular immobility . . .' Gauguin's exaltation and equation of the antique and the primitive are reminiscent of Delacroix in Algeria.

XIV-XV *D'OÙ VENONS-NOUS? QUE SOMMES-NOUS? OÙ ALLONS-NOUS?* 1897
Oil on canvas. 56⅝ in. × 164⅖ in.
MUSEUM OF FINE ART,
BOSTON, U.S.A.

Gauguin painted this large picture as a testament and allegory of the human situation before attempting to commit suicide in January 1898. Although he wrote to the critic André Fontainas, 'My dream is intangible, it implies no allegory; as Mallarmé said, "it is a musical form and needs no libretto"', he did, in fact, give some explanations: 'an idol, both arms rhythmically and mysteriously raised, seems to indicate the Beyond . . . an old woman, approaching death, appears reconciled and resigned to her thoughts . . .'

XVI *RIDERS ON THE BEACH* 1902
Oil on canvas. 26⅔ in. × 30⅔ in.
FOLKWANG MUSEUM, ESSEN

Gauguin painted two pictures of riders on the beach near Aluana in the Marquesas shortly before he wrote 'Avant et Après' in which he frequently mentions Degas, whose race-course scenes probably inspired them. The sense of interval and empty space and the clarity of the figures are particularly reminiscent of Degas. Picasso's neo-classical *Boys at the Watering Place* of 1905 was probably derived from Gauguin's riders.

160

I

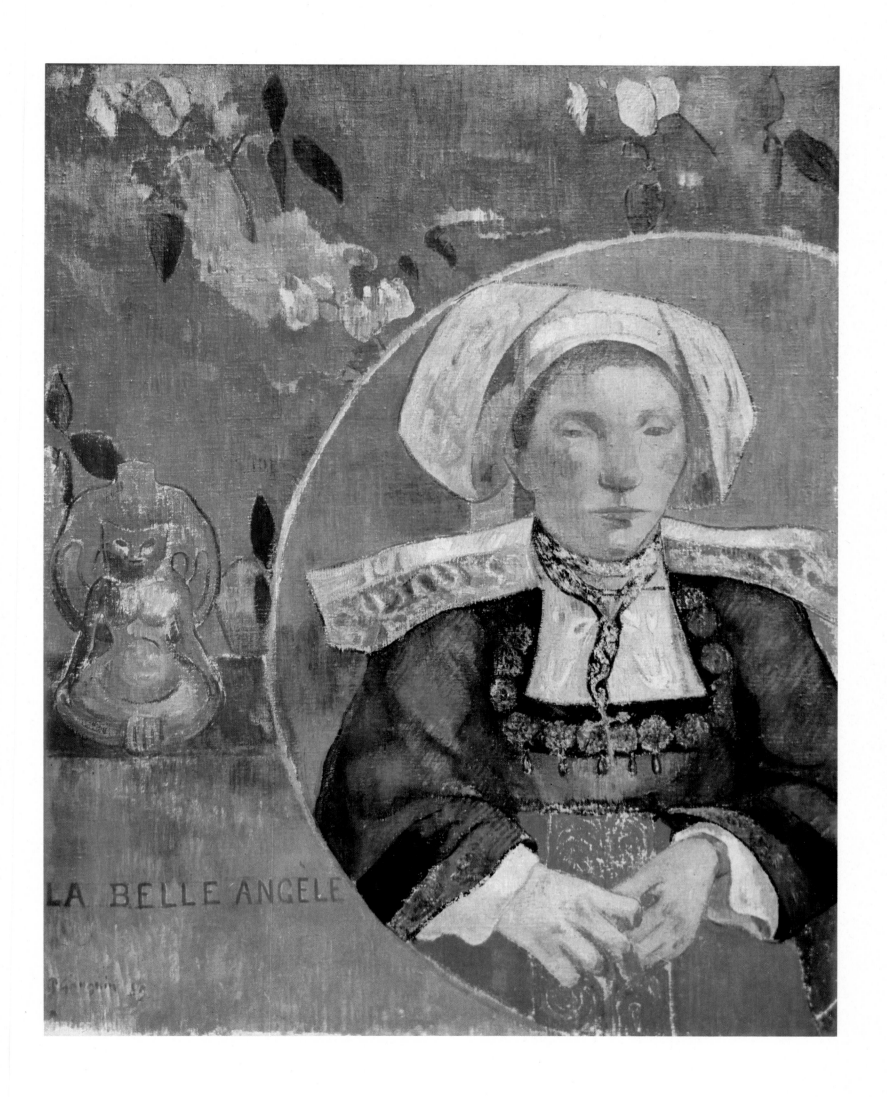

LA BELLE ANGÈLE

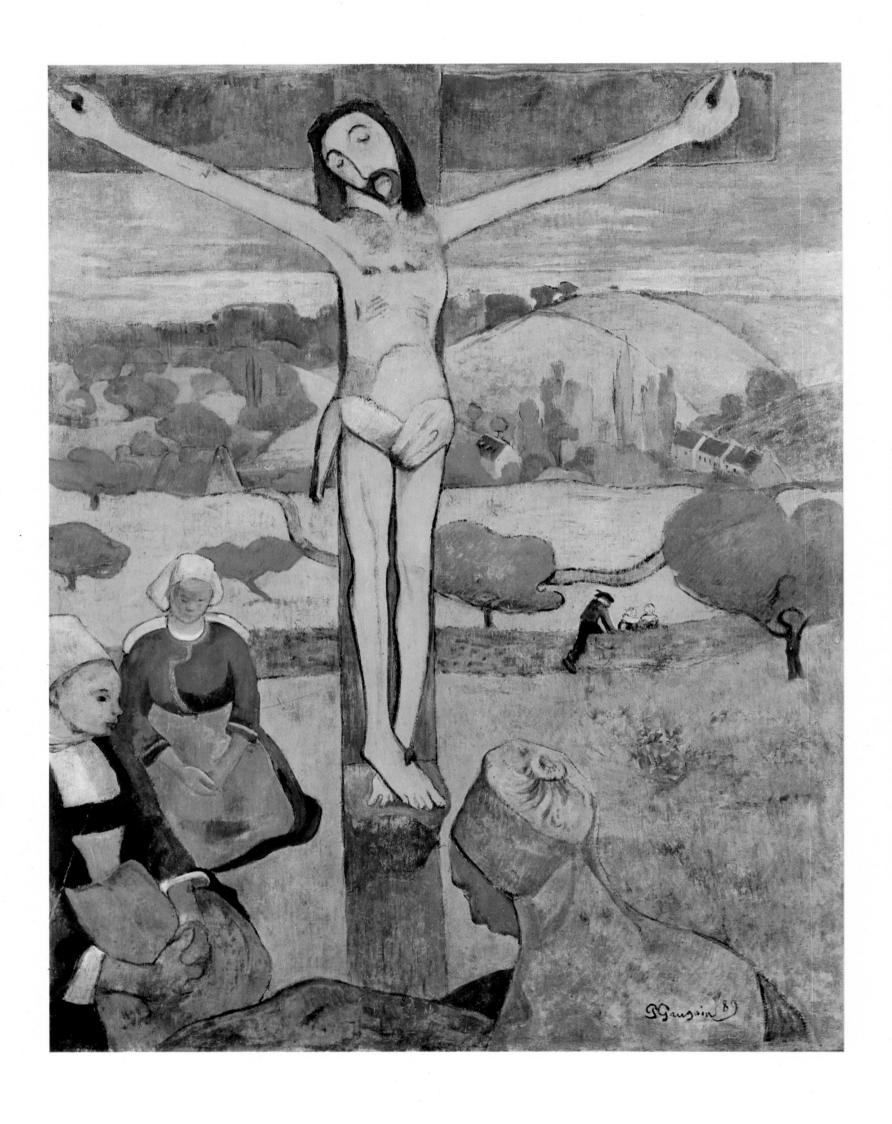

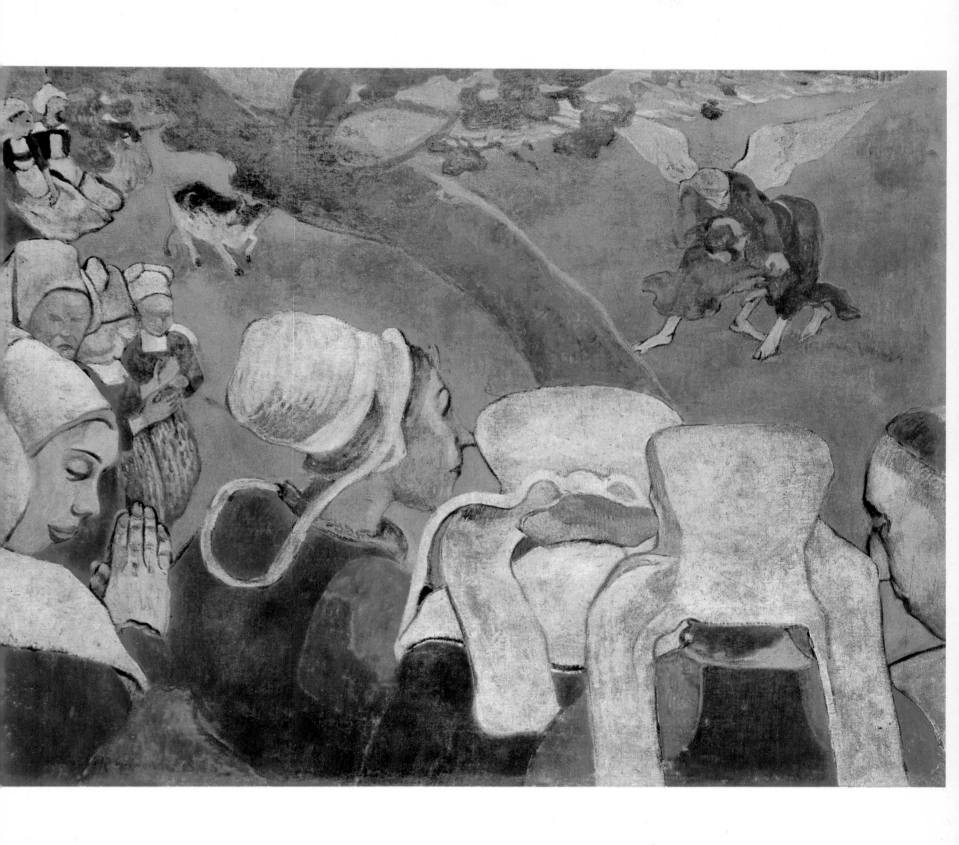

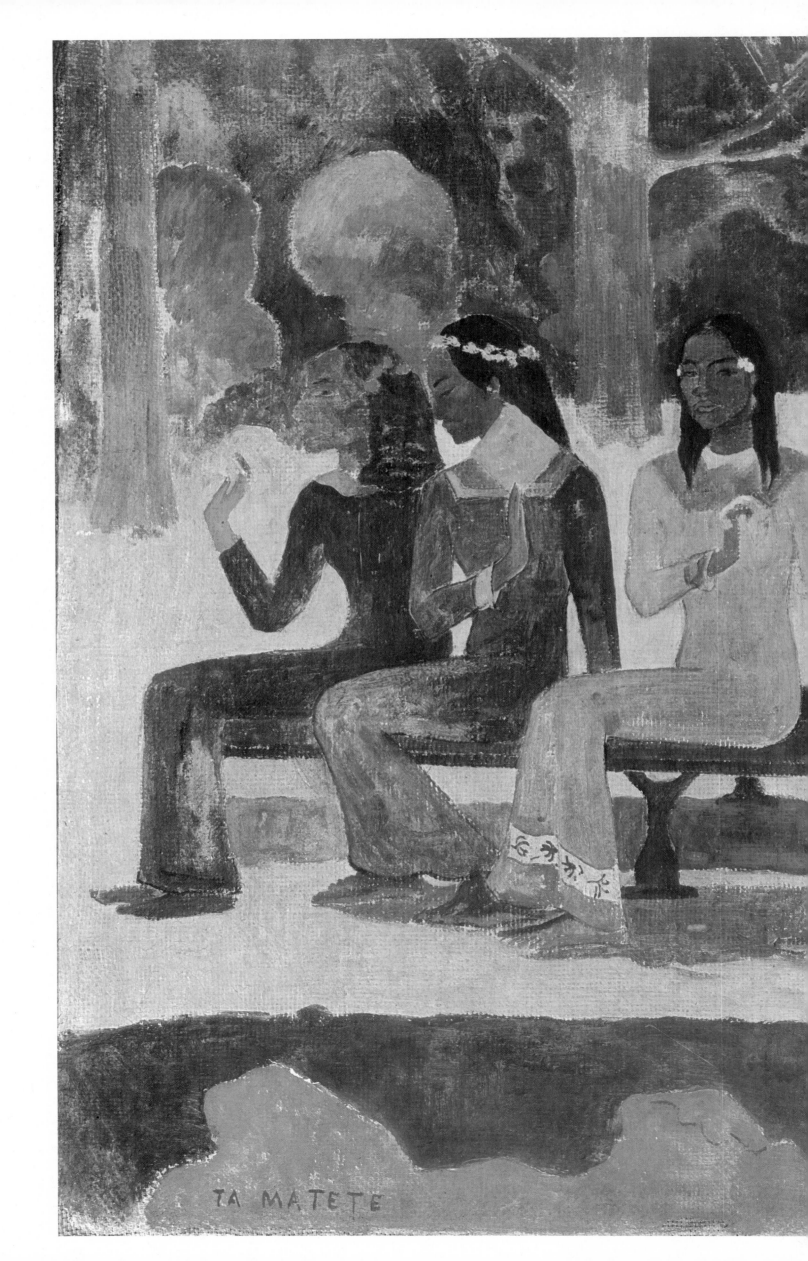

TA MATETE

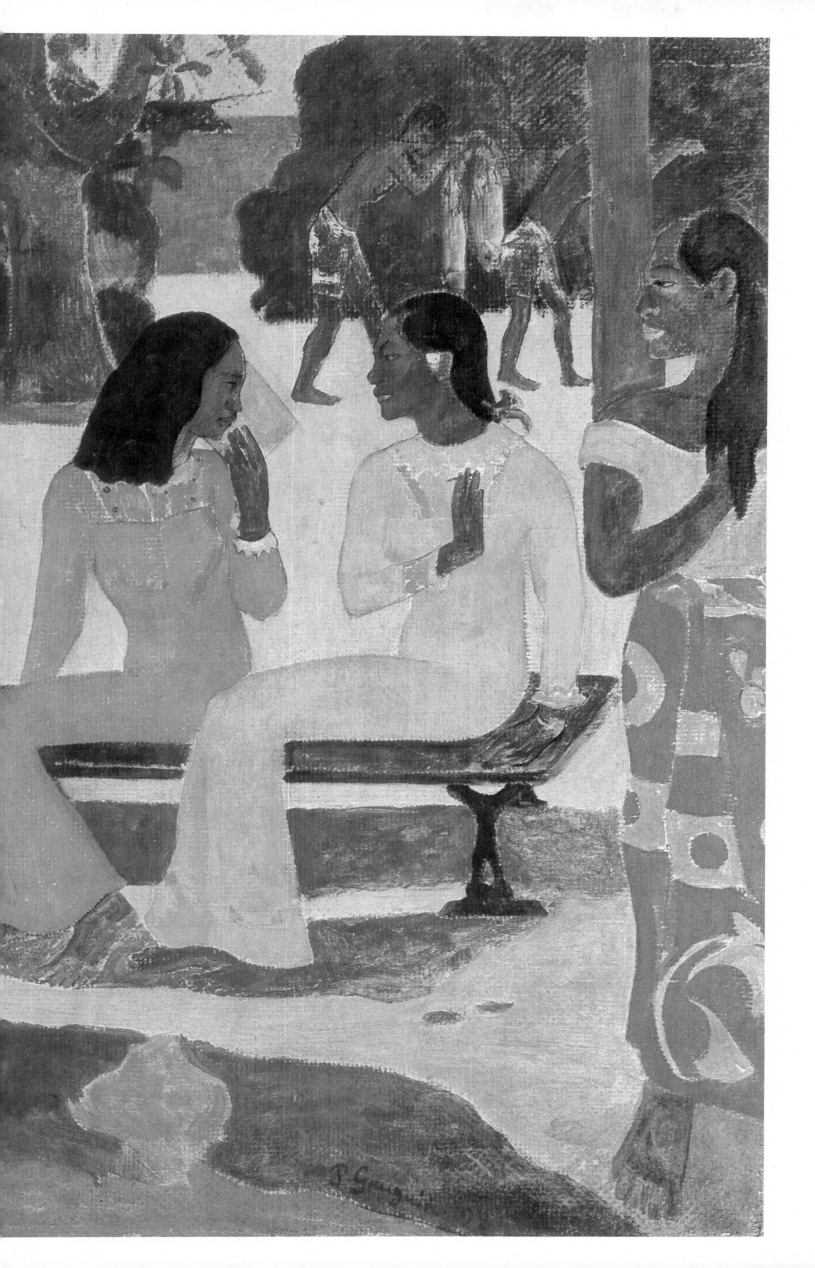

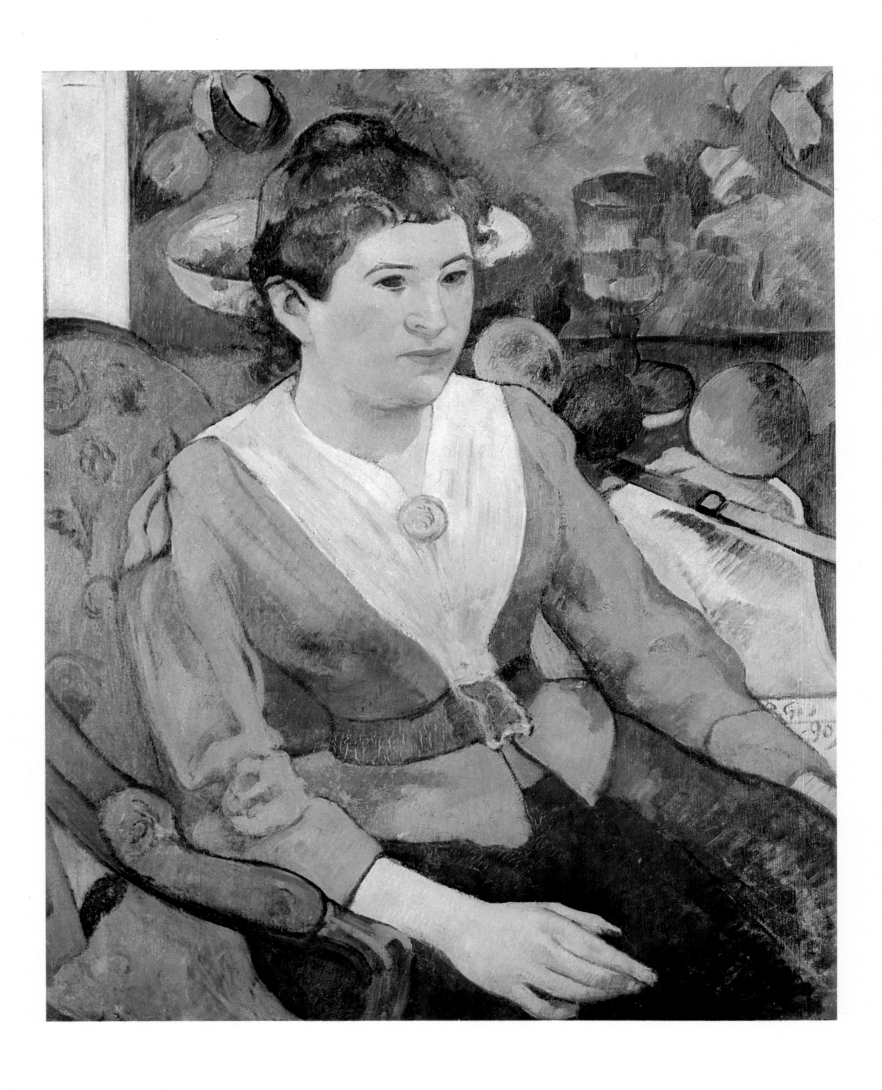

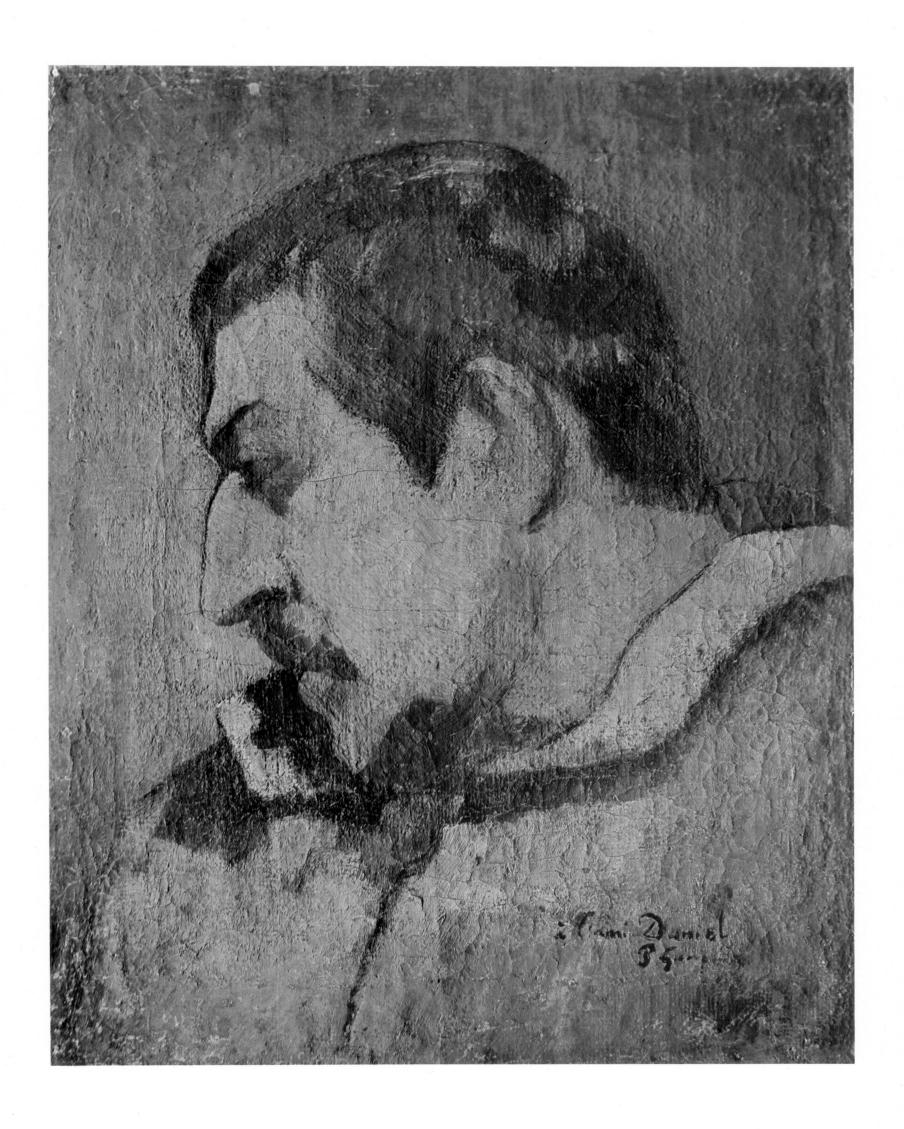

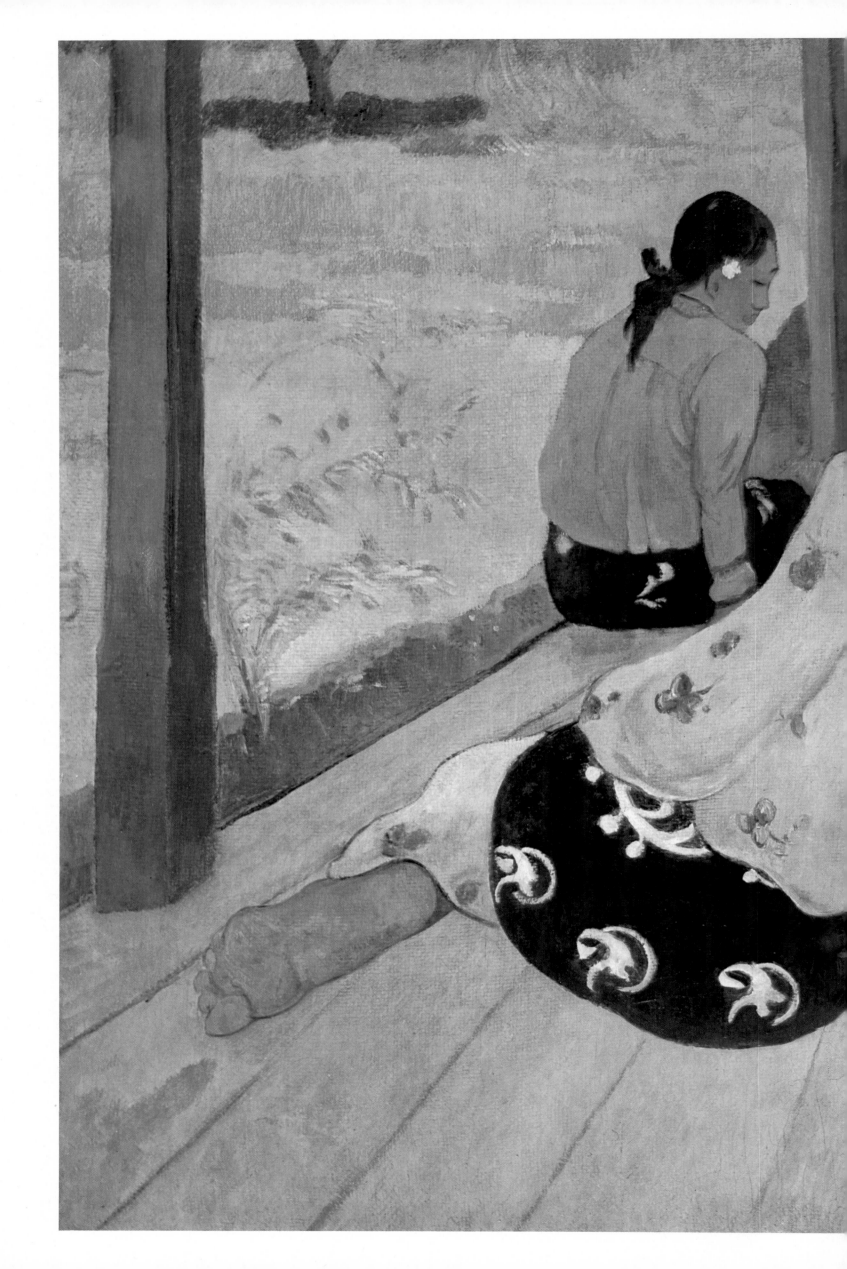

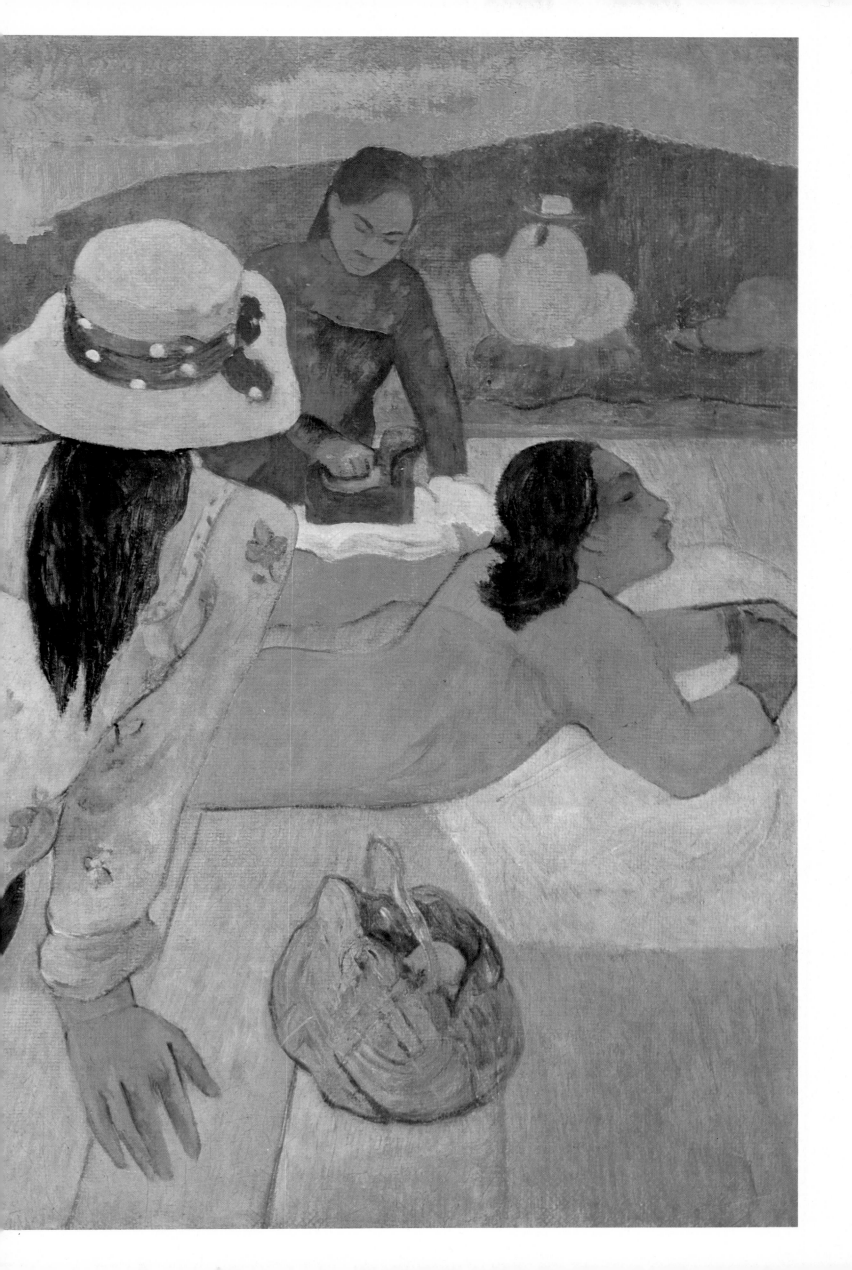

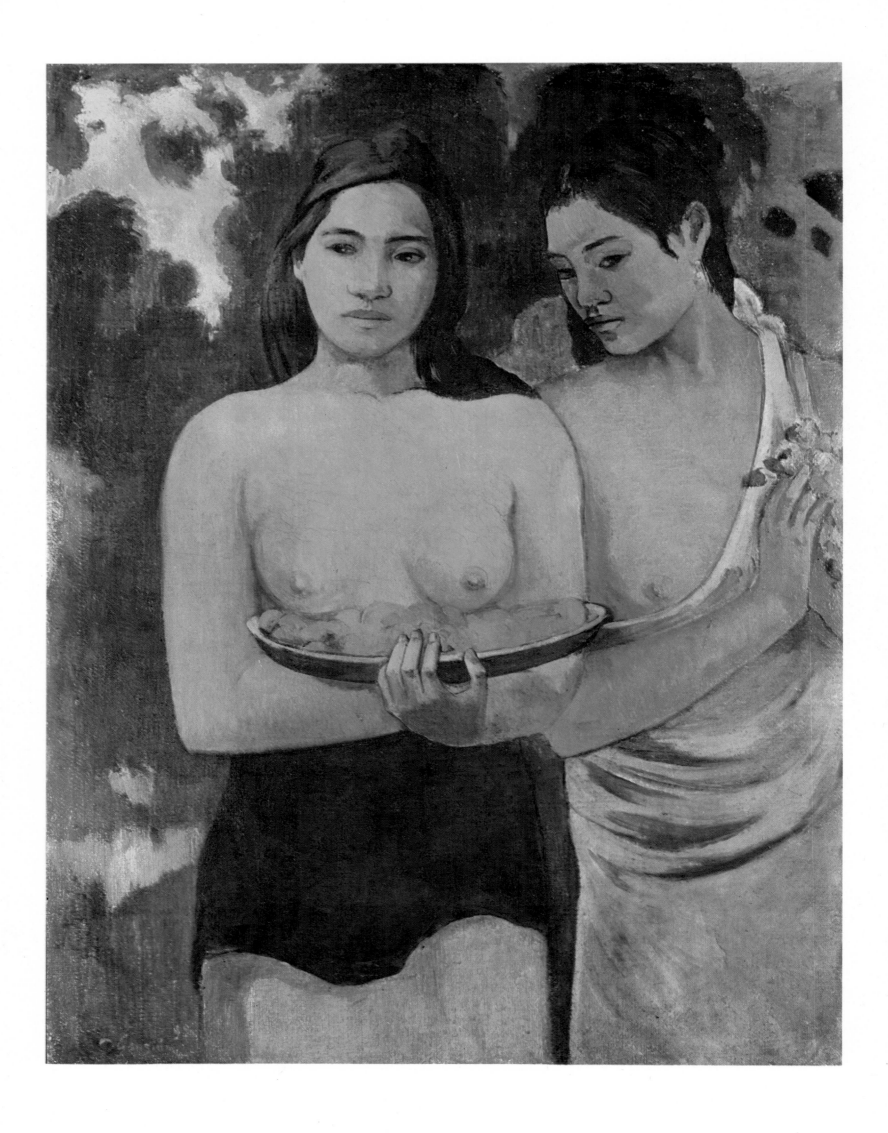

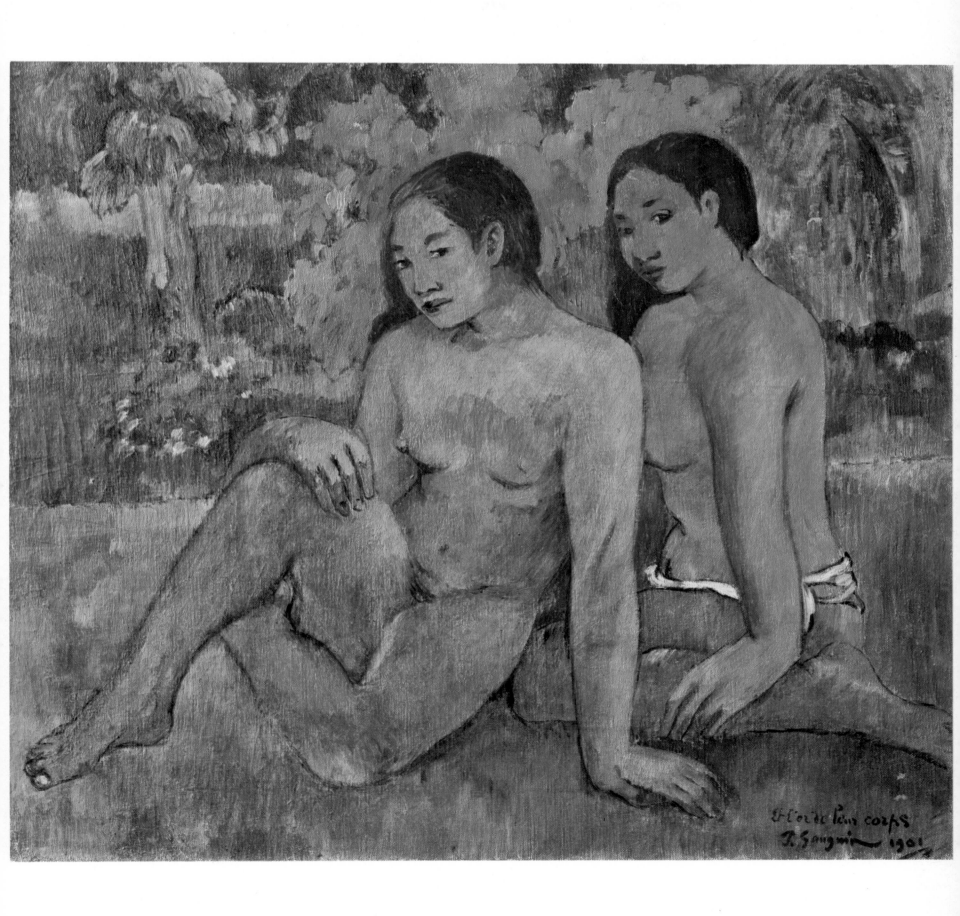

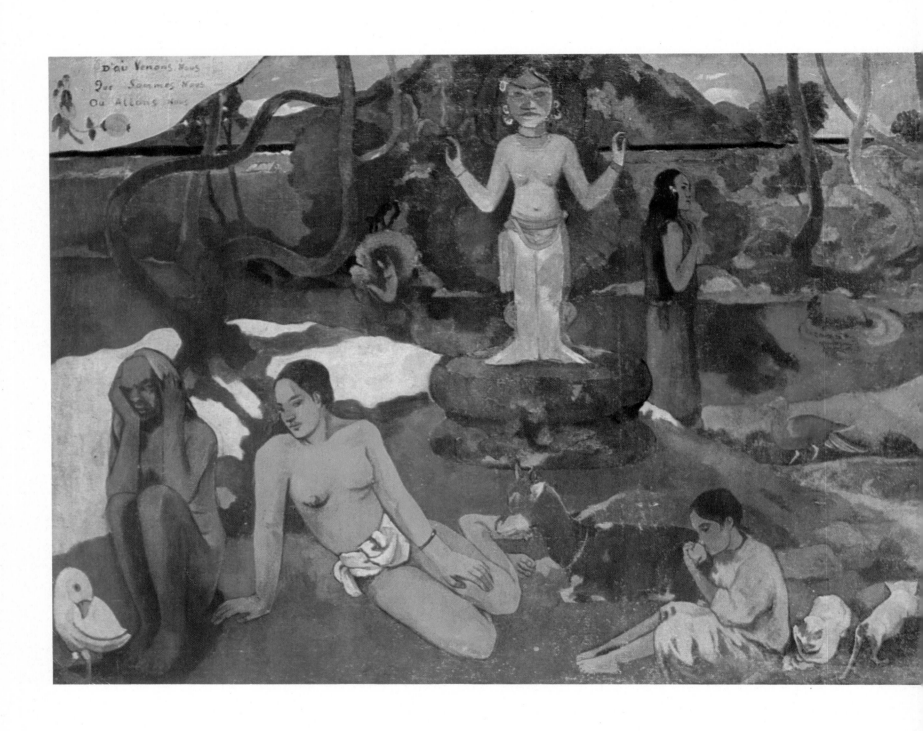

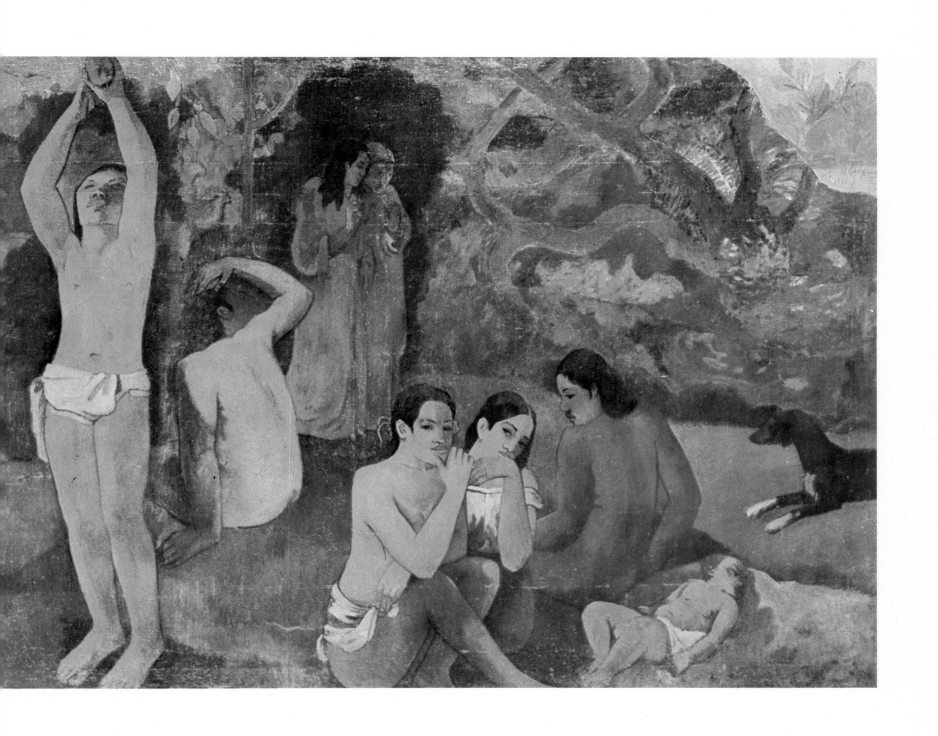

Vincent Van Gogh

Vincent Van Gogh 1853-1890

'We cannot always say what it is that surrounds us, imprisons us, and seems to bury us; and yet we do feel these indefinable barriers, these railings, even walls.' Throughout his life Vincent van Gogh tried to escape from this sense of imprisonment through his love for the world and mankind. Yet his work as a missionary, his efforts to help people, and his devotion to painting made overwhelming demands on him, which caused him much suffering and eventually led to his death.

Van Gogh was born on 30 March, 1853 at Groot-Zundert, a village in Dutch Brabant. His father, a Lutheran minister, wanted him to be an art dealer, so at the age of sixteen he started work at the Goupil Galleries, which had been founded by an uncle. He was employed at their branch office in The Hague for three years between 1870 and 1873, then at the more important London branch for two years, finally graduating to their main office in Paris in 1875. Although he spent many hours in museums and art galleries studying the works of the great painters, he was totally uninterested in his job as an art dealer.

Acting on a sudden impulse, and even though he did not know what else he wanted to do, he left the gallery and returned home early in 1876. There he read a great deal, made a number of sketches, and went through periods of intense religious fervour. He then began to wander restlessly from place to place, going first to Ramsgate to teach languages, then to a curacy at Isleworth, to Dordrecht where he worked in a bookshop, to Amsterdam where he studied theology, and on to Brussels where he followed a course on preaching. In January, 1879, he was appointed as a missionary to the Borinage, a mining district in Belgium. During his stay

there he found out, as he said himself, what it was to be wretched. He insisted on sharing the hardships and poverty of the miners, and often gave them all he had. It was a period in which he wore himself out, mentally and physically, and he never entirely recovered his health.

During the summer of 1880 while he was still working in the Borinage, Van Gogh decided that the best thing he could do with his life would be to devote it to painting. He explained how he felt to his brother, Théo, who from then on helped him unstintingly in every way he could. Van Gogh's training as an artist was as erratic as his earlier efforts to be a missionary. After leaving the Borinage, where he had filled his notebooks with drawings of the miners and their way of life, he went first to Brussels, in 1880, to study anatomy and perspective, and then to Etten, where his family had recently gone to live. Not only did he have to put up with their disapproval of his artistic ambitions, but he also experienced his second unhappy love affair, this time with a widowed cousin who was staying there. (The first had taken place during his stay in London in 1874.) He spent the winter of 1881 at The Hague where he began to paint for the first time, under the supervision of his cousin, Anton Mauve. He was then sharing what little he had to live on with Christine, a prostitute whom he left only when forced by his lack of money to join his family who were then at Nuenen. He stayed for about two years at Nuenen, working extremely hard; during this time he was deeply affected by the attempt of Margot Begemann, a neighbour, to commit suicide after her family had refused to allow her to marry him.

After the sudden death of his father, Van Gogh again needed money and went first to Antwerp in the winter of

1885 and then, inevitably, to Théo in Paris, where he spent the next two years. During this time he further developed his technique and laid the foundations for the great paintings which were to follow. He attended the art school run by Cormon where he became acquainted with Toulouse-Lautrec, Bernard, and other young painters. He took part in the lively arguments about the further development of the Impressionist style, and sided with the Divisionists and the Synthetists. He met artists like Pissarro, Seurat, Signac and Gauguin, to the last of whom he grew very attached; after Van Gogh had gone to Arles to rest, he invited Gauguin to join him there. He came in October 1888 and for the next two months both he and Van Gogh worked extremely well together. They were, however, utterly different in character, and their endless arguments wore out Van Gogh. On 24 December, in a fit of madness, he tried at least twice to attack Gauguin with a razor blade and ended by cutting off a piece of his own ear in order to punish himself. It was the first of the attacks of insanity which eventually caused his death.

In May, 1889, he entered the mental asylum at Saint-Rémy-de-Provence in order to be under closer supervision, but his health became increasingly unstable. After a year there he went to Auvers-sur-Oise, where Doctor Gachet (Plate XVI), a supporter and pioneer collector of the Impressionists' works, had agreed to look after him. On his way there he was able to stay for a short time with Théo in Paris. Although things seemed to be going better for him, only two months after his arrival at Auvers, he succumbed to a particularly severe attack of madness and shot himself. He died two days later on 29 July, 1890, with Théo and his friend Gachet by his side.

'For an artist death is not, perhaps, the hardest thing to bear.'
— VINCENT VAN GOGH

'THERE IS AN insistence throughout on the right to dream, the right to paint grass blue, the right to reach up to the stars which is impossible in a photographic facsimile of nature. Short-sighted descriptions of social events, blind portrayal of the superfluous aspects of nature, observation without insight, visual tricks, pride in being as scrupulously and as tritely accurate as a daguerreotype, none of these can any longer satisfy any painter or sculptor worthy of the name.' In these words Albert Aurier, a young poet who, during Van Gogh's lifetime, was one of the few critics to value his work and the only one to write about it, summarized the attitude towards painting in France around 1892, when Symbolism was at its height. Van Gogh occupies a unique and, some think, certainly superior, position to that of Gauguin, Redon, Seurat or Toulouse-Lautrec, the other major artists of this Post-Impressionist period. He was a visionary whose main interest lay in probing the depths of human emotions and in moving beyond the outward appearances of things, but his imagination was never abstract or escapist. On the contrary, it sprang from and was developed by his study of reality. Van Gogh felt committed to reality, to discovering more about both the world outside and that within him. Even though frightening emotions might destroy his peace of mind, the rotating sun seem to threaten him, the olive trees to writhe in mute suffering, and the cypresses to turn into dark flames of despair, he felt that he must portray the actual world in which he lived rather than a fantasy world created in his imagination. He represented the stars above (Fig. 5), the flowers (Plate IX), and the growing wheat (Plate VI-VII) as illustrations of how nature continues her life-giving cycles of germination and birth, regardless of human suffering. 'I preferred the melancholy which hopes and aspires and seeks to that which despairs in stagnation and woe,' Van Gogh wrote, courageously resolving not to run away from his suffering in flights of escapism, but to accept it for what it was and to try to master it, realizing that he must do this in order to create something of positive value. He achieved this aim, but at appalling cost; and the intense strain under which he worked can be felt in every one of his paintings. He found in painting a means of bringing his influence to bear on other people in a way which he personally had been unable to achieve: through his vision he shows us his own feelings. Yet to Van Gogh reality was not merely an

1. SELF-PORTRAIT WITH BANDAGED EAR 1889
Mr. & Mrs. Leigh B. Block Collection, Chicago

appearance which could be distorted as the artist pleased in order to allow his emotions and imagination freer play; it was a condition of his art that his paintings should reflect his own feelings and at the same time represent natural appearances.

This approach to painting, which undoubtedly owed much to the theories of the Symbolists, necessitated absolute honesty in portraying his own emotions and, at the same time, abolished reliance on traditional techniques. Van Gogh realized how difficult a task he had set himself but he undertook it with a degree of courage and enthusiasm the more remarkable in one who was suffering from severe neurosis. He tore down all his defences and rejected symbolic and figurative representation in order

to reveal his inner state. Each painting seems like the page of an illustrated diary in which he has set down his hopes and disappointments, his suffering and his flashes of enlightenment. At first his neurosis did little damage to the record, but as time went on it came to obliterate whole weeks and months. The diary is unfinished, but the obvious worth of what he did manage to set down has established Van Gogh's reputation both as a painter and as a poet.

THE GREAT PAINTINGS which Van Gogh finally achieved were preceded by long periods of exhausting studies and frequent doubts. As a boy he had taken pleasure in drawing houses and landscapes in the naturalistic Dutch style, but at that time he did not feel a real vocation for painting, rather an appreciative interest which grew during his apprenticeship as an art dealer. He went on to devote himself enthusiastically to his work as a missionary. This was a bitter failure; and yet it was during the years which he spent among the miners in the Borinage that he discovered his true vocation as a painter. His art formed a part of his efforts to help humanity: his drawings became a way of honouring the life of the miners with its hardships and its poverty.

Among the modern painters he admired above all Millet who, as he said, had opened up 'new vistas'. Of the Old Masters he preferred Rembrandt and Hals. It was the human element in painting which interested him: he dwelt on the emotional content of a picture rather than on its style. His early drawings are technically awkward, rather amateurish in their rough outlines and shading. Van Gogh realized that he needed to study further and applied to his cousin, Anton Mauve, a talented painter of The Hague School, who gave him advice and introduced him to other artists in the city. Mauve did not succeed, however, in making his restless pupil work in a disciplined or in a consistent fashion.

It was in 1882 during this stay in The Hague that Van Gogh first began to paint. Until this time he had confined himself to drawing. His early paintings (Plate I) are heavily

2. PEASANT WOMAN PLANTING BEETROOT 1885
Museum Boymans-van Beuningen, Rotterdam

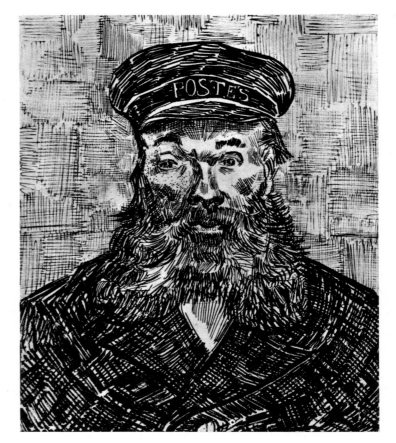

3. THE POSTMAN ROULIN 1888
H. Hahnloser Collection, Winterthur

indebted to the realism of the Dutch School. They show a marked use of chiaroscuro and of dark patches of colour, and the paint is applied very thickly. He had not yet mastered the technique of oil-painting. His style was freer and more immediately expressive in his water-colours in which he achieved some complex spatial effects against boldly executed landscapes. In his drawings, besides sketches of people, he also attempted symbolic themes derived from contemporary English art. He continued to base his subject matter on the labours of men and the cycle of nature during his years at Nuenen (1883-85). The unsophisticated paintings of this period are nevertheless far from naive. They show a deliberate attempt to use clumsy outlines, thick and bituminous paint, bold and distinct brush strokes, and basic contrasts of light and shade in order to portray the life of the local peasants and workmen in all its harshness and suffering (Fig. 2). *The Potato Eaters* (Plate I) marks the final stage in this experiment. Van Gogh's social and moral purpose in painting is successfully realized in the hands disfigured by work and the bony and lined faces which are harshly emphasised by the forceful brush strokes. The painting also shows that he had exhausted the possibilities of this style. His aim had been to paint entirely in the Dutch manner, to imitate Rembrandt and Hals; and he had ignored the recent developments taking place in Paris. But once he had completed the painting on which he had placed all his hopes, he felt that he had come to a dead end, and that he must from then on approach his work in a completely different way.

IN THE LETTERS he wrote in October, 1885, Van Gogh frequently remarked on how expressive was the medium of colour. Up till then he had neglected colour for dark chiaroscuro and heavy impasto. This interest in the use of colour grew when he discovered Japanese colour prints

180

during his stay at Antwerp in the winter of 1885. Now that he had decided to change his style, he began to pay attention to Théo's descriptions of how the painters in Paris were making their colours shine with all the brightness of sunlight. He decided to go to Paris; and arrived there in February, 1886.

Van Gogh's two years in Paris mark a new stage in the development of his technique. At the age of thirty-three he had to start again from scratch. After some still-lifes in which, influenced by Monticelli, he again applied the paint thickly, he finally shook off all the traces of traditional techniques. The Impressionists did not influence him as much as did the original ideas and aims of those artists who wanted to go beyond 'plein air' and the exact reproduction of nature to conquer new fields. On the one hand there were the Divisionists who were attempting to systematize the lyrical improvisations of Monet and Renoir, trying to create the effects of volume and space through the use of small dots of colour which, though separated on the canvas, would merge when seen from a distance. On the other hand there were the Synthetists, Bernard and Gauguin, who used large areas of colour devoid of any descriptive or naturalistic function, and who loaded their work with symbolic and literary meanings. Van Gogh did not join either of these movements. Both of them were foreign to his nature; the first because of its extremely

strict rules, and the second on account of its intellectual and escapist attitude to reality. However, he took from them whatever he found useful: a decorative use of colour from the Synthetists and abrupt, clearly defined brush work from the Divisionists. Added to these influences and of primary importance, was his renewed admiration for the Japanese colour prints with which he had decorated his room at Antwerp. In Paris he made use of them in his paintings, and they even form the background to some of his portraits (Plate II).

Van Gogh's connection with oriental art and its importance to his stylistic development seem hard to understand, for the serenity of Japanese prints bears no resemblance to the tortured mood of his own paintings. It was, however, precisely this serene and joyous quality, free from all trace of suffering, which attracted Van Gogh as a welcome change from his own unhappiness. The most easily available prints in Paris were those of Hokusai, Hiroshige and Utamaro: they were displayed in large numbers at the Bing Gallery, and they introduced him to a style which relied exclusively on colour and outline to define space and atmosphere, form and light, and which finally led him to abandon the use of chiaroscuro. The influence of these prints can be seen not only in some very light, brilliant landscapes which he painted between the end of 1886 and the beginning of 1887 (see Plate III), but

4. THE RHÔNE RIVER AT NIGHT 1888
Private Collection, Paris

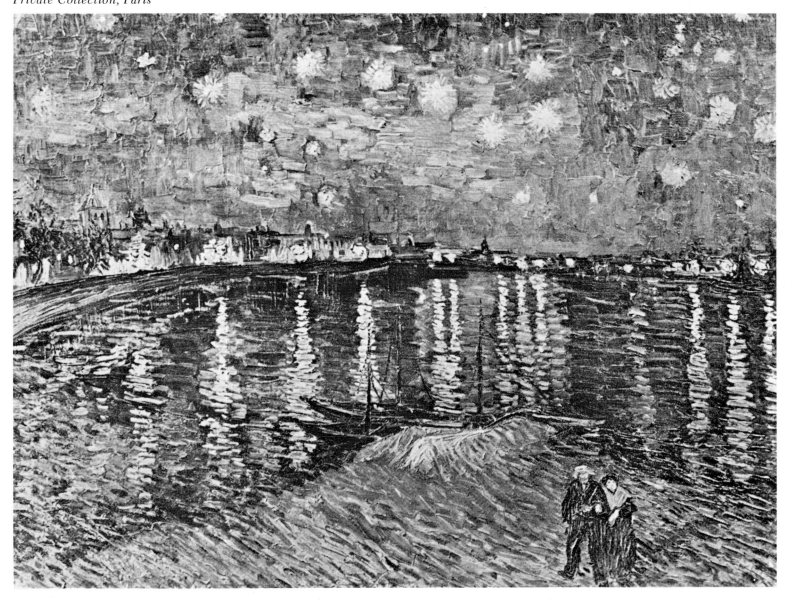

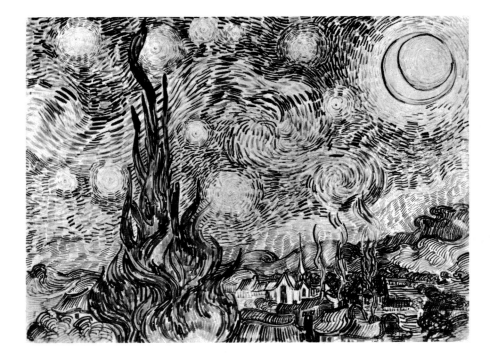

5. STARRY NIGHT 1889
Kunsthalle, Bremen

also in drawings where outlines and short brush strokes are emphasised in order to give an impression of depth and a solar brightness of colour.

In 1887 Van Gogh's interest in Japanese prints led him to make greater use of the Divisionists' technique. He had noticed how their small dots of colour helped to increase the brilliance of the paintings. He did not follow, however, the strict rules to which Seurat and Signac adhered (of the two, Van Gogh's work more closely resembles that of Signac, particularly in his graphic use of brush strokes), for he could not contain the great stress of emotion under which he worked within any predefined limits. He never identified himself completely with the Divisionists, and may have seemed to them to have only partially understood their methods. In fact, he seldom used isolated dots of colour, preferring to convey the full force of his colours through brief outlines and vigorous brush strokes whose constant interaction was charged with his own energy. By the end of 1887 this stage in his development was complete. He was now equipped with an entirely original technique based on vibrant colour and light; his work was designed and constructed with freedom and immediacy; and his writhing forms were fully expressive of his intense emotions, which ranged from wild elation to the depths of despair.

THE ENDLESS CONTROVERSIES and dissensions between the different movements in Paris exhausted Van Gogh, and in February, 1888, he settled in the more peaceful surroundings of Arles, in Provence, in order to gather his thoughts and to work undisturbed. At first, there was little change in his painting, but during the summer his colours became intensified and light blazed from his canvases. This development marks the successful end of a process which he had begun months before with the second version of the *Portrait of Père Tanguy* (Plate II); and it also heralds the period of intense activity which lasted until his death two years later. His use of decorative colours and distorted forms now fully and vividly conveyed his feelings about the people and objects which he painted and the emotions which he discovered in even the most ordinary things.

Van Gogh's greatness lies in his having penetrated the defences which we erect against reality, and in having given the image of reality the imprint of his own inner-most feelings. After Gauguin had joined him at Arles, Van Gogh's technique grew less sure and at times he painted in large areas of colour which do not fully convey his meaning; yet some of these paintings have an intensely luminous quality that he was never again to achieve.

AFTER THE FIT of madness which led to his attack on Gauguin, Van Gogh's life became increasingly unhappy, and his work suffered correspondingly. Periods of furious activity alternated with times of depression when he was unable to accomplish anything. His neighbours insisted that he go into the hospital at Arles. This was a severe blow. He lost his self-confidence, was afraid that the attacks of insanity would recur, and eventually, of his own accord, entered the mental asylum at Saint-Rémy. Painting was now the only way in which he could retain contact with normal life; and the approximately one hundred and fifty pictures which he painted during his year at the asylum bear witness to his desperate longing to live. Whenever the neurosis did not prevent his working, he gave vent to his tormented sensibility and his longing for communication with the world, in his painting. His brush strokes twisted and turned with his fluctuating emotions; for him nature came to represent the inescapable disasters which overwhelm mankind.

In May, 1890, Van Gogh bravely decided to leave Saint-Rémy for Auvers-sur-Oise where Doctor Gachet, himself a painter and a friend of Cézanne and Pissarro, had agreed to take care of him. Once away from the depressing atmosphere of the mental asylum, he felt happier and more at peace with himself and the world, as can be seen in the paintings of this period. The deceptive nature of this calm is shown, however, by the frequently harsh brush strokes and the overriding sense of inner strain. In July, Van Gogh shot himself and put an end to his suffering on a day when the sun shone, the wheat was at its most golden, the sky bluer than ever, and the black crows were flying away in alarm, just as in one of the pictures which he painted in that same month (Plate XV).

After his death his work attracted increasing attention, and has influenced many painters, from the Fauves to the Expressionists. Today, Van Gogh stands as a rare example of dedication to mankind and to art, a dedication which led to despair and eventually to his death.

The Plates

I. THE POTATO EATERS 1885
Oil on canvas. 32 in. × 44¾ in.
Detail.
National Museum Vincent Van Gogh, Amsterdam

Van Gogh worked on this painting for a long time during his stay at Nuenen. It marks the end of the first stage in his development when he relied on the use of heavy chiaroscuro. His deep love for the earth, and the peasants who work it, is shown here most vividly.

II. PORTRAIT OF PÈRE TANGUY WITH JAPANESE PRINTS 1887-88
Oil on canvas. 25½ in. × 20 in.
Stavros S. Niarchos Collection, Paris.

Van Gogh painted several portraits of this humble dealer in artists' materials who was a friend of his. In this version the brushwork and the vivid colours look forward to the period at Arles. The inclusion of Japanese prints in the background was not only meant to serve a decorative purpose. As in Manet's portrait of *Zola* (Louvre, Paris), they are a conscious allusion to the great interest *avant-garde* artists took in Oriental art.

III. THE DRAWBRIDGE AT LANGLOIS 1888
Oil on canvas. 20¼ in. × 26⅜ in.
Wallraf-Richartz Museum, Cologne

This is probably the last of a number of paintings of this scene. The small drawbridge is portrayed in a light and even tonality in the Japanese style. The intensity of feeling foreshadows Van Gogh's last works.

IV. LA MOUSME 1888
Oil on canvas. 29 in. × 23½ in.
National Gallery of Art, Washington D.C.
(Chester Dale Collection)

This is a sensitive and expressive portrait in which Van Gogh successfully and distinctively made use of all that he had learnt from the Japanese prints: a light and brilliant tonality and the juxtaposition of patches of colour. The title comes from a novel by Pierre Loti.

V. BOATS AT SAINTES-MARIES 1888
Oil on canvas. 26 in. × 32 in.
V. W. van Gogh Collection, Laren

This very fine painting with its brilliant decorative colours reveals how effectively Van Gogh combined reality and his own emotions in his work. The intense light which the colours throw upon the scene makes an immediate emotional impact.

VI-VII. HARVEST — THE PLAIN OF LA CRAU 1888
Oil on canvas. 29 in. × 36¼ in.
V. W. van Gogh Collection, Laren

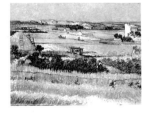

At Arles Van Gogh put into practice all that he had learnt in Paris, using brilliant colours and short brush strokes. The sunny Provencal countryside was one of his favourite motifs.

VIII. THE ARTIST'S BEDROOM AT ARLES 1888
Oil on canvas. 28⅜ in. × 36¼ in.
V. W. van Gogh Collection, Laren

Just as Van Gogh showed the 'terrible passions of humanity' by means of jarring colours and conflicting brush strokes in his two versions of *The Café at Night* (Plates X-XI and XIII), so here the luminous harmony of light and colour gives an impression of quiet and rest.

183

IX. SUNFLOWERS 1888
Oil on canvas. 37¾ in. × 28¾ in.
V. W. van Gogh Collection, Laren

Van Gogh decorated the little yellow house at Arles with several paintings of sunflowers. Here he concentrates on a brilliant yellow, with an almost dazzling effect.

X–XI. THE NIGHT CAFÉ 1888
Oil on canvas. 28¾ in. × 36¼ in.
Stephen C. Clark Collection, Yale University Art Gallery, New Haven, Conn.

'In my picture,' wrote Van Gogh, 'I have tried to show that the café is a place where one can ruin oneself, go mad, or commit a crime.' 'I have tried,' he added, 'to show the terrible passions of humanity by means of red and green' — a thought, incidentally, that is characteristically Symbolist.

XII. PORTRAIT OF ARMAND ROULIN 1888
Oil on canvas. 25⅝ in. × 21¼ in.
Folkwang Museum, Essen

This portrait, which was painted during Gauguin's stay at Arles, shows how Van Gogh succeeded in striking a note of lyric serenity and human sympathy when portraying those who were dear to him. The Roulin family were the only neighbours with whom Van Gogh was on friendly terms.

XIII. THE CAFÉ AT NIGHT: EXTERIOR 1888
Oil on canvas. 31 in. × 24¾ in.
Rijksmuseum Kröller-Müller, Otterlo

Under the stars which shine like a hope of future salvation, the uneasy light of the café attracts and ensnares the passer-by, threatening him with a ruin which is terrifyingly close at hand. The café, a typical feature of 'modern life', is a motif that constantly recurs in the work of artists dedicated to contemporary urban subject matter — for example, Degas, Manet, Toulouse-Lautrec and Renoir.

XIV. CYPRESSES 1889
Oil on canvas. 36¾ in. × 29⅛ in.
Metropolitan Museum of Art, New York

The intense strain of emotion which Van Gogh felt is brought out in the tonality and, even more forcefully, in the abrupt brush strokes of this work. The cypresses become dark flames of despair which rise up under a sky heavy with pain and sadness.

XV. CROWS OVER THE WHEAT FIELDS 1890
Oil on canvas. 19⅞ in. × 39½ in.
V. W. van Gogh Collection, Laren

The two months of ceaseless activity at Auvers yielded at least seventy paintings. Some of these show Van Gogh with renewed vitality; others, including this painting, express violent and uncontrollable emotion. Here his suffering and despair are vividly expressed. This is among the very last of his works.

XVI. PORTRAIT OF DOCTOR PAUL GACHET 1890
Oil on canvas. 26¾ in. × 22½ in.
Louvre, Paris

Van Gogh wrote 'I should like to paint portraits which will seem like ghosts to people in a hundred years' time'. There is certainly a haunting quality about this portrait of his friend, in which he has expressed his affection by means of the more delicate tonality.

I

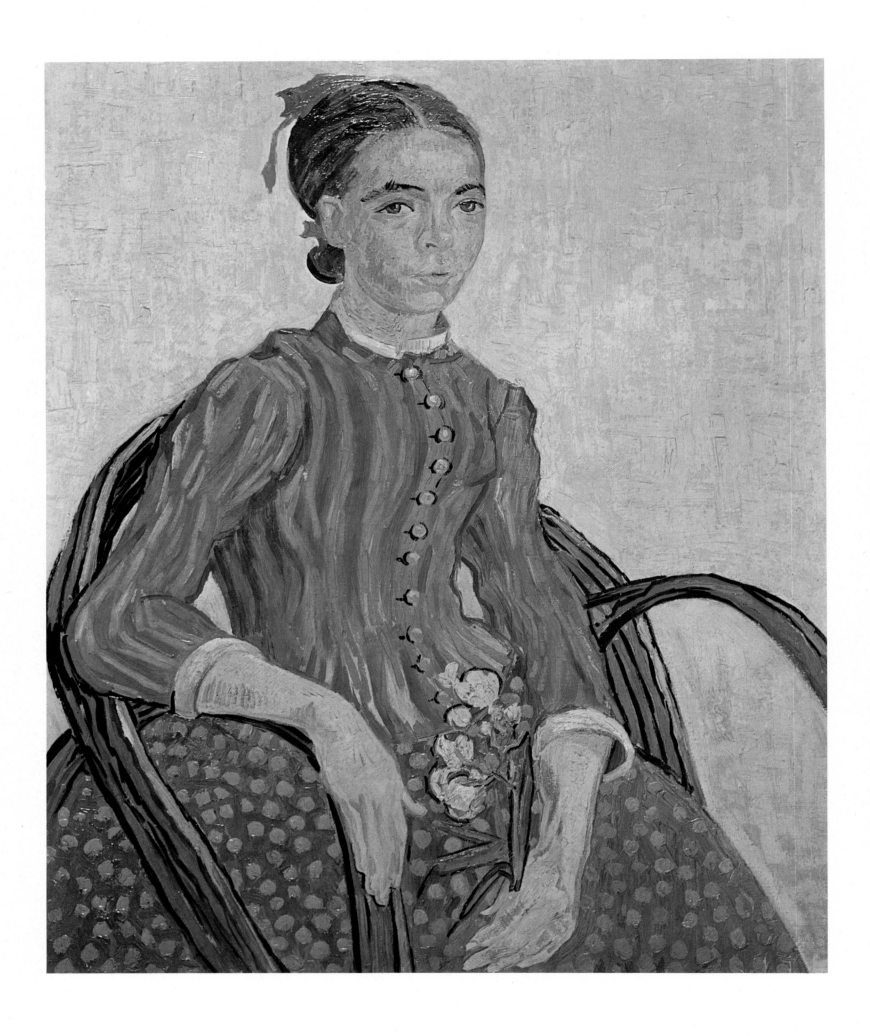

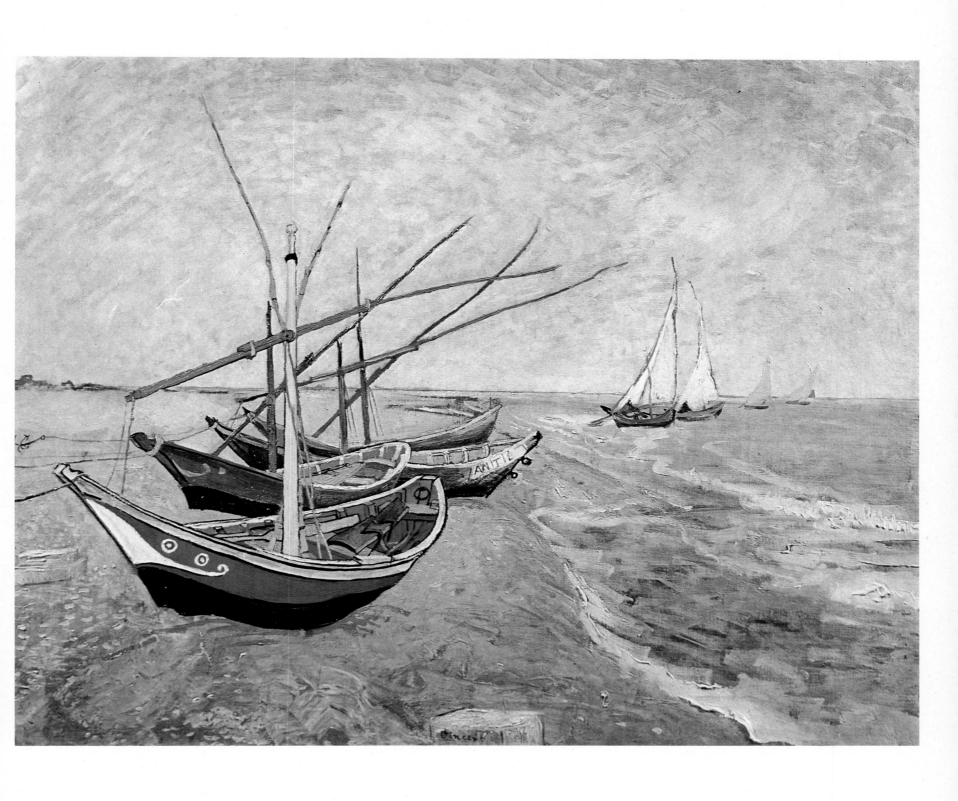

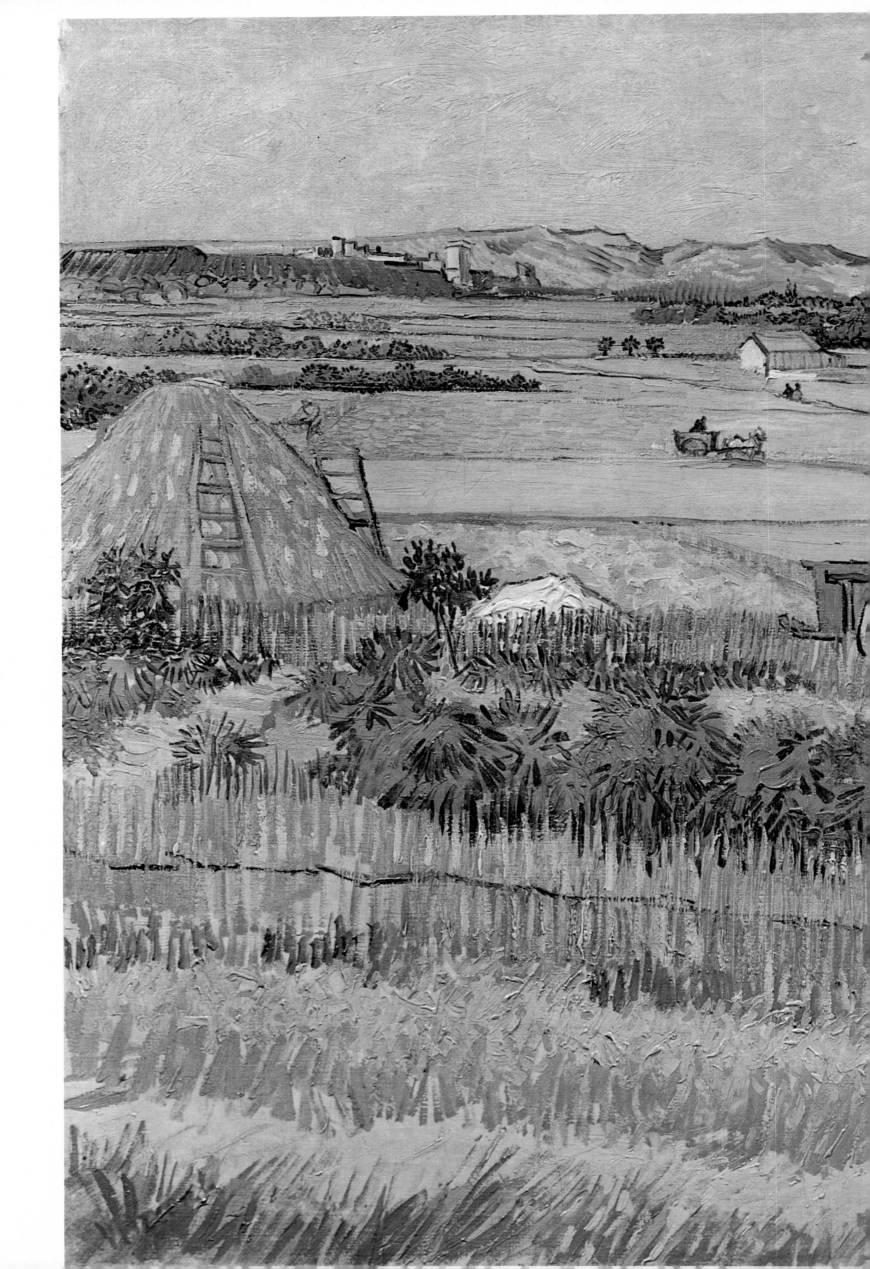

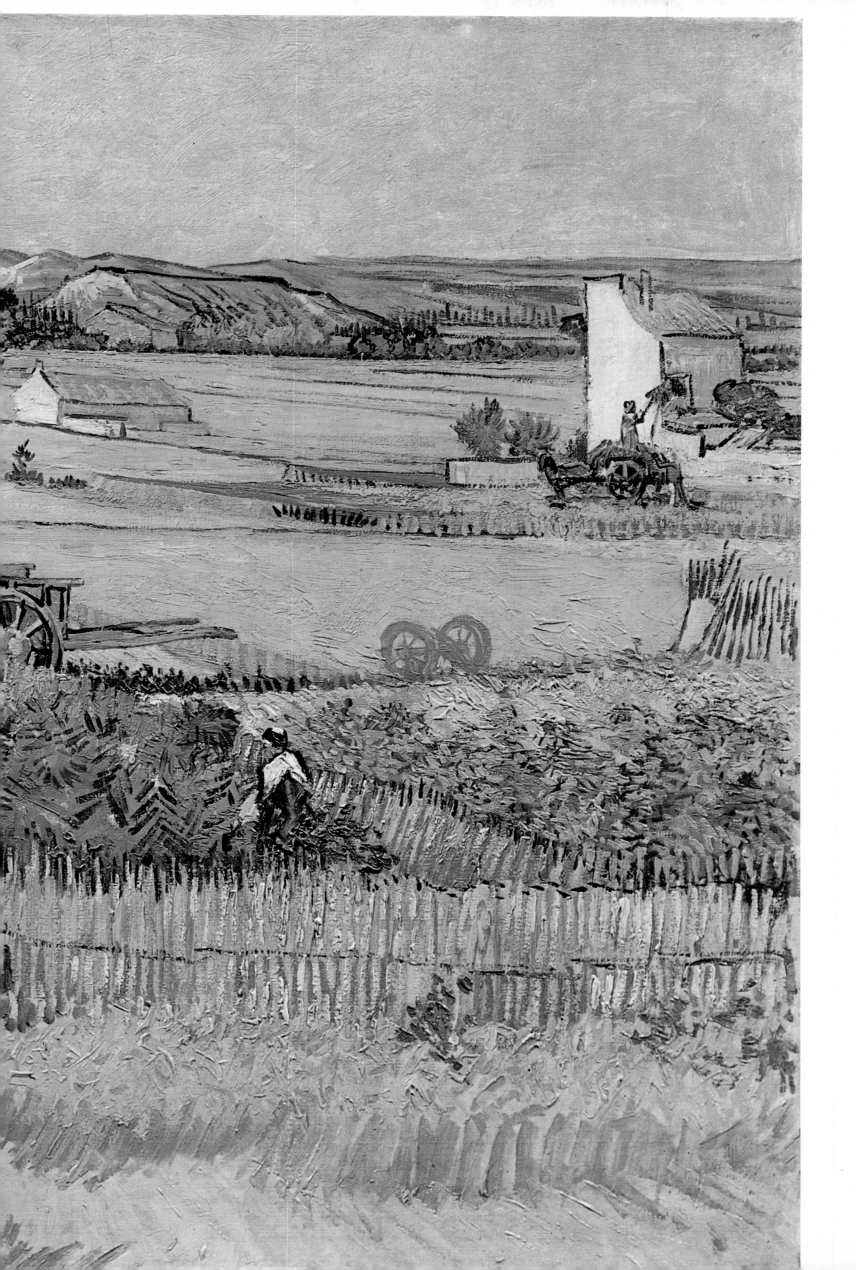

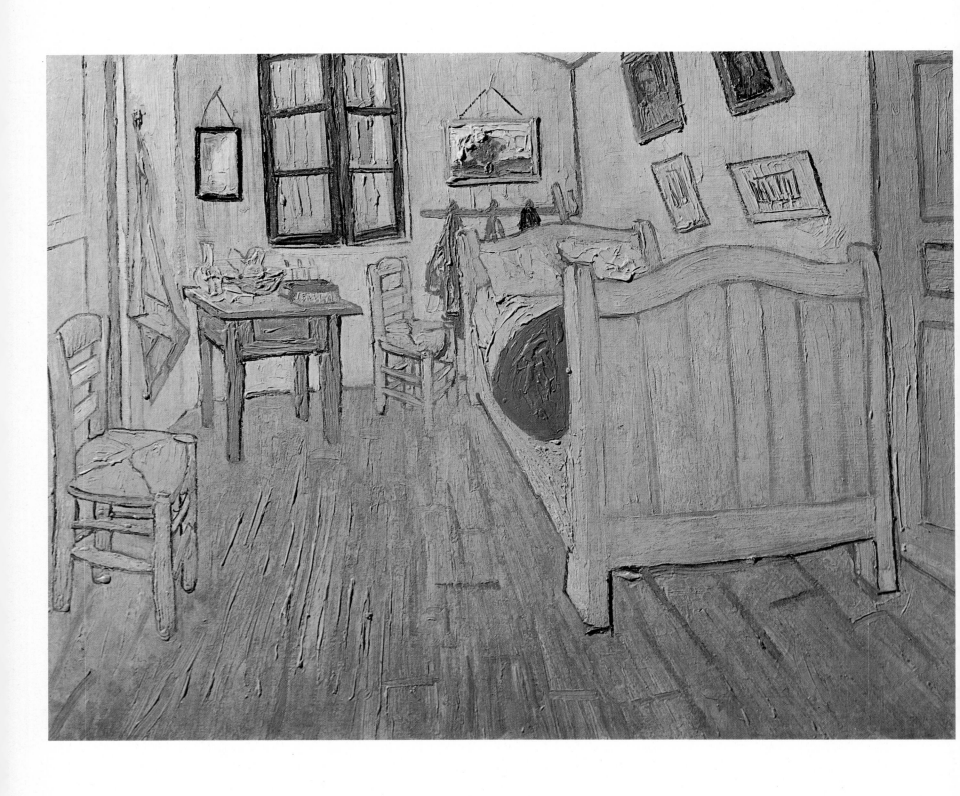

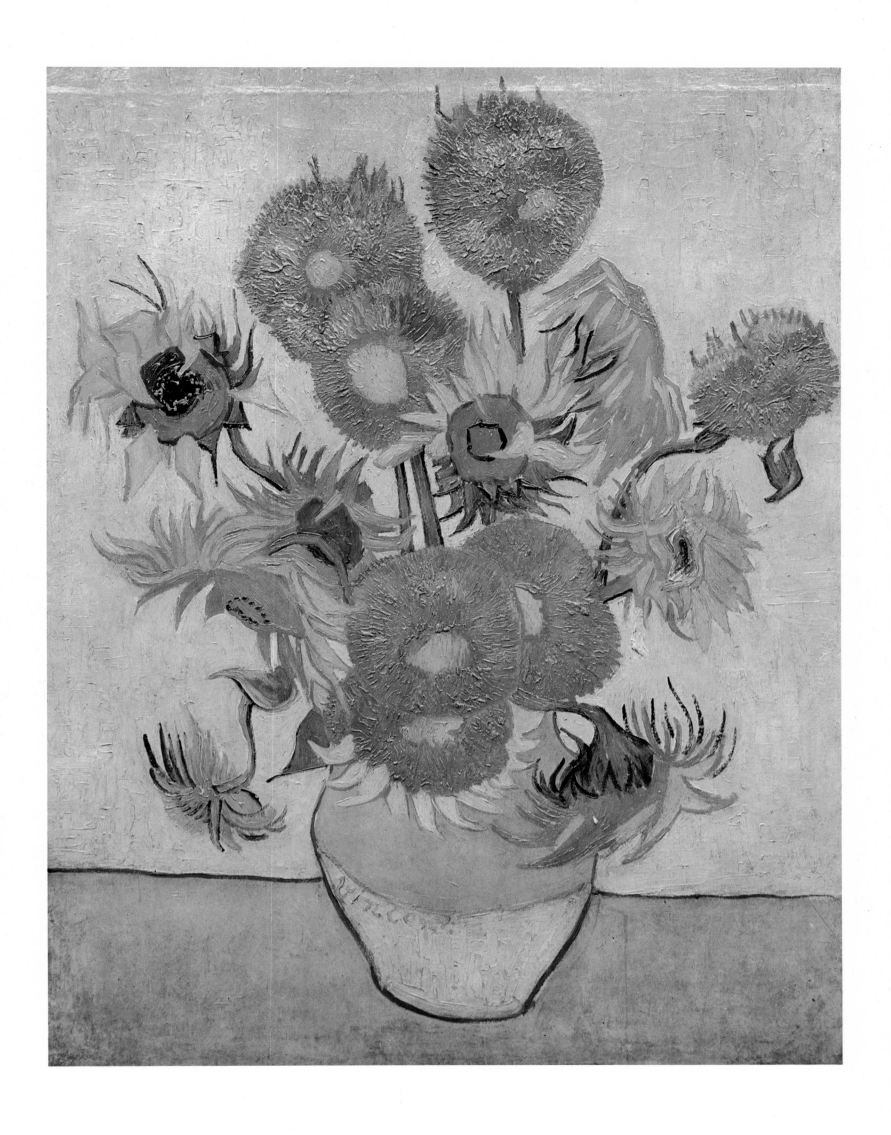

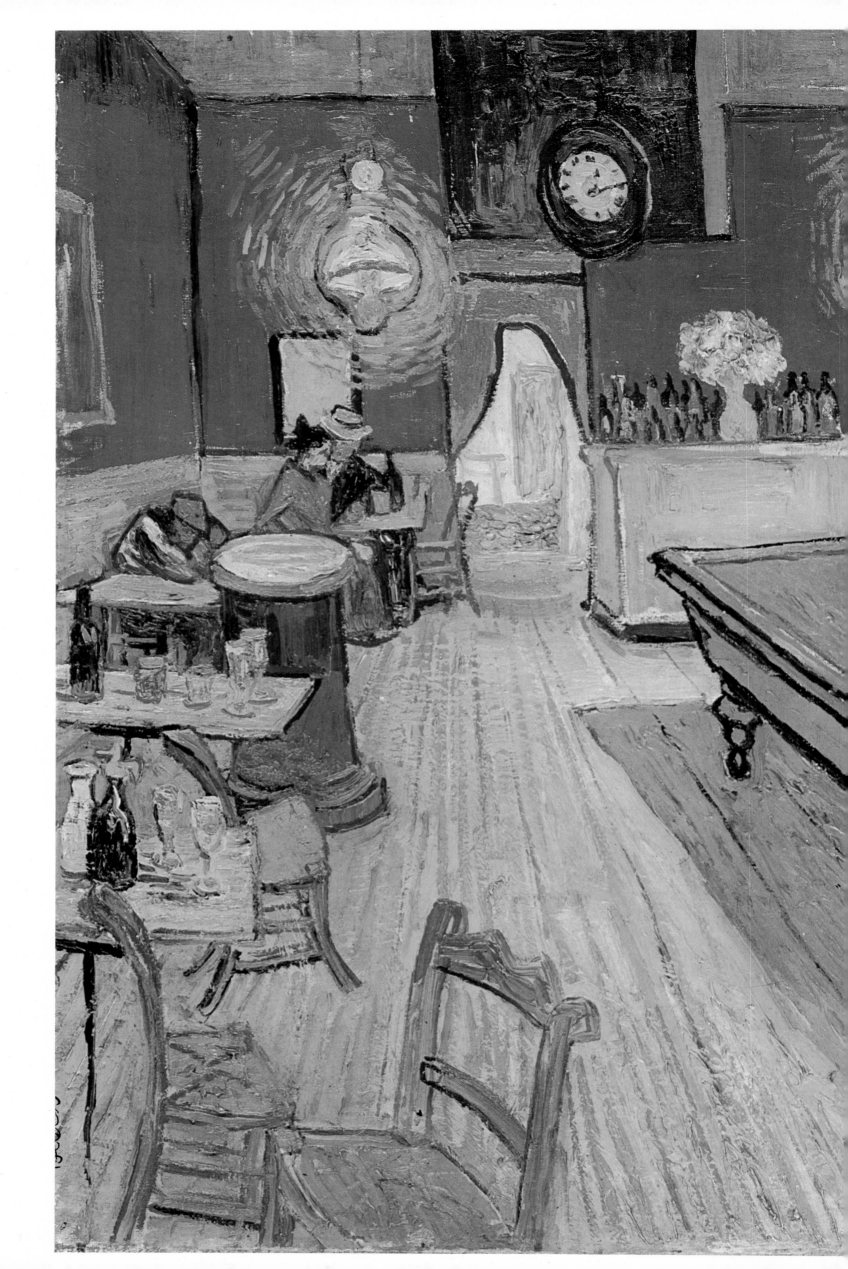

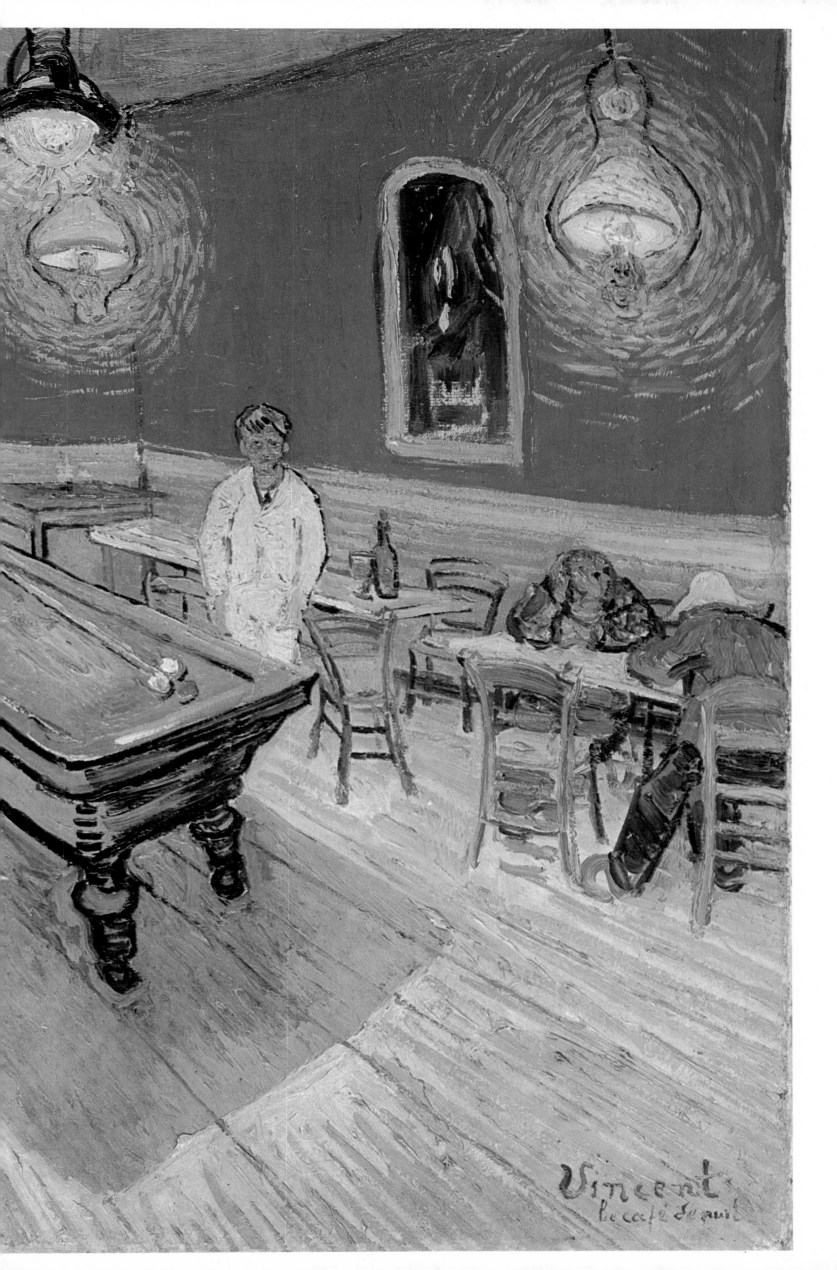

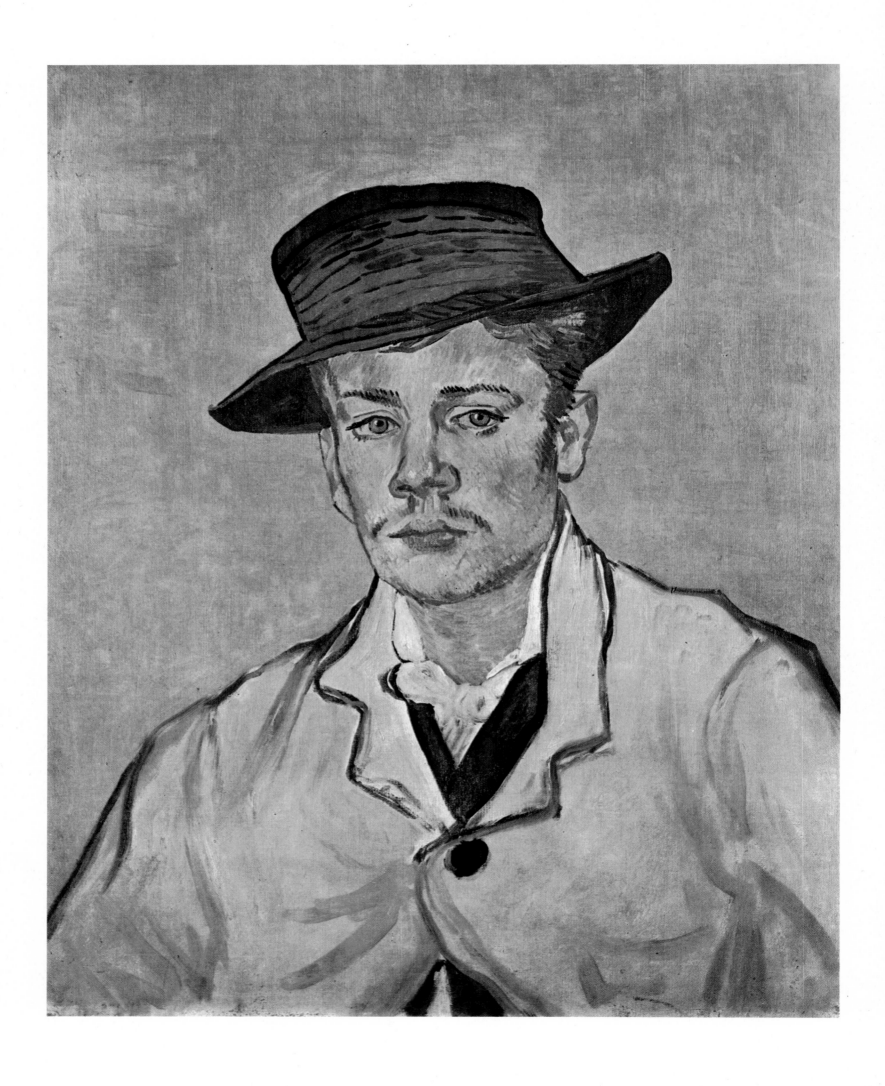

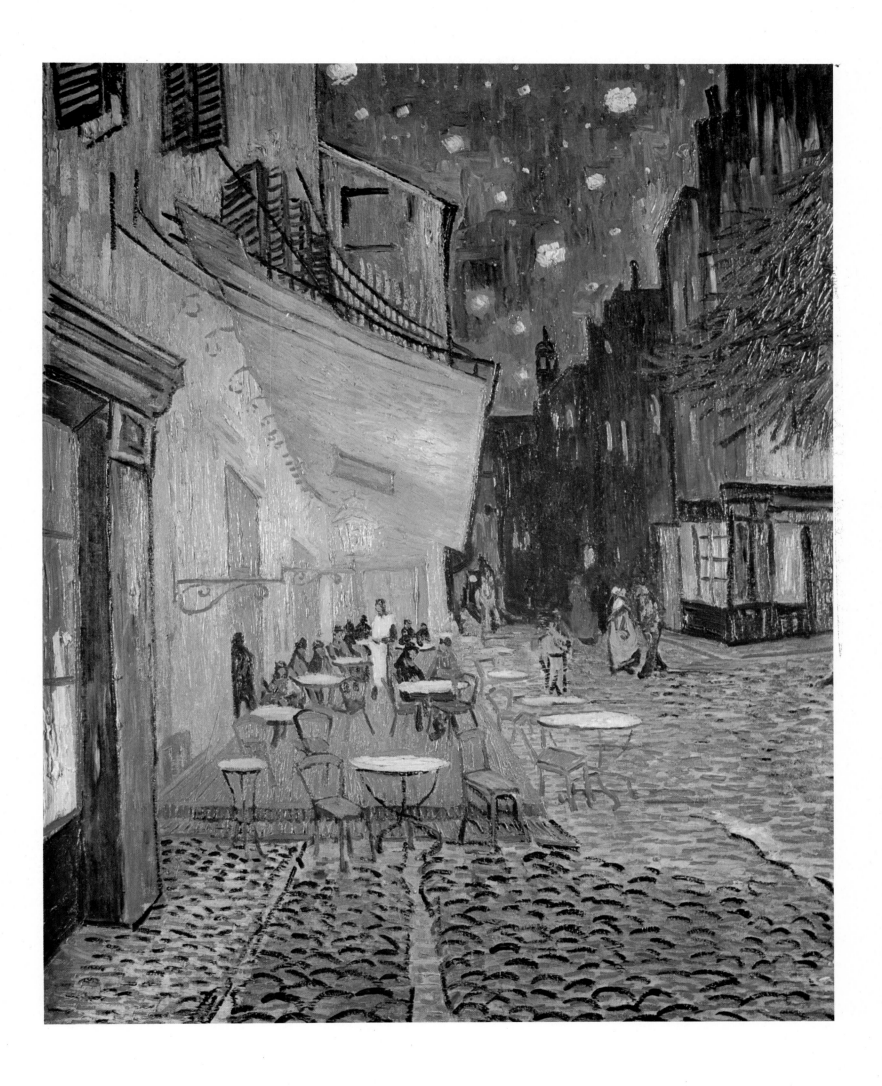

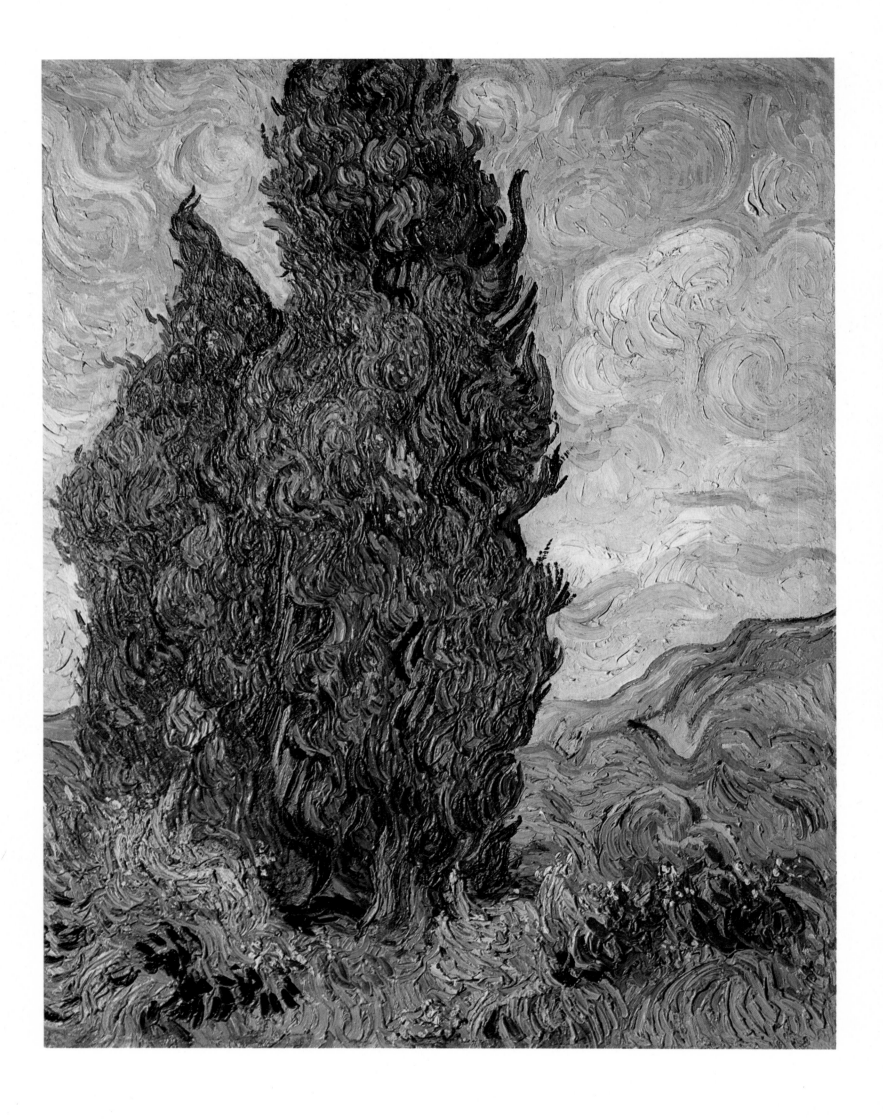

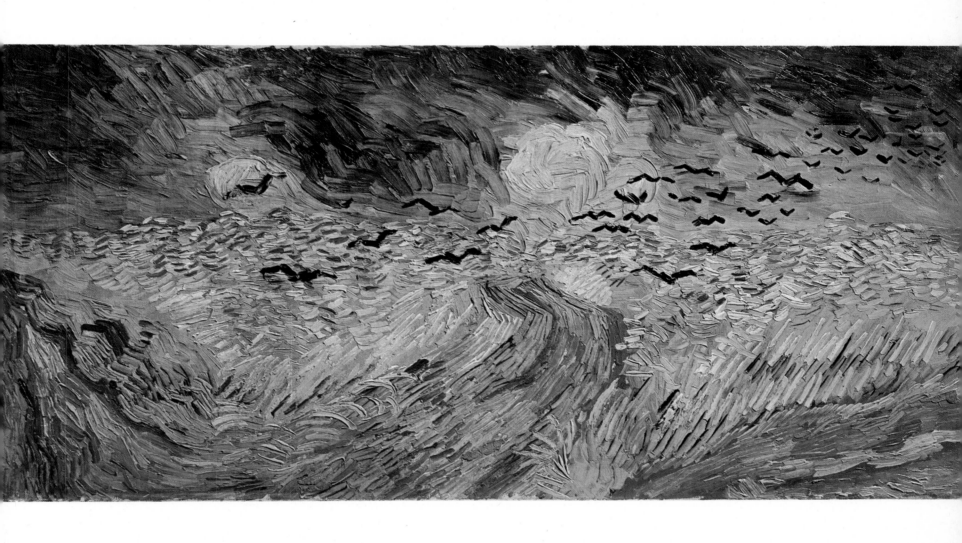

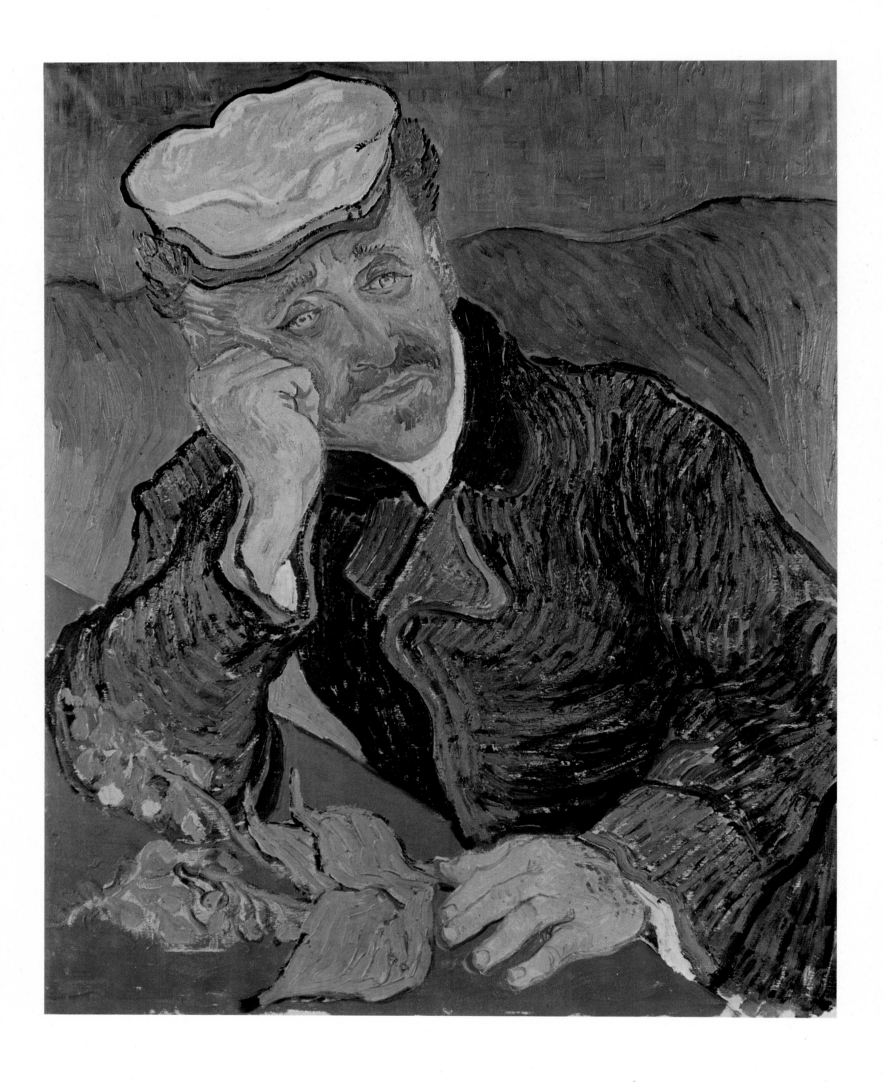

Henri Matisse

Henri Matisse 1869-1954

The son of a grain merchant, Henri Matisse was born at Le Cateau-Cambrésis, in northern France, on 31 December 1869. After spending a year at the Law Faculty in Paris, without ever having visited a museum or an art exhibition, he returned to the provinces and took a post as a clerk in a law office. In 1890, when Matisse was aged twenty-one, chance brought to light a vocation of which there had been not the slightest indication: to distract him during a long convalescence, his mother bought him a box of paints; and he was at once transported into 'a kind of paradise' which was to become his natural dwelling-place. After some lessons in drawing in his native city, he overcame his father's opposition and in 1891 was allowed to go to Paris to follow regular courses in painting. He attended the Académie Julian, then in October 1892 enrolled in the evening courses at the École des Beaux-Arts, where he struck up a firm friendship with Marquet.

In 1892 Gustave Moreau became interested in his work and admitted him without examinations to his famous studio where Rouault, Desvallières, Piot and Evenepoel were already assembled, to be followed by Flandrin, Camoin, Manguin and Linaret. In this open and liberal environment, his interests expanded, while he continued to study patiently and methodically by copying at the Louvre and from the model, showing a preoccupation with 'values' which preceded the later explosion of colour. In 1896 and 1897, while he was exhibiting at the Salon de la Société Nationale pictures which were still low in tone, he spent two consecutive summers at Belle-Ile welcomed by the Australian painter and friend of the Impressionists, John Russell, who put him in touch with Rodin and Pissarro. After his marriage, which took place in January 1898, he travelled to London where he saw the works of Turner, then settled for a year in Corsica and in the region of Toulouse, dazzled by the light of this Mediterranean region in which he was to discover his natural environment.

On his return to Paris, in 1898, he gave up all official connections to carry out his own personal research unperturbed by his grave material difficulties. He studied the figure in an art school in the rue de Rennes, where he met Derain and Jean Puy, and also began sculpture under the influence of Barye and Rodin. He exhibited regularly at the Salon des Indépendants from 1901 and at the Salon d'Automne from the year of its foundation (1903). A first one-man exhibition at Vollard's, in June 1904, recorded his intensive formation. He afterwards went to St. Tropez to join Signac and Cross, and from them he adopted for a short time the pointillist technique. In the summer of 1905 he took Derain to Collioure. Shortly afterwards he became the chief protagonist in the historic Salon d'Automne in which the central room devoted to the Fauves created a scandal and sensation. In 1906 he sent to the Indépendants a major composition, La Joie de Vivre (Barnes Foundation, Merion), held a second one-man exhibition at the Galerie Druet, took up etching and lithography, and met at Gertrude and Leonard Stein's, his young rival Picasso.

A series of journeys took him to Algeria in 1906, to Italy in 1907, to Germany in 1908 and 1910, to Spain in 1910, to Moscow in 1911, and finally to Morocco in 1912 and 1913.

In this way his influence spread across the entire world and this prompted him to open, from 1908 to 1911, a private art school. In 1909 he settled at Issy-les-Moulineaux on the road to Clamart where he remained until 1917, painting a succession of great works most of which were bought straight away by the Russian collectors Shchukin and Morosov.

In 1917 he accompanied Marquet first to Chenonceaux, afterwards to Marseilles, and discovered at Nice the brilliant light which forms an essential part of his vision. In 1921 he decided, while keeping a house in Paris, to settle once and for all on the shores of the Mediterranean, and this climate of luxury and serenity permeated the second half of his life. He revisited England in 1920, Italy in 1925 and 1930, went back twice to the United States in 1930 and 1933, while a stay in Polynesia in 1933 encouraged him to make a journey round the world. He designed costumes and scenery for ballets in 1920 and 1939, and devoted himself from 1948 to 1951 to the construction of the Dominican Chapel of the Rosary at Vence, which was to be the monumental synthesis of his activity and his artistic testament. He died on 3 November 1954 on the hill of Cimiez, where he lies in the landscape he loved, close to the museum devoted to his memory and his genius.

'What I dream of', said Matisse, 'is an art of balance, of purity and serenity.'

Painter, sculptor, engraver, decorator, for the whole of the first half of this century Matisse (with Picasso) dominated the artistic scene, on account of the importance of his work and the prestige of his personality. He was already twenty-one years old in 1890, when he suddenly became aware of a vocation of which there had been till then not the slightest intimation; but this enabled him all the better to appreciate the exceptional nature of the turn taken by his destiny.

In 1895 Gustave Moreau recognised his gifts and guided them, telling him prophetically: 'You are going to simplify painting.'

BEFORE MASTERING colour, Matisse applied himself systematically to the study of tones, variations of light and subject in a sober, restrained colour range. In the Louvre he copied Chardin, Poussin, Ruysdael; he concentrated on still-life and intimate composition, to such an extent that on 12 March 1896 his Belgian colleague Evenepoel described him as 'a delicate artist, a master of the art of greys'. It was in this vein that he revealed himself in his first exhibits at the Salon de la Société Nationale and the following year in a large canvas of extreme refinement *La Desserte* (Niarchos Collection, Paris), the final work of his classical apprenticeship. During two consecutive summers at Belle-Ile, he was encouraged by John Russell, who gave him two drawings by Van Gogh, stimulated his interest in colour and introduced him to his friends Pissarro and Rodin. Thanks to their encouragement the pace of his development accelerated unexpectedly. This was the start of an explosion of colour, both instinctive and controlled, which continued until 1901 and which burst forth in the 'impressions' brought back from Corsica and Toulouse, in the views of Arcueil and the Luxembourg sketched in company with Marquet, and in the still-lifes seen against the light or viewed looking down from above, and especially in a series of male and female nudes painted with violent expressiveness, as though to liberate himself from every academic convention. The strengthening of his colours led to a corresponding boldness of form, to an incisive assurance of drawing. Matisse moved closer to

Cézanne, instinctively attracted by the structure and energy of his painting. From him he learnt that the colours in a painting are 'forces' which must be integrated and brought into equilibrium. From 1901 to 1903, the art of Matisse, who was now burdened with the responsibility of a family, passed through a somewhat obscure phase. His wife opened a milliner's shop to provide for their necessities and posed in her spare moments. Matisse worked temporarily on a smaller scale in order to accentuate his volumes and masses and also began to make sculpture under the guidance of Rodin. Experimenting with every kind of expressive means carried to its extreme limit, he aspired to the possession of a complete artistic language. Roger Marx, introducing his first one-man exhibition at Vollard's in June 1904, praised 'the ruthless demands upon himself' made by the artist and called attention, behind his varied researches, to his obstinate struggle to develop his natural quality as a colourist. This quality revealed itself with revolutionary consequences during his Fauve period (1905-1908), which was preceded by a phase of pointillist transition produced by contact with Signac and Cross. The classic painting of this phase was the one shown at the Salon des Indépendants of 1905, a modern pastoral with a Baudelairean title: *Luxe, calme et volupté* (Mme Signac Collection).

In the summer of 1905 Matisse left for Collioure on the coast of Roussillon, taking with him Vlaminck's usual companion, Derain. There they had as neighbour the collector Daniel de Monfreid, an old friend of Gauguin's to whom they were introduced by Maillol, and who showed them the then still unknown, sumptuous Tahitian pictures. This was a decisive revelation, which occurred at an opportune moment. Matisse gave up pointillist brush-strokes for flat areas of pure colour, creative of space and light. The change was completed in the *Portrait with a Green Stripe* (Plate V), which was exhibited as soon as it was painted at the historic Salon d'Automne of 1905. The painting has this title because of the bold stripe which divides the face into two beneath the hair and which gives it luminosity and relief without recourse to illusionistic effects. The colours are situated in clearly distinct zones, and they

constitute a harmony made up of dissonance and shock whose intensity is founded on the purity of the elements themselves and on the simplicity of their tension. 'Fauvism was for me', said Matisse, 'an experimentation with means, a way of placing side by side, of combining in an expressive and constructive manner a blue, a red, a green. It was the result of an instinctive need which I felt, and not of a deliberate decision.'

In March 1906, a second one-man exhibition at the Galerie Druet brought together the different aspects of his work, paintings, drawings, sculpture, and the new series of lithographs and woodcuts, but was overshadowed by the presence, at the Salon des Indépendants, of the outstanding monumental composition *La Joie de Vivre* (Barnes Foundation, Merion)—a typical manifestation as well as an epitome of his art—which combines in a brilliant synthesis the traditional contrasting themes of the pastoral and the bacchanal, embodies at one and the same time dionysiac energy and apollonian peace, rhythm and melody, and overcomes the western alternation between line and colour. After the opening of this second exhibition, Matisse made his first journey to North Africa, long a centre of attraction for colouristic painters including Delacroix and Renoir. He returned there many times, attracted by the sun and by Islamic art. From a fortnight's stay at Biskra he brought back Arab textiles and ceramics which he used later to embellish his paintings; he returned straight

to Collioure where he remained until the end of the summer. With tireless energy, he produced numerous landscapes, still-lifes and figure studies, and carried on his experiments in a variety of directions, now towards massive forms surrounded by bold outlines, now towards flowing and decorative arabesques. The *Still Life with a Red Carpet* (Plate II-III), the finest of these paintings, combines in its magnificence an extraordinary range of technical procedures. Fauvism at its peak is none other than this free experimentation with colour and drawing carried to its ultimate in economy and expression.

The Salon d'Automne of 1906, which included the largest retrospective exhibition of Gauguin that had ever been organised, was centred around Matisse and the Fauves who at that time were at the height of their splendour. The basic principles of the movement, which Matisse defined in an important article in the 'Grande Revue', in December 1908, may be summarised as follows: the equivalence of light and spatial construction through colour, the dominance of flat planes without chiaroscuro or modelling, purification of the expressive means, complete correspondence between the expression, that is to say the emotional content, and the decoration, that is to say, the order of the composition. 'Composition is the art of arranging in a decorative manner the various elements at the painter's disposal for the expression of his feelings.' Form and content coincide and modify one another through

2. SEATED NUDE
MUSEUM OF MODERN ART, NEW YORK

mutual reaction since 'expression comes from the coloured surface which the spectator takes in in its entirety'. Born from a spontaneous reaction to colour ('the expressive side of colour affects me in a purely instinctive way'), Fauvism was for Matisse a dynamic sensualism, 'the impact of a scene on the senses', disciplined by synthesis, by 'condensation of the sensations', and subjected to the fundamental economy of painting.

'Every part is visible and must fulfil its allotted role, primary or secondary. That is to say everything which is not useful in a picture is detrimental.' Intensity of colour taken by itself, without this constructional severity and this unity of transposition, is insufficient to characterise the movement. 'It is no more than the external aspect,' said Matisse; 'Fauvism came about because we excluded all imitative colours, and because we obtained more powerful reactions with pure colours — stronger simultaneous reactions; and it was concerned furthermore with the *luminosity* of colours.' It involved therefore, like Gauguin's painting, a completely arbitrary way of using pure colours in flat areas, subject to imagination and not to reality, an ability to create on the picture surface the kind of pure harmony which Matisse called 'spiritual space'. The retrospective exhibition at the Salon d'Automne of 1907 was devoted to Cézanne, whose constructional influence succeeded the decorative one of Gauguin, and Matisse himself was not uninfluenced by this change. In face of the rise of the cubist group led by Picasso, which resulted in the breakup of Fauvism, Matisse continued his luminous explorations on his own, while tightening the construction of his works in response to the new developments. The expressionist intensity and the contrasting tendencies which came together in the course of this year, so crucial in the history of modern art, led to the extraordinary *Pink*

Nude (Plate XVI), while the two related versions of *Luxury* (Plate IV and Nationalmuseet, Copenhagen) tend towards monumental purification, a harmonious resolution of the relationship between the figures and the background by means of arabesques and planes which are all the more evocative for being simplified. At the Salon d'Automne of 1908, at the moment when he opened an art school of international renown and published a lucid account of his aesthetic views, Matisse took stock of his recent efforts, and, with the exhibition of the decorative panel which he executed for the Russian collector Shchukin based on a dominant blue which was later changed to red, initiated the magnificent audacities of the following decade.

From 1909 to 1917 Matisse moved away from Paris and went to live at Issy-les-Moulineaux in the neighbourhood of Clamart, in a large peaceful house in the middle of a garden. In this setting and at this period he created his most important works, works whose majestic serenity seems like a victory over disquiet and inner struggles. A visit to an exhibition of Islamic art at Munich in October 1910, the discovery of icons during a trip to Moscow in November 1911, long winter stays in Andalusia and Tangier from 1910 to 1913, stimulated a new interest and confirmed his line of development. In reaction against the intimate character of easel painting, he turned to Asiatic and Byzantine models, aspiring after the solemnity of mural compositions which several commissions gave him the opportunity to achieve. In 1911 he completed two

3. STUDY REPRODUCED FROM A NOTEBOOK OF PRELIMINARY DRAWINGS FOR 'LA PERRUCHE ET LA SIRÈNE'

205

panels commissioned by Shchukin, *Dance* and *Music* (now in the Hermitage Museum, Leningrad); restricted to three dominant colours, the blue of the sky, the red of the figures, the green of the hillside, they embody the universal essence of movement and repose. Also in 1911, he executed for Michael Stein a decoration in tempera, now the pride of the Museum at Grenoble, *Still-life with Egg-plants* (Plate VII), dazzling in its profusion of ornamental motifs. The same year the couturier Poiret refused *The Blue Window* (Museum of Modern Art, New York), a hieratic transformation of the view from the artist's bedroom, a symphony of blue offset by the red of a carnation. The magisterial series of *Interiors* begun likewise in 1911 —*The Red Studio* (Museum of Modern Art, New York), *The Painter's Studio* and *The Painter's Family* (Hermitage Museum, Leningrad) with their continuous decorative background—attained its supreme perfection in 1916 with *The Piano Lesson* (Plate VIII) in which the basic tonality is provided by a grey offset by the geometry of the coloured planes. The varied and sumptuous series inspired by Tangier ended similarly in 1916 with a monumental synthesis, *The Moroccans* (Museum of Modern Art, New York): elements, condensed in the memory, and brought back to life as poetic symbols, compose a majestic harmony of black, mauve and green. The interior of the studio which the artist took in Paris, on the Quai Saint-Michel, from June 1914 to work in during the winter months, is recognisable, with its window opening onto the Seine and the Palais de Justice, in many compositions of severe construction and sober coloration (Musée d'Art Moderne, Paris; Phillips Collection, Washington). In 1917, with *The Music Lesson* (Barnes Foundation, Merion), he re-evoked for the last time, before abandoning it for ever, the festive atmosphere of Clamart and brilliantly recapitulated all the themes which had occupied him during his stay there.

Dazzling successes like the *Interior with a Violin* (Plate IX) or the *White Plumes* (Plate X) mark on the other hand his move to the shores of the Mediterranean. Caught up in the mood of relaxation following the war, he turned briefly to a facile and ingratiating style of painting, exemplified in numerous odalisques in a rather self-conscious atmosphere of luxury. In the second half of the 1920s, however, he recovered himself, returning to density of colour and firmness of structure. He also took up sculpture again. The *Odalisque with a Tambourine* (Plate XI), the *Decorative Figure against an Ornamental Background* (Plate XII) testify to this renewal of energy which continued without respite right up to the final catharsis. In 1930, on his way to Pittsburgh where he was a member of the jury of the Carnegie International, Matisse spent three months in Tahiti, receiving impressions which were later to bear fruit. He visited the famous Barnes Foundation near Philadelphia and received a commission for a vast decoration on the ancient theme of the dance (studies in Petit Palais, Paris) which he re-made completely after three years of preparatory studies and set in place. Concurrently, and in the same spirit, he made a series of twenty-nine etchings to illustrate the 'Poems' of Mallarmé (1932), a first and decisive contribution to graphic art which he dominated in sovereign fashion, with a nobility of design which was both architectonic and evocative of light-creating. Initiated in the requirements of mural painting, Matisse tended increasingly towards a decorative treatment, especially in his most successful works, *Pink Nude* (Plate XVI), *Music* (Plate XIII) and, naturally, in the tapestry cartoons made in 1946 and based on Polynesian memories. In 1948, after final masterpieces such as the *Interior with the Egyptian*

curtain (Phillips Collection, Washington) or the *Large Interior in Red* (Plate XIV-XV), Matisse deliberately gave up oil painting and easel pictures to invent, when more than eighty years old, techniques which he used in a more and more simplified and striking way. From 1948 to 1951 he concentrated his energies on the Chapel of the Rosary at Vence, a monumental synthesis for whose design he was entirely responsible: he undertook the architecture as well as decoration, including windows, ceramics and liturgical ornaments. His main object, in his own words, 'was to make a balance between a surface of colours and lights and a flat wall, with black drawing on white'.

From 1950 until his death in 1954, pale drawings in chinese ink alternated with large compositions in gouache and areas of colour cut out with a pair of scissors. Unlike cubist 'papiers collés' or surrealist 'collages', these 'papiers découpés' by Matisse consist of coloured forms indissolubly linked, which are adapted to the mural support by the precision of their relationships and of their arrangements.

Instead of tracing in an imaginary space forms derived from outside, the artist cuts in a pre-existing block of colour, like a sculptor in wood or marble, forms originating from within and consubstantial with the material in which they are inscribed. To achieve such skill, the reward of a lifetime of unremitting hard work, 'it is obviously necessary'—wrote Matisse—'to have at one's disposal all one's accumulated experience and to know how to preserve the freshness of one's instincts'. Thanks to his recourse to complete simplicity and absolute radiance, Matisse recapitulated and sublimated his entire work, extolling the transparency of clear skies, the flowers and fruits of the earth, the inexhaustible arabesque of the female body, the triumphant disc of the sun, and revived on the verge of death the enchanted visions of Tahiti. Only his mastery of 'papiers découpés' allowed him to evoke the impression of the vast limpid spaces of Polynesia, the iridescence of the lagoons which, he said, are a painter's paradise. An oceanic light irradiated his last compositions, carrying to fulfilment his life-long desire 'to create a crystalline abode for the spirit'.

4. SEATED NUDE WITH ARMS FOLDED
MUSEUM OF MODERN ART, NEW YORK

The Plates

I *STUDY FOR THE*
JOIE DE VIVRE 1905
Oil on canvas. 18⅛ in. × 21⅝ in.
ROYAL MUSEUM OF FINE ARTS,
COPENHAGEN

This is one of many studies executed in the summer of 1905 for the *Joie de Vivre*, and it already shows the characteristics of Fauvism: pointillist dots forming strokes are juxtaposed with flat areas of fluid colour, speckled spots elongate to become rhythms and solid blocks, the picture is aflame with colour.

II-III *STILL LIFE WITH A*
RED CARPET 1906
Oil on canvas. 35 in. × 45¾ in.
MUSÉE DES BEAUX-ARTS,
GRENOBLE

In this still-life, painted at Collioure, on Matisse's return from Biskra, all the technical elements contribute to the richness of colour. On a table viewed from above and set cross-wise in an interior, are ceramics laden with fruit and sonorous oriental rugs.

IV *LUXURY* 1907
Oil on canvas. 82¾ in. × 54¾ in.
MUSÉE NATIONAL D'ART
MODERNE, PARIS

This is the first version of the famous and ambiguous work in the Museum of Copenhagen. Three female nudes on three different planes and in contrasting attitudes, static or in movement, are silhouetted against the simplified background of a marine landscape, which matches the harmony of their rhythms.

V *PORTRAIT WITH A*
GREEN STRIPE 1905
Oil on canvas. 16 in. × 12¾ in.
ROYAL MUSEUM OF FINE ARTS,
COPENHAGEN

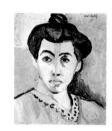

Composed of flat areas of pure colour, this portrait of Mme. Matisse is typical of Fauvist paintings. A particularly daring feature is the yellowish green stripe which, beneath the crown of blue hair, separates the area of the face in shadow from that in the light.

VI *STILL LIFE WITH*
GOLDFISH 1911
Oil on canvas. 45¾ in. × 39⅜ in.
MUSEUM OF MODERN ART,
NEW YORK

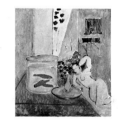

Matisse loved to surround himself with rare flowers, exotic birds and fish. A bowl of goldfish is the focal point of several important pictures, particularly those produced in the years 1909 to 1915. From 1911 date two outstanding variants, one in the Pushkin Museum in Moscow and this one in the Museum of Modern Art, New York.

VII *STILL LIFE WITH*
EGG-PLANTS 1911-12
Tempera. 82¾ in. × 96⅜ in.
MUSÉE DES BEAUX-ARTS,
GRENOBLE

The artist bought this decoration in tempera back from its owner in order to give it to the Museum in Grenoble. Three egg-plants on the low table, in the centre, strike a solemn note which contrasts with the exuberant ornamentation which spreads across the single flat plane of the floor and of the wall of the room.

VIII *THE PIANO LESSON*
1916
Oil on canvas. 96½ in. × 83¾ in.
MUSEUM OF MODERN ART,
NEW YORK

The living-room space is organized here with the maximum of perfection and sobriety. Delicate decorative arabesques (the wrought iron of the balcony, the grid of the music-rest) interrupt the tension of the vertical and diagonal lines, and the colour planes demarcated by them, stand out against the grey of the background.

IX *INTERIOR WITH A VIOLIN* 1917-18
Oil on canvas. 45¾ in. ×35 in.
ROYAL MUSEUM OF FINE ARTS, COPENHAGEN

Matisse expressed a special liking for this serene and powerful picture. The beautiful reddish brown violin in its blue case glows like a jewel in a casket. His extraordinary mastery as a colourist is also apparent in the play of deep blacks.

X *WHITE PLUMES* 1919
Oil on canvas. 29 in. ×24 in.
INSTITUTE OF ARTS, MINNEAPOLIS

The sitter for this portrait was Antoinette, the artist's favourite model in the years immediately after the war. The locks of black hair and the fine features of the noble face stand out beneath the extraordinary baroque headdress created by the artist with a foundation of straw, ostrich feathers and loops of black ribbon.

XI *ODALISQUE WITH A TAMBOURINE* 1926
Oil on canvas. 28 in. ×21 in.
COLLECTION OF MR. WILLIAM S. PALEY, NEW YORK

Coming after a series of odalisques of a rather mannered grace, this one imposes itself by its strong expressiveness. The forms have regained their rhythmical fullness; the contrasting colours, dominated by burning reds, blaze in the room with a gem-like magnificence.

XII *DECORATIVE FIGURE AGAINST AN ORNAMENTAL BACKGROUND* 1927
Oil on canvas. 51½ in. ×38¾ in.
MUSÉE NATIONAL D'ART MODERNE, PARIS

The banal model becomes here a sort of idol, surrounded by a profusion of decorative elements. The floral motifs of the wallpaper are combined with the diagonal plane of the carpet, and what could have been merely a bazaar-like exoticism is magically transformed by the colour.

XIII *MUSIC* 1939
Oil on canvas. 45¼ in. ×45¼ in.
ALBRIGHT-KNOX ART GALLERY, BUFFALO

Matisse loved to play the violin and musical themes recur frequently in his work. In this case, photographs record the different phases of the composition, which developed organically like a plant: the musician was raised little by little towards the top and integrated with the floral decoration.

XIV-XV *LARGE INTERIOR IN RED* 1948
Oil on canvas. 57½ in. ×38¾ in.
MUSÉE NATIONAL D'ART MODERNE, PARIS

One of Matisse's last oil paintings and the supreme synthesis of his art. Four principal motifs, grouped around a black armchair, stand out in the same red light: the painting and the drawing on the wall and, in the real room, like an echo of them, the circular and rectangular tables laden with flowers.

XVI *PINK NUDE* 1935
Oil on canvas. 26 in. ×36½ in.
MUSEUM OF ART (CONE COLLECTION), BALTIMORE

A number of drawings and twenty-one photographs allow us to follow the successive stages in the development of this majestic nude. It is one of the principal pictures in the Matisse collection formed by Etta and Claribel Cone and now given to the Baltimore Museum.

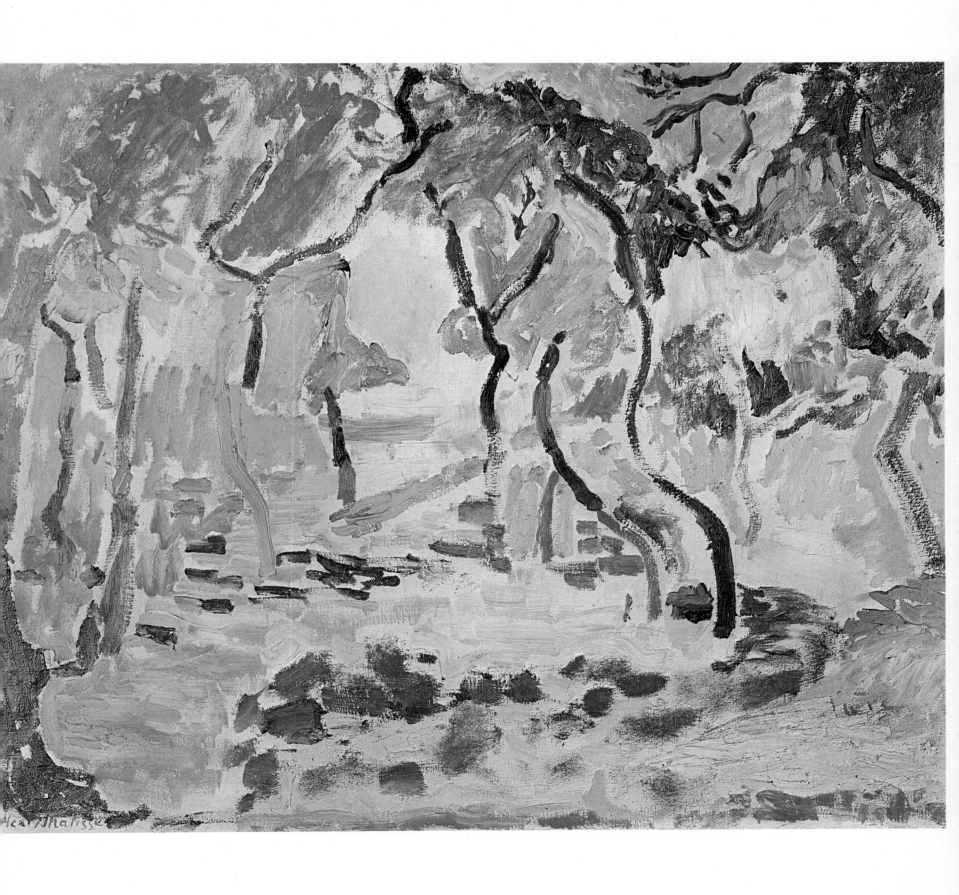

I

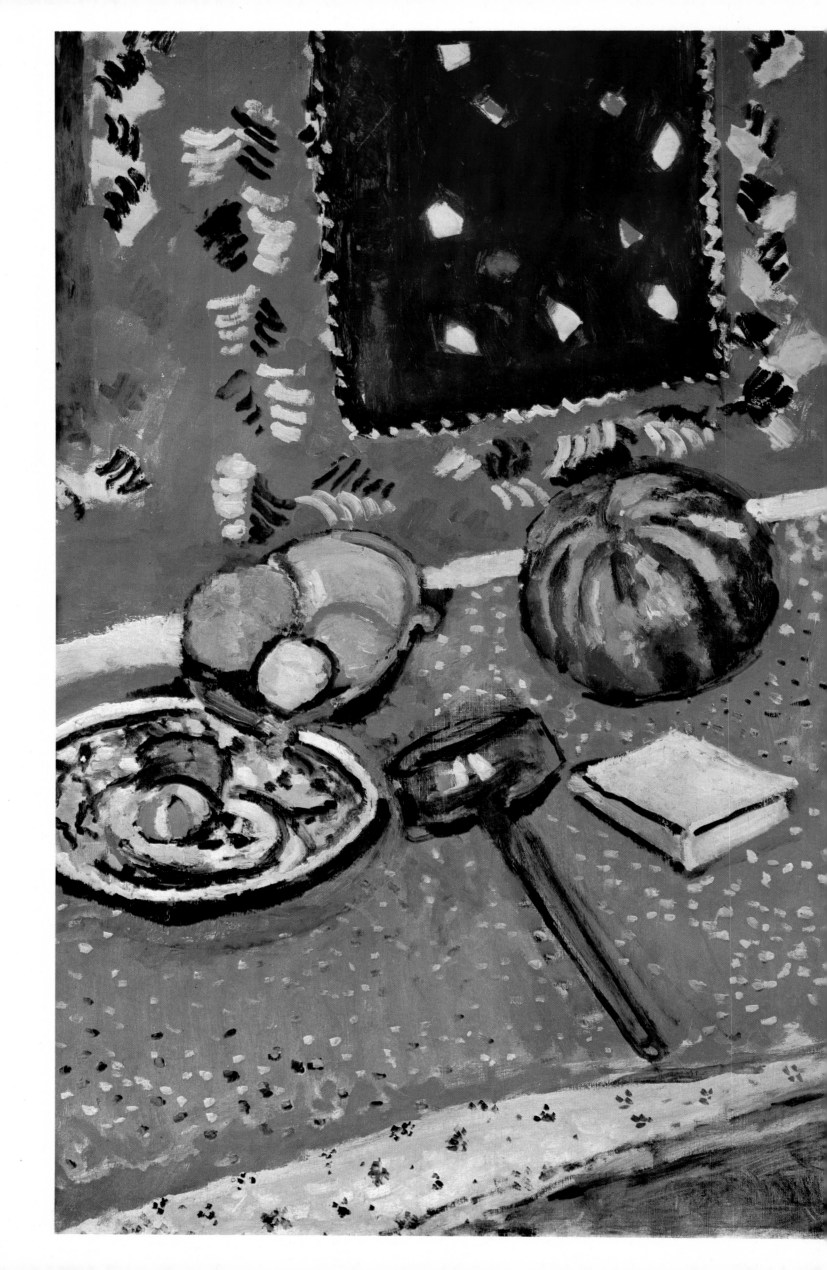

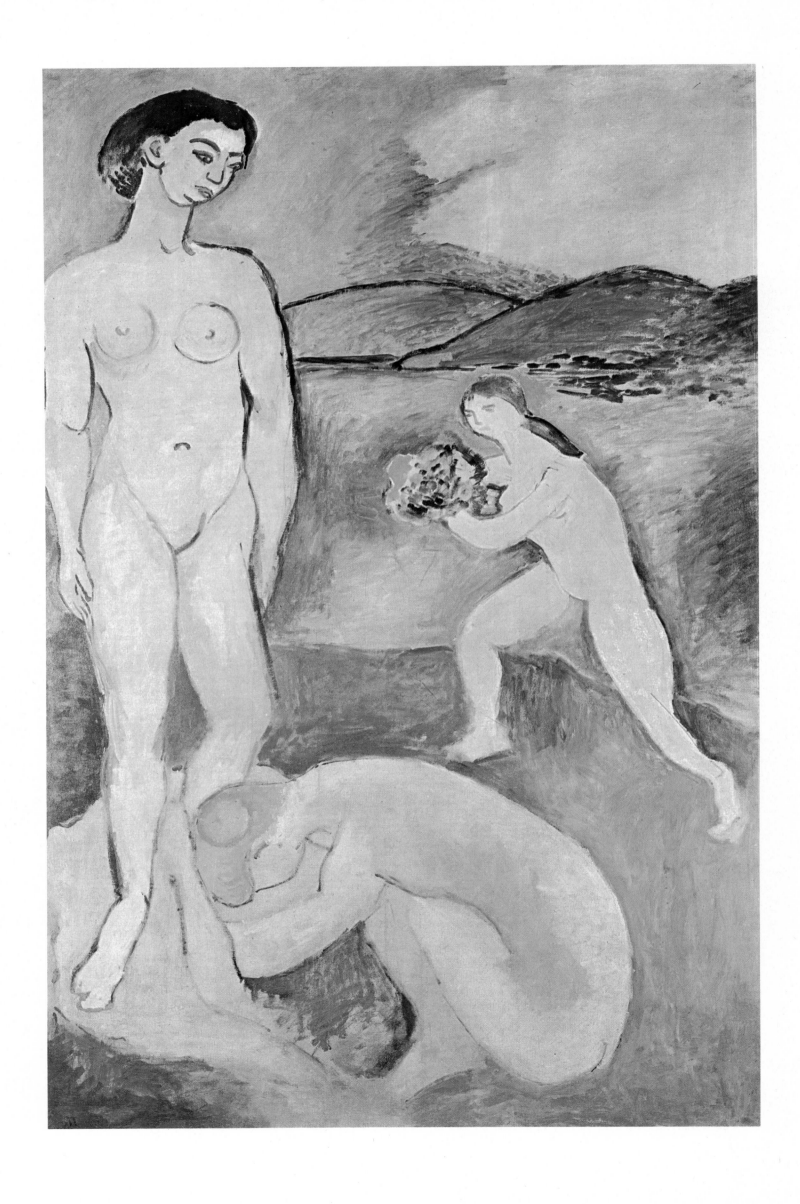

IV

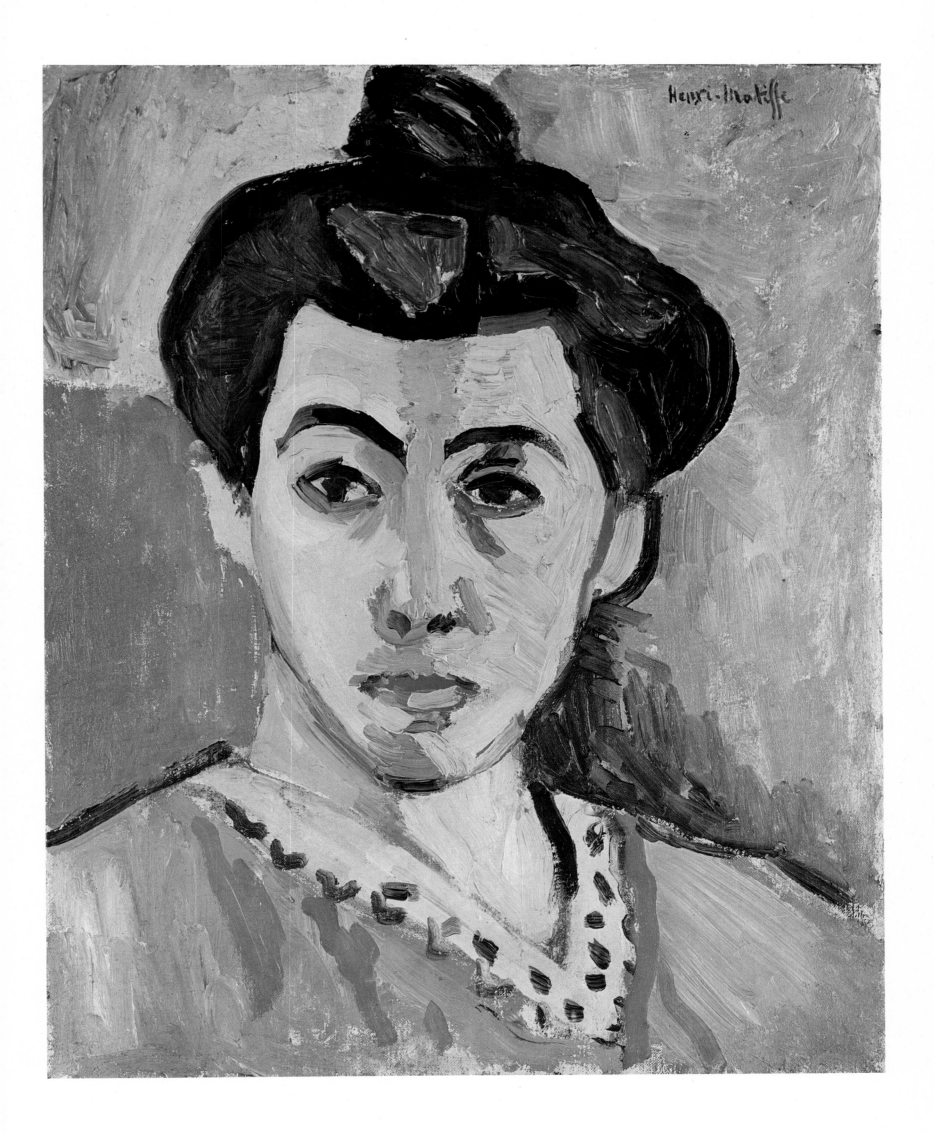

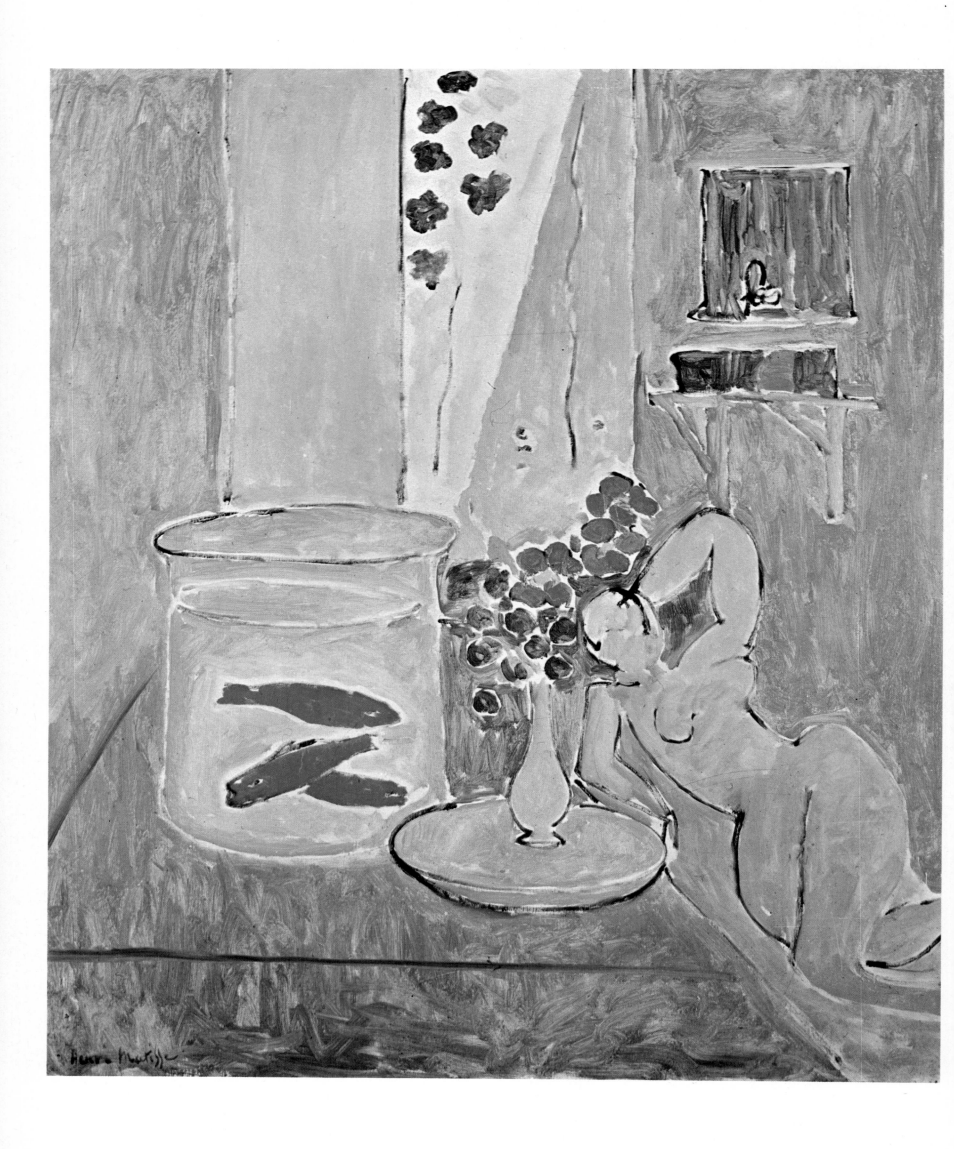

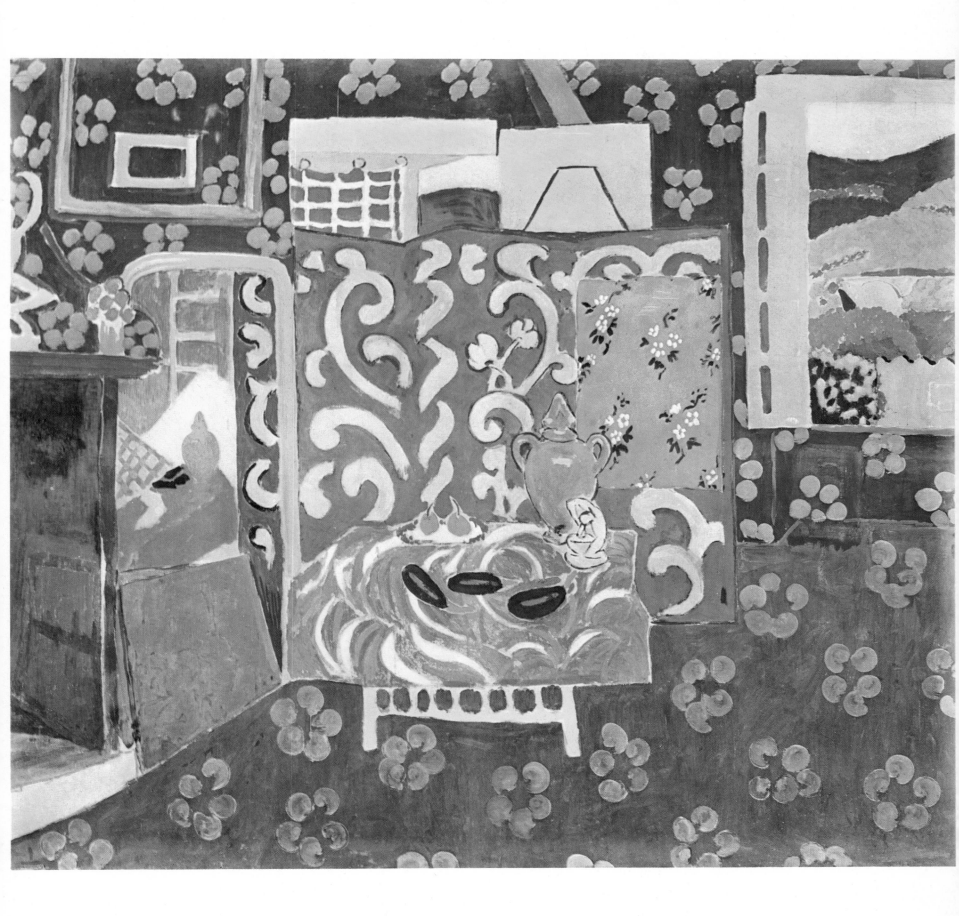

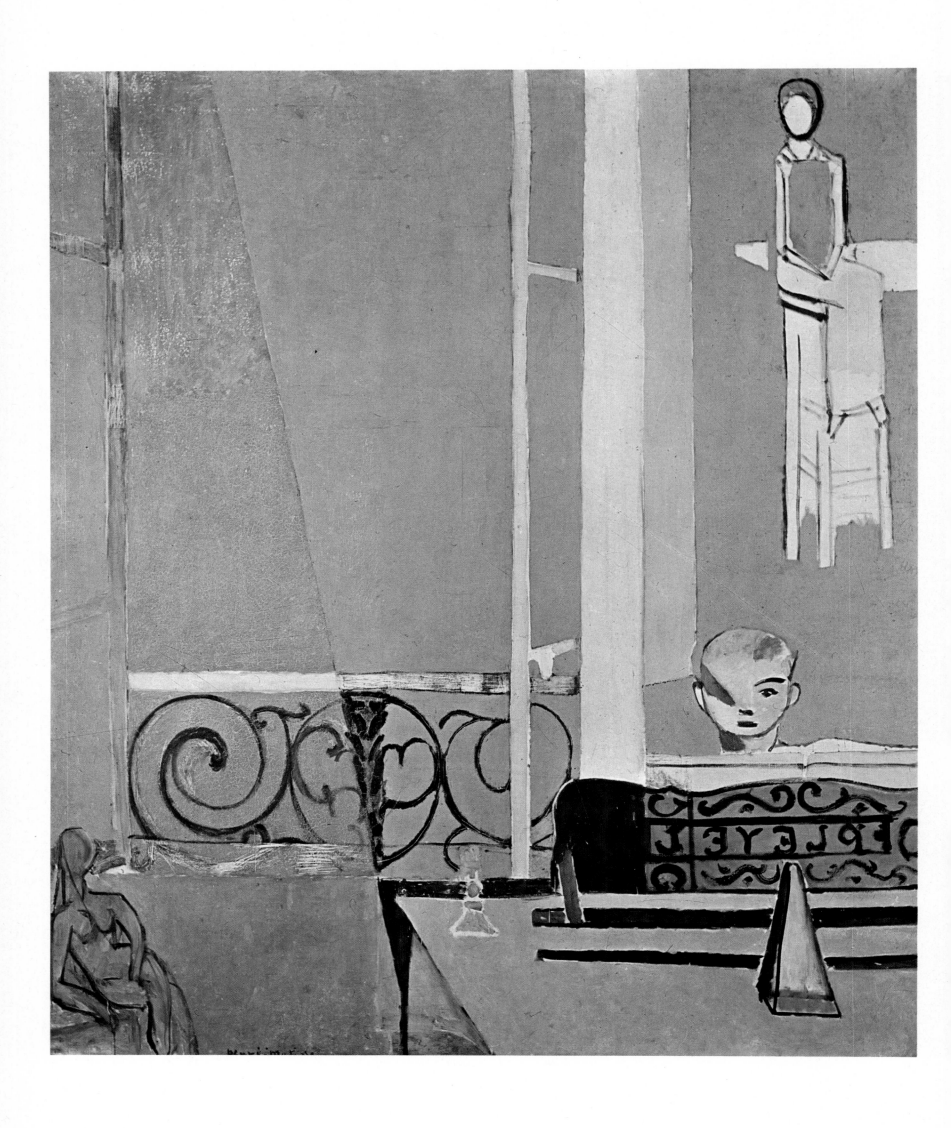

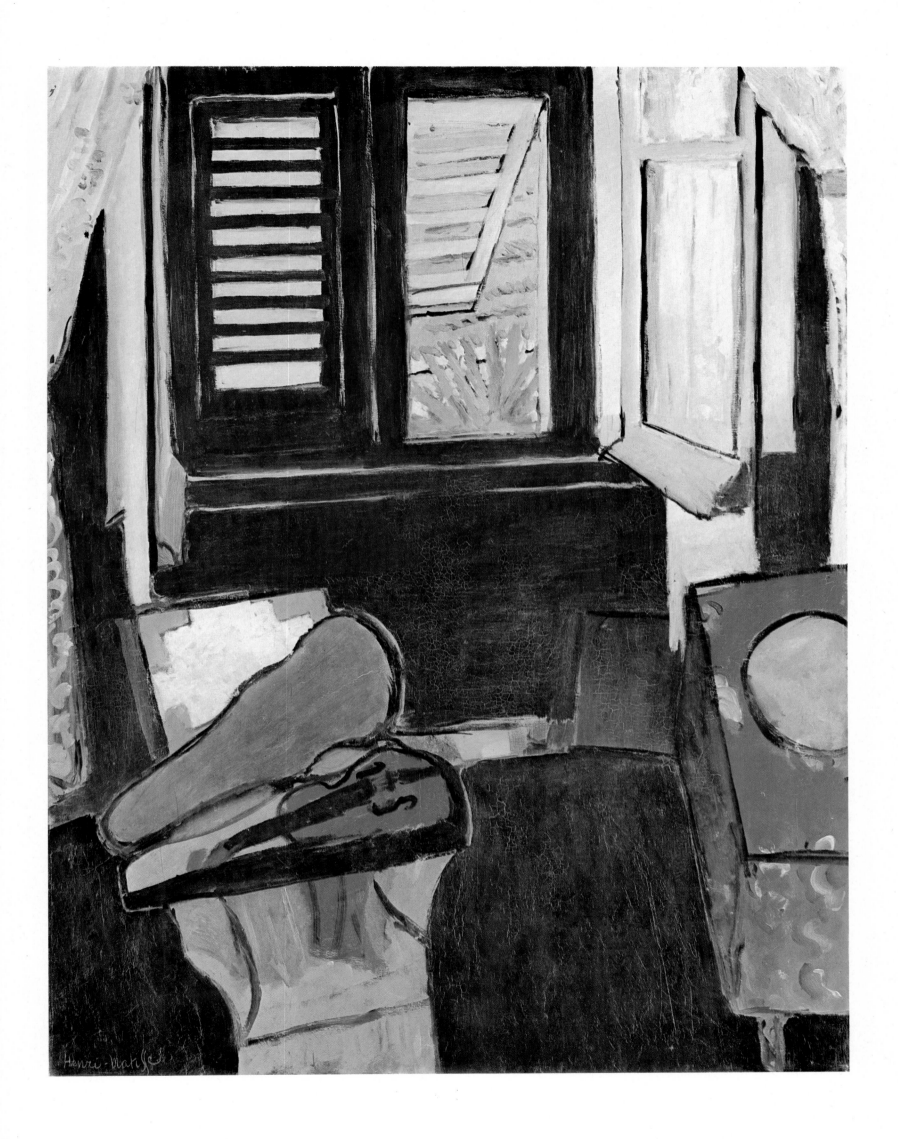

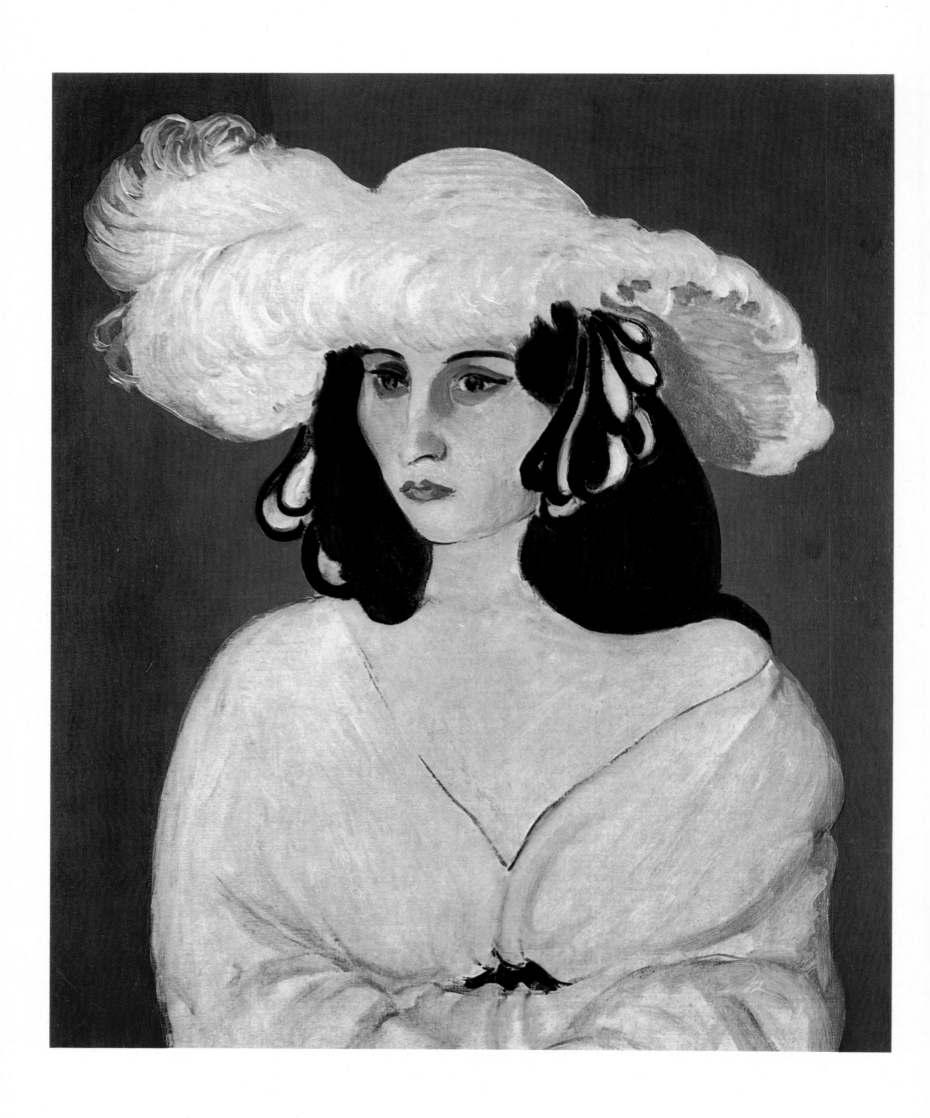

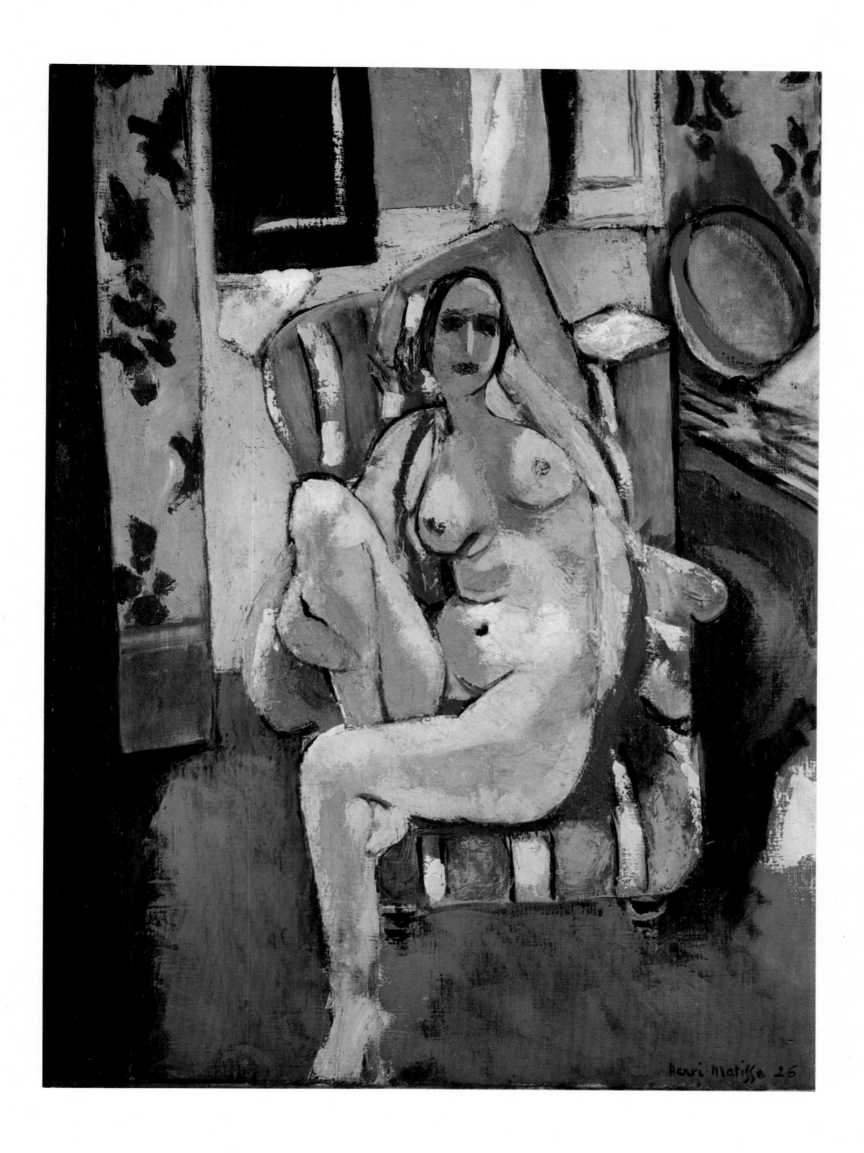

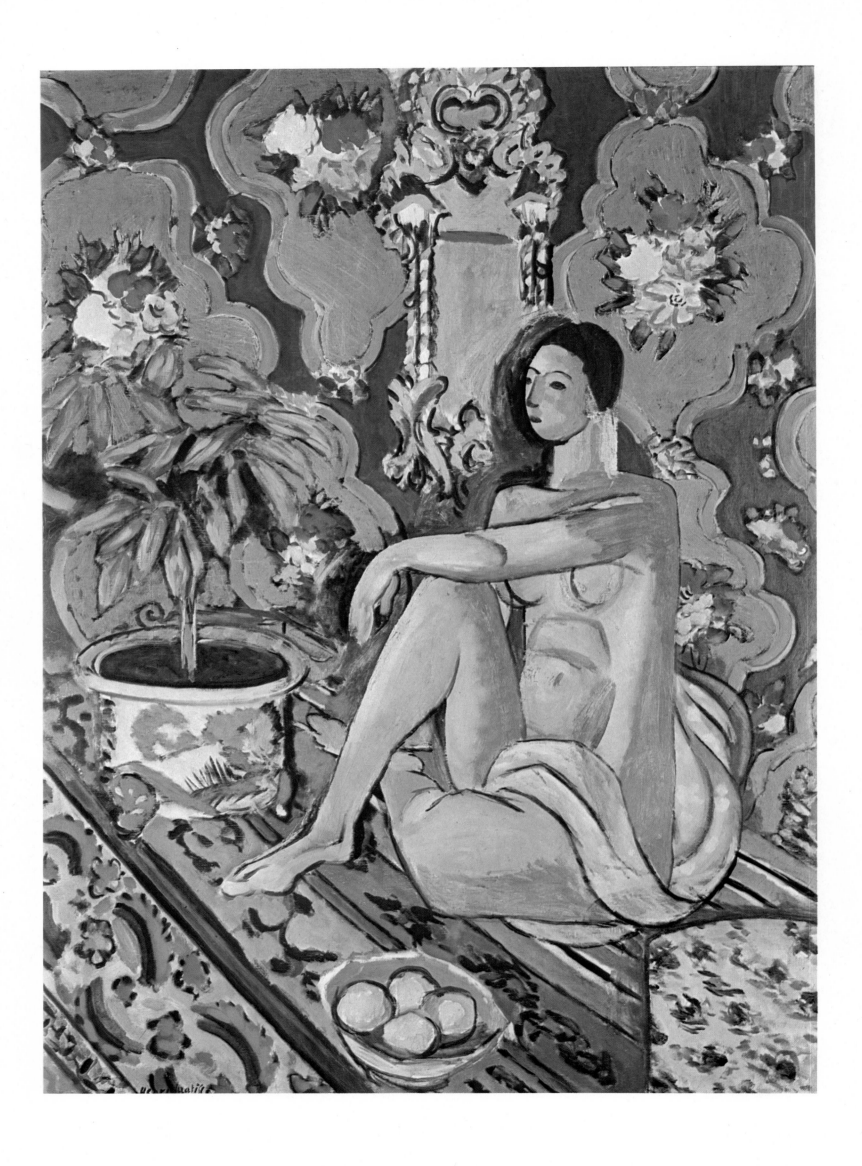

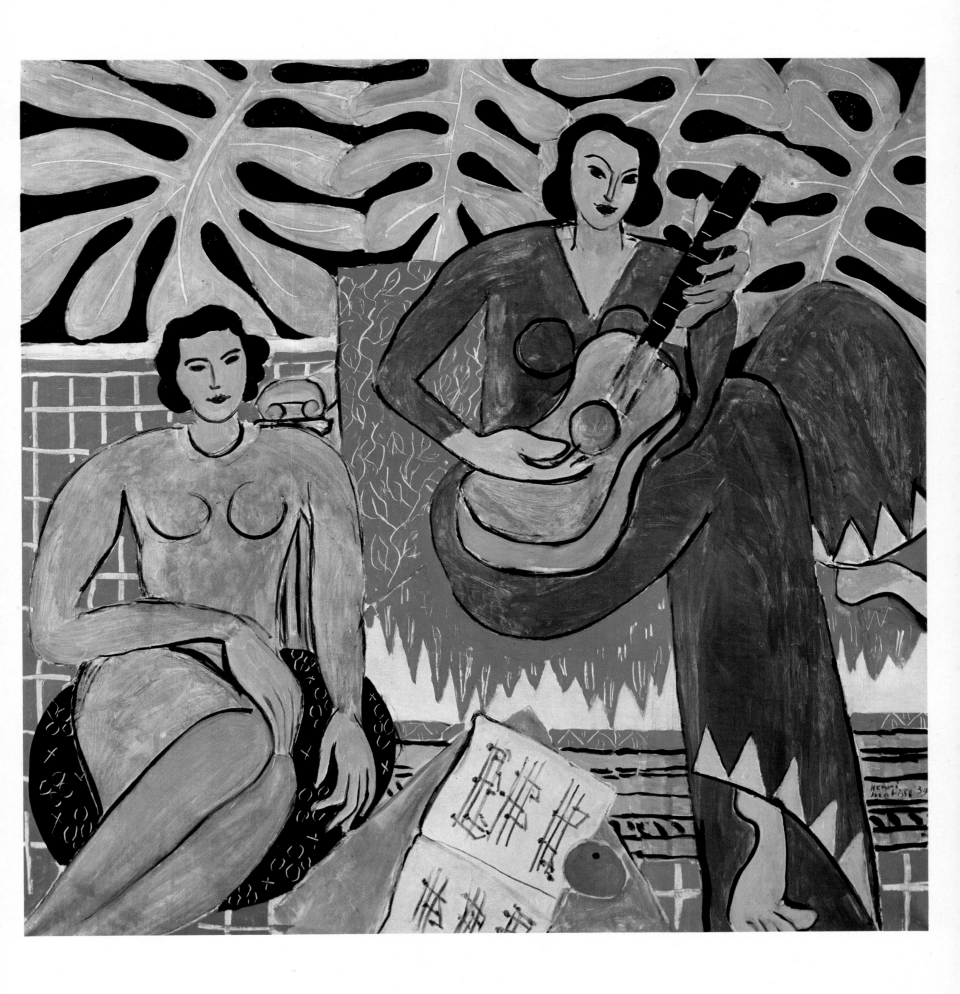

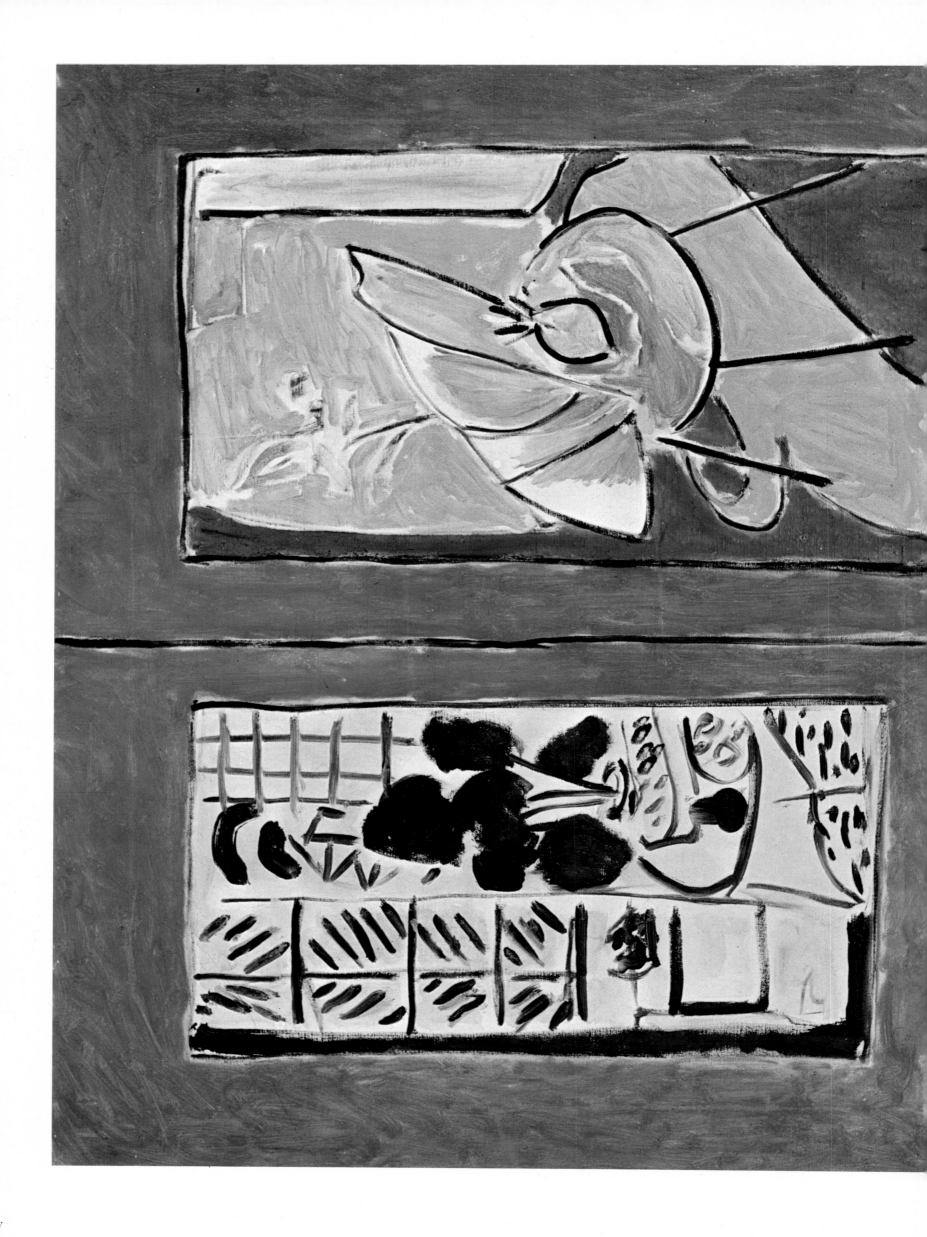

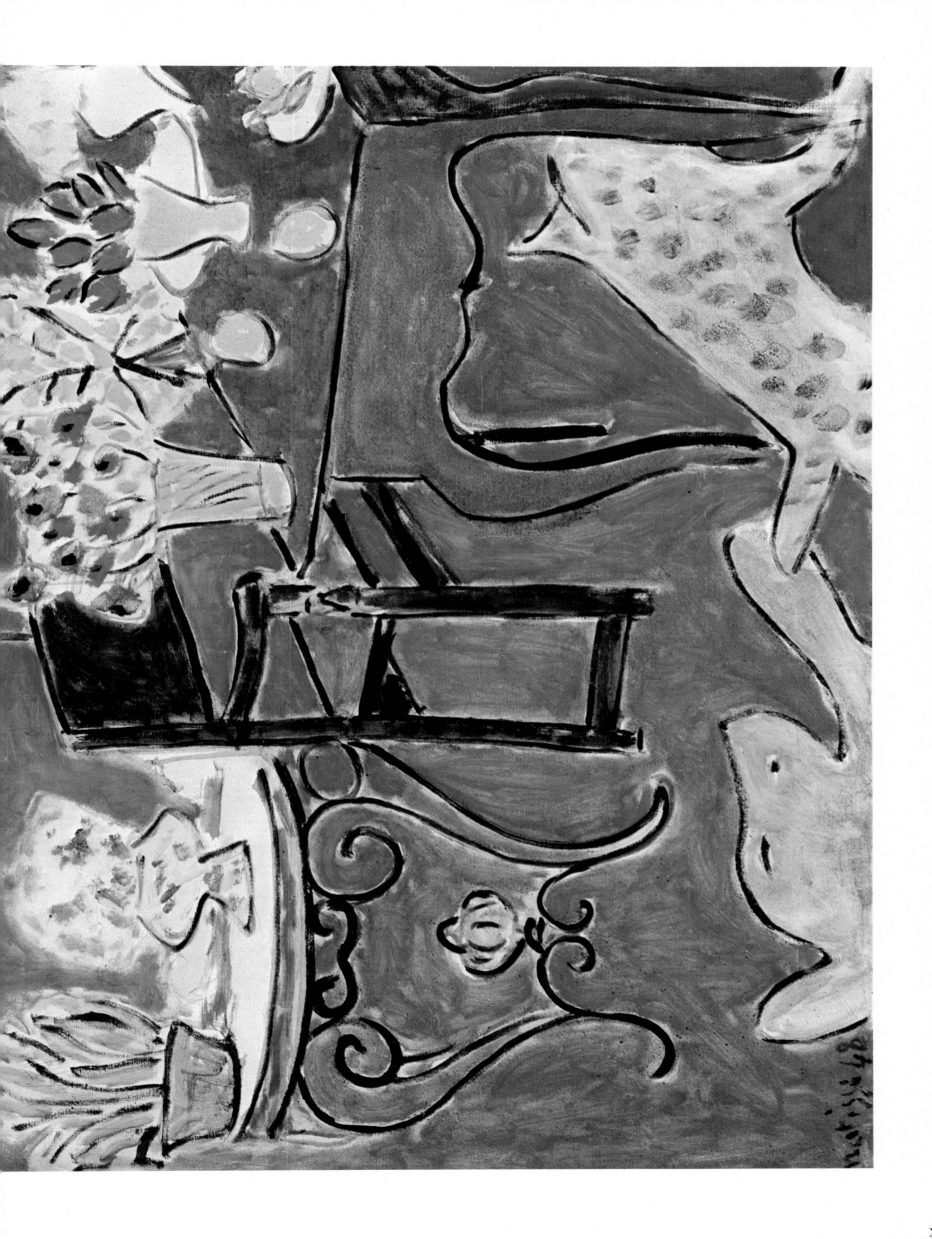

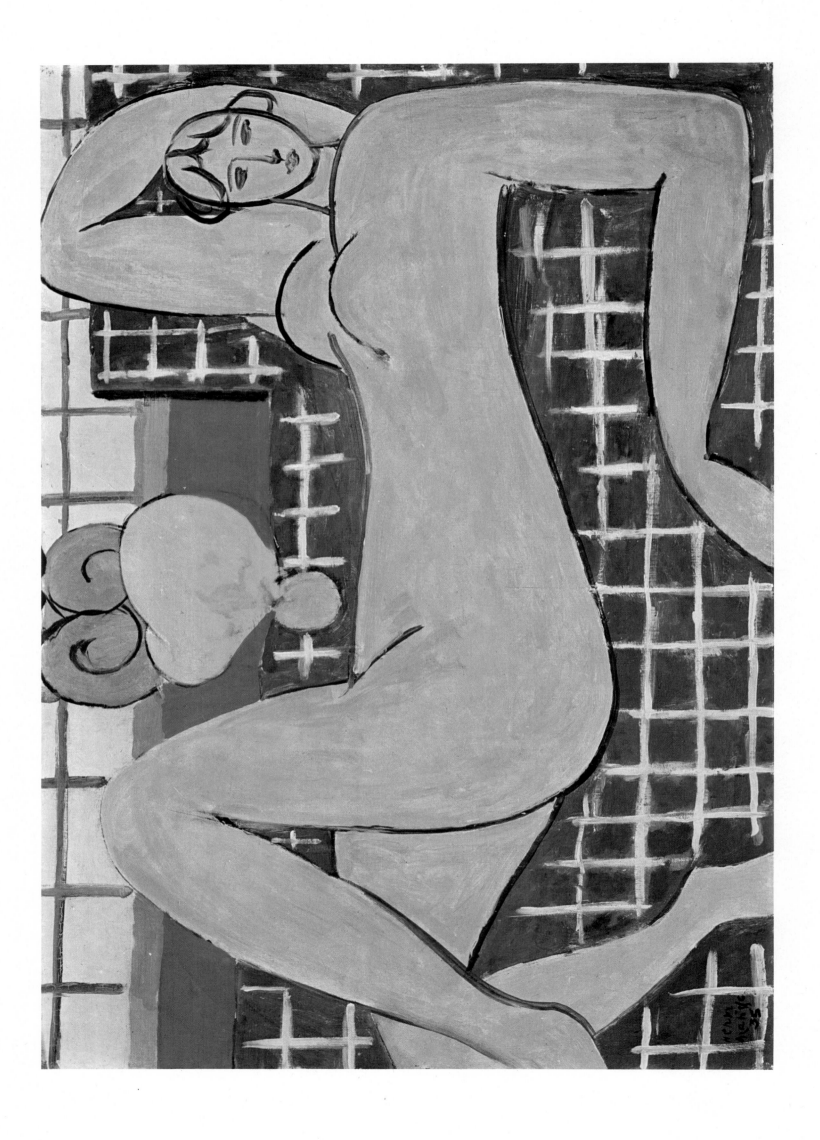

Pablo Picasso

Pablo Picasso 1881-1973

It was in Malaga on the southern Mediterranean coast of Spain that Pablo Picasso was born on October 25, 1881, and there that he gained his first knowledge of the arts from his father, José Ruiz Blasco, an academic painter of average talent. Pablo when still a child showed a remarkable ability to draw and amuse his friends by quick sketches which already went beyond the imaginative innocence of childhood. In 1891 the family moved to Corunna and in 1895, after a second move to Barcelona, the young Pablo began to assert his independence and find friends among the avant-garde poets, painters and philosophers who frequented the famous tavern, Els Quatre Gats, and urged each other on in ideas of anarchy, socialism and fin de siècle melancholy. Their revolutionary trends of thought were dominated by a desire to escape from the narrow limitations of Spanish society and in 1900 Picasso set out on a journey to the north.

This first contact with Paris was of great importance, but brief owing to his very limited means, and for the next four years he divided his time between Barcelona, Madrid and Paris. In Barcelona, still supported in a modest way by his family, he painted pictures now classified as of his Blue Period. It was at this time that he began to sign his paintings with his mother's name, Picasso.

From 1904 onwards Picasso made Paris his home. He found a studio in a building in Montmartre known as the Bateau-Lavoir, where he lived surrounded by other artists and poets and shared with his devoted mistress, Fernande Olivier, the bohemian life of Montmartre. Among his companions were Max Jacob, Alfred Jarry, André Salmon and Guillaume Apollinaire.

He was also fortunate in meeting collectors and dealers who could appreciate the extraordinary vitality that he showed in his thought and his work. Vollard, Gertrude and Leo Stein, the Russian merchant Schukine, and the young Daniel-Henri Kahnweiler supported him by buying his pictures. But the disconcerting speed with which Picasso pursued new discoveries without concern for his material security often caused them considerable dismay. Of the artists who knew him well, including Matisse, Derain and Vlaminck, it was only Braque who immediately understood the implications of Les Demoiselles d'Avignon (Plate III), that astonishing painting produced by Picasso in the spring of 1907.

Cubism, however, could not have come to life had it not been for Picasso's sudden understanding of the importance of African sculpture. Its primitive power contributed to the inventions and the rapid development of a revolutionary style which within five years had become widely known.

In 1917 Picasso widened his activities by designing scenery and costumes for the Russian Ballet of Serge Diaghilev and shortly afterwards he married one of the dancers, Olga Koklova, who bore him a son, Paulo, in 1921. His marriage tended to lead him away from the bohemian world of Montmartre and towards the wealthy international circle who patronised the arts after the war and began to set a high value upon his work. However, in 1925 he again asserted his independence and showed his disdain for the approval of society by painting pictures which contained violent movement and distortions distasteful to those who expected the arts only to please and flatter them. The violence of his expression continued to increase and was translated into sculpture, drawings and engravings which for many reasons won the admiration of the Surrealists. Although he remained somewhat aloof from their group his close association with André Breton and Paul Eluard afforded a mutual stimulus between them, which lasted in the case of Eluard until the poet's death in 1952.

Throughout these decades Picasso spent his life mostly in Paris paying frequent visits to the south of France. He was accompanied on many of these visits by Dora Maar, whose intelligence and profound understanding made her for many years his most intimate companion after his estrangement from his wife Olga.

Seeking more space for his activities he bought the small seventeenth-century Château de Boisgeloup in Normandy where he produced a splendid series of sculptures inspired by the blonde beauty of Marie-Thérèse Walter. In Paris, in addition to the apartment in the rue la Boëtie where he had lived with his wife, he acquired spacious rooms in the rue des Grands Augustins which for ten years were to be his studio.

The progressive darkening of the political climate in the thirties reached its climax for Picasso with the Spanish Civil War and the wanton destruction of Guernica in 1937. This event roused in Picasso a fury which found its expression in the great mural painted for the Spanish Republican pavilion in the Paris World Exhibition of that year (Fig. 3). This mood continued to dominate his work during the even darker years to follow. His prodigious activity throughout this period extended to sculptures that include the more than life size figure of the Man with a Sheep.

In 1946 Picasso was again able to travel to the Mediterranean and soon after settled in Vallauris with Françoise Gilot and their two children, Claude and Paloma. In this small town he was able to add ceramics and lithography to the wide range of his activities. Feeling once again the urge to use his influence in current events, he joined the Communist Party as a sign of his solidarity with their ideals and made special trips to peace congresses in Rome, Warsaw and London.

The emotion caused by his separation from Françoise Gilot in 1953 is revealed in an extraordinary series of lithographs which show him symbolically in the role of the old and dedicated painter caught in a dilemma between his devotion to his living model and to his own work (see Fig. 2). This attitude of self-criticism which can be traced throughout his life is a shield against the dangers of great wealth and universal recognition, which came upon him in his later years. After leaving Vallauris he installed himself in 1955 in a large villa in Cannes, and twice added to his properties by the purchase of the ancient Château de Vauvenargues beneath the Mont Ste. Victoire, and a house near Mougins. In these new surroundings he found a retreat looking out over the sea and towards the mountains. In 1971, a retrospective exhibition of his works was held at the Louvre. This was the first time that a living artist had been honoured in this way. He died in 1973 at the age of ninety-two.

'The role of the artist is to guide, to open even the most obstinate eyes, to teach us to see just as we are taught to read and to show us the way from the letter to the spirit' — PAUL ELUARD

THE NAME OF Pablo Picasso is without doubt one of those most widely known in the world today; even so there are few who are familiar with every part of his work and his closest friends would be the first to admit that they cannot say truthfully that they understood him as a man, nor could they predict what would be his humour or what new theme would capture his attention within the coming day. So many books have been written about him and so many legends have formed that there could be an army of Picassos rather than one man as their source. It is widely admitted, however, that he was a great revolutionary genius who during the ninety-two years of his life did more to change the meaning and the appearance of art than any other man in this century. Indeed the most widespread and popular view has arisen from this knowledge that he was a rebel. But also, if we look closer, we find frequent and surprising evidence in his work, often where we expect it least, of a continuity which links it basically with artistic expression throughout the ages. These links with the past were due partly to his far-ranging interest in all vital forms of human expression, even those that were little known, partly to experiences that haunted him from his youth, containing valuable clues to his deepest loves and preoccupations and also to an exceptionally retentive visual memory.

This paradox, this unlikely marriage between invention so startling that we often fail to find any trace of its origins, and well-established tradition, is a persistent characteristic of the genius of Picasso. If it had not been for his power of invention quickened by his natural discontent with existing conventions, it is possible that his rare and precocious talent and the laborious academic education in art given to him by his father could have resulted in an honourable career as a good traditional painter. But two things made Picasso unique from his earliest youth — his extraordinary ability to express himself as an artist and his restless search for a new and more penetrating understanding of life.

When Picasso was fourteen his father, an academic painter who came of a bourgeois family in Malaga, handed his brushes and palette to his son with the admission that he had already been outstripped. The next triumph came a year later when the family moved to Barcelona and without effort the young painter passed the traditional tests for entry into the municipal school of art. But instead of using his talent in the conventional way laid down for him, he made his first friendships among a group of youthful poets and painters who frequented certain popular cafés, their attraction being that they combined a turbulent revolutionary impulse with romantic, fin de siècle melancholy. Rather than paint pictures which might be easily disposed of to wealthy citizens, he chose for his subjects the outcasts, blind beggars and prostitutes of the streets and scenes in taverns and the bull ring.

In spite of the great traditions of Spanish art and the impressive, dramatic style of Spanish life, to which he was not insensitive, the limitations of Barcelona soon became too narrow. With eagerness to explore wider horizons he decided to risk the little money he had, and in 1900 he set out not for Paris but further north, for London, the city where he expected to find beautiful and intelligent women who had gained their freedom, and beggars walking the streets in top hats. However, on the way it was Paris that captured his attention. He found there the climate he needed for his imagination, friends who could inspire him and the great riches of the museums. He has rarely left French soil since.

PICASSO ALWAYS FOUND his most intimate friends among the poets. It was Max Jacob who introduced him to the delights and miseries of the bohemian life in Montmartre. The satirical violence of Alfred Jarry and the penetrating criticism of Apollinaire guided him towards ideas that were to lead not only to a new style in painting but also to a new conception of the meaning of art. Later it was through the appearance of the youthful Jean Cocteau at an opportune moment during the 1914-1918 war that Picasso first became interested in the ballet. During the 'twenties and 'thirties he followed with close interest the writings of the Dadaists and Surrealists and formed enduring friendships with poets such as Tristan Tzara, Paul Eluard, Pierre Reverdy, Jacques Prévert and Michel Leiris. By this I do not wish to suggest that Picasso ignored the painters. In early years he became a friend of the Douanier Rousseau, then an old man. He frequently met Matisse, Derain and Braque in the days when they were absorbed in the daring experiments with colour that earned them the name of Les Fauves (The Wild Beasts). Picasso's preoccupations were, however, very different. Unlike them he painted, during his Blue Period, pictures with subjects such as maternity, children and blind beggars, and some large compositions expressing with pathos poetic and transcendental ideas. These were prompted by the last vestiges of his academic upbringing.

By 1906 he had emerged from this period with the conviction that art should free itself from the anecdotic and find at the same time a more profound motive than the representation of the fleeting effects of light and colour that were the obsession of the Impressionists. Picasso wanted to revive in painting the sense of reality that he found in the frescoes of the Catalan primitives, and in Egyptian, pre-Hellenistic Greek, Byzantine and early Gothic sculpture. These styles seemed to be animated by a mysterious dynamic force, sometimes beautiful, sometimes frightening.

But it was not only these discoveries that brought about a major crisis in the spring of 1907. Picasso had always known that no progress is made without continuous questioning of other people's solutions and a relentless criticism of one's own achievements. Max Jacob could have intended his saying 'le doute c'est l'art' to describe Picasso's attitude. Throughout his life and in spite of success, he retained an underlying humility and uncertainty that can be regarded as one of the main reasons for his ability to produce original work even in old age.

In the autumn of 1906, after making many drawings, he began a large composition of female figures with a strange

227

mixture of deliberation and uncertainty as to where it would lead him. The painting, which later was given the title *Les Demoiselles d'Avignon* (Plate III), provided a battlefield and a testing ground for new conceptions. Among them was Picasso's discovery while the painting was in progress of the significance of African sculpture. In an outburst of revolutionary violence he introduced two heads on the right of the canvas which seemed strangely discordant with the other more classical figures and at the same time offered a ferocious insult to all aesthetic traditions. 'Such faces, compounded so of hell and heaven,' to borrow Herman Melville's words, 'overthrow in us all foregone persuasions and make us wondering children in this world again.'

AT THIS TIME Picasso had already won a considerable international reputation and the poverty of his first years in Paris was at an end, but the consternation caused by this painting to those who greatly admired his former work of the Blue and the subsequent Pink periods was appalling. The concern they felt for him as well as their disapproval of his picture was expressed by Derain who remarked: 'One day we shall find Pablo has hanged himself behind his big canvas,' and Apollinaire, summing up later this extraordinary event, wrote: 'Never has there been so fantastic a spectacle as the metamorphosis he underwent.'

As time brought understanding, artists, of whom Braque was the first, began to see the significance and the power of this painting. Although some painters had already questioned the belief that beauty and perfection are the sole purpose of art, *Les Demoiselles d'Avignon* proved convincingly for the first time that the presence of a primitive magic power, the vital force of tribal art, could be reinstated in contemporary western painting and that beauty and ugliness are both incidental by-products in any

1. THE FRUGAL REPAST 1904

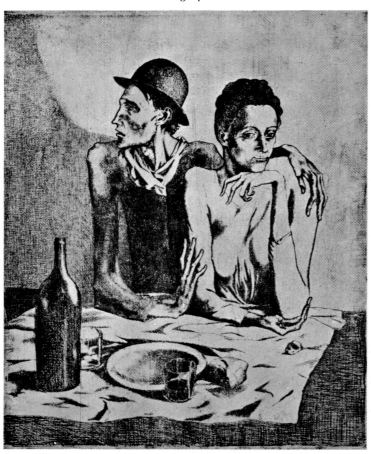

form of expression containing this dynamic emotional force. The means used by Picasso, the deliberate distortions, the displacement of limbs, the geometric simplifications, were revolutionary steps towards a new analysis and synthesis of form as we see it and form as we know it to be. Picasso's saying, 'I do not paint what I see, I paint what I know,' was not only meant as an attack on the Impressionists; it also announced a new attitude towards art which was to find its expression in the style which has been given the name Cubism, a style which is both fundamentally a product of the thought and the discoveries of our century and the foundation of new conceptions of the meaning of art.

During the six years that preceded the outbreak of war in 1914, Picasso was joined by Braque in a momentous trail of discoveries. 'Roped together like mountaineers', as Braque said, they explored the riches of their new territory. The early years, known as the analytical cubist period, led to a crisis in 1911 when the new style attained a deliberate anonymity and a degree of abstraction which ran the risk of becoming too remote in its perfection, and too hermetic. To escape this risk, they introduced real objects stuck to the surface of their paintings and reinstated colour, which had been minimised in their desire to accentuate form. This was done in order to re-establish a link with reality and from this came the now widely used technique of collage—the method of incorporating in a picture fragments of paper, images, newsprint or objects by sticking them to its surface. Another equally important development was the great picture *Woman in an Armchair* (Plate VII) of 1913, in which Picasso introduced into painting concepts and poetic associations of a new order. The picture now existed in its own right, its form became sculptural and objective and the sequence of images it set in motion in the mind did not spring from imitations of external objects but seemed to create an autonomous reality in itself.

BUT THERE are a great variety of ways in which Picasso chooses to express himself. As though he found it necessary to prove that he did not wish to establish a rigid style or a school but to continue an exploration to which there is no end, he produced drawings of a classical realism and purity even during the period of the most rigorous cubist discipline, and in 1918, after his first marriage, he returned to the theme of mother and child with a new orientation. To the giantesses playing with their infants or brooding by the sea in the paintings of the early 'twenties, he gave plastic strength and monumental proportions which transposed them in all their mundane reality into a world of Homeric myth (see Plate VIII). In contrast, during the same years he produced pictures such as *The Three Musicians* (Museum of Modern Art, New York) and many still life paintings composed of flat geometric shapes systematically controlled and as serenely monumental as the gigantic nudes, but in a completely different manner.

In 1925, however, a crisis occurred as violent and far-reaching in its effects as that of *Les Demoiselles d'Avignon*. Picasso produced another revolutionary canvas at a time when he was deeply troubled by the death of an old friend, a canvas which no longer relied on the static constructional poise of the cubist compositions. *The Three Dancers* (Plate X) of 1925 introduces elements of torment and distortion which had not been seen in his work before. A new and terrifying grimace appeared to be integrated into the exuberance of a bacchanalian orgy. We realise suddenly

that Picasso was not searching for a harmonious solution, a well-balanced composition, but rather to express a fierce struggle between the forces that create life or tear it apart.

This mood, violent and convulsive, continues to reappear frequently in Picasso's work during the next two decades. The human form is torn apart and reconstructed. Eyes, ears, nose and mouth move into new positions decorating the human head with the insignia of agony or joy and we move with them, seeing at a glance the face from behind, in profile or full. Such devices, discovered in wonder and contemplation more than ten years before, now become the supple grammar of a language which was preparing for a momentous outburst in the great mural, *Guernica* (Fig. 3), during the Spanish Civil War and was to continue in many pictures painted in Paris in the dark years of the Nazi occupation.

But just as Picasso does not allow a style even of his own invention to limit him, so also he reacts to his moods however extreme they may be Anger, anxiety and disillusionment give place to a savage humour or a tender enjoyment. The women he paints can be monsters and harpies or more often they are bred of the love and acute observation of their beauty revealed in the shining intelligence of their eyes and the enveloping embrace of their bodies.

PICASSO WAS ONCE heard to say that in his work he was above all a realist, like all Spanish painters, and on examination we find that the violent distortion of objects and of the human form, particularly in his works painted after 1925, revealed his dissatisfaction with solutions that pointed towards a harmonious equilibrium. He was interested above all in the great rifts which were everywhere apparent and in the tension provoked by the contradictions of which reality is composed. In order to see more clearly he compels us to pierce through to reality in every sense, and question the accepted standards that have become meaningless. 'One does not love Venus,' he once said, 'one loves a woman.'

As I have already said, Picasso must be thought of as a poet who expresses himself visually, as well as an artist who gives plastic form to poetry. His meeting with Paul Eluard and André Breton in the early 'twenties, when they were tracing the origin of inspiration to the ambiguities of dreams and the illogical workings of the subconscious in surrealist poems and manifestos, coincided with his own desire to arrive at a more penetrating understanding of reality. It is easy to trace these poets' influence but if we consider the work of Picasso as a whole, it is also evident that interwoven among his revolutionary changes in style are certain personal themes and obsessions that can only be attributed to his own conscious experience, often dating back to memories of his childhood. Among the more obvious examples are his attachment to the themes of mother and child, the nude, certain familiar animals, the wonder or horror found in the human head, the eye or the hand, his fear of blindness and the haunting presence of death. There are other subjects to which he returned with undiminished interest, themes such as landscape, the still-life composed of familiar sights and objects and that eternal triangle, full of psychological tension—the painter, his model and his work—which gave Picasso ample scope for new discoveries.

TO MAKE A STUDY of these persistent themes is to examine the subject-matter of Picasso's work with the probability of finding clues to his loves and hopes as well as his revulsions and fears. From this it would also emerge that sculpture absorbed his thoughts almost to the same degree as painting and that the two arts are often made to overlap. It was in 1906, immediately after he had painted those nudes of the Pink Period whose classical proportions and grace suggest the goddesses of ancient Greece, that the first sculptural figure paintings appeared, squat and solid in their convincing presence. This happened soon after Picasso had modelled several bronze figures in the studio of his friend the Spanish sculptor Gonzalez. Later it was Picasso's discovery of African sculpture that led to new conceptions in cubist painting. These early signs, followed by the large number of paintings of solid sculptural forms and the many painted sculptures found throughout his work gave proof of his desire to unite the two arts and enhance each one with qualities that conventionally belong to the other.

I have already mentioned the persistence with which certain themes reappear throughout the work of Picasso. Closely associated with this was his capacity to enter into the life or existence of his subject whether it be a guitar, an ape, or mythical characters such as Harlequin or the Minotaur. Each seems to correspond in a mysterious way to an idea he had formed of himself. There are many reasons why the personality and appearance of Harlequin should have appealed to Picasso in his youth. This elegant and attractive character is by nature elusive, amorous, the strolling player, spiritual companion of outcasts, drunkards and prostitutes, the brilliant juggler and the jester who lies in order to speak the truth. These are all qualities that could be said to have belonged to Picasso himself. In addition there is the undoubted appeal of the diamond suit of many colours which in later years found its appropriate place in cubist compositions. The early self portraits of Picasso dressed as Harlequin leave no doubt that he wished to identify himself with this mercurial and melancholy character and accept him as an eloquent symbol of his own enigmatic personality.

In a similar way we find in later years a second impersonation. The Surrealists had already drawn attention to psychological implications in the story of the Minotaur when in 1933 Picasso introduced his disturbing presence into a series of etchings known as *The Sculptor's Studio*. (See 'Picasso, 55 years of his graphic work', Thames and Hudson, 1955.) On the other hand, as far back as 1913

2. *WOMAN AND MONKEY PAINTING* 1954

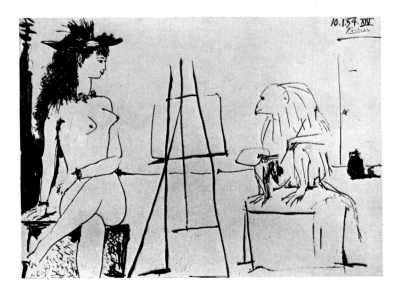

Apollinaire had mentioned Picasso's 'Hybrid beasts that have the consciousness of the demi-gods of Egypt', but it was not until twenty years later, when he had for a short period made sculpture his main preoccupation, that we find the deliberate appearance of the horned demi-god in circumstances which lead to the suggestion that if Harlequin was the chosen symbol of the young painter, the Minotaur corresponds more closely to his conception of himself as a sculptor in the prime of life—closer to the earth, less vagrant and ethereal, although still the outcast unacceptable to society because too brutally attached to the desires and weaknesses of the flesh. This is strengthened by the allusion to blindness with which the Minotaur is afflicted in some of Picasso's last etchings. Blindness although a disaster can still permit the sculptor to enjoy and refine his sense of touch.

Although the myth is an ancient and fundamental aid to the understanding of reality, Picasso does not accept it as a ready-made symbol. He reinvents myths as metaphors for himself and his own life, and although the characters represent his own problems and emotions they remain timeless and universal. The most important instance of this transposition of myths is to be found in *Guernica*. In this great picture, painted in 1937 in a spirit of fury and anguish brought into focus by the destruction of the ancient Basque capital by Franco's bombers, Picasso instinctively used a process of substitution. Archetypal conceptions taken from common experience allowed him to give to this catastrophic scene a realism which surpassed the horror of the event itself. Animals, a house in flames and the distorted image of the sun are given the same dramatic importance as the distraught women and their murdered children. The animals depersonalise, purify and intensify the human properties for which they stand.

THE SPANISH WAR, in which Picasso found himself emotionally involved to a degree that he had not experienced in the First World War, was the prologue to the years of misery and privation he suffered with his friends in occupied Paris. Its barbarity reawakened in him a social consciousness which can be traced back to the outcasts and blind beggars of the Blue Period. Many paintings give evidence of his profound anguish by the violence with which the human form is torn apart and reassembled with new and often sinister significance. When the war ended and it was again possible to travel he returned to the south of France, where in more tranquil surroundings he continues to this day to live and work with undiminished activity as painter, sculptor, ceramist, engraver and poet.

The fame of Picasso grew to such a degree that it was frequently an embarrassment for him to appear in public.

However, in the seclusion of his house near Mougins, he worked often late into the night, protected from the inroads of his admirers by the tact of his young wife, Jacqueline, whose classical profile and eyes, black and ardent like his own, appear in many of his pictures. His work was his life, varied as often and as unpredictably as changes in the weather by the excitement of unexpected discoveries and the great range of media which he had at his disposal. Nor had he lost that sense of humour and delight that comes from questioning and doubting even the most revered ideas and from playing with everything in such a way that new meanings suddenly appear. He enjoyed the absurdity of masks and hats which outrageously change the identity of the wearer and the metamorphosis he could bring about by aptly using, for example, a child's toy motor-car for the face of an ape in one of his sculptures.

Although at this time he travelled very little he was highly conscious of the rapid changes taking place in the world. Travel was an unnecessary distraction to an imagination so well nourished and a mind so alert. He was sufficiently enthralled by the people and objects he saw daily, the books he received, an occasional bullfight in a nearby town, or a television programme. It was his great capacity for continuous renewal that allowed him to see familiar objects as though for the first time and to discover in them the wonder that he conveys to us in his work.

It will be many years before the significance and greatness of Picasso can be truly assessed. To understand him requires an understanding of the mystery of life itself. But we can already see clearly the immense influence he has had on the art of this century. The strength and variety of his entire work constitutes a great monument whose details and ramifications can be explored endlessly. We realise that his strength arose from great physical and mental energy combined with a dynamic personality. The existence of a genius of such stature depends upon an unusual combination of talents such as an ability to identify himself with his subject, to select in it the quintessence that has formerly escaped notice and hence to surprise, shock and awaken us to the mysterious depths of its reality. There is also his phenomenal visual memory to be taken into account and his power to absorb both the new and the traditional. We must not forget either his rare ability to co-ordinate spontaneity and good judgement while working in such a way that mind and hand are so perfectly in accord that they provoke each other simultaneously to greater heights of achievement. Finally there is also his ability to question and doubt everything profoundly, above all his own work, and gain from this exacting process a more vigorous and more creative approach to life itself.

3. *GUERNICA* 1937

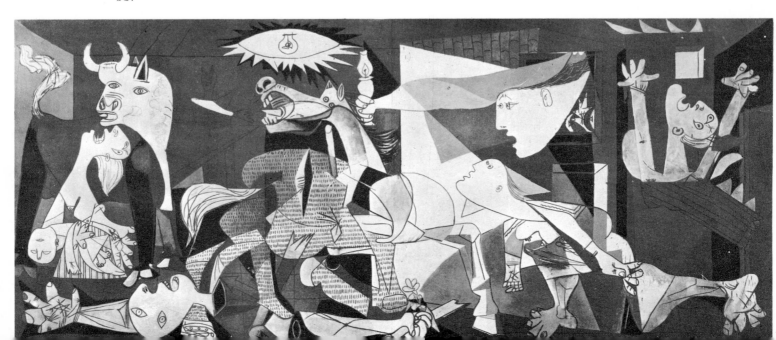

The Plates

I *LA VIE*
BARCELONA, 1903
Oil on canvas. 77⅜ in. × 50⅞ in.
CLEVELAND MUSEUM OF ART, OHIO
(GIFT OF HANNA FUND)

As in many paintings of the Blue Period, the theme of this painting is maternity, but it is complicated by allusions to love and disillusionment which make it a 'problem' picture. The device of continuing the allegory by the introduction of other significant pictures within the picture itself· suggests already the 'collage' technique of the cubist period.

II *SELF-PORTRAIT*
PARIS, 1906
Oil on canvas. 35½ in. × 27½ in.
PHILADELPHIA MUSEUM OF ART
(A. E. GALLATIN COLLECTION)

In early years Picasso frequently made portraits of himself in drawings and paintings. The influence of pre-Roman Iberian sculpture which he had seen during a recent visit to Spain is noticeable in the bold treatment of the head and the forceful almost primitive drawing of the black and penetrating eyes, a characteristic of the painter which has become famous.

III *LES DEMOISELLES D'AVIGNON*
PARIS, 1906-7
Oil on canvas. 96 in. × 92 in.
MUSEUM OF MODERN ART, NEW YORK (ACQUIRED THROUGH THE LILLIE P. BLISS BEQUEST)

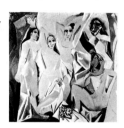

This picture can be considered as a landmark in the development of twentieth-century art. Picasso had the originality and the courage to break away from his earlier and more easily understood style and introduce in the first place the influences of pre-Roman Iberian sculpture in the three figures on the left and later the fierce distortions of the two on the right. Their mask-like faces are related to his newly discovered enthusiasm for Negro sculpture and their strong barbaric structure can be traced to West African masks.

IV *STILL LIFE* PARIS, 1908
Oil on canvas. 63¾ in. × 51¼ in.
KUNSTMUSEUM, BASLE

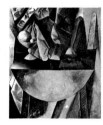

Picasso never allowed himself to become completely absorbed by one influence and, in contrast to the powerful turbulent effect that Negro sculpture was having on his work at this time, we find in this composition a classical sense of order and geometric simplifications which Cézanne had shown in his analysis of forms in nature. The sobriety of the greens and earth colours are reminiscent of Cézanne and also herald the coming discipline of Cubism.

V *PORTRAIT OF KAHNWEILER* PARIS, 1910
Oil on canvas. 39½ in. × 28½ in.
THE ART INSTITUTE OF CHICAGO
(GIFT OF MRS. GILBERT W. CHAPMAN)

The breaking up of the forms of objects so as to rebuild their structure with new significance became a basic principle of Cubism between 1909 and 1912. At this time Picasso painted six portraits of friends—Pallares, Sagot, Braque, Vollard, Uhde and Kahnweiler. Although it was rare for Picasso to require the presence of his model, Kahnweiler well remembered the interminable hours he had to pose. Being the last of this series and painted at the height of the analytical cubist period, it is however the least compromising towards the sitter.

VI *THE AFICIONADO*
SORGUES, 1912
Oil on canvas. 53¼ in. × 32½ in.
KUNSTMUSEUM, BASLE

Although Picasso had established in Cubism a style which appeared to be abstract rather than representational he never lost contact with his subject matter. We find in this composition that covers the whole canvas with a rectilinear pattern not only a man seated at a table on which is placed a glass and a bottle but also clues to the topical interests that had inspired the painting; for instance, the newspaper 'le Torero' and the flag with 'Nimes' written across it.

VII *WOMAN IN AN ARMCHAIR* PARIS, 1913
Oil on canvas. 58¼ in. × 39 in.
BY KIND PERMISSION OF DR. INGEBORG PUDELKO EICHMANN, FLORENCE

This painting is of great importance in the development of Cubism. It was acclaimed later by the Surrealists as a marvellous example of 'fantastic art'. There is a return to greater variety in colour and a new disquieting relationship between abstraction and sensuality and also between dreamlike images and reality.

VIII *MOTHER AND CHILD*
PARIS, 1921
Oil on canvas. 55⅞ in. × 63¾ in.
THE ART INSTITUTE OF CHICAGO

Between 1920 and 1922, about the time of the birth of his eldest son Paulo, Picasso chose a style of monumental classical character to paint nudes and pictures of mother and child. The bold statuesque modelling of the figures, excluding all sentimentality, is related to certain nudes of 1906, and the use of the sea as a background often recurs throughout his work.

231

IX *STILL LIFE* PARIS, 1924
Oil with sand on canvas.
56 in. × 79¾ in.
SOLOMON GUGGENHEIM
MUSEUM, NEW YORK

In spite of changes in style, the still-life remained a constant theme to which Picasso often returned. This is a fine example of a series of large paintings in which he developed with great freedom of form and brilliant colour the technical discoveries of Cubism.

X *THE THREE DANCERS*
PARIS, 1925
Oil on canvas. 84½ × 56¼ in.
TATE GALLERY, LONDON

This picture—to which the artist attached great importance, painted immediately after the death of an old friend, marks a turning point in Picasso's work by its sudden outburst of violence. It is the first painting in which the well-ordered, static serenity of the preceding years gives way to violent movement and distortions that herald even greater and more disturbing liberties.

XI *TWO WOMEN (LA MUSE)*
PARIS, 1935
Oil on canvas. 51 in. × 65 in.
MUSÉE D'ART MODERNE, PARIS

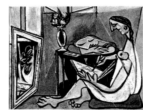

There are several pictures of this period of girls sitting together reading or painting. This in particular shows a masterly combination of colour and linear arrangements that give solidity to the figures and a sense of depth and space to their surroundings. The face of the girl watching her companion drawing is a convincing example of the ease with which he can induce us to accept the irrational placing of the two eyes on the same side of the face.

XII *BATHERS WITH A TOY BOAT* LE TREMBLAY-SUR-MAULDRE, FEBRUARY, 1937
Oil, charcoal and chalk on canvas.
51 in. × 76¾ in.
BY KIND PERMISSION OF
PEGGY GUGGENHEIM, VENICE

The cubist technique of reconstructing human anatomy according to the artist's choice has here been carried further with bold and significant invention. The rounded grape-like clusters of the female bodies are given monumental proportions by the minute faces drawn on the distended surfaces of their heads, but the scene is dominated and given a legendary atmosphere by the appearance from beyond the horizon of a head, simple and godlike.

Picasso's main preoccupation in the summer of 1937 had been the great composition *Guernica* (Fig. 3), painted as an angry protest against the bombing by Franco of the capital of the Basques in the Spanish Civil War. In the earlier studies he had used subdued, acid hues or monochrome as in the great mural itself. But in this an explosion of strident colour is used to enhance the despairing misery and terror in the woman's face.

XIII *WOMAN WEEPING*
PARIS, OCTOBER, 1937
Oil on canvas. 23½ in. × 19¼ in.
PRIVATE COLLECTION, LONDON

On the evidence of preliminary drawings made early in June it seems certain that this painting reflects Picasso's dismay and anger at the arrival of German troops at Royan on the Atlantic coast of France where he was staying. The power of the anatomical inventions and their monumental solidity is increased by the acid colour. The insolent eyes, distended belly, aggressive swing of the breasts suggesting the movement of a swastika and the squat legs with their monstrous feet make this terrifying female a disquieting image associated with catastrophic events.

XIV *WOMAN DRESSING HER HAIR* ROYAN, MARCH OR JUNE, 1940
Oil on canvas. 51¼ in. × 38⅛ in.
BY KIND PERMISSION OF MRS.
BERTRAM SMITH, NEW YORK

XV *THE COIFFURE*
PARIS AND VALLAURIS,
MARCH 1954
Oil on canvas. 51⅝ in. × 38¼ in.
BY KIND PERMISSION OF
GALÉRIE ROSENGART, LUCERNE

The treatment here of the female nude is an example of Picasso's continued use of cubist technique which allowed all sides of an object to be shown simultaneously. The boy holding the mirror, however, receives a more simple treatment without upsetting the unity of the composition.

XVI *THE RAPE OF THE SABINES* MOUGINS 1962
Oil on canvas. 38¾ in. × 52 in.
MUSÉE D'ART MODERNE, PARIS

Picasso was always intrigued by classical subjects. He transformed them freely to express his own emotions in a way that removes them from the past and gives them contemporary significance. Aggression by the strong and the abuse of the weak are balanced together in the movement of this brilliant composition.

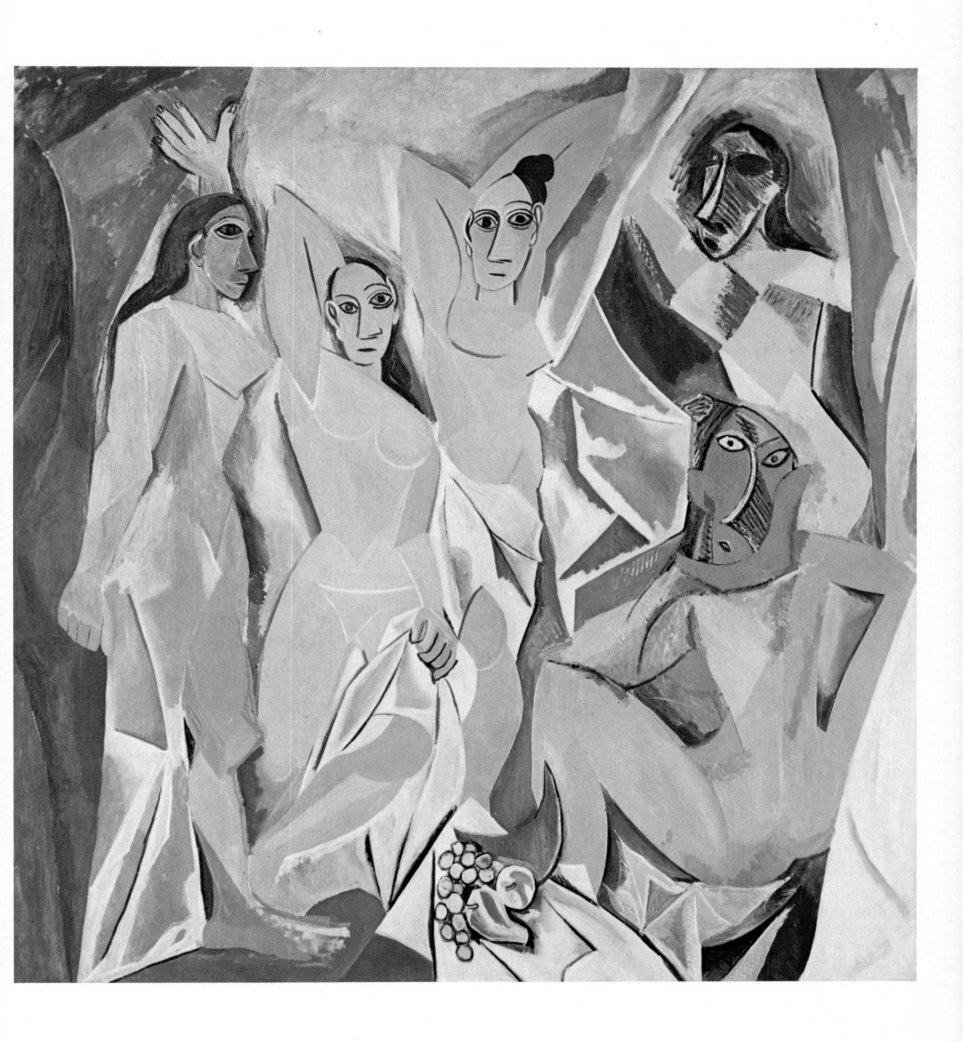

V

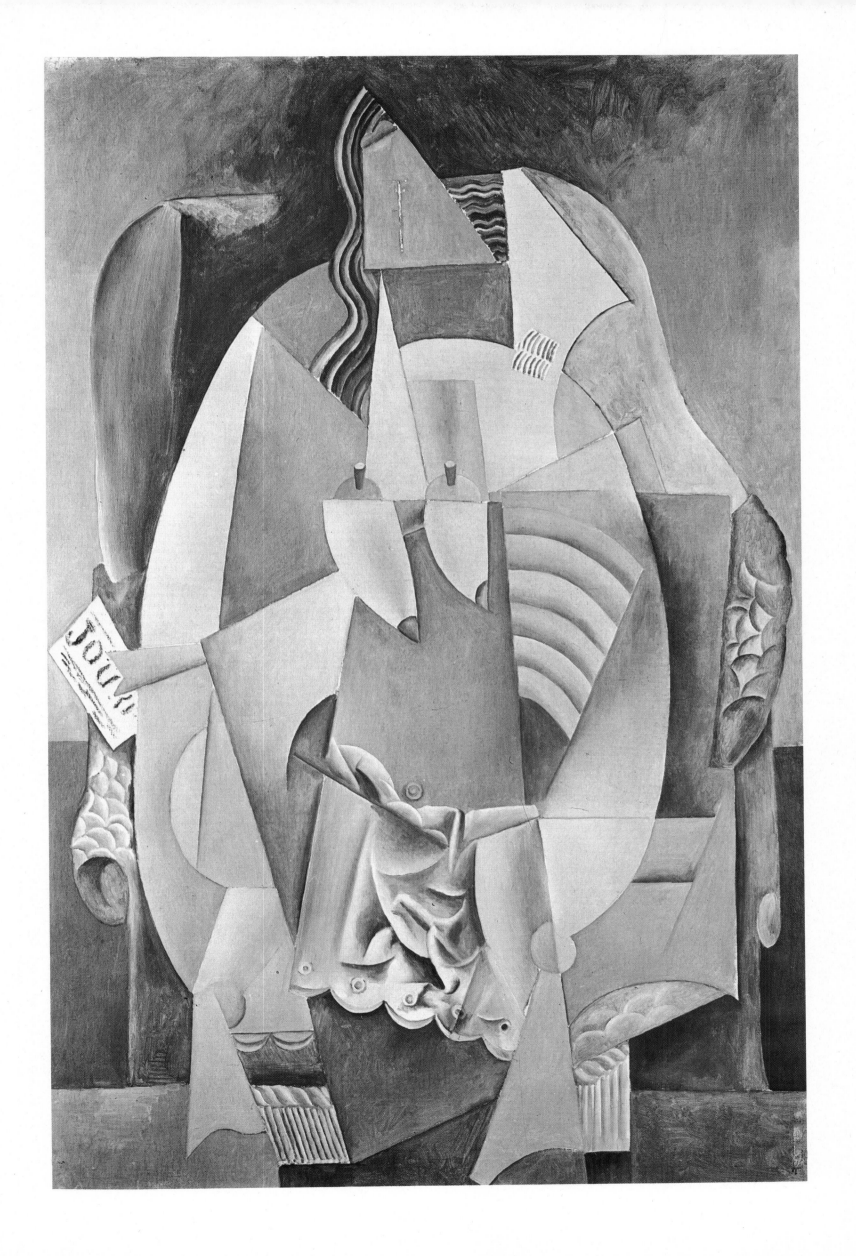

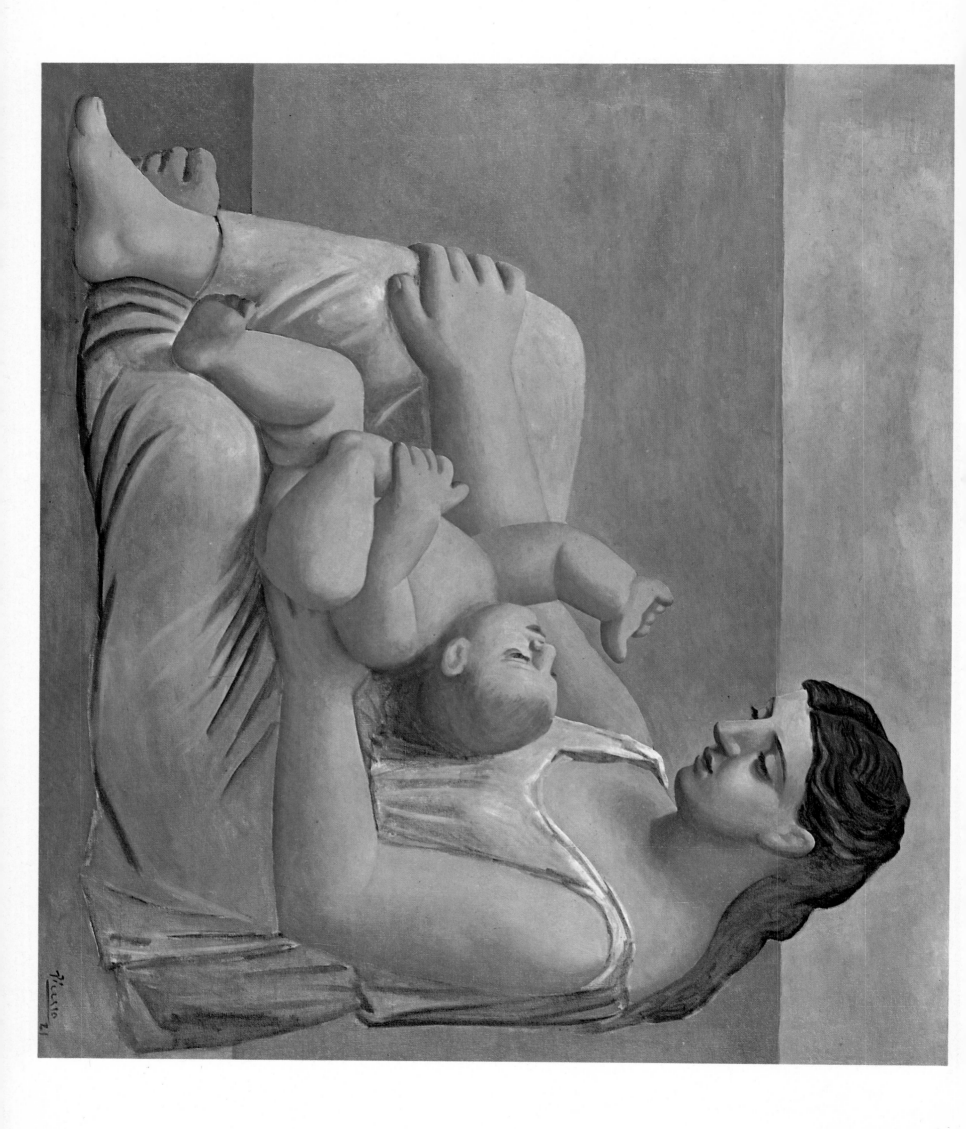

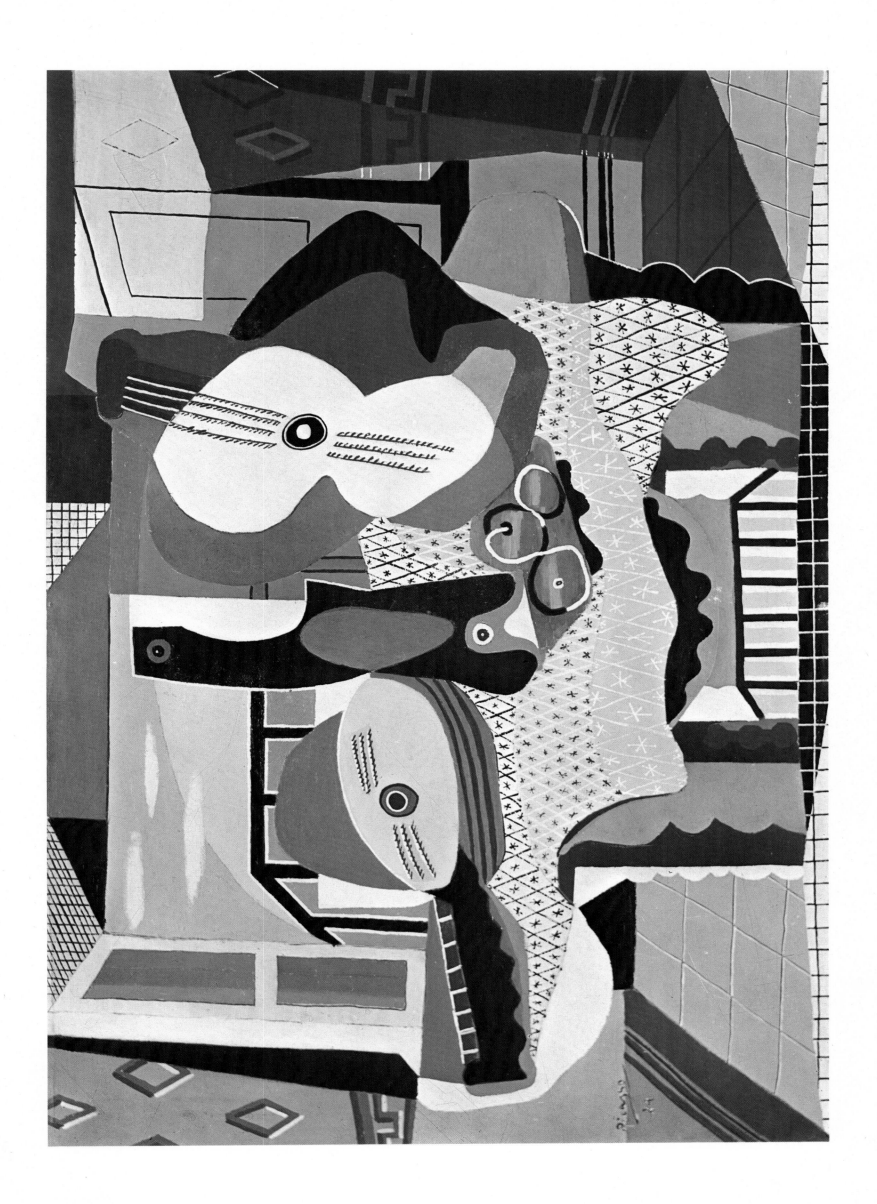

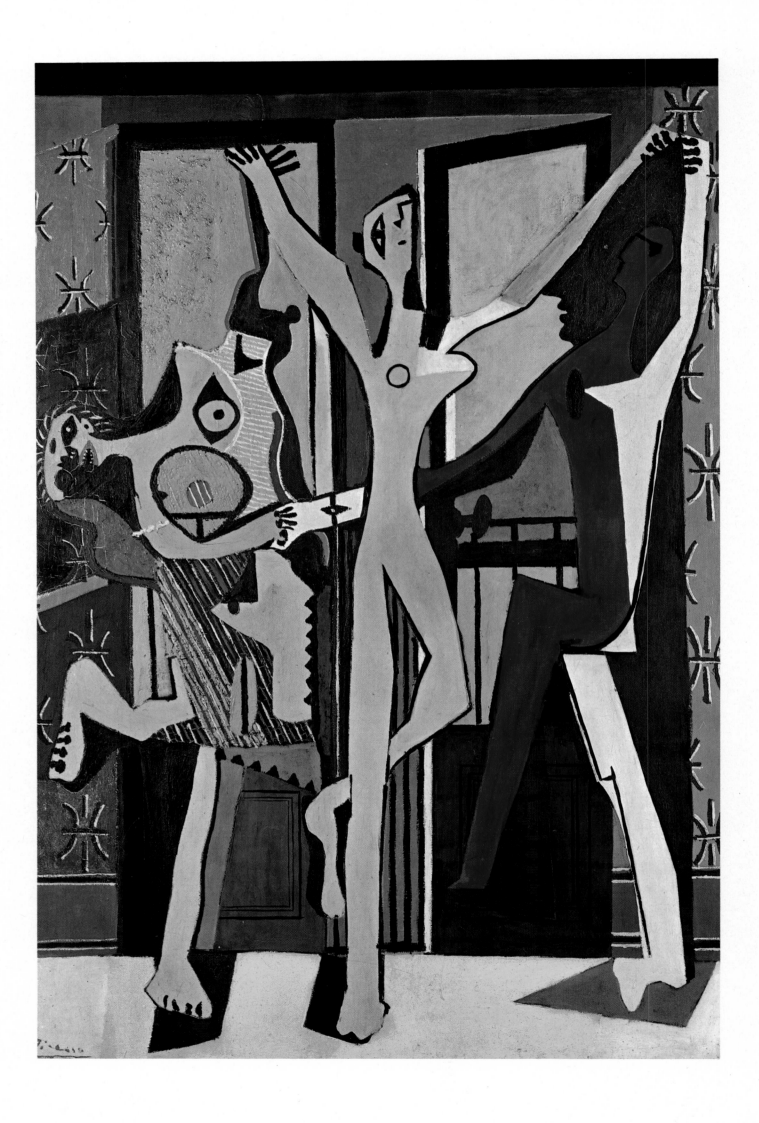

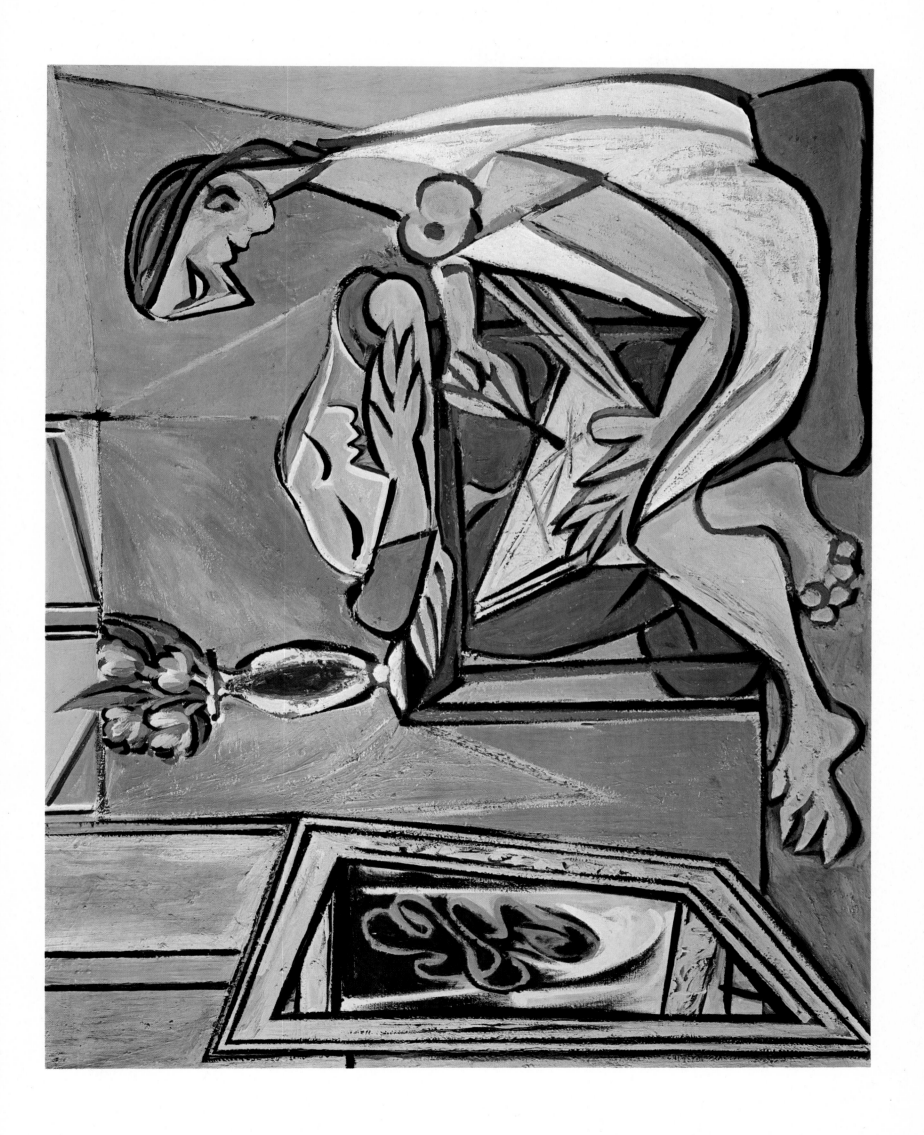

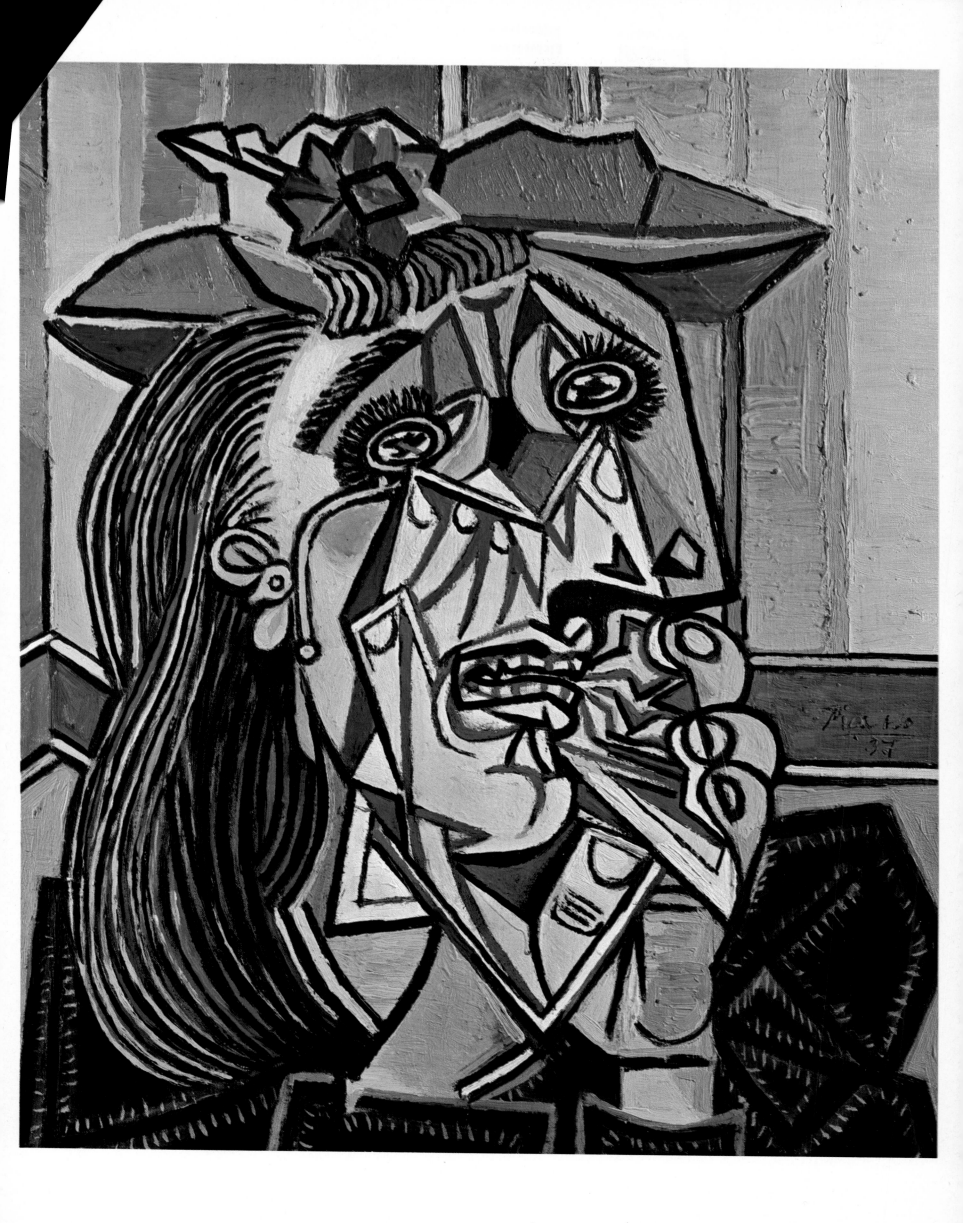

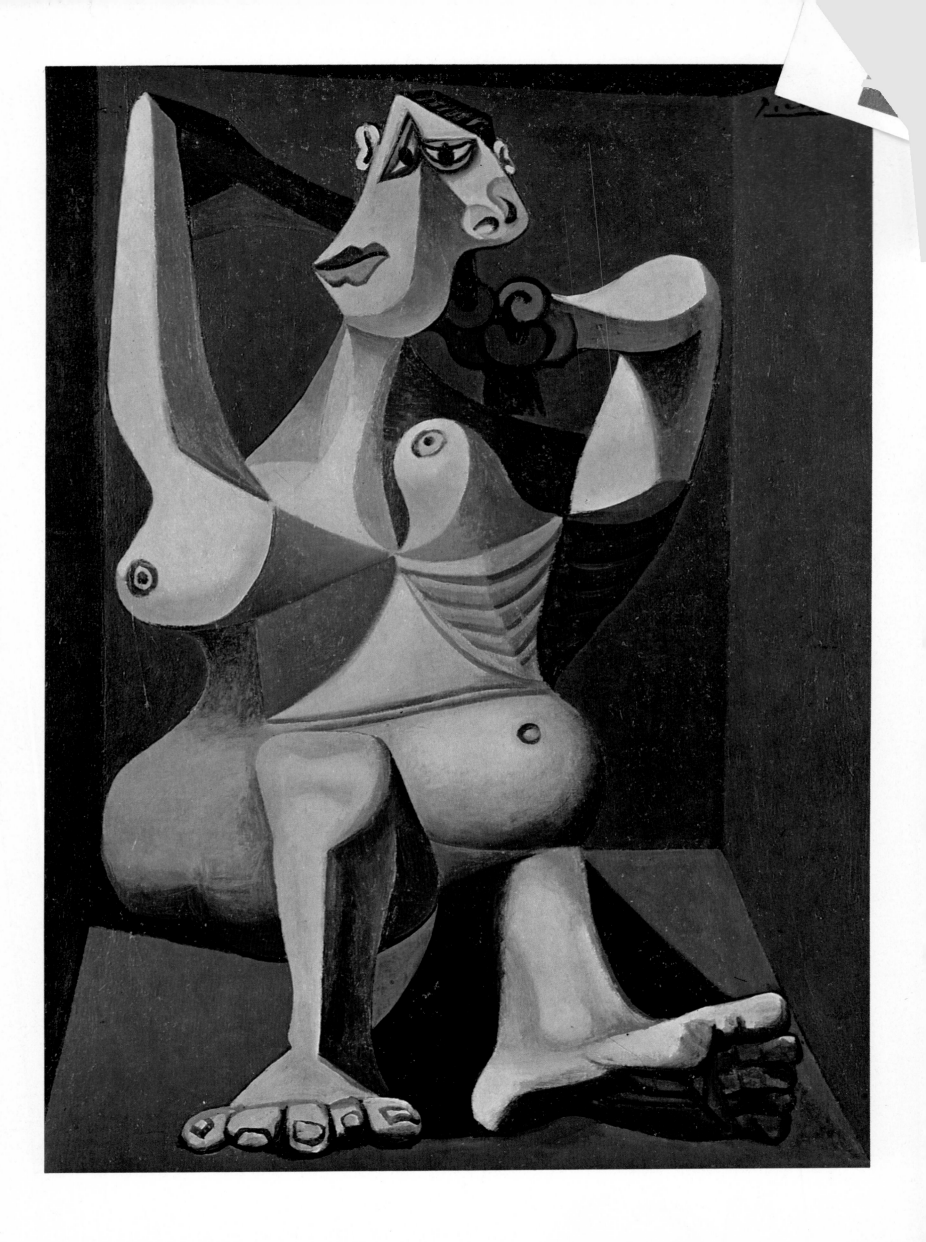

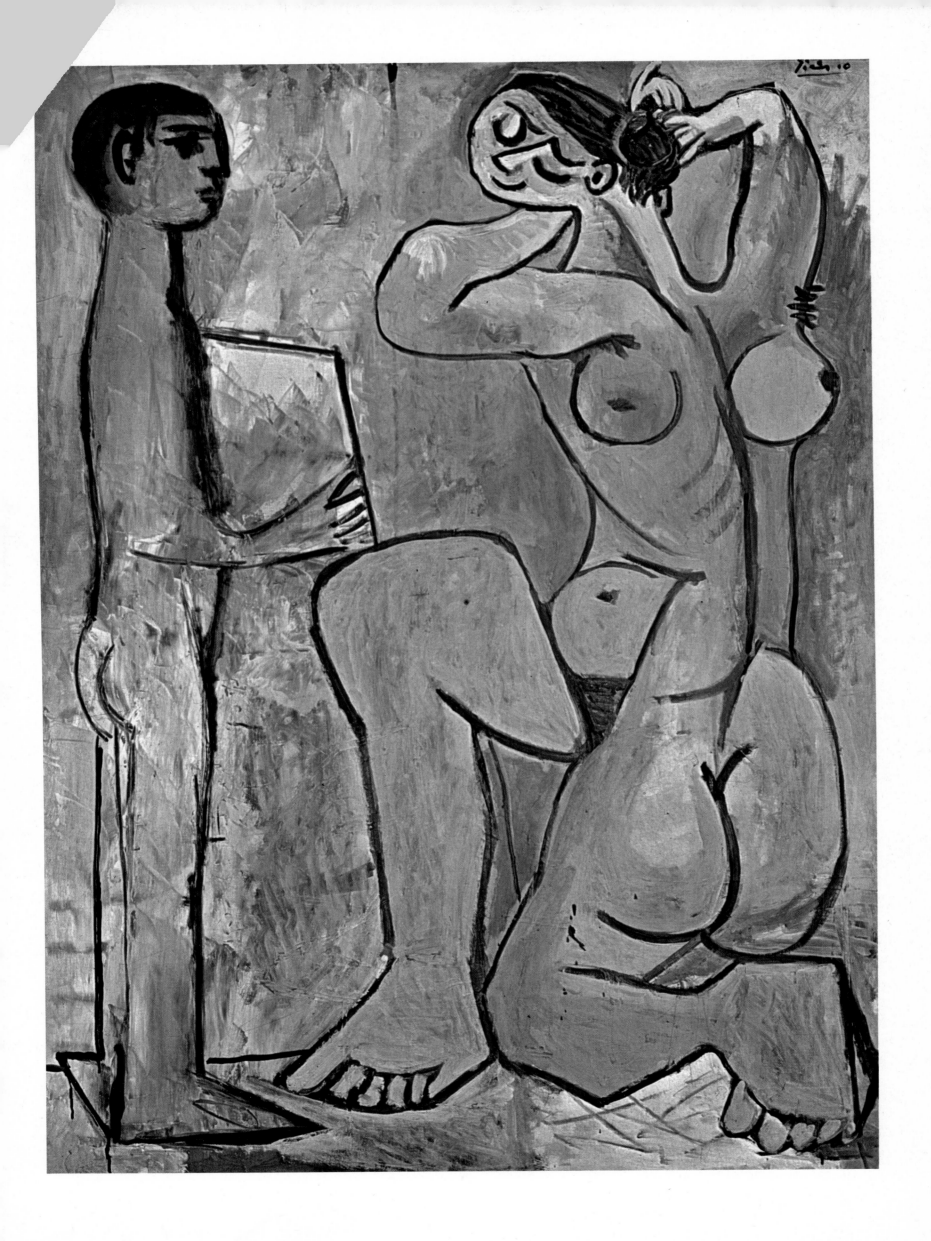

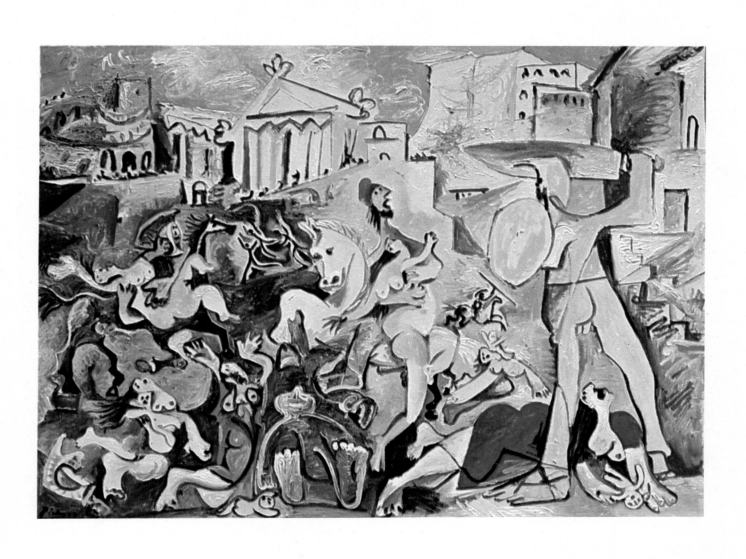

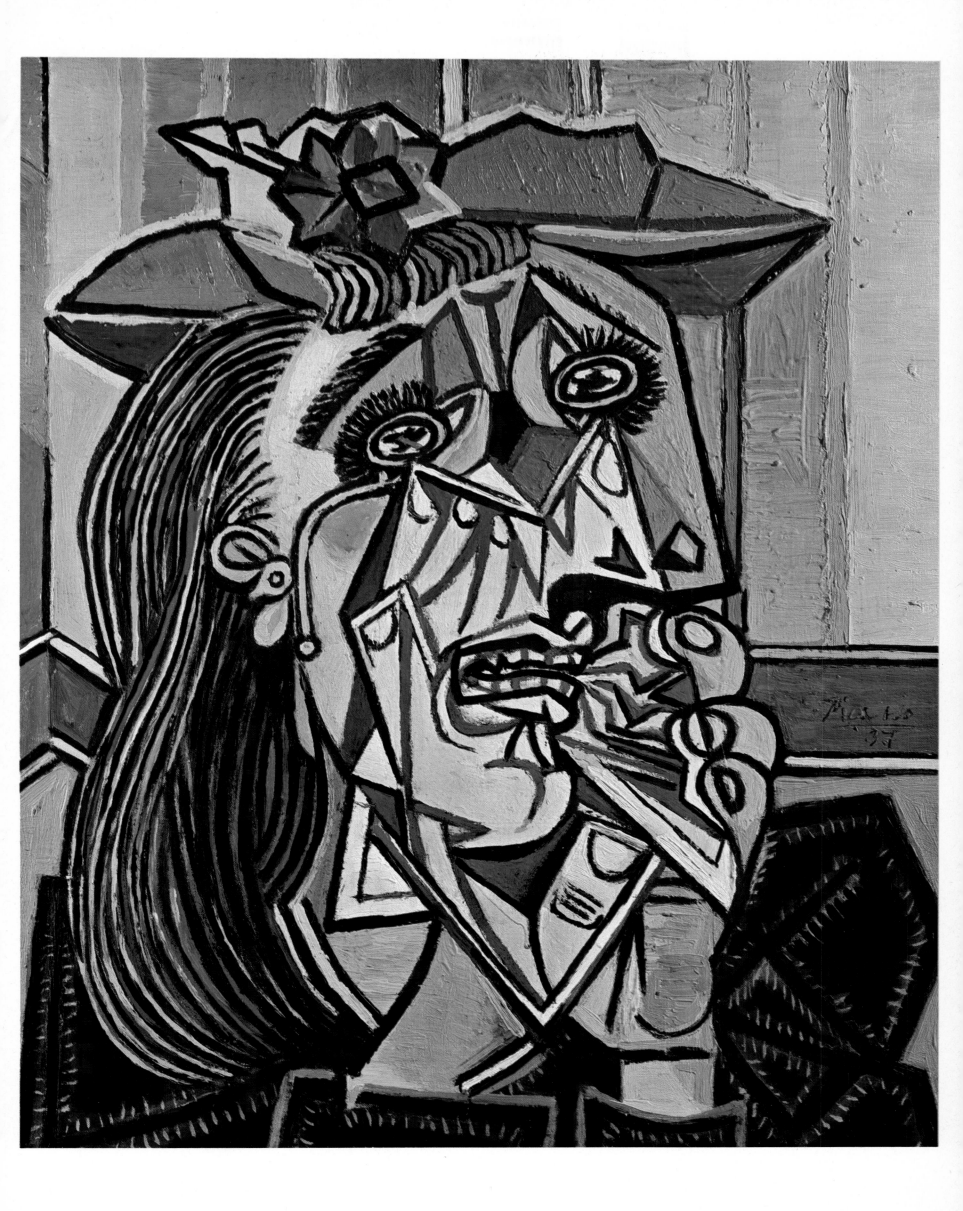

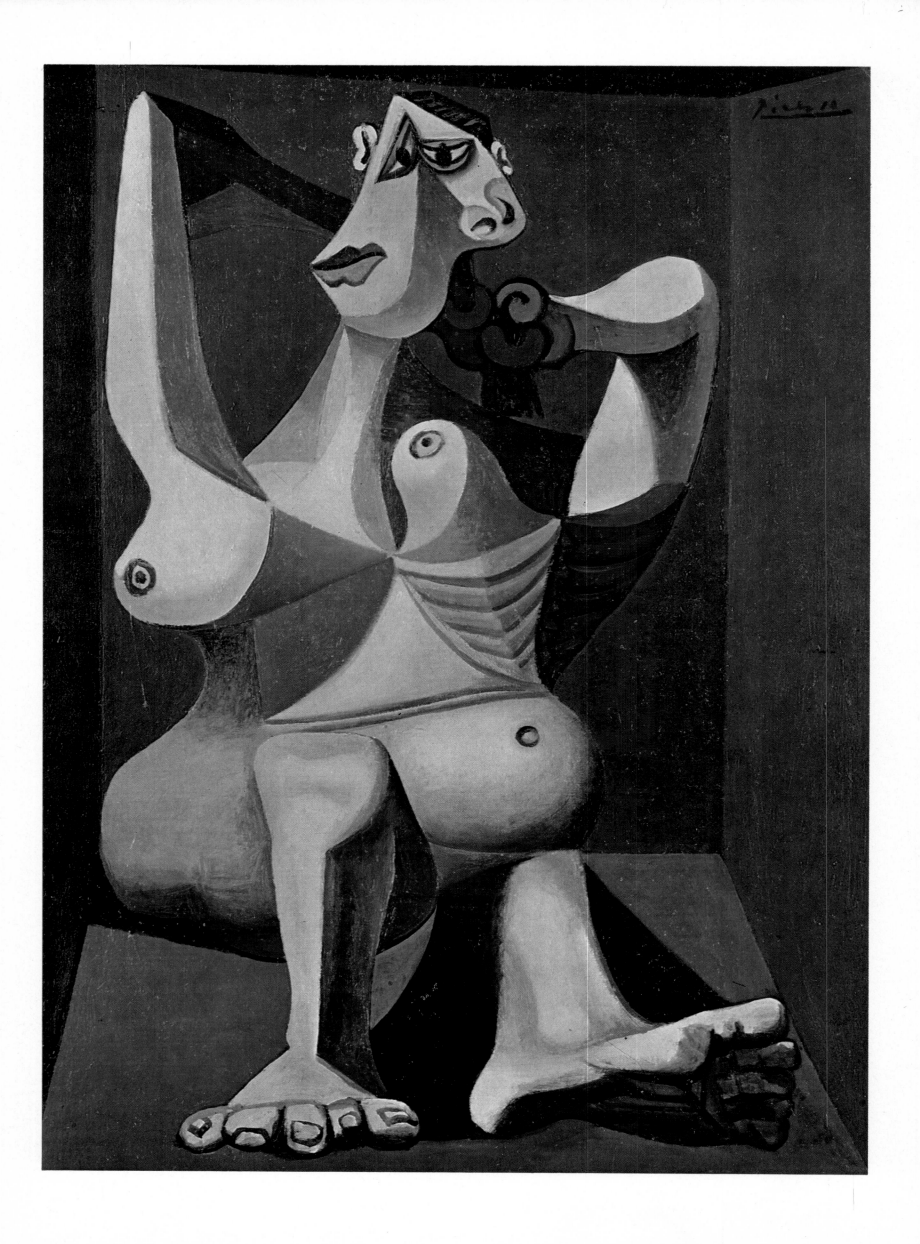

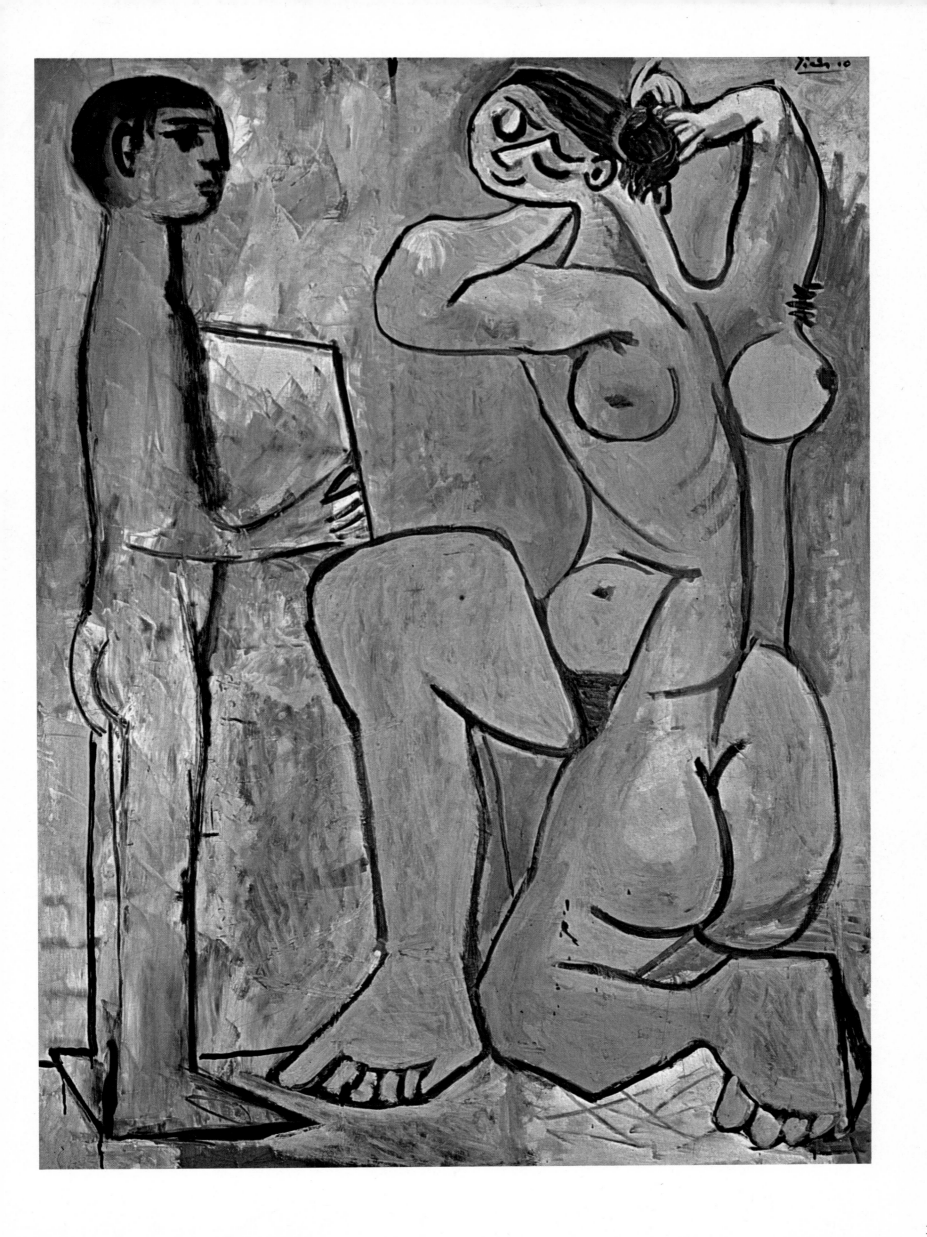

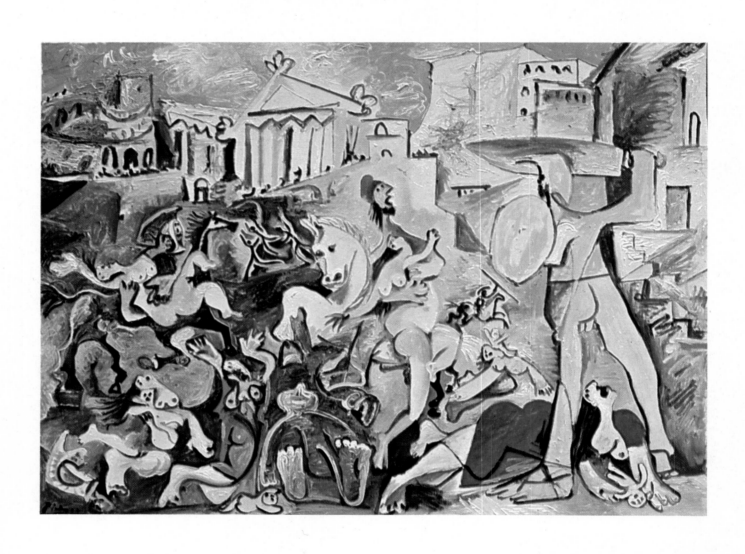